AdvertisingAnnual2008

Published by **Graphis** Inc. | CEO & Creative Director: B. Martin Pedersen | Publishers : B. Martin Pedersen, Danielle Baker | Editor : Anna Carnick
Graphic Designer: Yon Joo Choi | Production Manager: Eno Park | Support Staff: Rita Jones, Carla Miller | Design/Production Interns: Malia

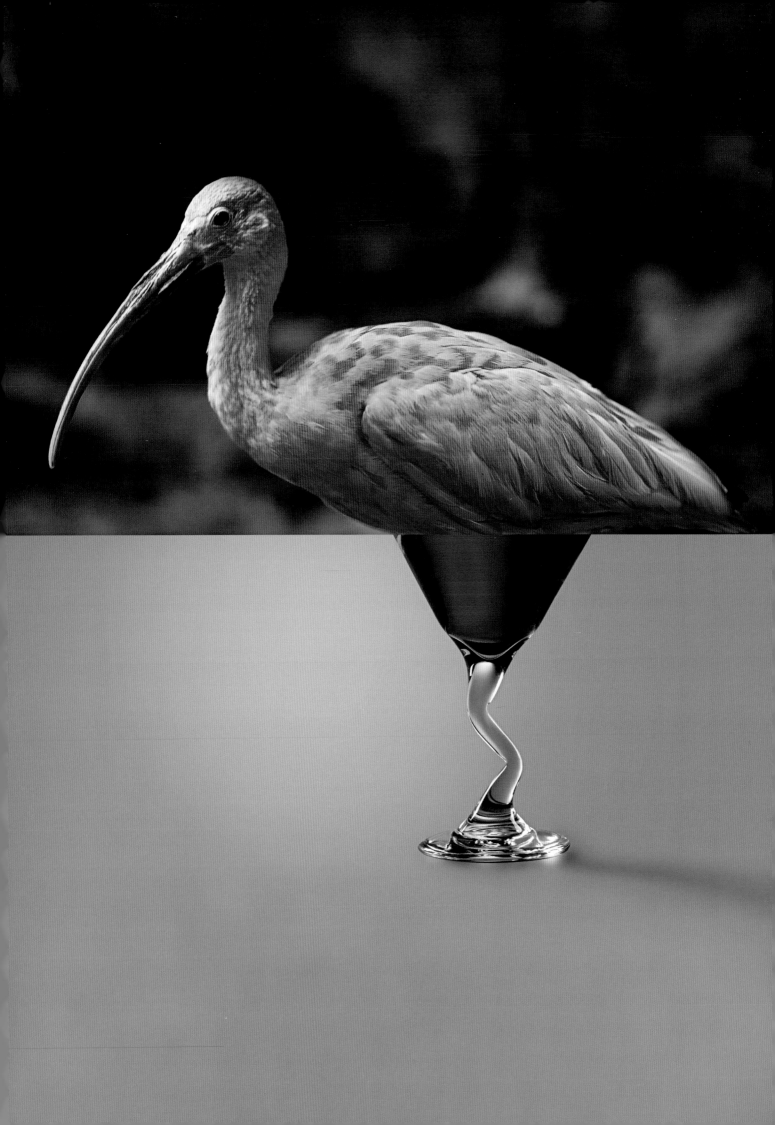

Contents

Previous Spread:
image from ad by Sibley/Peteet Design
Opposite Page:
image from ad by Jay Advertising

Since 1944, Graphis has been a beacon for outstanding work in the visual arts. With the introduction of the Annuals, each piece selected for inclusion was always considered an award winner. This year, we further recognize any piece included in the Annuals as a Gold Medal winner, and a limited few as Platinum Award winners, with accompanying certificates and awards. We congratulate and thank each and every one of our talented contributors for the amazing work we continue to see every year, and proudly present you with this year's winners.

Goodby, Silverstein & Partners: The Comcast Campaign

Project: The Comcast Campaign
Account Director: Chad Bettor
Art Director: Dave Muller
Creative Directors: Jamie Barrett and
Mark Wenneker
Designer: Claus Due
Photographer: Tom Nagy and stock

Print Producer: Hillary DuMoulin
Writer: Rus Chao
Client: Comcast
Goodby, Silverstein & Partners
720 California Street
San Francisco, California 94108
United States

Q&A with Senior Copywriter Rus Chao

What was the problem?
Comcast was launching their highest high-speed Internet connection. In fact, the connection is so fast, Comcast was afraid people would see it as overkill.

What was the client's directive?
Give their customers a reason to want a connection this fast.

What was your solution?
Tell consumers that even big files can be downloaded fast.

How did this project evolve from a concept into a finished project?
We wanted to make the visuals graphically stunning to convey the sophistication of this technology. But at the same time, we wanted to make them humorous to fit in with the rest of the brand work. We were able to achieve both with some amazing photography by Tom Nagy.

What is your definition of good Advertising?
Anything that makes me jealous.

What is your agency's greatest professional achievement?
Got Milk?

How do you establish an agency environment that fosters creativity?
From the boss all the way to the intern, hire people who are actually creative.

How important are research and planning in creating great ads?
Research and planning play a big role, but the best ideas always come from the gut.

Do you invite the client into the process?
Making the client feel a part of the process always helps you sell work.

What part of your work do you find most demanding?
Goodby's standard of work. But that's a good thing.

When you take on a project, how do you insure success?
Work till it's great.

Why should a client come to you, and what do you feel your agency offers?
The work this place does speaks for itself.

Who do you most admire in the Advertising profession, past or present?
Jeff Goodby.

Name a specific ad or campaign by one of your peers that you admire.
Right now it's the Skittles and Starburst work.

What is your creative approach and/or philosophy?
Make it funnier.

Is there any subject that should be off-limits to Advertisers?
Everything should be fair game during the creative process. What makes it to the client is a different story.

Do you consider Advertising to be an art, a science, or both?
Neither. It's dumb luck.

What is your prediction for the future of Advertising?
I keep hearing about this internetts thing. But we'll have to wait and see.
For more information, please visit *www.gspsf.com* and *www.comcast.com*.

Research and planning play a big role, but the best ideas always come from the gut.

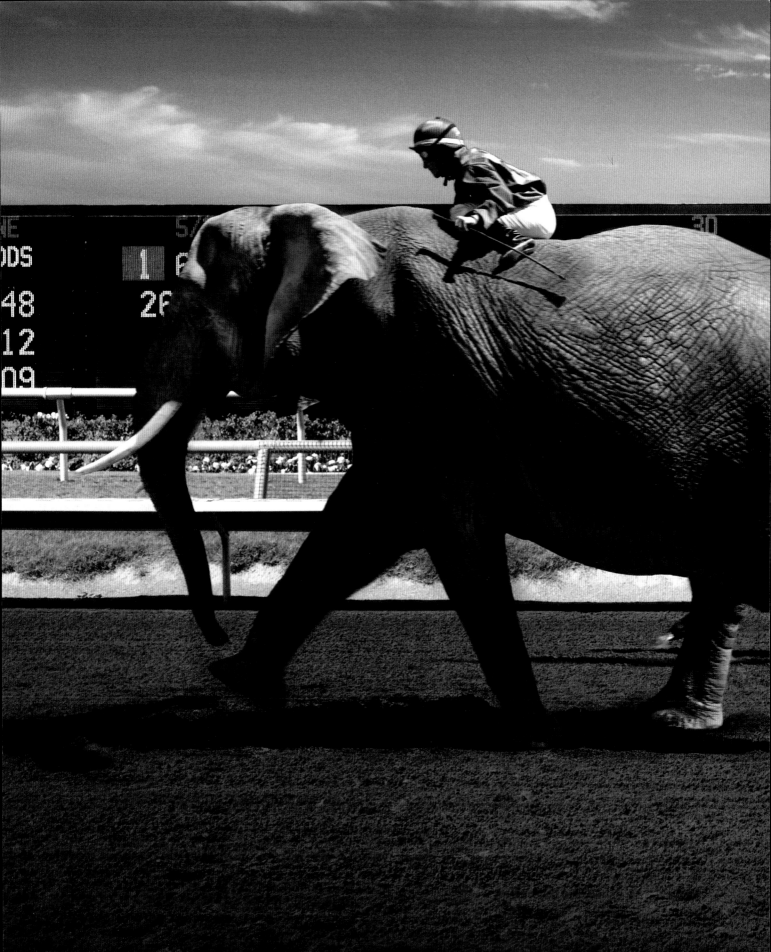

Project: So You
Art Director: Naomi Cook
Creative Directors: Jeff Hopfer and Mike Renfro
Photographer: Stan Musilek
Print Producer: Brenda Talavera
Writer: Bennett Holloway

Client: Thomasville
The Richards Group
8750 N. Central Expressway
Ste 1200
Dallas, TX 75231
United States

A Conversation with Writer Bennett Holloway and Art Director Naomi Cook of The Richards Group.

What was the problem?
Thomasville in recent years has been seen as an old, stodgy brand that you would only put in your grandmother's living room. They wanted to appeal to a newer, younger audience as a fashionable brand.

What was the client's directive?
Create Advertising that will renew Thomasville's image as a fashionable brand, keeping in mind that the furniture-buying target consists primarily of women.

What was your solution?
Create furniture ads that look like fashion ads. We wanted to stand out in the shelter publications from all of the ads that are nothing but room shots, so we just showed the details of the furniture that make it fashionable. It's a truth that women decorate their homes the way they accessorize their bodies. Not many furniture companies have picked up on that in their Advertising.

How did this project evolve from a concept into a finished project?
This was one of those once-in-a-lifetime hole-in-ones, where the same campaign we pitched the business with is what we've been producing for the last year and a half – zero revisions. Once they signed off on the idea, we found the Photographer Stan Musilek, who has the perfect brain for this campaign. He's a fashion shooter with an incredibly mathematical mind, which helps him to get all the details lined up in the two shots perfectly, but still maintain the art of the piece.

What is your definition of good Advertising?
Within the bombardment of messages that are thrown at us daily, good Advertising is something that makes you stop, pay attention and think of something in a way you never have before.

How important are research and planning in creating great ads?
Research and planning are crucial in making sure you are saying the right thing to the right audience. It is useful as fodder to come up with insightful ideas that will also resonate with that audience.

Do you invite the client into the process?
With Thomasville, we've been lucky that our client is very fashion-savvy and has totally embraced the campaign for what we wanted it to be. They've helped us identify upcoming trends so that our ads stay on top of the fashion world.

What part of your work do you find most demanding?
The juggling act. And trying to avoid the feeling that any moment they'll find out we suck.

When you take on a project, how do you insure success?
You can't. Creativity is not black or white – it's gray.

What inspires you?
Our lives outside of Advertising. In this job, it's easy to get so caught up you realize you just don't have one. Good Advertising is inspired by real life. Otherwise you're just talking to other Advertising people.

Who do you most admire in the Advertising profession, past or present?
The person who makes more coffee when they take the last cup.

Name a specific ad or campaign by one of your peers that you admire.
"Dogs rule." That campaign is so simple. It focuses more on a connection with the target than pushing a product. Bennett would like to point out that cats also rule.

What is your creative approach and/or philosophy?
There's not a formula. You just work on something until you feel like you have nothing and then you look down and there it is.

Is there any subject (politics, religion, etc.) that should be off-limits to Advertisers?
Not if done tastefully, and with the right motives.

Do you consider Advertising to be an art, a science, or both?
Our part is an art, but without all the other people involved – media, planning, etc. – who have perfected their science, it would fail.

What is your prediction for the future of Advertising?
Your guess is as good as ours.
For more information on the Richards Group and Thomasville, please visit *www.richards.com* and *www.thomasville.com*.

Good Advertising makes you stop, pay attention and think in a way you never have before.

LKM: Catholic Radio Campaign

Project: Radio Tower
Art Director: Jim Mountjoy
Creative Director: Jim Mountjoy
Print Producer: Sarah Peter
Writer: Ed Jones

Client: Catholic Radio
LKM of Charlotte, North Carolina
6115 Park South Drive, Suite 350
Charlotte, NC 28210
United States

A Conversation with LKM's Art and Creative Director, Jim Mountjoy

What was the problem?
Charlotte, North Carolina has an ever-growing number of Catholics, but this booming Bible-belt city has never had a Catholic radio station (The city is and always has been predominantly Protestant, and some southern Baptist types here still think of the Catholic Church as "the whore of Babylon").

What was the client's directive?
Introduce our new Catholic radio station in this melting pot of a market in such a way that it appeals to faithful Catholics, fallen away Catholics and non-Catholics alike. If we just attract faithful Catholic listeners, chances are we won't succeed.

What was your solution?
We simply took one of the great stereotypes about Catholicism (which happens to be true!), applied a little creative jujitsu, and turned a perceived negative into a positive. Hopefully, humor can disarm even the most rabid of anti-papists.

How did this project evolve from a concept into a finished project?
The Art Director, who is a fallen away Catholic, coincidentally stumbled upon the perfect stock photo which happened to fit the concept AND the budget (about $10). Or was it divine intervention?

What is your definition of good Advertising?
Relevant to a need, original in its presentation and resonant.

What is your agency's greatest professional achievement?
Empathy. Because you make great work possible not by accident but by first understanding clients' needs and expectations, then exceeding them.

How do you establish an agency environment that fosters creativity?
Respect of others' ideas and viewpoints. Embracing an atmosphere that welcomes endless curiosity and a passion to help solve problems. And try to stay calm and focused when the kitchen gets hot.

How important is research/planning in creating great ads?
It's first and foremost. To act otherwise destroys possibilities to discover and be original, and, most importantly, to be relevant.

Do you invite the client into the process?
Not as much as we should…Creativity is our business, and we would all be better served if we dedicated more of that energy on relationship development - on ourselves.

What part of your work do you find most demanding?

Administrative.

When you take on a project, how do you insure success?
Don't assume you know the answer or even the right questions out of the gate. Be innocent and open to possibilities.

Why should a client come to you, and what does your agency offer?
We fervently believe in the power of truth and what a few people with a great idea can do. But we also work hard to see our suppliers, clients and ourselves as good people with great intentions. We don't work for each other, we work with each other.

What inspires you?
Staying curious inspires me. I also firmly believe that if you are not interesting to yourself how can you be interesting to others? So I have a personal mantra: A.Y. It means Amaze Yourself. It requires you to take large and small acts that you would not normally do and go do them. Things you fear, don't understand or know nothing about. Things that I would not normally do. It makes it more challenging and interesting for me to hang out with me. A.Y.

What do you most enjoy about the Advertising profession?
Meeting and working with passionate people who bring art to commerce and ideas to life.

Name a specific ad or campaign by one of your peers that you admire.
The Economist's campaigns are enviable.

Is there any subject that should be off-limits to Advertisers?
None that come to mind. It's the caliber of taste applied to any subject, the purpose it serves, and, as any good actor will tell you, "timing," that all enhance or diffuse volatile subject matter.

Do you consider Advertising to be an art, a science, or both?
It is both. Art is a disciplined process of discovery. Cannot the same be said of science?

What is your prediction for the future of Advertising?
Change has caused some people to feel as though they are being left behind and others to feel they are riding the crest. I vacillate with these feelings moment to moment. But at the end of the day, the world will still desire a relevant, original and resonant idea. I do think the future of Advertising is more interesting than ever. But I choose to focus on the present. To paraphrase Emerson, he said you cannot change the past or predict the future. So take hold of the present. If we become more empathic to a world that is feeling off balance and provide ideas that are relevant then a bright future is possible. Use your fear and make change a positive thing in your life. Start by practicing change on ourselves. A.Y.

For more information, please visit
www.lkmads.com and *www.catholicradioassociation.org.*

You make great work possible not by accident but by first understanding clients' needs and expectations, then exceeding them.

Project: Infinite horizon
– Molecular Body and Elastic Body
Account Director: Christine Man
Art Directors: Lee Pui Ho and
Cetric Leung
Artist: Lee Pui Ho
Creative Directors: Danny Chan,
Cetric Leung and Eliza Yick
Design Director: Cetric Leung
Designer: Lee Pui Ho
Executive Creative Director: Cetric Leung

Illustrator: Lim Peng Yam
Photographer: Daniel Zheng
Print Producer: Hillary DuMoulin
Writers: Danny Chan, Antonius Chen,
and Eliza Yickv
Client: Y+ Yoga Center
Cetric Leung Design Co
1504 Valley Centre
80-82 Morrison Hill Road
Hong Kong
Hong Kong

Q&A with Art Director Cetric Leung

What was the problem?

Established in 2003, Y+ Yoga Center provides members with accomplished international yoga instructors and a contemporary setting. Currently, it has 10,000 members at its centers in Shanghai and Hangzhou, China, and offers a full variety of classes, workshops and specialty yoga programs. Over the years, Y+ introduced an "all-dimensional yoga life concept," including five principles of exercise: relaxation, health preservation, breathing and diet. Such principles are the basis for practitioners to fully acquire both physical and spiritual nourishment. Yoga is a good way to unleash the body's inner energies and to achieve new highs, regardless of the practitioner's experience. The challenge of this campaign was to introduce the concept of yoga as not only physical training, but an opportunity to discover oneself.

What was the client's directive?

To build a community through health, wellness and yoga at Y+.

What was your solution?

To encourage everybody to discover themselves through yoga. To practice with empathy and willpower, opening the heart to enjoy the inner peace yoga can bring.

The theme " Infinite Horizon" inspires self-reflection.

How did this project evolve from a concept into a finished project?

About the concept: Yogic people are individualistic, but share a common belief. Yoga isn't about comparison or competition, but about achieving one's own standard of excellence. At Y+, we help one pursue his own goal and feel the boundless horizon of yoga. Ride on the platform of "Infinite horizon." We came up with different print ad creative to depict this concept from the perspective of the yoga practitioner.

About the art direction and execution: All images are liquefied in order to project the mind's eye of the yoga practitioner. Everything seems to flow in the mind. In the "Molecular Body" version, the visual is an illusion of the body in the moment in between being deconstructed and reconstructed. The bended body in the "Elastic body" version shows the force of unlimited willpower.

What is your definition of good Advertising?

I would like to see something unexpected but relevant to the brand or the product such as a strong, simple idea with artistic and abstract execution. Advertising which is rich in cultural context, and a reflection of life, may influence people's thinking.

What is your agency's greatest professional achievement?

In 2005, Shanghai FCB commissioned us for a total branding exercise. The client was Natural Beauty Group, a Greater China brand from Taiwan with significant presence in China. It has a complete range of cosmetic products as well as spa shops throughout the region. We demonstrated a strong conceptual idea and artistic craftsmanship, resulting in significant and prominent branding status for the client. We won over 30 local and international awards, from corporate identity Design to print Advertising, in one project.

How do you establish an agency environment that fosters creativity?

Chemistry is very important. I try to bring creative minds together. Beyond our own team, I invite different creative experts or fine artists to work with us on a project basis.

How important is research/planning in creating great ads?

A good strategic plan is the platform of marketing communication.

Do you invite the client into the process?

We really appreciate client involvement in strategy development.

When you take on a project, how do you insure success?

Of course, we need to understand the project: what is the problem and what's the solution? But it's most important we do something interesting.

Why should a client come to you, and what does your agency offer?

We build good relationships with our clients with creativity and flexibility. Our creative team deals with clients directly, closing the communication gap between agency and client.

What inspires you?

Inspiration comes from life...people and culture, good design, music, sports, books, art, movies…

Who do you most admire in the Advertising profession, past or present?

Lee Clow. He sees Advertising as not only business or commercial work, but as an art.

Name a specific ad or campaign by one of your peers that you admire.

The campaign is "Marriage, Beauty, Height" for McDonald's, created by Poh Hwee Beng and Eliza Yick. That was a print campaign McDonald launched in China at 2005. The idea and execution are unusual, and it's a long copy ad with nice art direction. The content considers the relationship between the new Chinese generation and traditional Chinese culture.

Is there any subject that should be off-limits to Advertisers?

It depends on the region; there are different systems in different countries. I appreciate the creative freedom in some western countries.

Do you consider Advertising to be an art, a science, or both?

It is more fun to consider Advertising as an art that surrounds us.

What is your prediction for the future of Advertising?

More personal. More interactive.

For more information, please visit *www.cld.com.hk* and *www.yplus.com.cn*.

We bring creative minds together.

Yield Plays Matchmaker for Lajitas

Project: The Ultimate Hideout
Art Director: Mike Coffin
Account Director: Marti Grandinetti
Designers: Gaby Hoey and John Tullis
Executive Creative Director: Mike Coffin
Executive Creative Strategist: Scott Murray

Illustrator: A. J. Garces
Writer: Ed Jones
Client: Lajitas, The Ultimate Hideout
Yield of Austin, Texas
823 Congress Avenue Suite 525
Austin, Texas 78701, United States

An Interview with Yield's Art Director, Mike Coffin

Tell us about "The Ultimate Hideout."

Lajitas is a tough sell. It's an expensive luxury resort located in the middle of nowhere. Vacationers can choose from any number of other luxury destinations that are better established and a whole lot easier to get to. When they came to us, Lajitas had already developed a positioning line we thought was terrific: "The Ultimate Hideout." However, the work that had been done for them didn't really live up to that promise. Their ads looked and sounded just like most of the other ads in the luxury resort category.

We recommended a shift in the emphasis away from "Ultimate" and more towards "Hideout." This allowed us to differentiate Lajitas from the hundreds of other "ultimate" luxury destinations by connecting with the majesty, history, mystery and mystique of one of the most amazing places on the earth: West Texas' Big Bend.

To their credit, Lajitas showed a great deal of courage and challenged us to do work that broke from the conventions of the category. We created a series of print ads based on old western dime novels.

Three months after launch, the campaign has already surpassed anyone's expectations. Resort bookings are up 200% versus the same period last year. And Lajitas is attributing both the leads for and the sales of four lakeside cottages to the magazine ads. The average price per cottage is $375,000.

What is your definition of good Advertising?

We try to avoid the C-words: cute, clever, catchy, and the mother of all C-words, creative. Instead we try to make our work smart, insightful, evocative, transformational.

After 23 years in this business, I've realized that everything we do comes down to two things:

Finding stories.

Telling them well.

Find the message that makes you relevant to your customers and articulate that message in a way that can't be ignored. So for me good Advertising is the right story, well told.

What is your agency's greatest professional achievement?

We're a young agency without a lot of history. It's way too early to get all retrospective. That being said, I'm very proud of the people that have chosen to work for us and the clients that have chosen to work with us.

How do you establish an agency environment that fosters creativity?

That's a pretty big question. Lots of ways.

We hire people that get it.

We look for clients that demand it.

We give our people the freedom to fail and try to stay the hell out of the way (easier said than done).

We don't use creative as a noun. It's not a department or a title. We expect creative solutions from everybody. Besides, if we call one group of folks The Creatives, what do we call everybody else? The Mundanes?

We never stop looking for new ways to foster creativity.

How important is research/planning in creating great ads?

It's essential. All good work is based on insights, simple human truths. Otherwise you just end up with shallow, self-indulgent crap.

Do you invite the client into the process?

Absolutely. Of course. At every level, but particularly at the outset. If you don't have enough respect for your clients to want them involved in the work, you need different clients.

What part of your work do you find most demanding?

Timesheets.

When you take on a project, how do you insure success?

By refusing to fail. Okay, maybe that sounds a little trite—like Greg Kinnear's character in Little Miss Sunshine. Sorry. The truth is there's no magic formula for success, no real guarantees. Persistence comes in handy, though. You just gotta keep plugging away.

What inspires you?

I really hate this question. Is there any way to answer this that doesn't sound pretentious? Final answer: Everything. Especially Graphis.

Who do you most admire in the Advertising profession, past or present?

Bill Bernbach.

Name a specific ad or campaign by one of your peers that you admire.

Altoids. Especially the early stuff.

The Economist campaign. Pick an agency on any continent. All of it is outstanding.

The Guinness Noitulove spot.

What is your creative approach and/or philosophy?

Stay curious. Work your ass off. Work with great people.

Is there any subject that should be off-limits to Advertisers?

If it's legal to sell, it should be legal to advertise.

Do you consider Advertising to be an art, a science, or both?

Bill Bernbach said it better than I ever could. "Advertising is fundamentally persuasion. And persuasion is an art, not a science."

What is your prediction for the future of Advertising?

Rumors of Advertising's demise have been greatly exaggerated. Media may change, but it's always been that way. There will always be companies. There will always be customers. And there will always be guys like us who play matchmaker by finding stories and telling them well.

For more information, please visit

www.yieldinc.com and www.lajitas.com.

Stay curious.
Work your ass off.
Work with great people.

GraphisGold&PlatinumAwardWinners

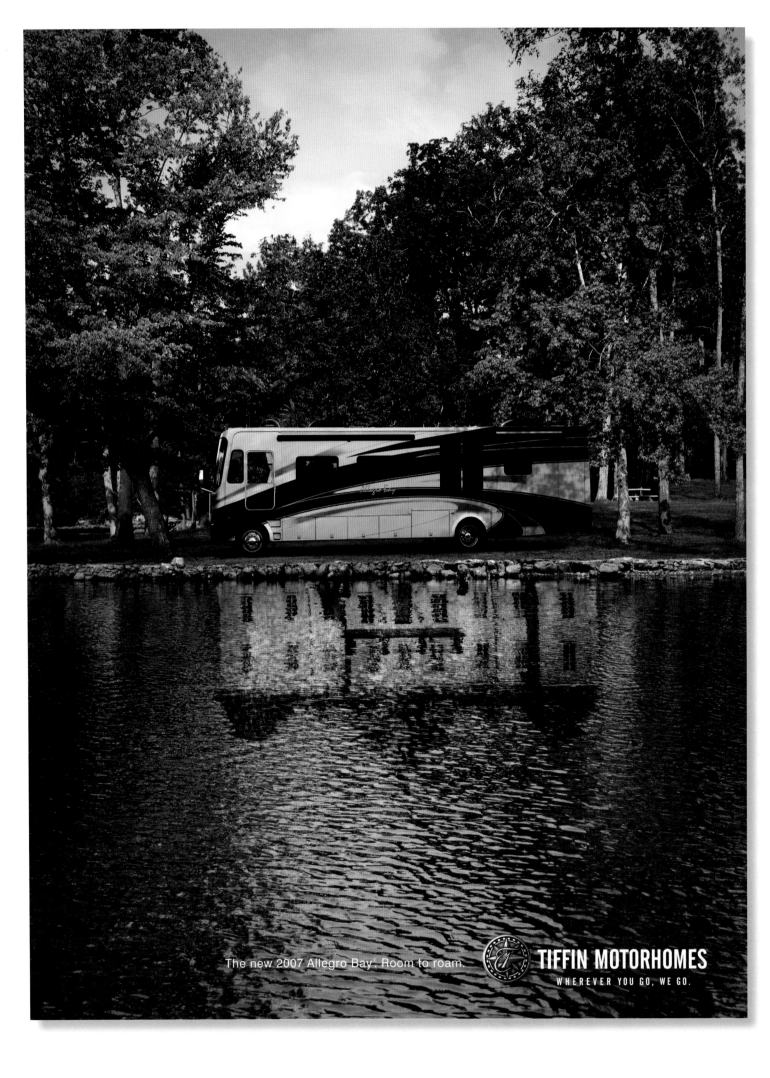

The new 2007 Allegro Bay™. Room to roam.

TIFFIN MOTORHOMES
WHEREVER YOU GO, WE GO.

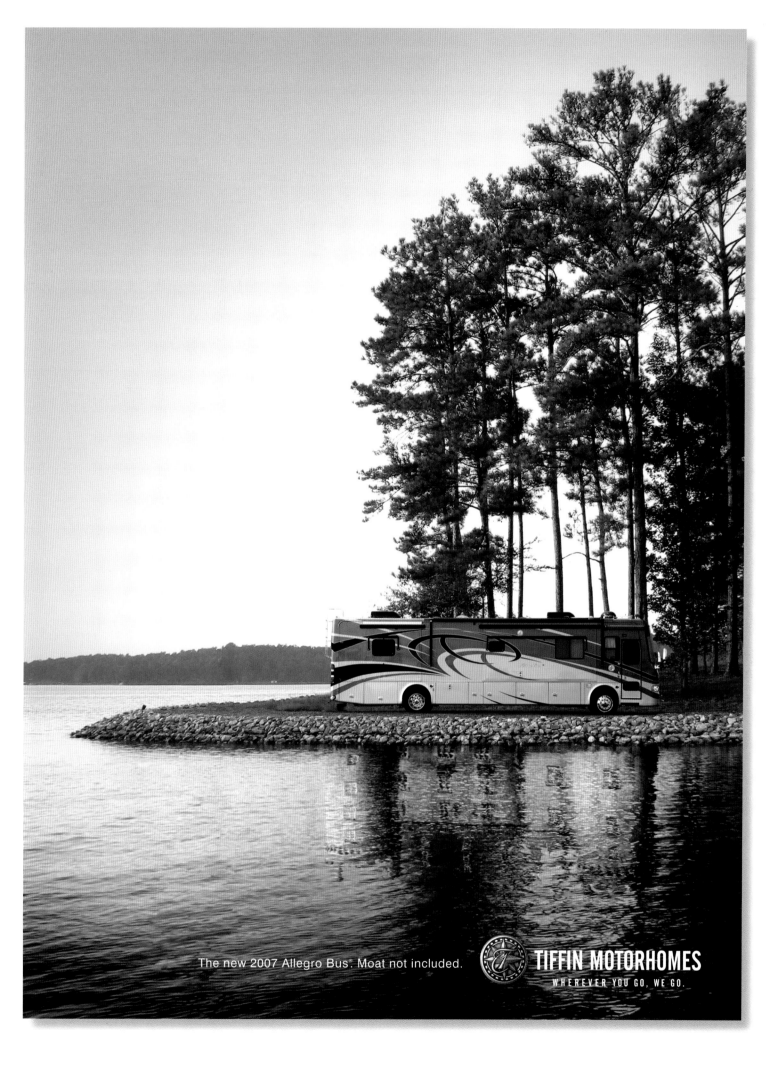

The new 2007 Allegro Bus.® Moat not included.

TIFFIN MOTORHOMES
WHEREVER YOU GO, WE GO.

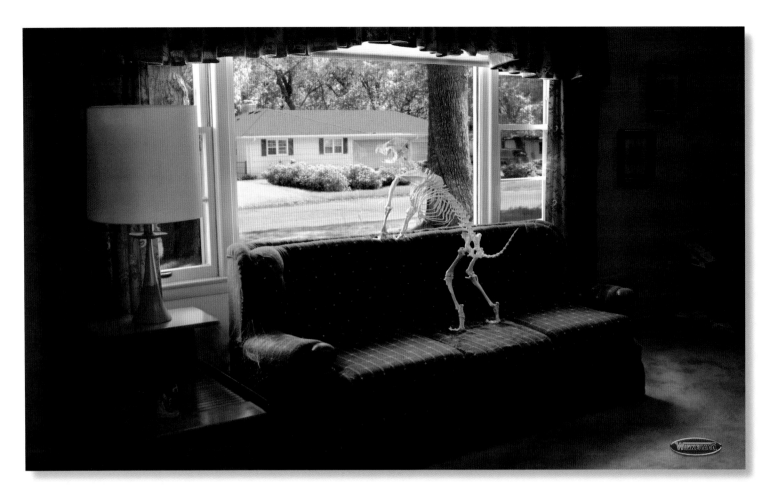

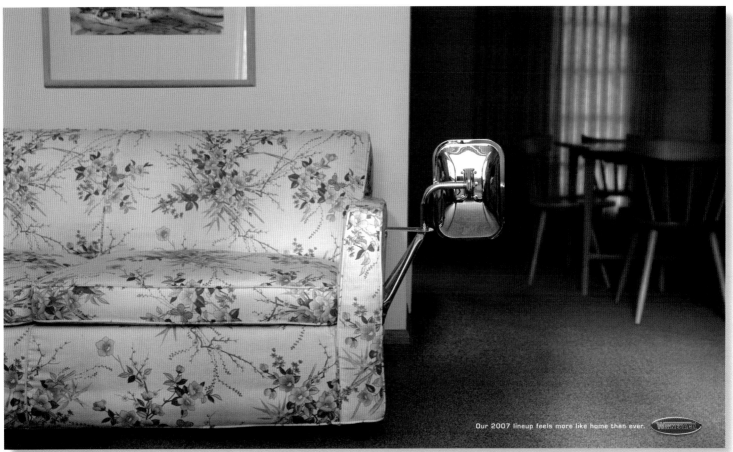

Our 2007 lineup feels more like home than ever. **WINNEBAGO**

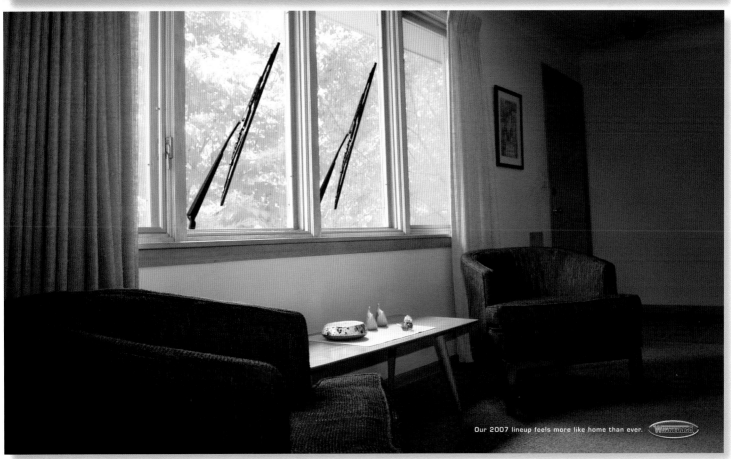

Our 2007 lineup feels more like home than ever. **WINNEBAGO**

The all new 2007 Yaris. A little money. A lot of fun.

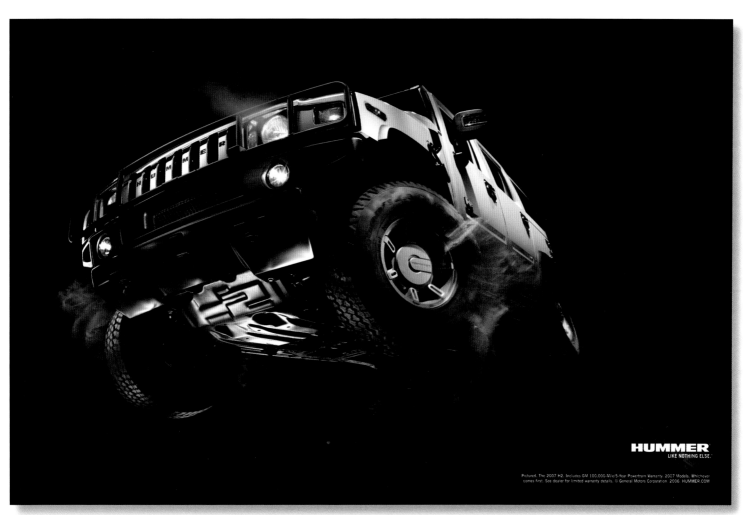

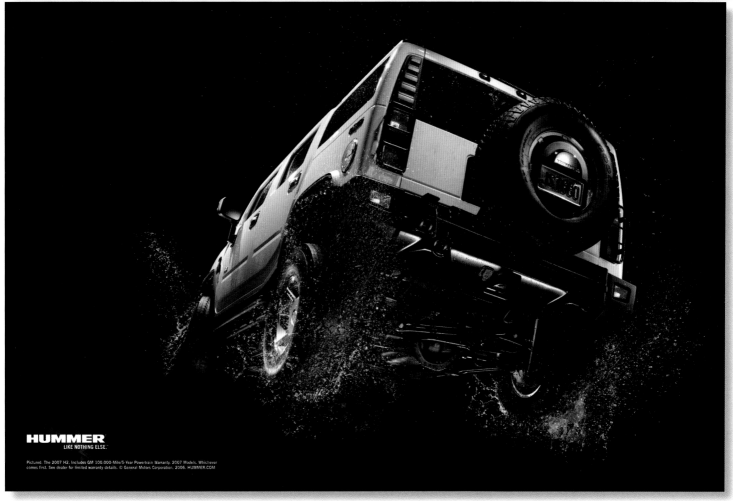

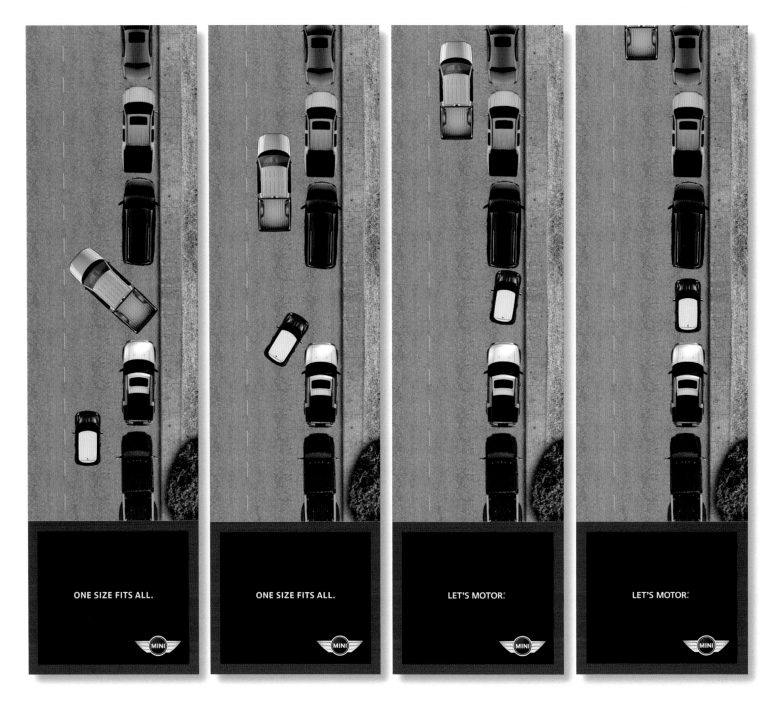

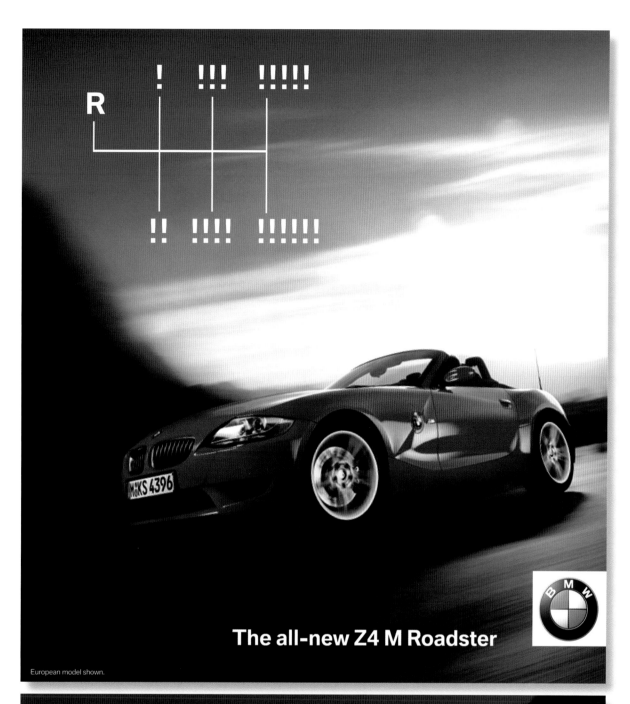

The all-new Z4 M Roadster

European model shown.

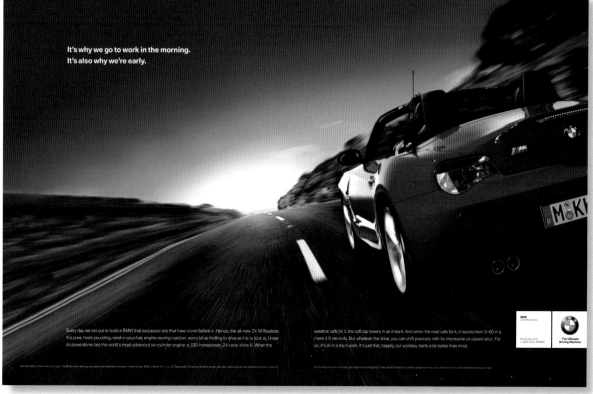

It's why we go to work in the morning.
It's also why we're early.

Every day we set out to build a BMW that surpasses any that have come before it. Hence, the all-new Z4 M Roadster. It is pure, heart-pounding, wind-in-your-hair, engine-revving roadster; every bit as thrilling to drive as it is to look at. Under its powerdome lies the world's most advanced six-cylinder engine: a 330-horsepower, 24-valve inline 6. When the weather calls for it, the soft top lowers in an instant. And when the road calls for it, it rockets from 0-60 in a mere 4.9 seconds. But whatever the drive, you can shift precisely with its impressive six-speed stick. For us, it's all in a day's work. It's just that, happily, our workday starts a bit earlier than most.

100% Genuine Leather ⬩ **SUZUKI Grand Vitara CLE**

100% Genuine Leather ⬩ **SUZUKI Grand Vitara CLE**

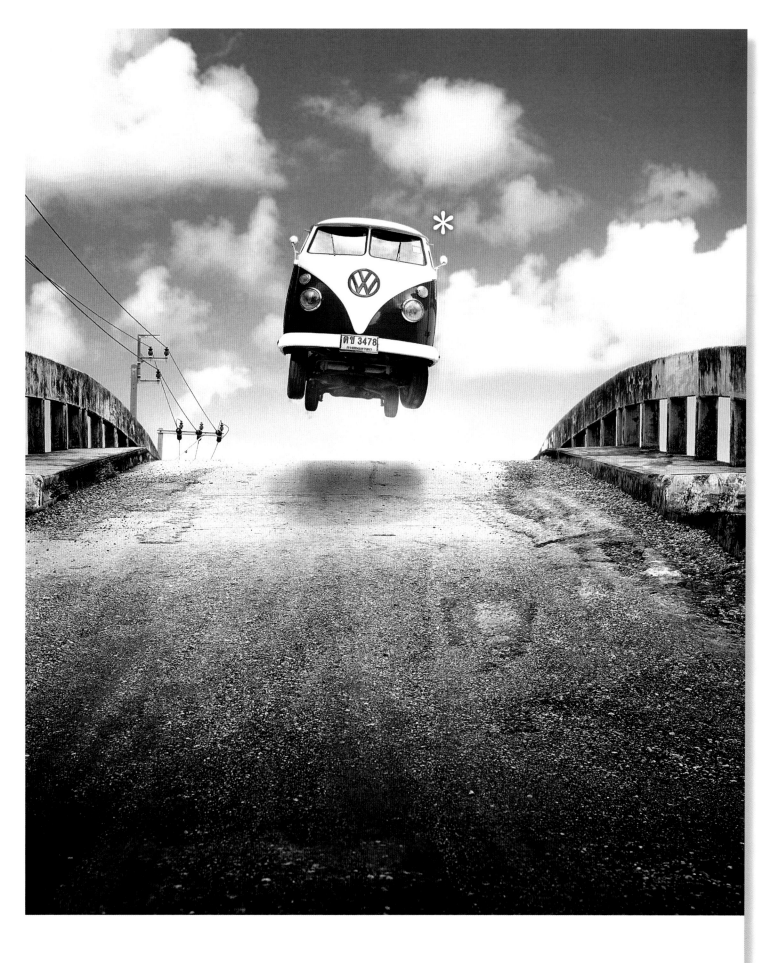

Volkswagen Genuine Parts®

*Please try this stunt ONLY IF you've had your VW serviced at an authorized shop – where all parts and service are warrentied for 2 years. Good luck!!

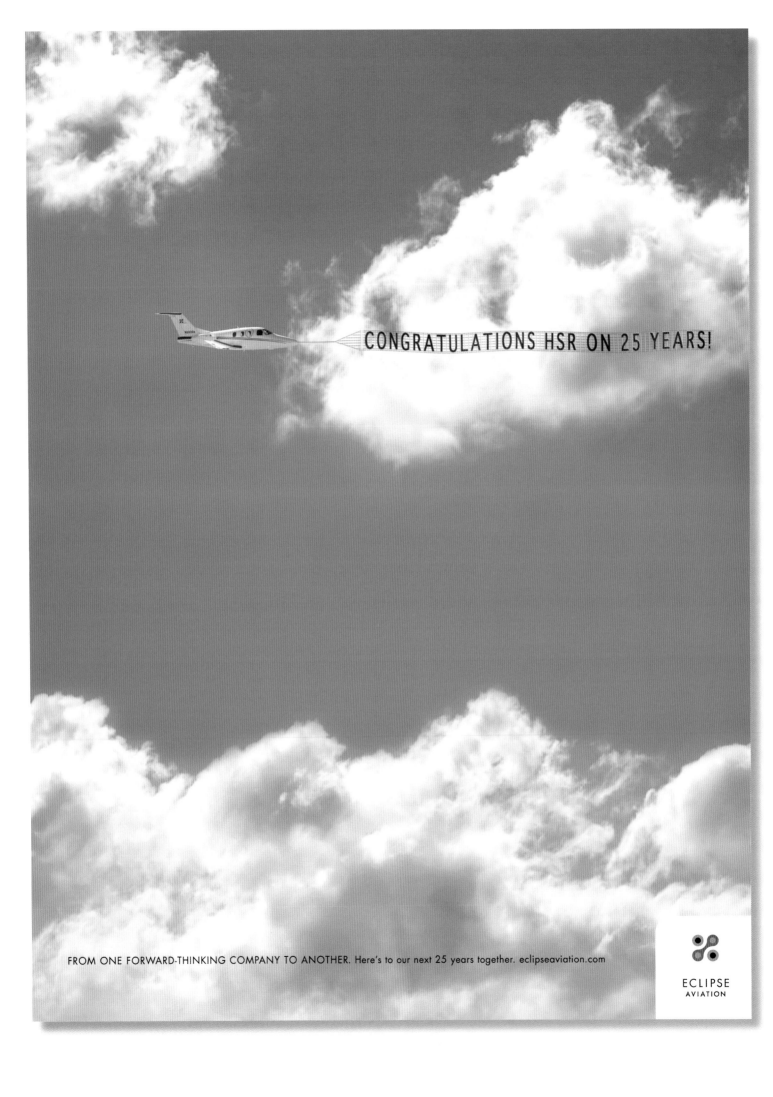

CONGRATULATIONS HSR ON 25 YEARS!

FROM ONE FORWARD-THINKING COMPANY TO ANOTHER. Here's to our next 25 years together. eclipseaviation.com

ECLIPSE
AVIATION

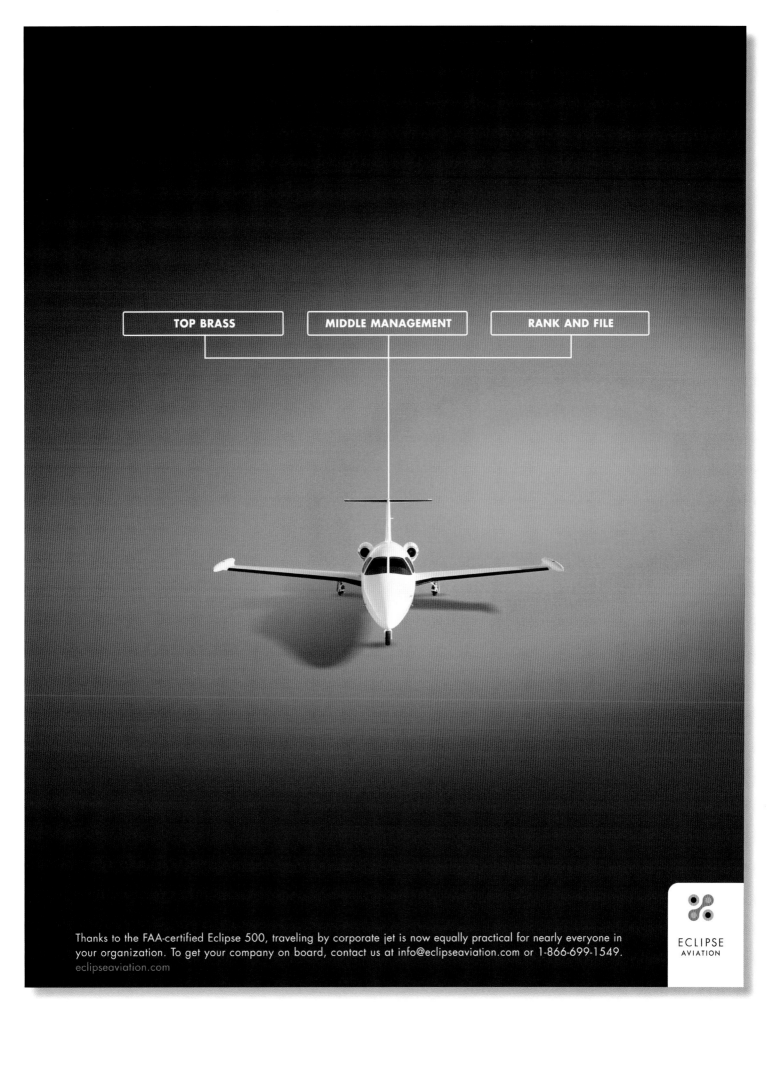

Thanks to the FAA-certified Eclipse 500, traveling by corporate jet is now equally practical for nearly everyone in your organization. To get your company on board, contact us at info@eclipseaviation.com or 1-866-699-1549.

eclipseaviation.com

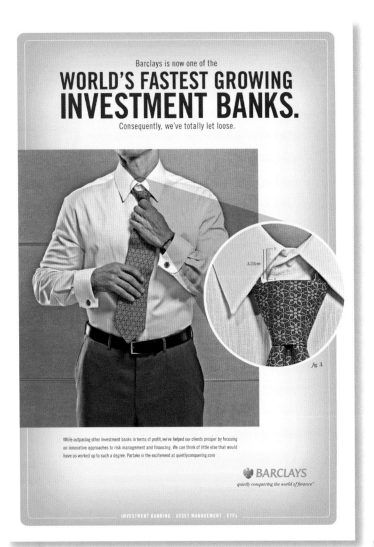

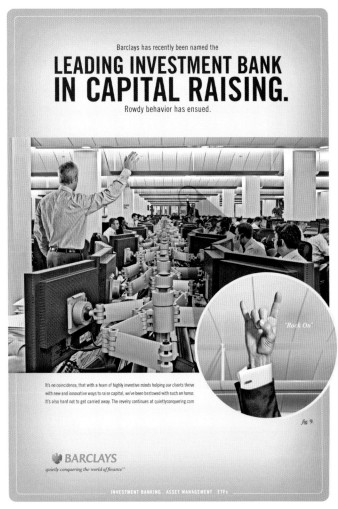

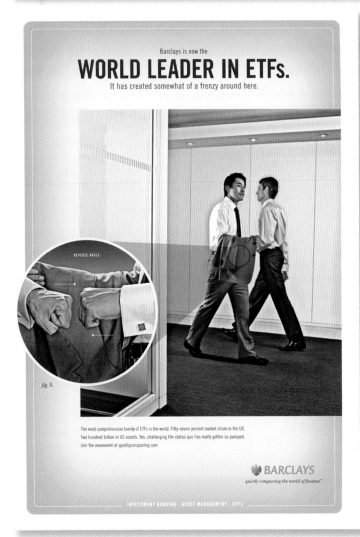

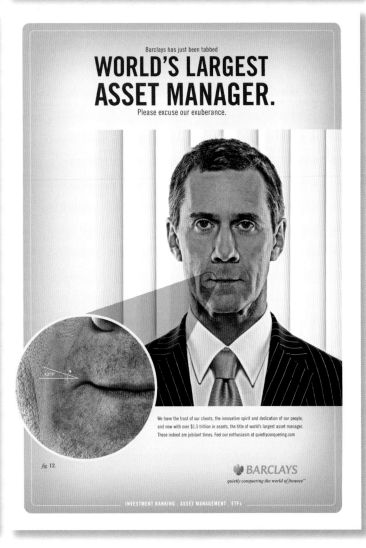

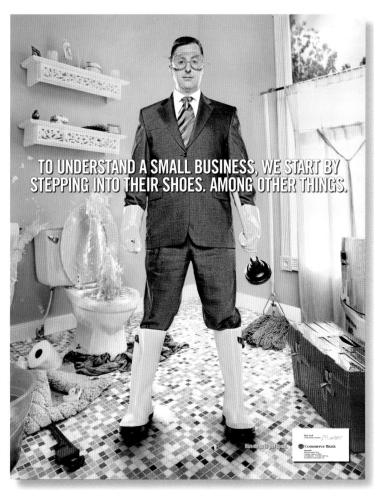

TO UNDERSTAND A SMALL BUSINESS, WE START BY STEPPING INTO THEIR SHOES. AMONG OTHER THINGS.

Business is personal. Commerce Bank

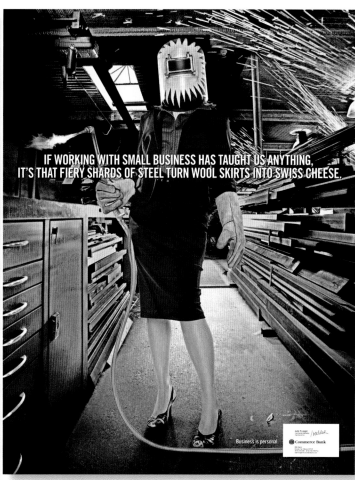

IF WORKING WITH SMALL BUSINESS HAS TAUGHT US ANYTHING, IT'S THAT FIERY SHARDS OF STEEL TURN WOOL SKIRTS INTO SWISS CHEESE.

Business is personal. Commerce Bank

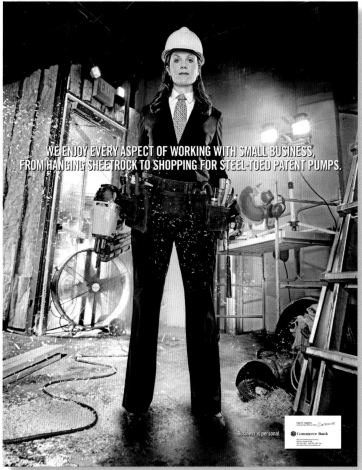

WE ENJOY EVERY ASPECT OF WORKING WITH SMALL BUSINESS, FROM HANGING SHEETROCK TO SHOPPING FOR STEEL-TOED PATENT PUMPS.

Business is personal. Commerce Bank

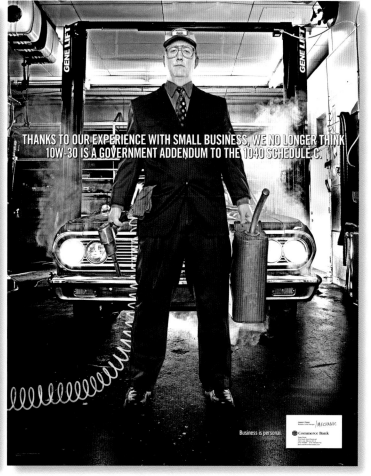

THANKS TO OUR EXPERIENCE WITH SMALL BUSINESS, WE NO LONGER THINK 10W-30 IS A GOVERNMENT ADDENDUM TO THE 1040 SCHEDULE C.

Business is personal. Commerce Bank

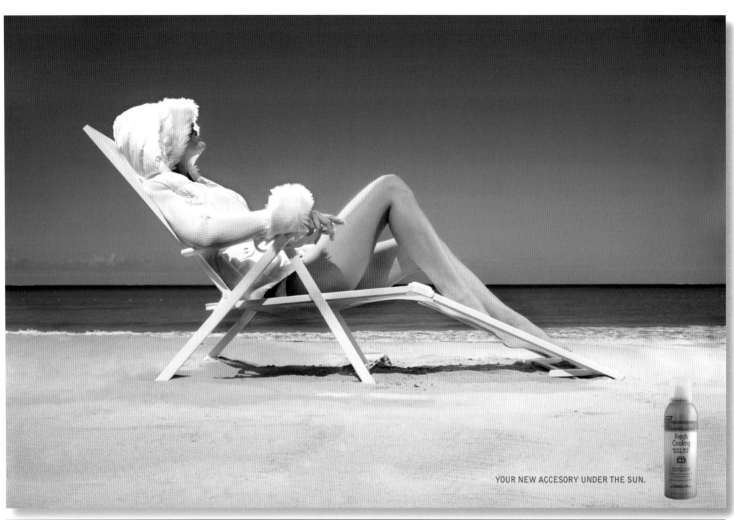

YOUR NEW ACCESORY UNDER THE SUN.

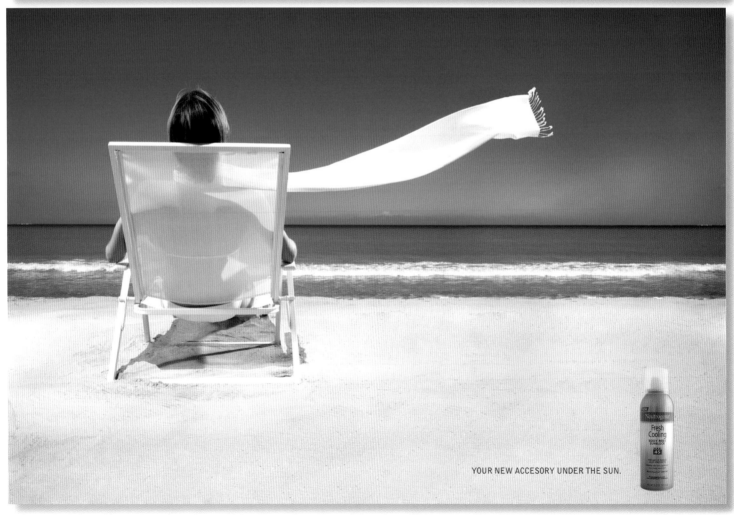

YOUR NEW ACCESORY UNDER THE SUN.

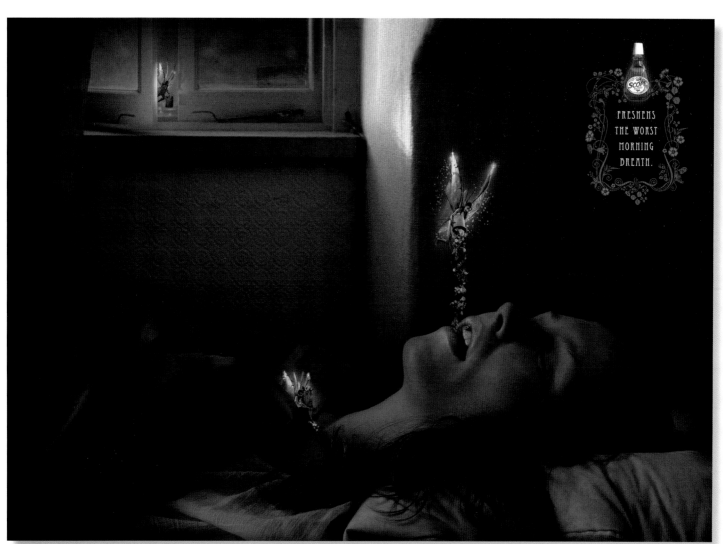

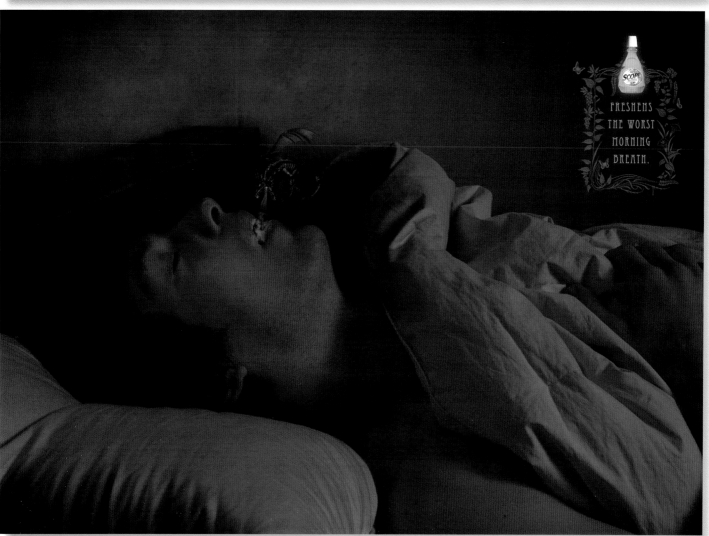

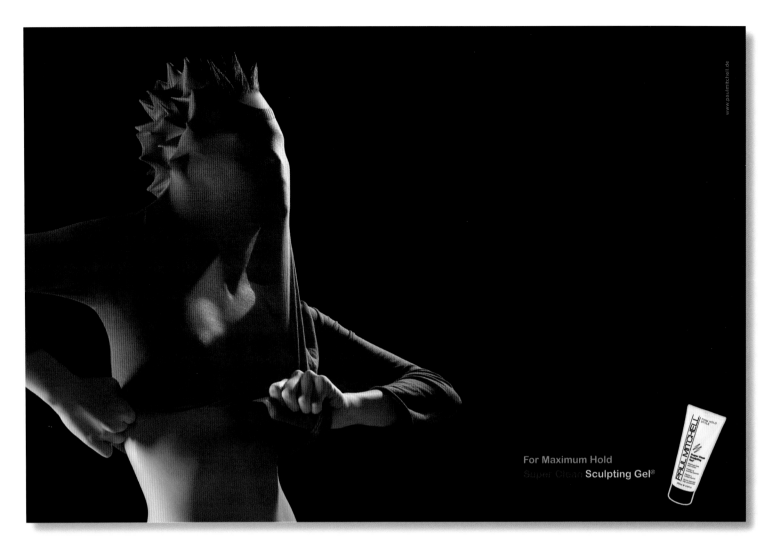

For Maximum Hold
Super Clean Sculpting Gel®

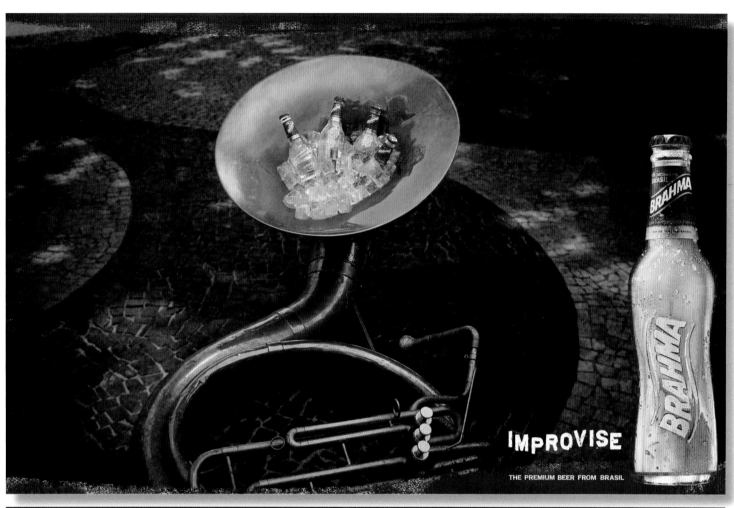

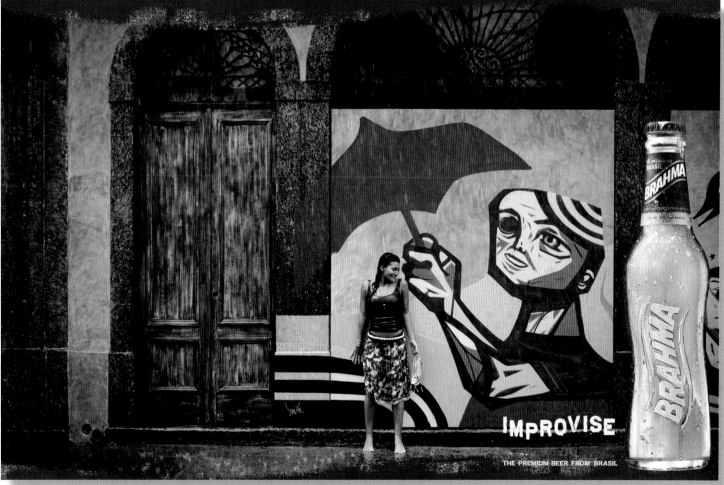

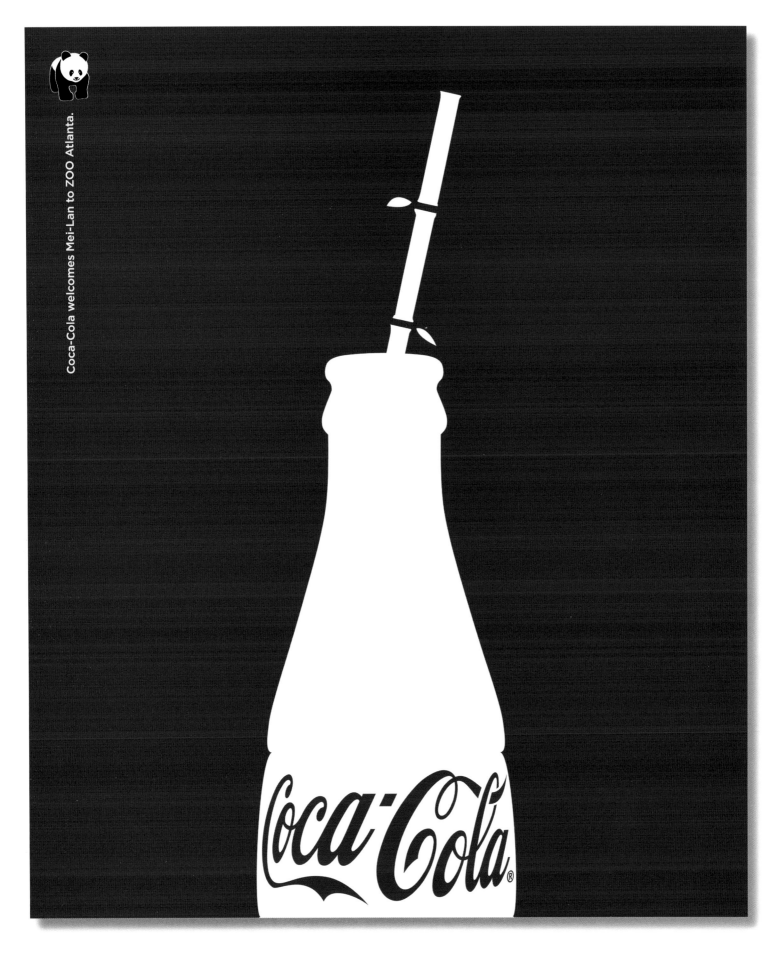

Coca-Cola welcomes Mei-Lan to ZOO Atlanta.

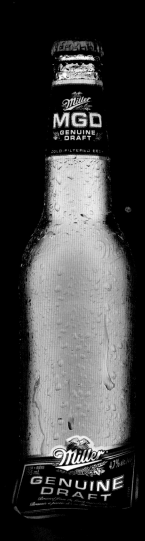

COLD FILTERED 4 TIMES.
THAT'S SMOOTH.

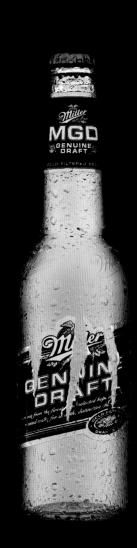

Proud sponsor of the Toronto Raptors

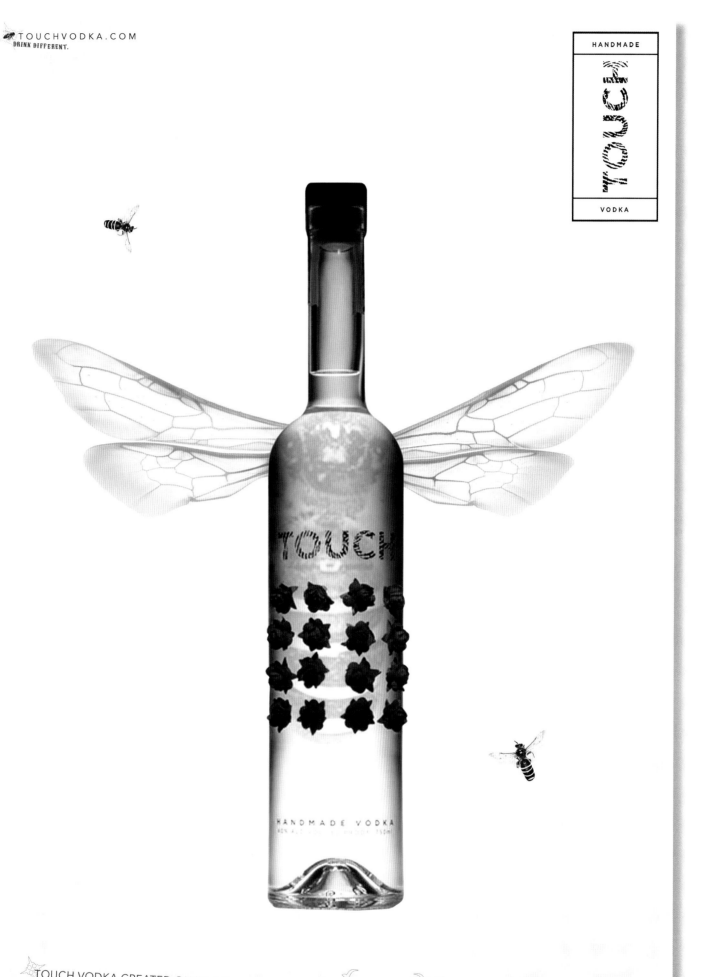

TOUCHVODKA.COM
DRINK DIFFERENT.

HANDMADE
TOUCH
VODKA

TOUCH VODKA CREATED QUITE A BUZZ IN WINNING THE **GOLD MEDAL** AT THE 2006 SAN FRANCISCO WORLD SPIRITS COMPETITION. HAND-DISTILLED IN LIMITED QUANTITIES FROM FLORIDA WILDFLOWER HONEY, THERE'S NOTHING ELSE LIKE IT.

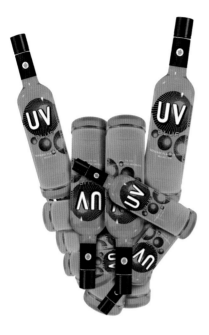

ROCK ON

Start your party at **UVVODKA.COM.**

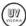

MIX & MOSH

Start your party at **UVVODKA.COM.**

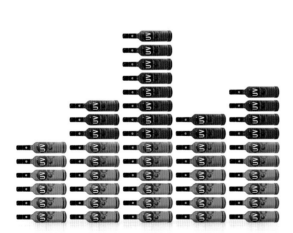

MIX IT

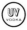

Start your party at **UVVODKA.COM.**

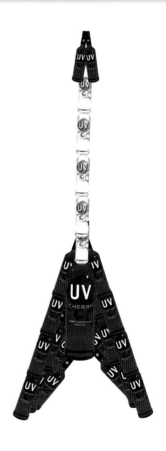

AMPLIFY

Start your party at **UVVODKA.COM.**

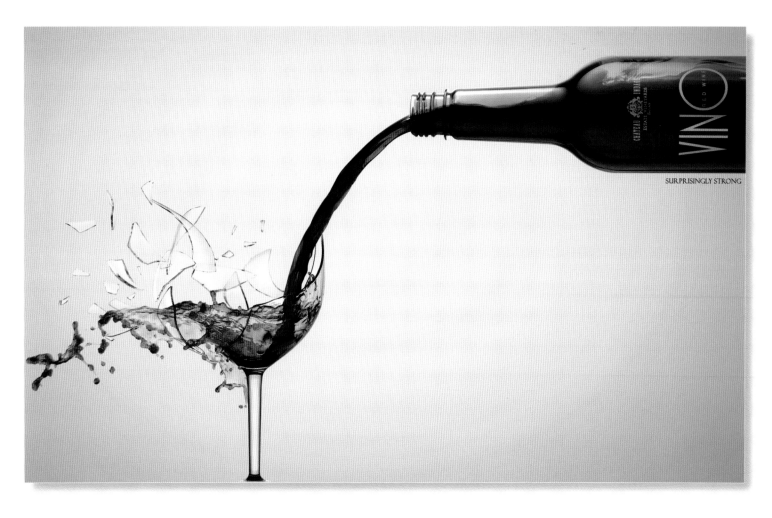

SURPRISINGLY STRONG

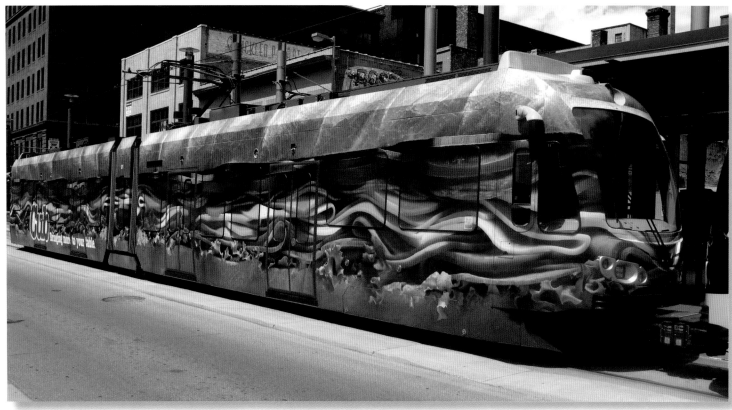

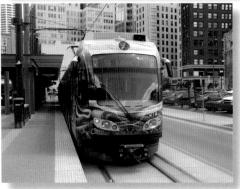
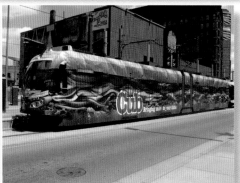
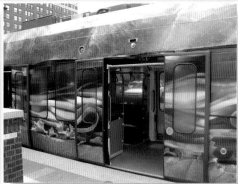

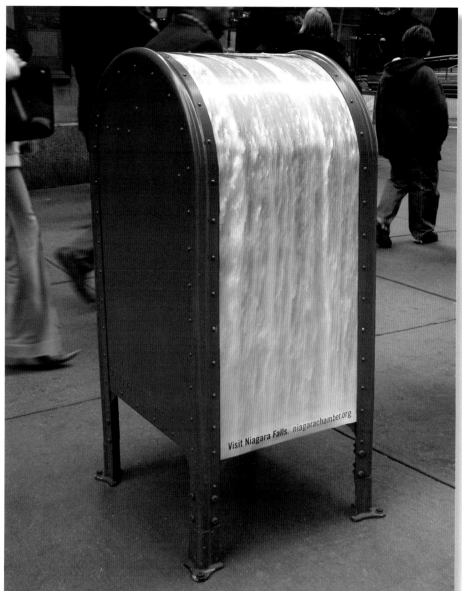

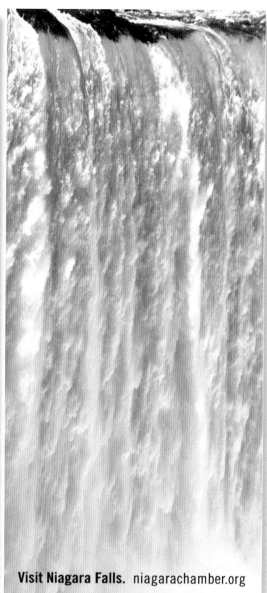

Visit Niagara Falls. niagarachamber.org

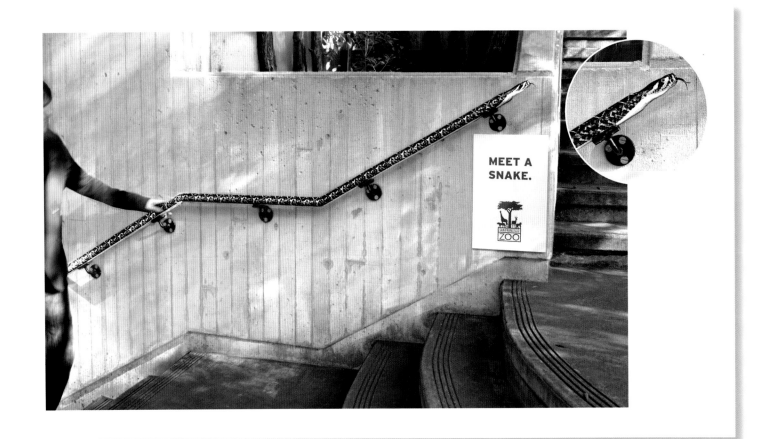

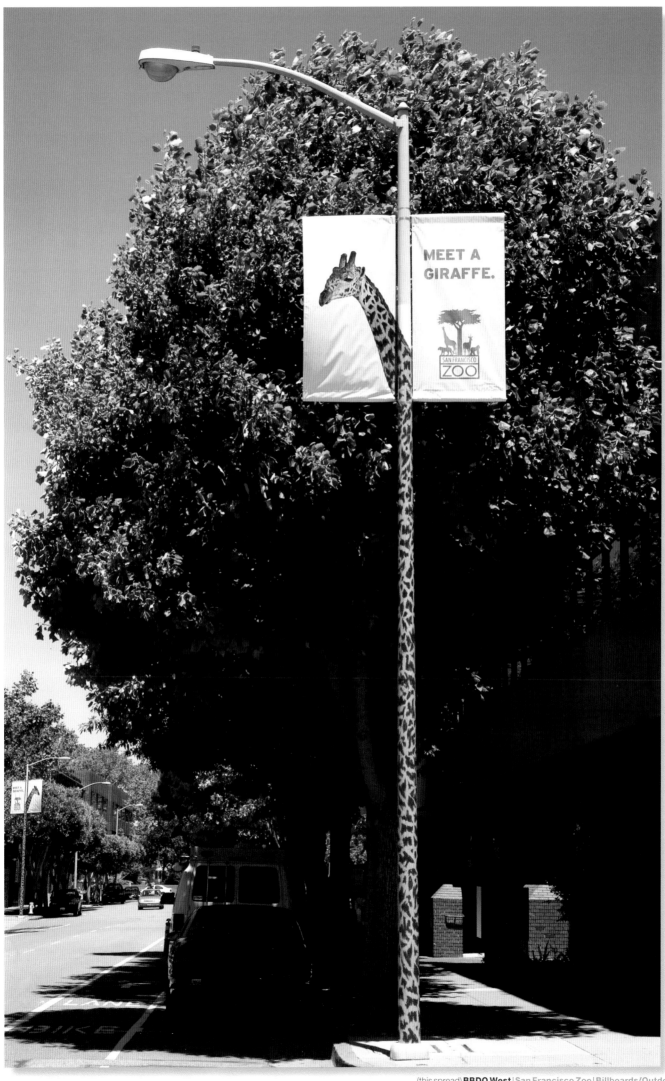

The banners on the light pole read "MEET A GIRAFFE." with the San Francisco Zoo logo.

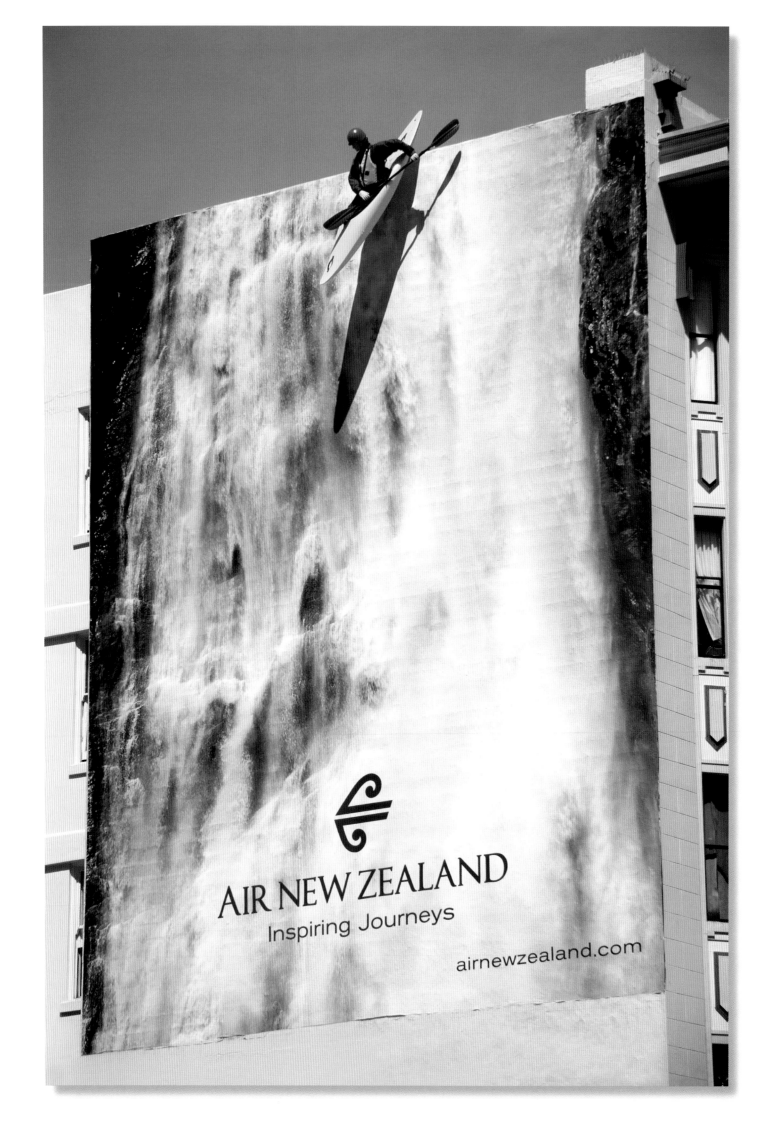

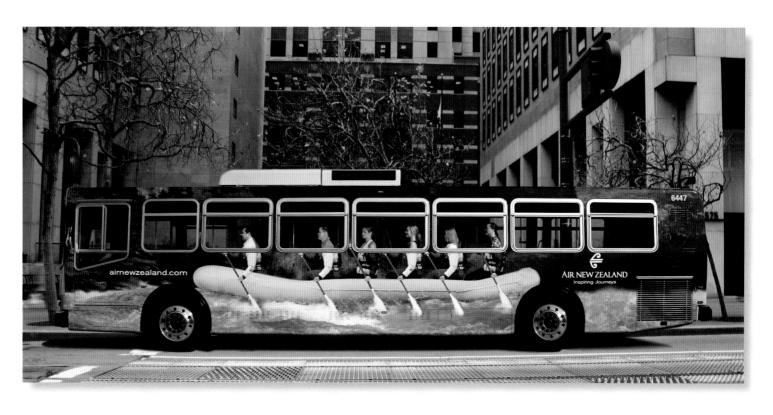

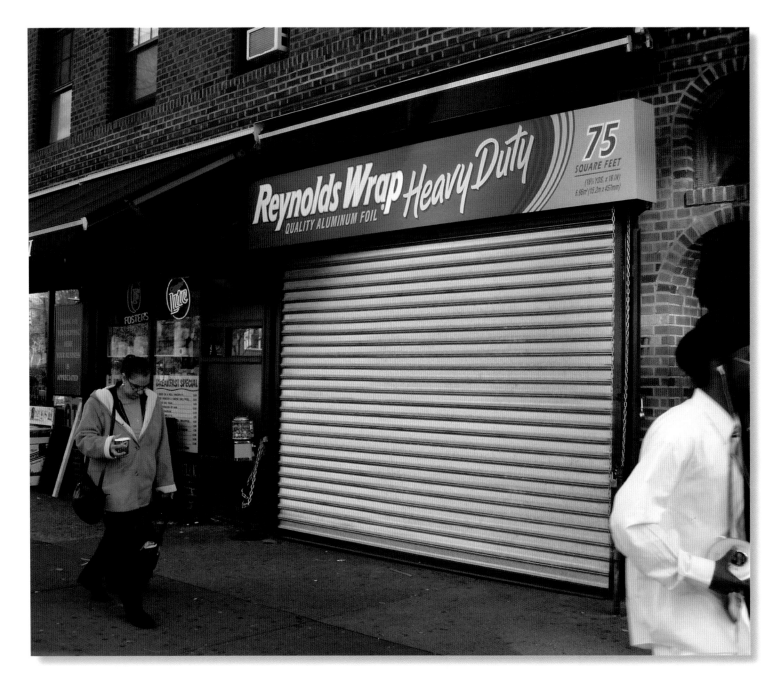

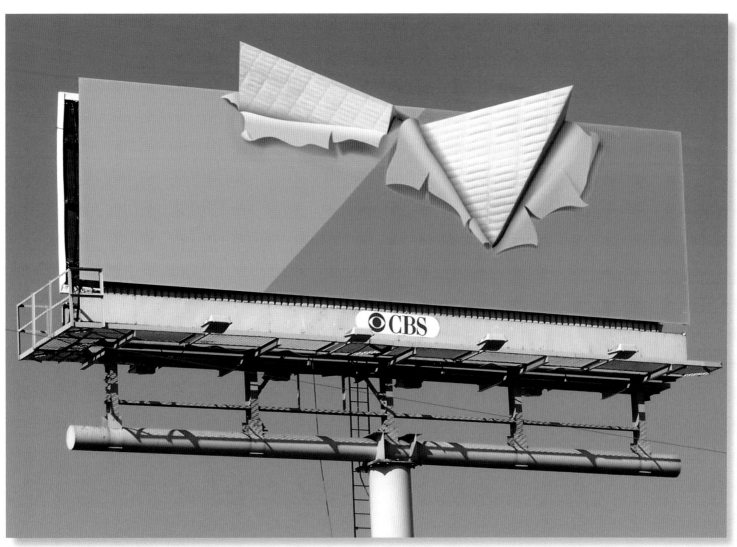

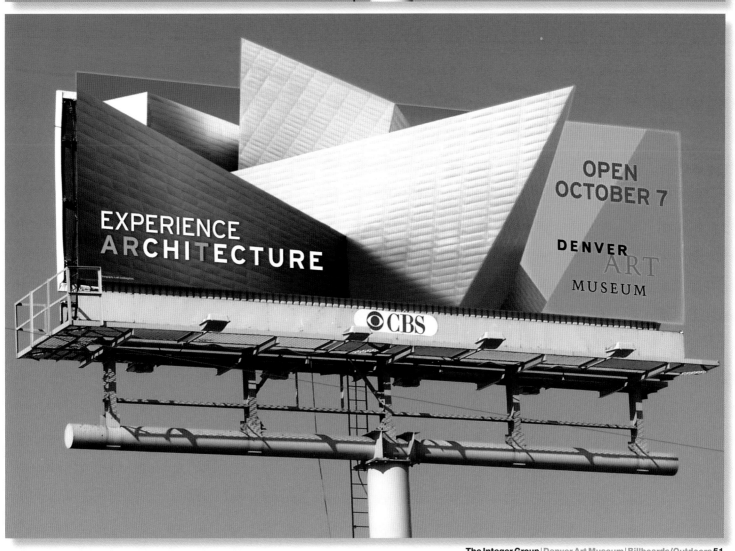

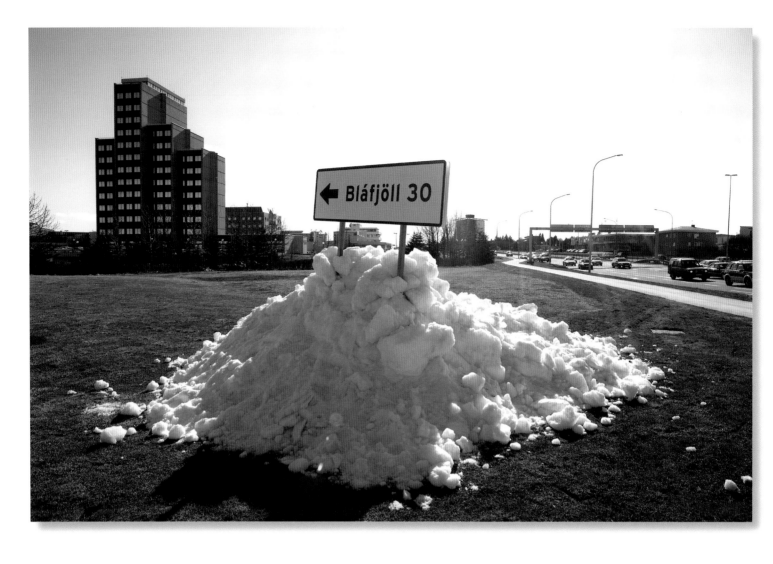

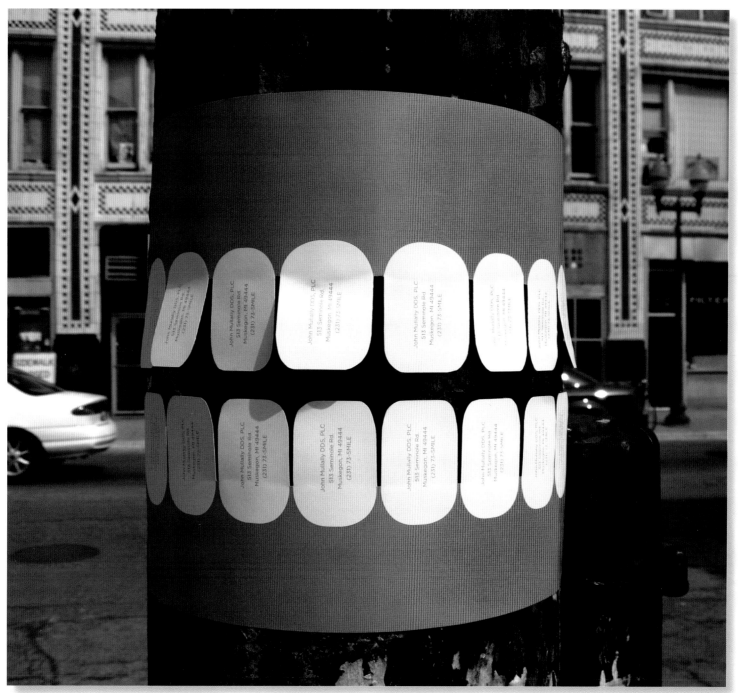

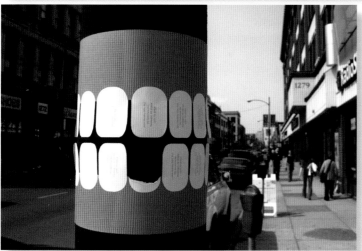

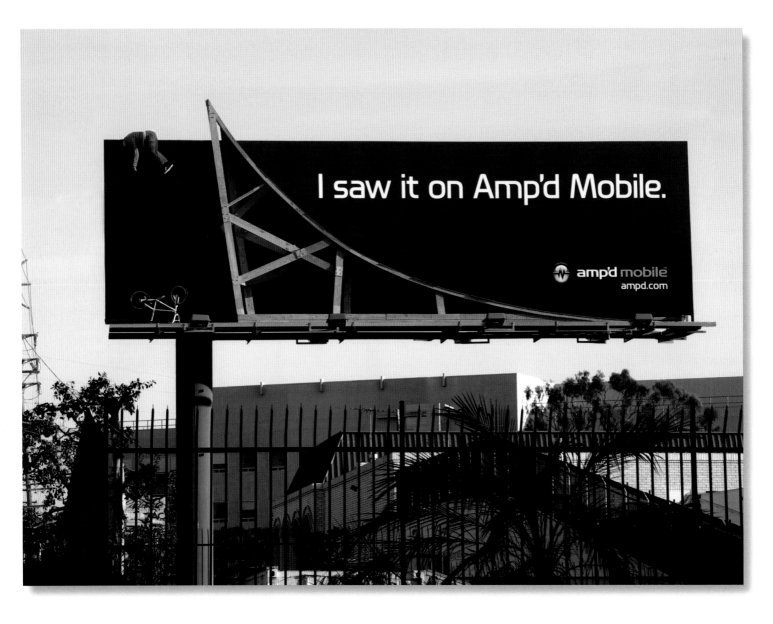

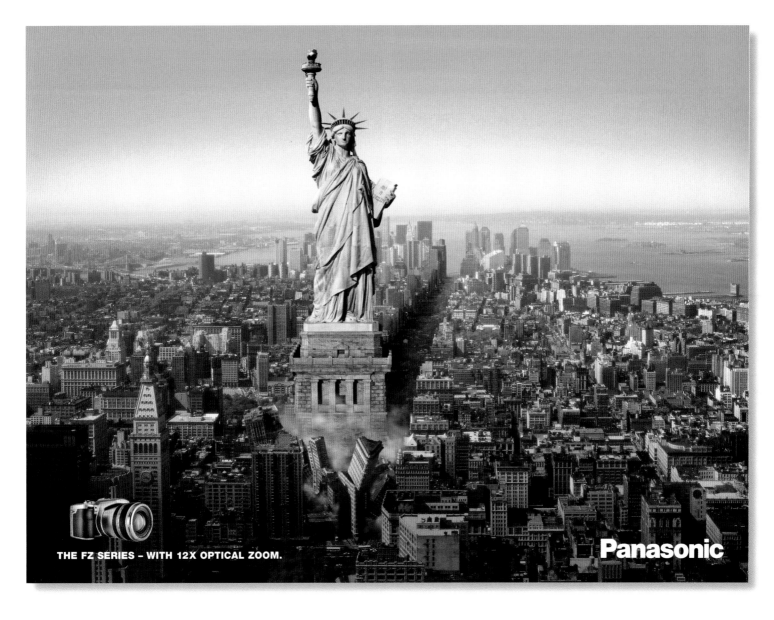

THE FZ SERIES – WITH 12X OPTICAL ZOOM.

Panasonic

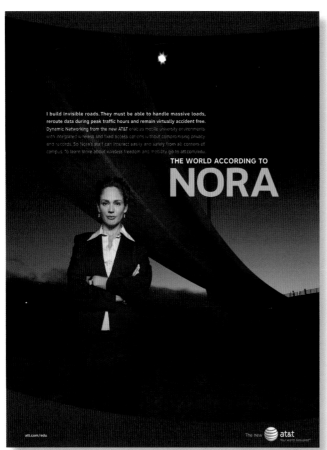

I build invisible roads. They must be able to handle massive loads, reroute data during peak traffic hours and remain virtually accident free. Dynamic Networking from the new AT&T enables mobile university environments with integrated wireless and fixed access options without compromising privacy and records. So Nora's staff can interact easily and safely from all corners of campus. To learn more about wireless freedom and mobility, go to att.com/edu.

THE WORLD ACCORDING TO

NORA

att.com/edu

The new **at&t**
Your world. Delivered.

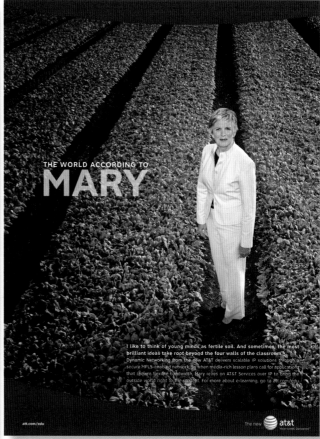

THE WORLD ACCORDING TO

MARY

I like to think of young minds as fertile soil. And sometimes, the most brilliant ideas take root beyond the four walls of the classroom. Dynamic Networking from the new AT&T delivers scalable IP solutions through a secure MPLS-enabled network. So when media-rich lesson plans call for applications that require flexible bandwidth, Mary relies on AT&T Services over IP to bring the outside world right to the student. For more about e-learning, go to att.com/edu.

att.com/edu

The new **at&t**
Your world. Delivered.

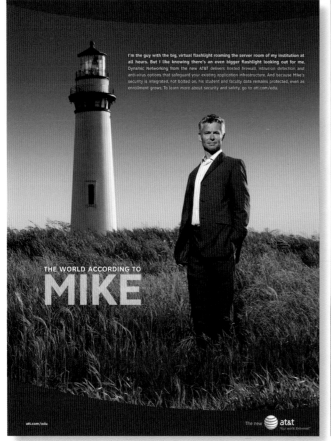

I'm the guy with the big, virtual flashlight roaming the server room of my institution at all hours. But I like knowing there's an even bigger flashlight looking out for me. Dynamic Networking from the new AT&T delivers hosted firewall, intrusion detection and anti-virus options that safeguard your existing application infrastructure. And because Mike's security is integrated, not bolted on, his student and faculty data remains protected, even as enrollment grows. To learn more about security and safety, go to att.com/edu.

THE WORLD ACCORDING TO

MIKE

att.com/edu

The new **at&t**
Your world. Delivered.

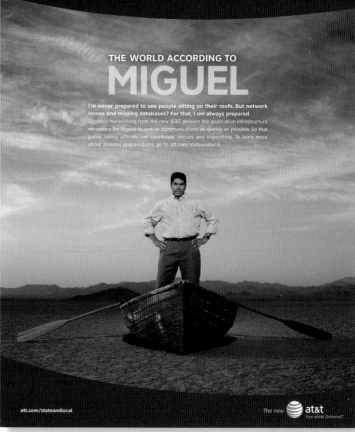

THE WORLD ACCORDING TO

MIGUEL

I'm never prepared to see people sitting on their roofs. But network losses and missing databases? For that, I am always prepared. Dynamic Networking from the new AT&T delivers the application infrastructure necessary for Miguel to restore communications as quickly as possible. So that public safety officials can coordinate rescues and inspections. To learn more about disaster preparedness, go to att.com/stateandlocal.

att.com/stateandlocal

The new **at&t**
Your world. Delivered.

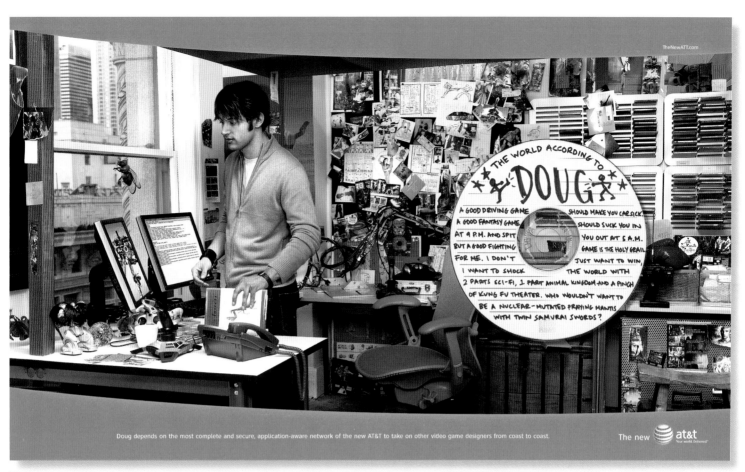

Doug depends on the most complete and secure, application-aware network of the new AT&T to take on other video game designers from coast to coast.

The new at&t

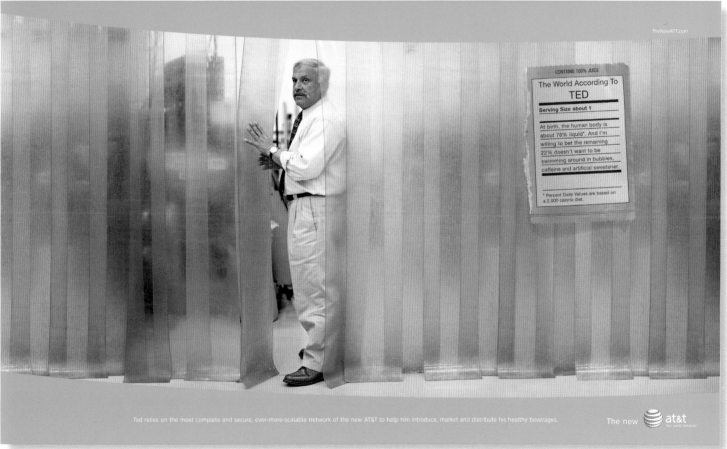

Ted relies on the most complete and secure, ever-more-scalable network of the new AT&T to help him introduce, market and distribute his healthy beverages.

The new at&t

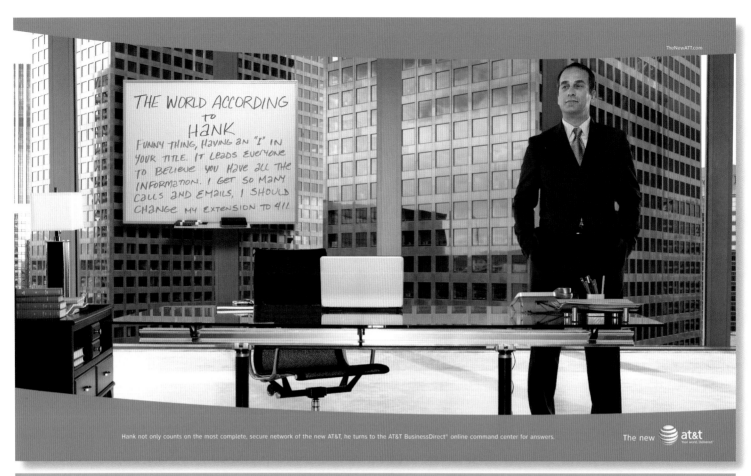

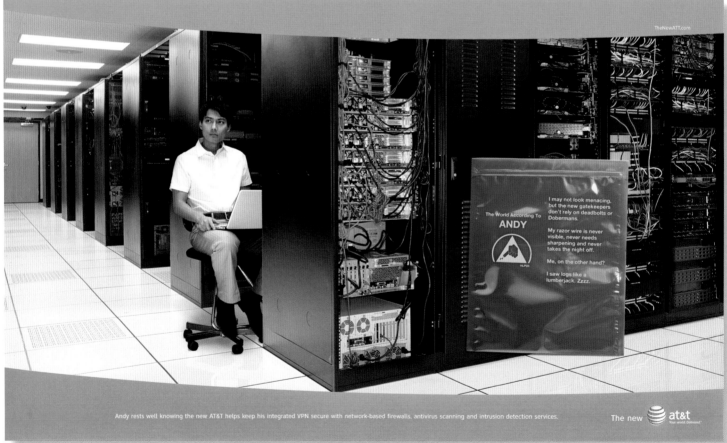

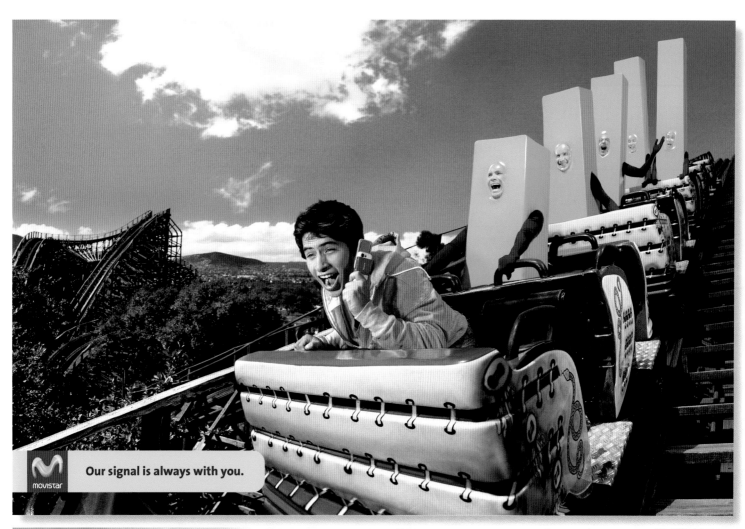

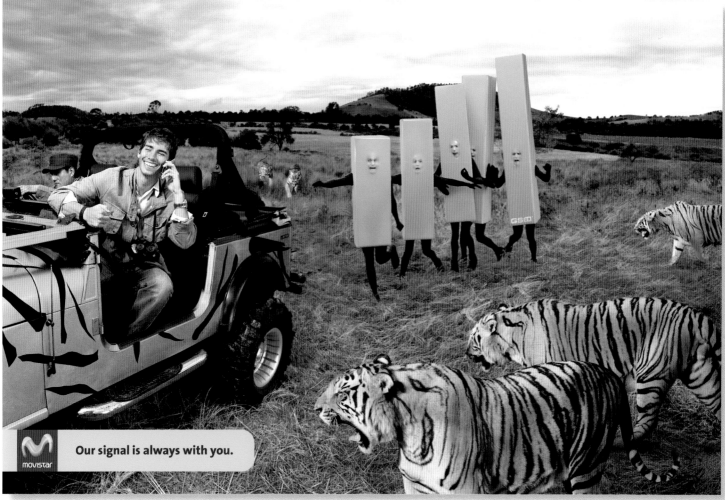

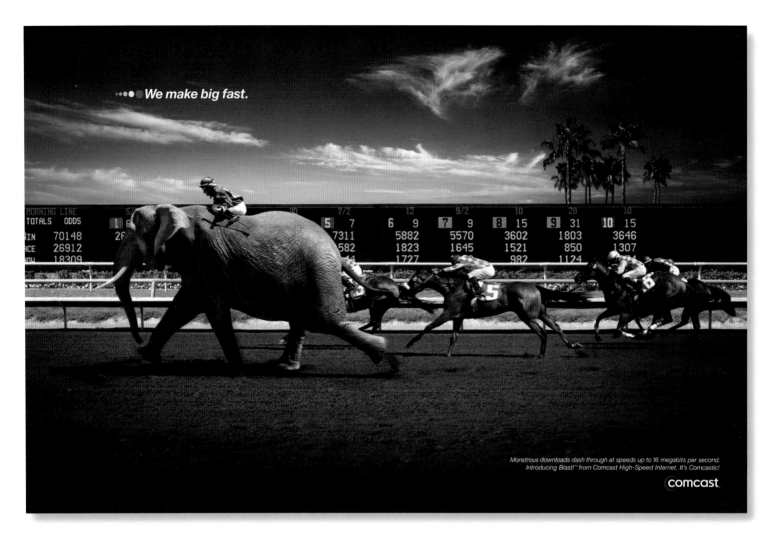

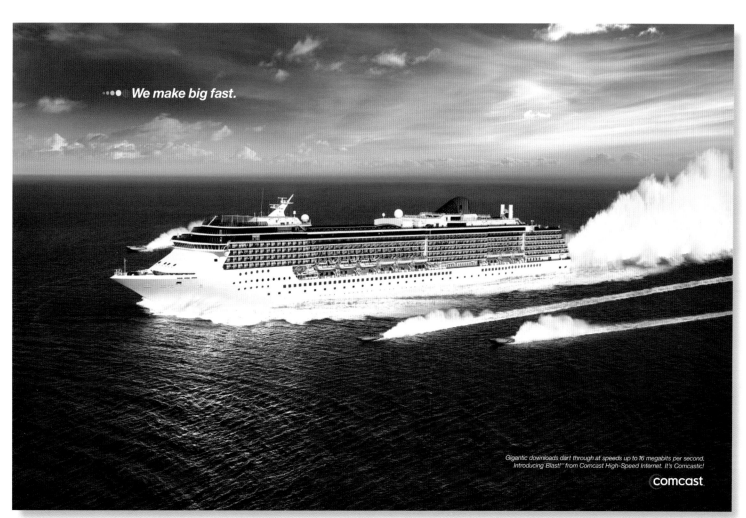

We make big fast.

Gigantic downloads dart through at speeds up to 16 megabits per second.
Introducing Blast!™ from Comcast High-Speed Internet. It's Comcastic!

comcast

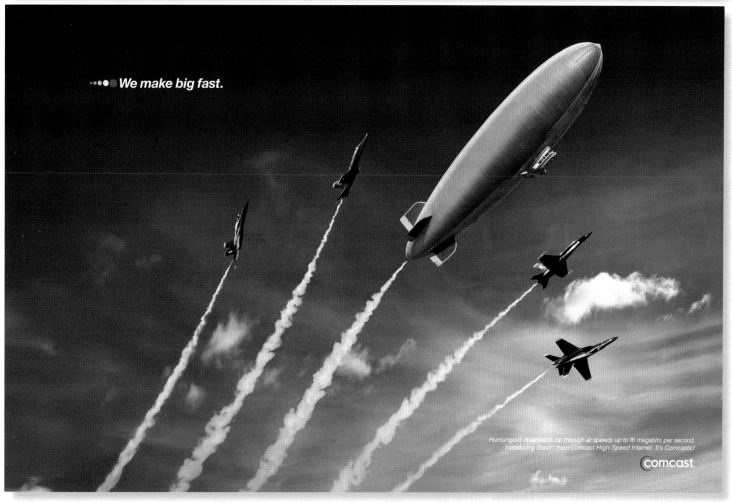

We make big fast.

Humungous downloads zip through at speeds up to 16 megabits per second.
Introducing Blast!™ from Comcast High-Speed Internet. It's Comcastic!

comcast

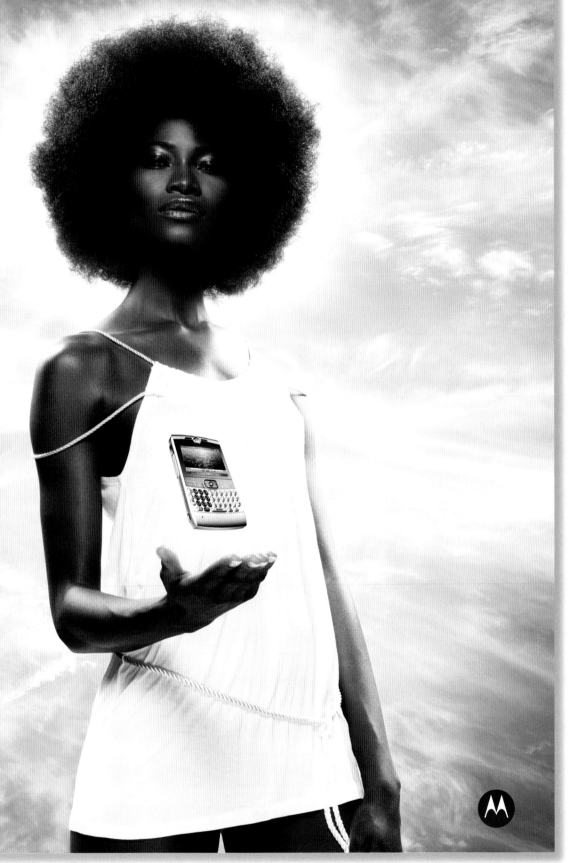

LET THERE BE Q™

Witness the marvel of crystal-clear voices, thundering music and dazzling video, Internet and e-mail* bursting from the 0.45-inch-thin motorola Q. HelloMoto. motorola.com/Q

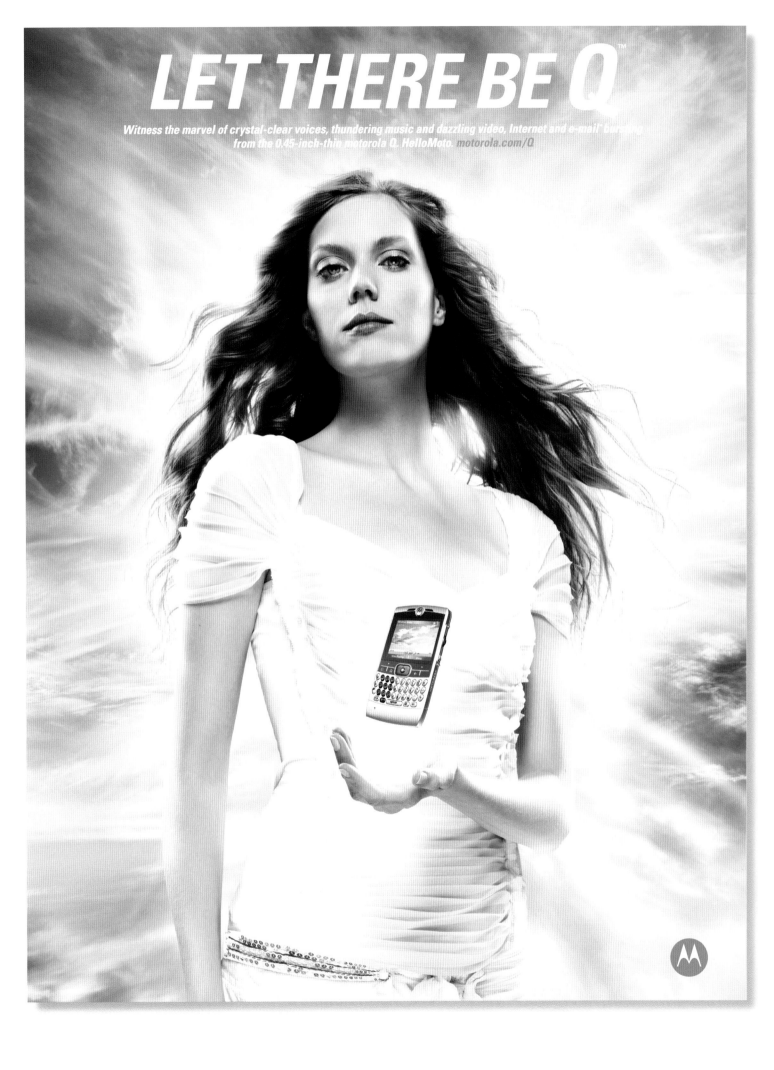

LET THERE BE Q™

Witness the marvel of crystal-clear voices, thundering music and dazzling video, Internet and e-mail* bursting from the 0.45-inch-thin motorola Q. HelloMoto. *motorola.com/Q*

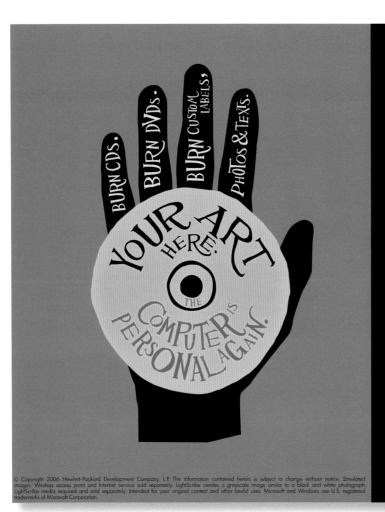

Burn the disc. Burn your own art on the disc. And make the felt-tip pen instantly and uncoolly retro. The LightScribe Direct Disc writer. Available in the HP Pavilion dv8000t Entertainment Notebook.

And it's all backed by our unrivaled HP Total Care services, for every stage of your computer's life.

hp

HP.COM / PERSONAL

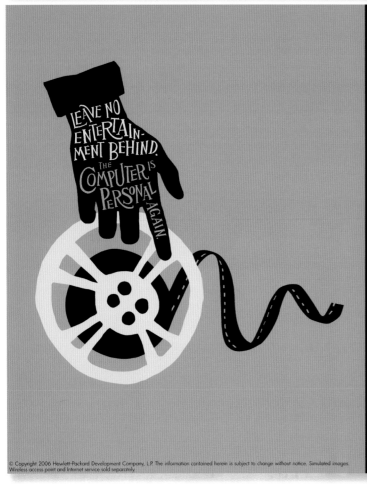

There are only seven basic movie plots. But now every movie is a road movie. The HP Pavilion dv8000z Entertainment Notebook with its 17" BrightView widescreen, it's your traveling picture show.

And it's all backed by our unrivaled HP Total Care services, for every stage of your computer's life.

hp

HP.COM / PERSONAL

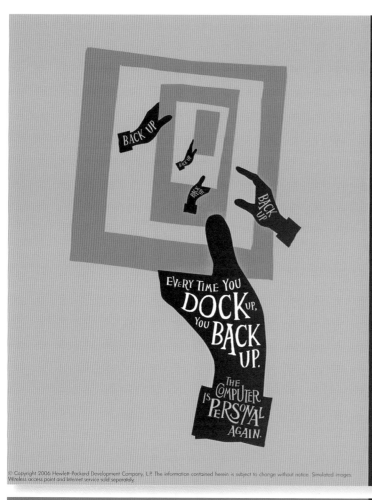

BACK UP

EVERY TIME YOU DOCK UP, YOU BACK UP. THE COMPUTER IS PERSONAL AGAIN.

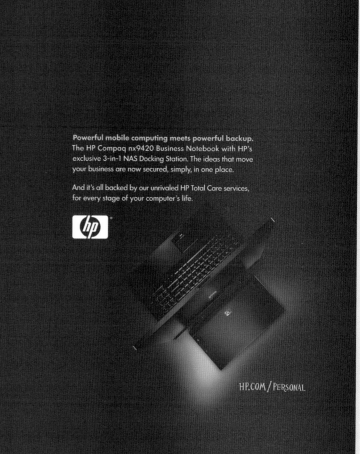

Powerful mobile computing meets powerful backup. The HP Compaq nx9420 Business Notebook with HP's exclusive 3-in-1 NAS Docking Station. The ideas that move your business are now secured, simply, in one place.

And it's all backed by our unrivaled HP Total Care services, for every stage of your computer's life.

HP.COM / PERSONAL

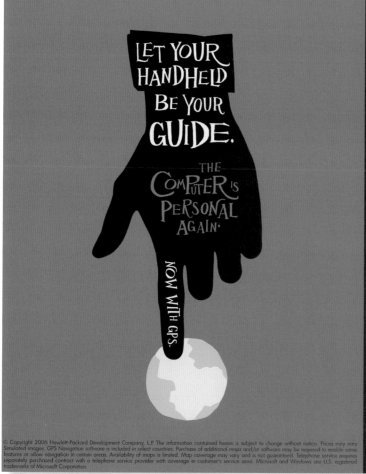

LET YOUR HANDHELD BE YOUR GUIDE. THE COMPUTER IS PERSONAL AGAIN. NOW WITH GPS.

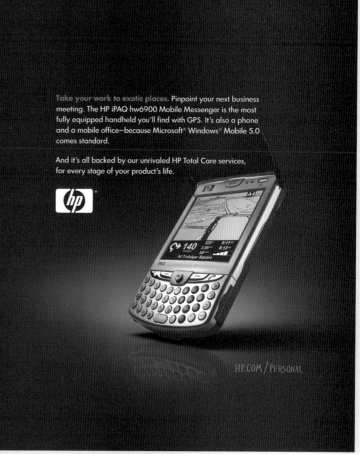

Take your work to exotic places. Pinpoint your next business meeting. The HP iPAQ hw6900 Mobile Messenger is the most fully equipped handheld you'll find with GPS. It's also a phone and a mobile office—because Microsoft® Windows® Mobile 5.0 comes standard.

And it's all backed by our unrivaled HP Total Care services, for every stage of your product's life.

HP.COM / PERSONAL

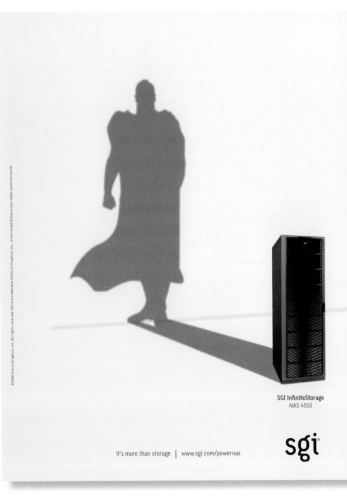

SGI InfiniteStorage
NAS 4550

It's more than storage | www.sgi.com/powernas

sgi

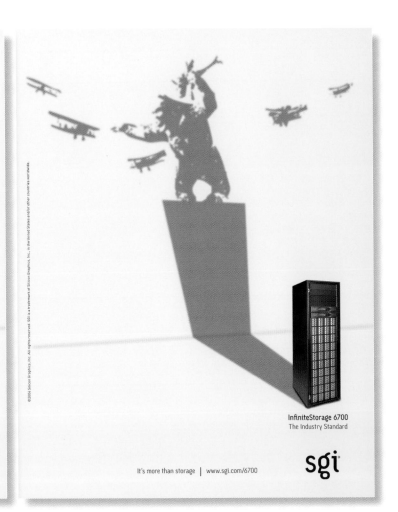

InfiniteStorage 6700
The Industry Standard

It's more than storage | www.sgi.com/6700

sgi

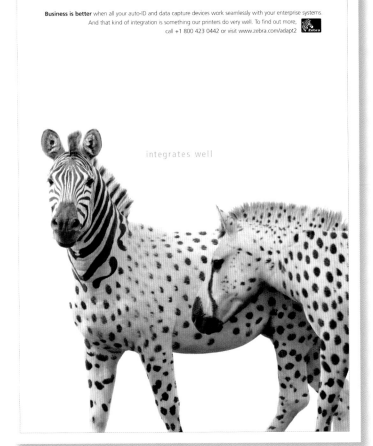

Business is better when all your auto-ID and data capture devices work seamlessly with your enterprise systems. And that kind of integration is something our printers do very well. To find out more, call +1 800 423 0442 or visit www.zebra.com/adapt2

integrates well

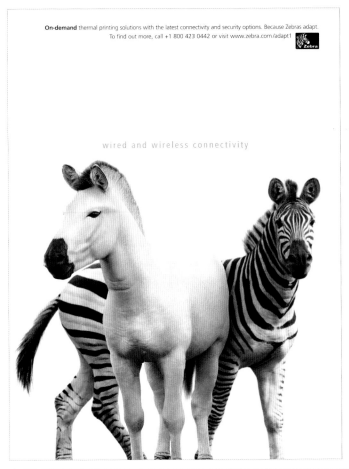

On-demand thermal printing solutions with the latest connectivity and security options. Because Zebras adapt. To find out more, call +1 800 423 0442 or visit www.zebra.com/adapt1

wired and wireless connectivity

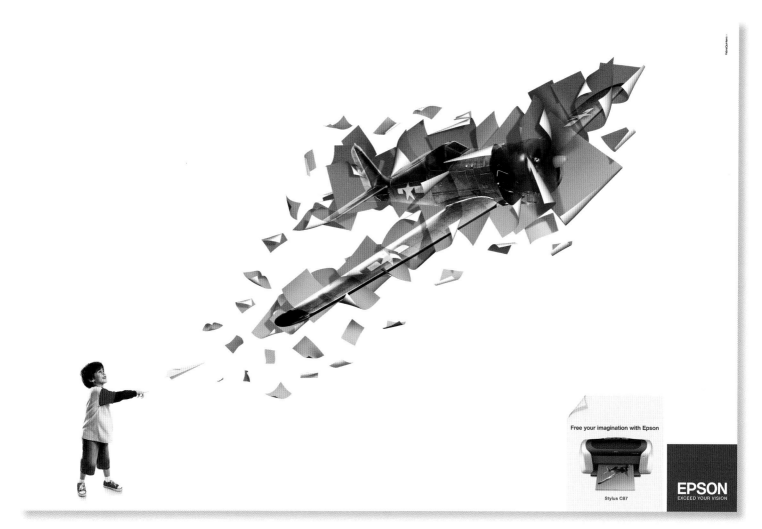

Free your imagination with Epson

Stylus C87

EPSON
EXCEED YOUR VISION

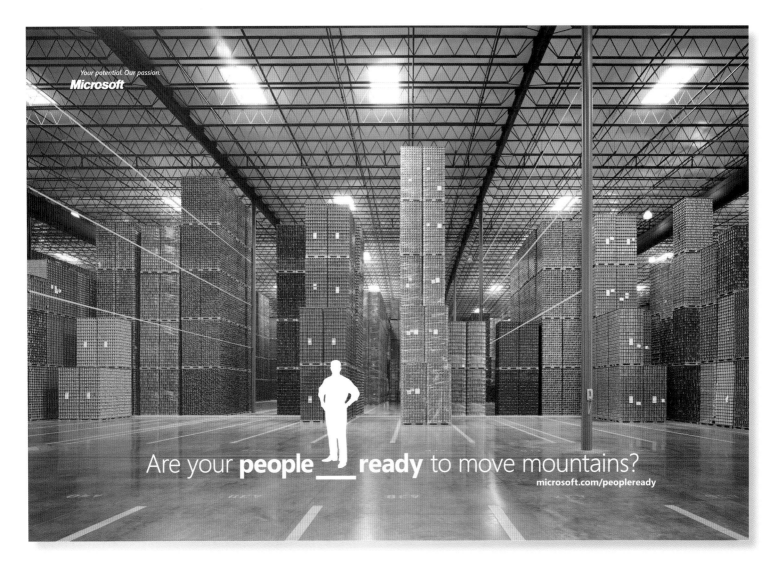

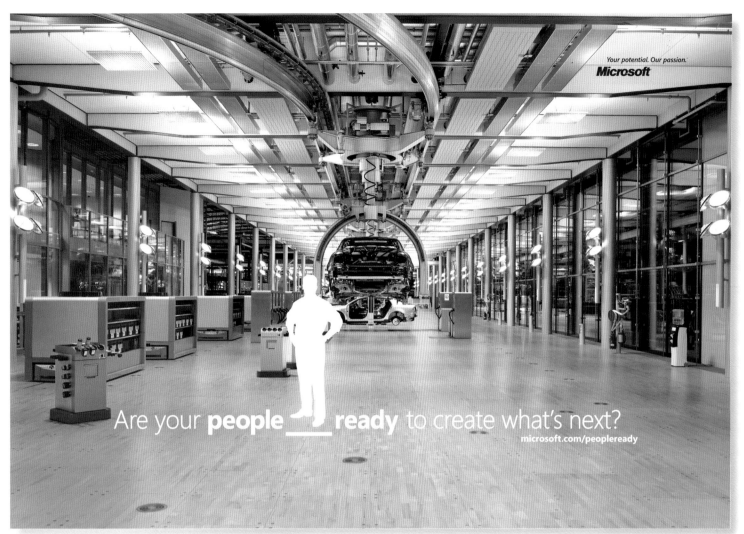

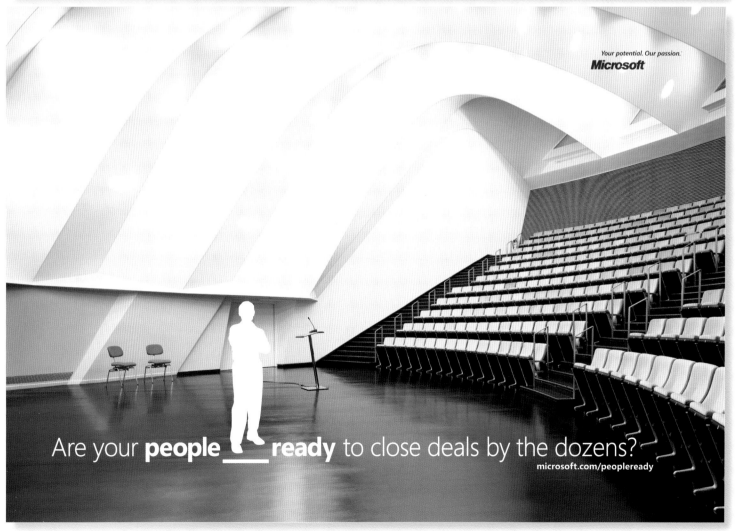

WE BUILD TO MORE THAN A BLUEPRINT.

At Opus, we never forget this is your project. So we work diligently to understand your vision and collaborate closely with you to build your dream. That's the Opus design-build promise—and that's why we're a leader throughout North America for office, industrial, retail and multi-family projects. Leave your mark. **Build Beyond at opuscorp.com.**

OPUS
BUILDING BEYOND

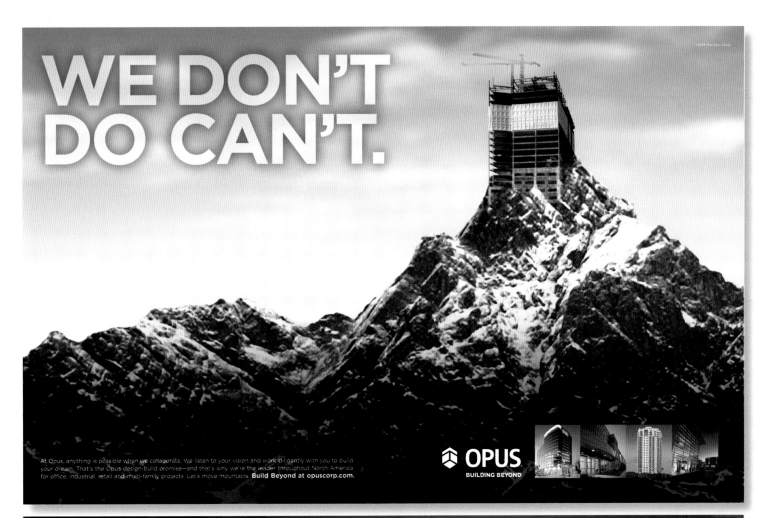

WE DON'T DO CAN'T.

At Opus, anything is possible when we collaborate. We listen to your vision and work diligently with you to build your dream. That's the Opus design-build promise—and that's why we're the leader throughout North America for office, industrial, retail and multi-family projects. Let's move mountains. **Build Beyond at opuscorp.com.**

OPUS
BUILDING BEYOND

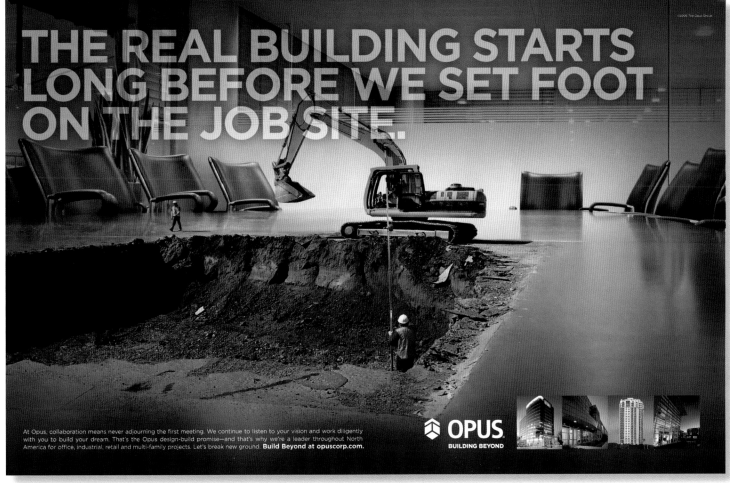

THE REAL BUILDING STARTS LONG BEFORE WE SET FOOT ON THE JOB SITE.

At Opus, collaboration means never adjourning the first meeting. We continue to listen to your vision and work diligently with you to build your dream. That's the Opus design-build promise—and that's why we're a leader throughout North America for office, industrial, retail and multi-family projects. Let's break new ground. **Build Beyond at opuscorp.com.**

OPUS
BUILDING BEYOND

The Norwegian oil adventure continues in Russia. Six service stations in Murmansk are currently the most visible signs of our activities in Russia, but there are more. Our work with Russia to exploit the oil and gas resources in the North is well underway. Our shared home ground requires shared solutions that allow us to extract oil and gas side-by-side with fishing, wildlife and vulnerable nature. The opportunities are enormous and many feel that large quantities of the world's undiscovered oil and gas can be found up here, some on our side and more on the Russian side.

Expertise and experience from the Norwegian shelf is therefore our most valuable contribution to the partnership and this is how we can generate revenue and look after future generations, when our own resources decline. Therefore, in the years to come our engagement in Russia, Algeria, Angola, USA, Azerbaijan and anywhere else where we can drive the Norwegian oil adventure forwards will increase – to the benefit of ourselves and the countries where the adventure continues.

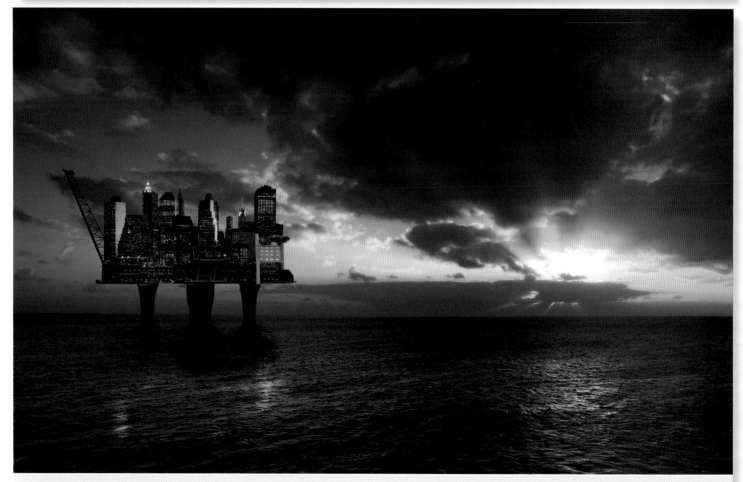

The Norwegian oil adventure continues in USA. For many years, Manhattan's taxi drivers have been pumping Norwegian petrol into their yellow Dodges and Chevrolets. Further south, off the Texas coast, our flag now flies over a number of oil fields in the Gulf of Mexico. And shortly, tankers will deliver liquefied natural gas from the Snøhvit field to the Cove Point terminal at Washington D.C. Only 37 years after we were first struck oil on the Norwegian continental shelf, Statoil is about to become a force to be reckoned with in the energy-superpower, USA. Knowledge,

experience and the values built up over many years on the Norwegian shelf will thereby continue to grow, even when our own oil and gas is finally depleted. The oil adventure will continue, and will generate revenue and look after future generations. Therefore, in the years to come our engagement in USA, Algeria, Angola, Russia, France and anywhere else where we can drive the Norwegian oil adventure forwards will increase- to the benefit of ourselves and the countries where the adventure continues.

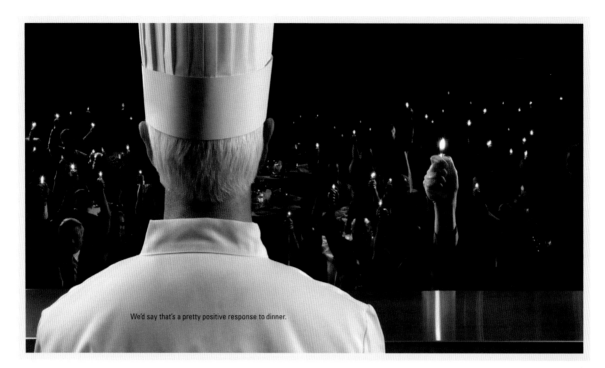

We'd say that's a pretty positive response to dinner.

It's a great feeling when your food is a hit with customers. And when you're successful, we're successful. Because it's our job to support your efforts in the kitchen by providing you with equipment and service you can count on. Day after day. Happy customer after happy customer. We're behind you all the way. Go to www.hobartcorp.com or call us at 1-888-4HOBART.

HOBART

Proud supporter of you.

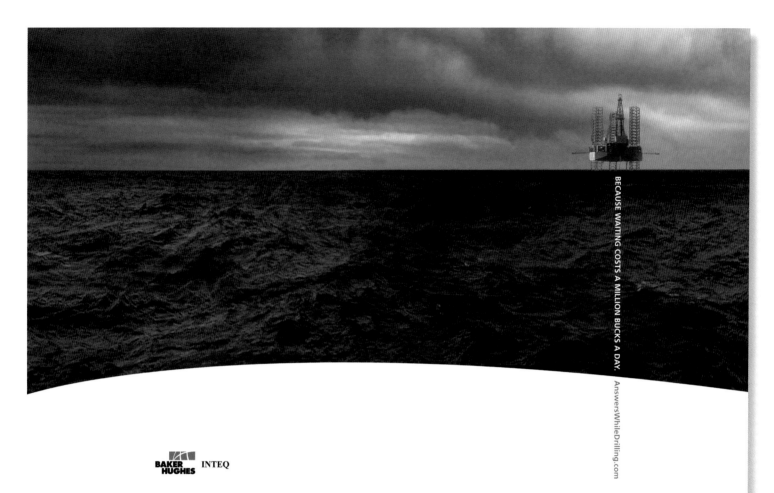

BECAUSE WAITING COSTS A MILLION BUCKS A DAY.

AnswersWhileDrilling.com

BAKER HUGHES INTEQ

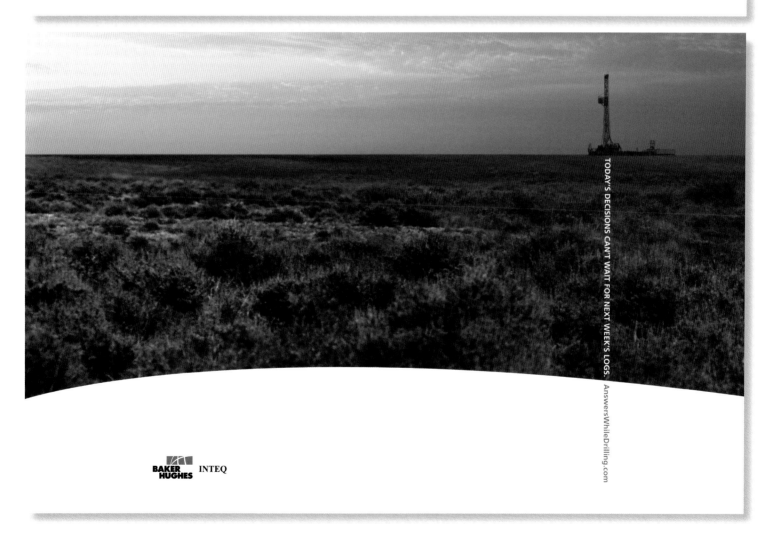

TODAY'S DECISIONS CAN'T WAIT FOR NEXT WEEK'S LOGS.

AnswersWhileDrilling.com

BAKER HUGHES INTEQ

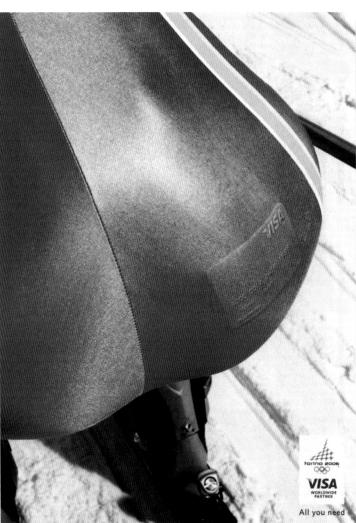

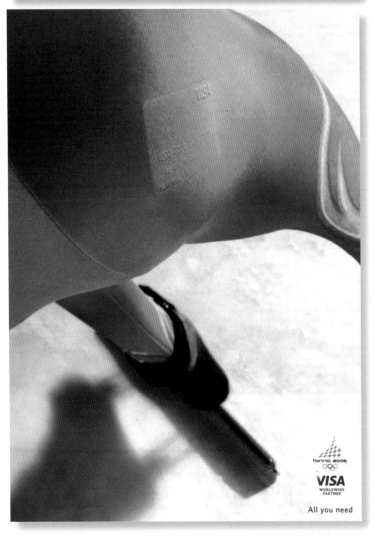

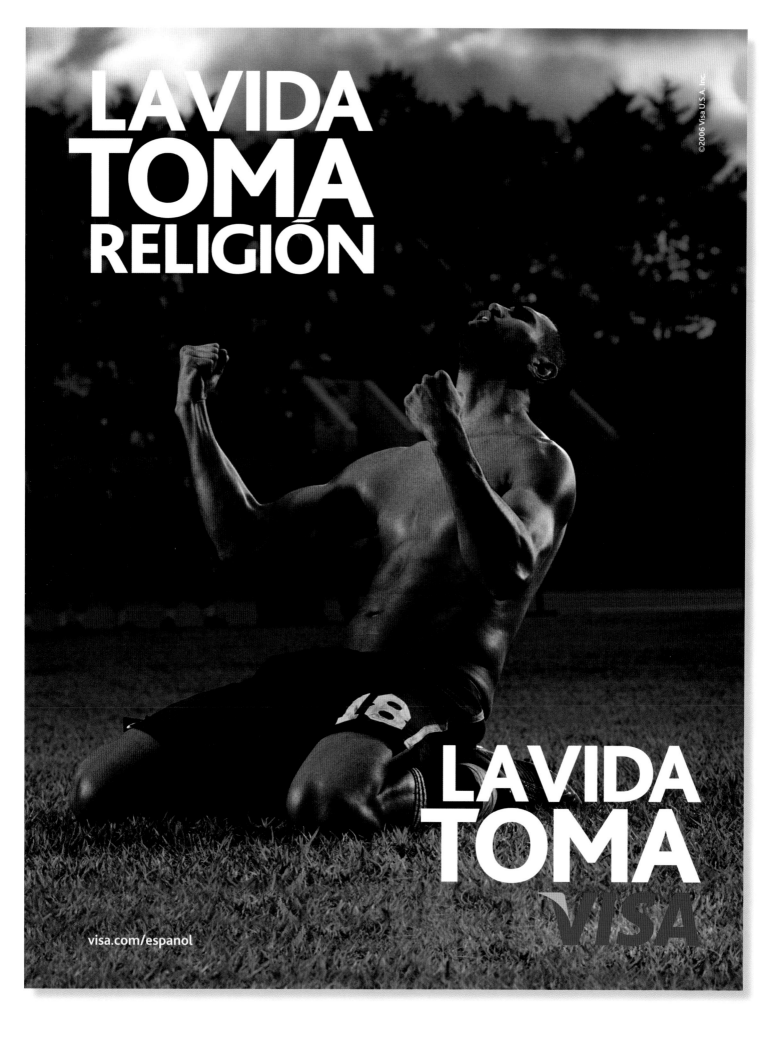

LA VIDA
TOMA
RELIGIÓN

LA VIDA
TOMA

VISA

visa.com/espanol

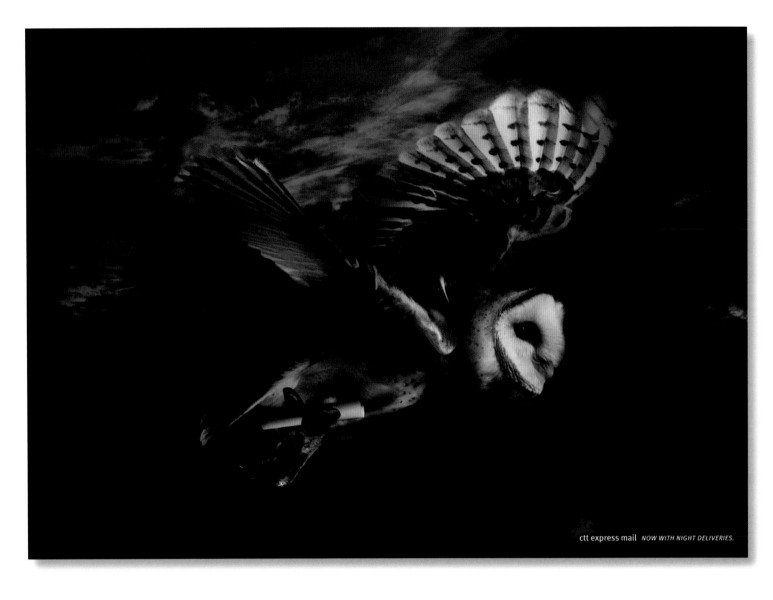

ctt express mail *NOW WITH NIGHT DELIVERIES.*

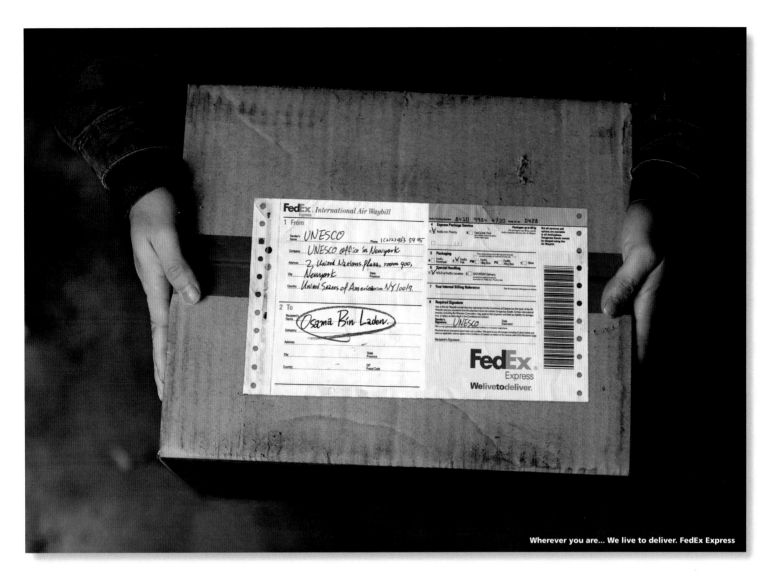

Wherever you are... We live to deliver. FedEx Express

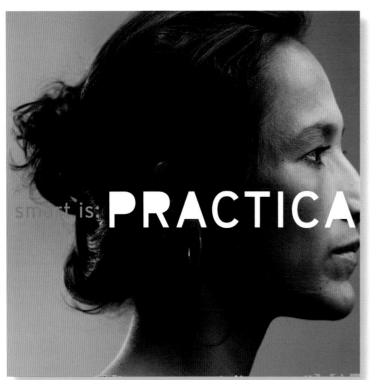

smart is: **PRACTICA**

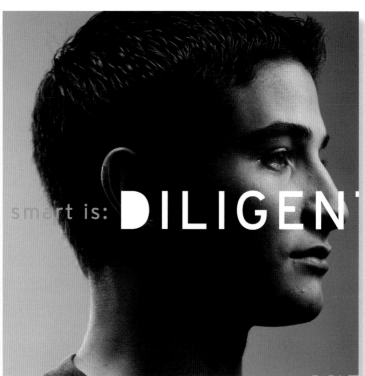

smart is: **DILIGEN**

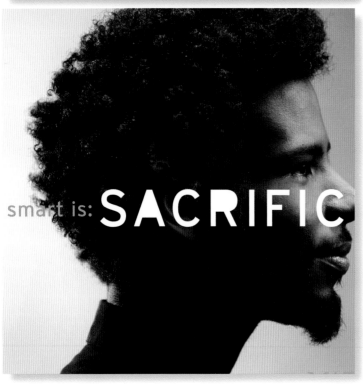

smart is: **SACRIFIC**

smart is: **DECISIVE**

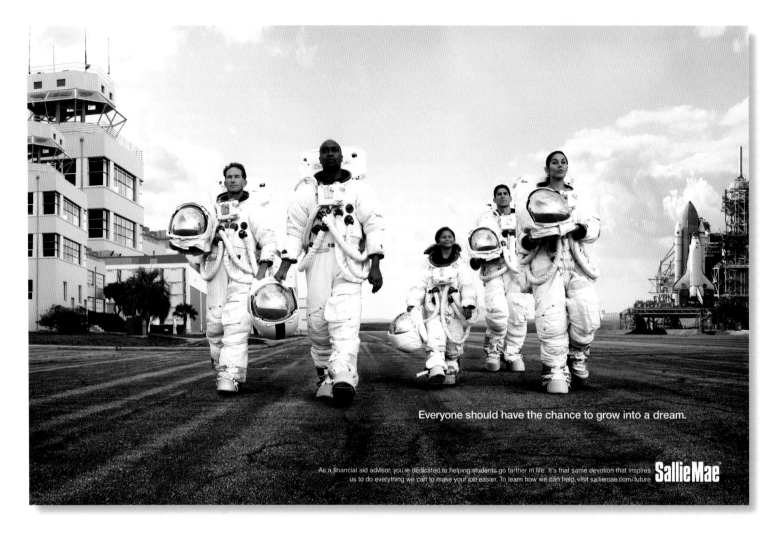

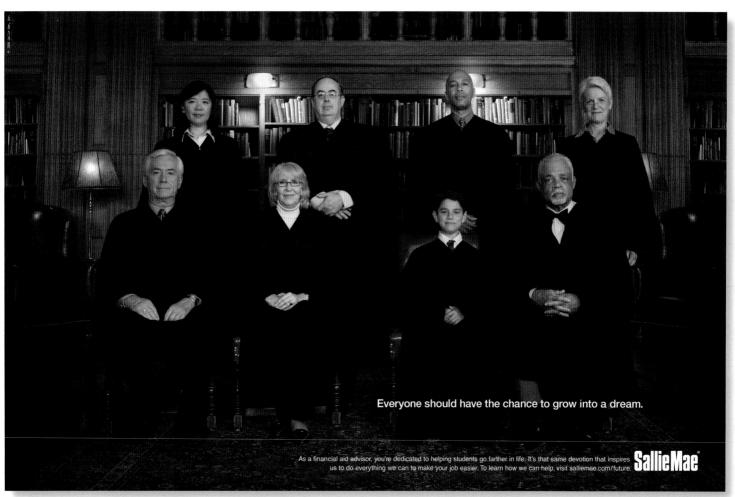

Everyone should have the chance to grow into a dream.

As a financial aid advisor, you're dedicated to helping students go farther in life. It's that same devotion that inspires us to do everything we can to make your job easier. To learn how we can help, visit salliemae.com/future. **SallieMae**

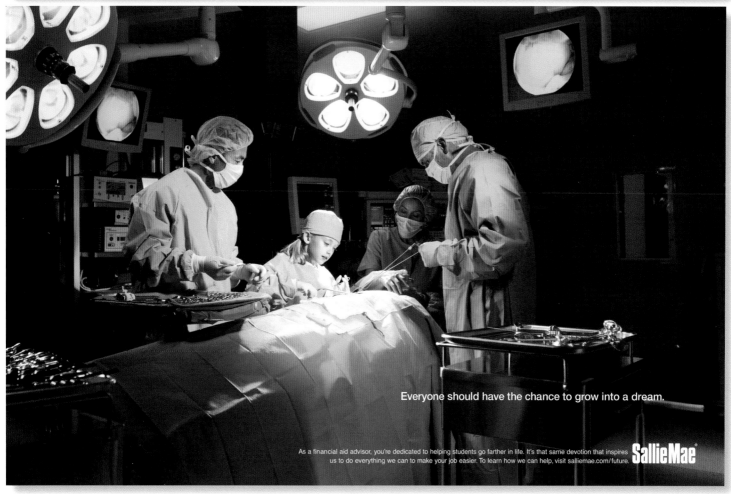

Everyone should have the chance to grow into a dream.

As a financial aid advisor, you're dedicated to helping students go farther in life. It's that same devotion that inspires us to do everything we can to make your job easier. To learn how we can help, visit salliemae.com/future. **SallieMae**

 Proud Sponsor of the Country Music Marathon and 1/2 Marathon.

www.publix.com

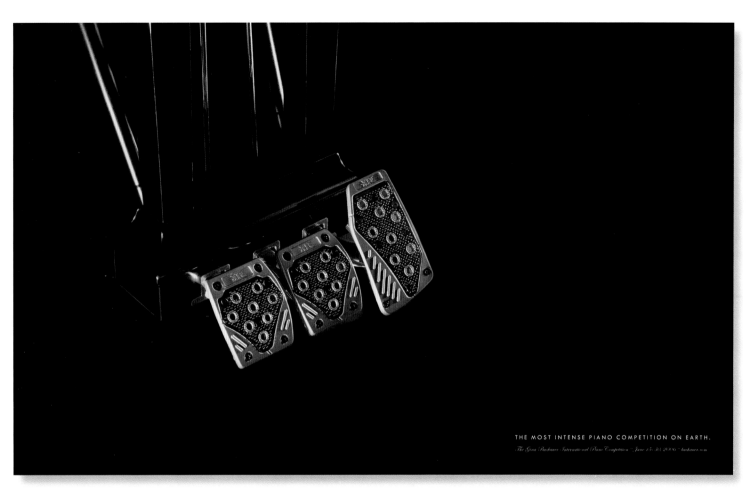

THE MOST INTENSE PIANO COMPETITION ON EARTH.

The Gina Bachauer International Piano Competition ~ June 15-30, 2006 ~ bachauer.com

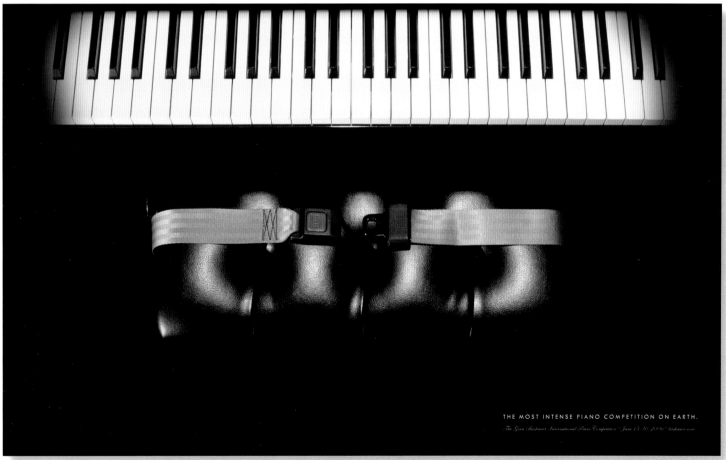

THE MOST INTENSE PIANO COMPETITION ON EARTH.

The Gina Bachauer International Piano Competition ~ June 15-30, 2006 ~ bachauer.com

NEW YORK
est. 1953

Nina
NINASHOES.COM

NEW YORK
est. 1953

Nina
NINASHOES.COM

NEW YORK
est. 1953
Nina
NINASHOES.COM

Wonderbra

THIS IS THE ONLY COPY
OF THIS DRESS.

TIME AFTER TIME
UNIQUE VINTAGE CLOTHING

414 FRANKLIN ST. CHAPEL HILL

The text on the card in the image reads:

This is the only copy of this shirt.

TIME AFTER TIME

UNIQUE VINTAGE CLOTHING

414 FRANKLIN ST. CHAPEL HILL

john varvatos

Iggy Pop: Central Park, N.Y.C.
Photographed by Danny Clinch, 2006

"HELLO, CLEVELAND."

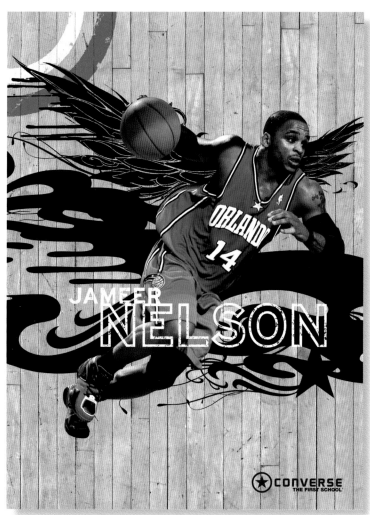

JAMEER **NELSON**

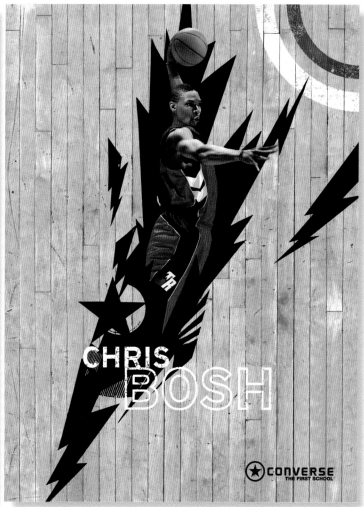

CHRIS **BOSH**

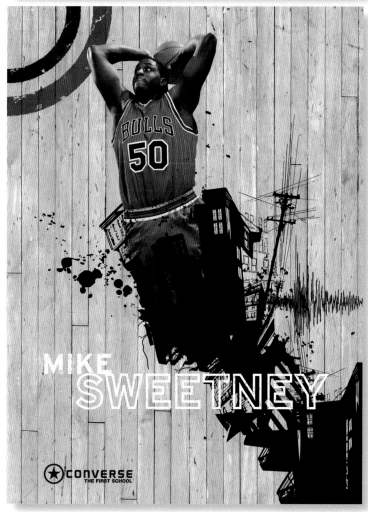

MIKE **SWEETNEY**

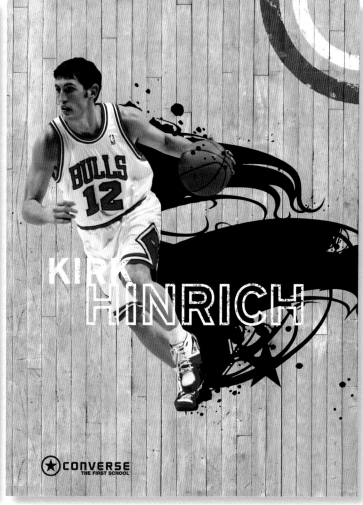

KIRK **HINRICH**

FILIBUSTER

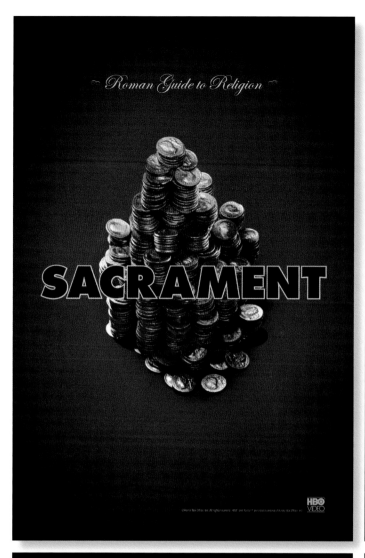

~ Roman Guide to Religion ~

SACRAMENT

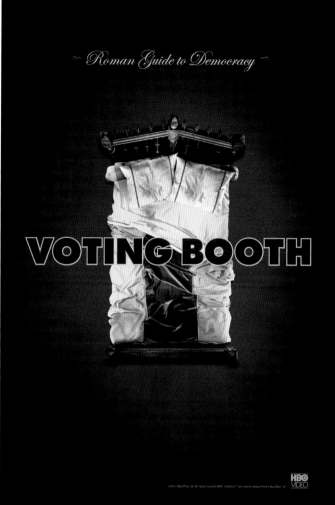

~ Roman Guide to Democracy ~

VOTING BOOTH

WELCOME TO ROME.

OWN THE COMPLETE FIRST SEASON.
AUGUST 15TH.

~ Roman Guide to Communication ~

GREETING CARD

MEET THE WOMAN WHO GAVE THE WORLD
A REASON TO TURN A MAGAZINE SIDEWAYS.

THE ORIGINAL PIN-UP ICON.
NOW ON DVD.

ON THE INSIDE, THIS WOULD BE IN MY LUNG.

ON THE INSIDE, **THIS WOULD** BE IN MY HAND.

Eight Hours of Choices
You'll Never Want to Make.
The Final Season of OZ on DVD.

HBO
VIDEO

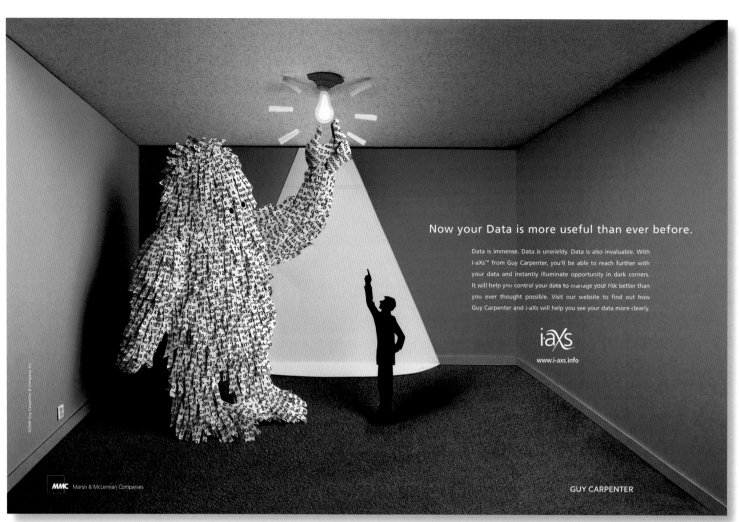

Now your Data is more useful than ever before.

Data is immense. Data is unwieldy. Data is also invaluable. With i-aXs™ from Guy Carpenter, you'll be able to reach further with your data and instantly illuminate opportunity in dark corners. It will help you control your data to manage your risk better than you ever thought possible. Visit our website to find out how Guy Carpenter and i-aXs will help you see your data more clearly.

i·aXs
www.i-axs.info

MMC Marsh & McLennan Companies

GUY CARPENTER

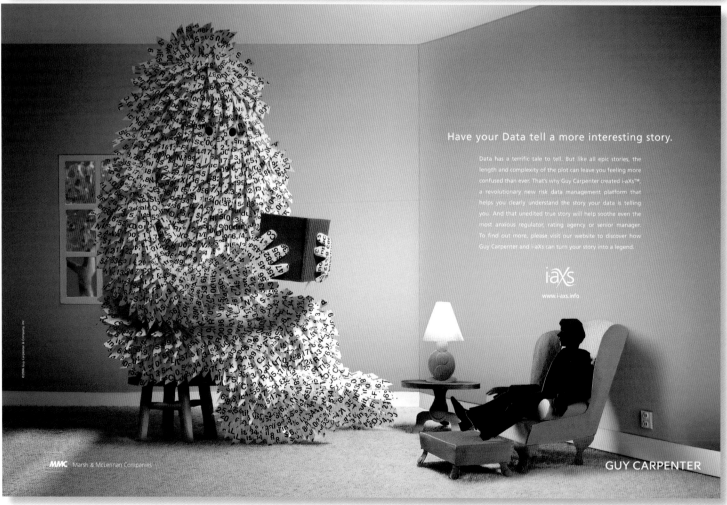

Have your Data tell a more interesting story.

Data has a terrific tale to tell. But like all epic stories, the length and complexity of the plot can leave you feeling more confused than ever. That's why Guy Carpenter created i-aXs™, a revolutionary new risk data management platform that helps you clearly understand the story your data is telling you. And that unedited true story will help soothe even the most anxious regulator, rating agency or senior manager. To find out more, please visit our website to discover how Guy Carpenter and i-aXs can turn your story into a legend.

i·aXs
www.i-axs.info

MMC Marsh & McLennan Companies

GUY CARPENTER

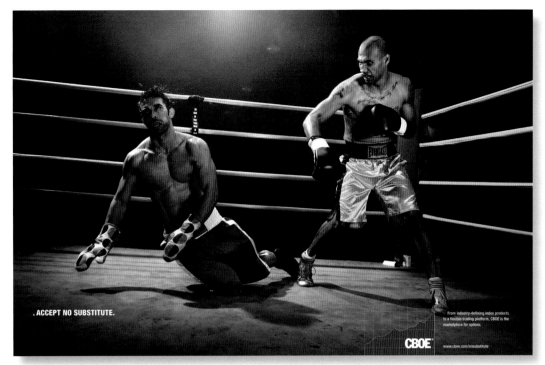

. ACCEPT NO SUBSTITUTE.

From industry-defining index products to a flexible trading platform, CBOE is the marketplace for options.

CBOE

www.cboe.com/nosubstitute

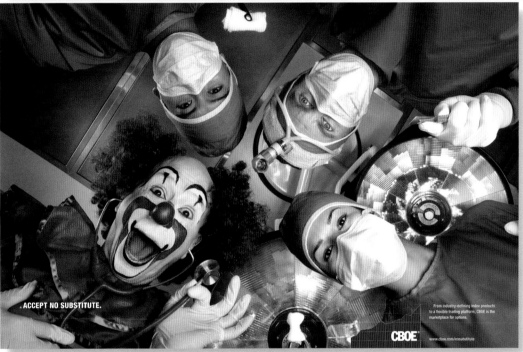

. ACCEPT NO SUBSTITUTE.

From industry-defining index products to a flexible trading platform, CBOE is the marketplace for options.

CBOE

www.cboe.com/nosubstitute

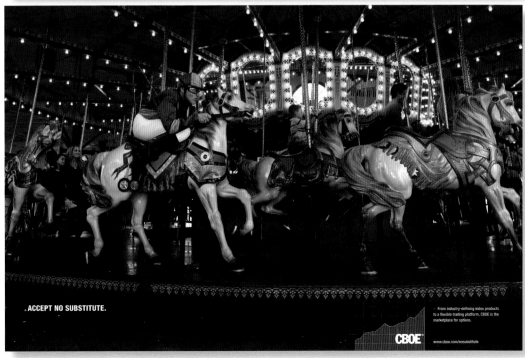

. ACCEPT NO SUBSTITUTE.

From industry-defining index products to a flexible trading platform, CBOE is the marketplace for options.

CBOE

www.cboe.com/nosubstitute

The wild criollo mango from deep within
Peru. Unequaled in its sweet, orange
wonderfulness. All other mangoes bow. It is
unlike any flavor you have had before.
Häagen-Dazs Mango Sorbet

czar of all mangoes

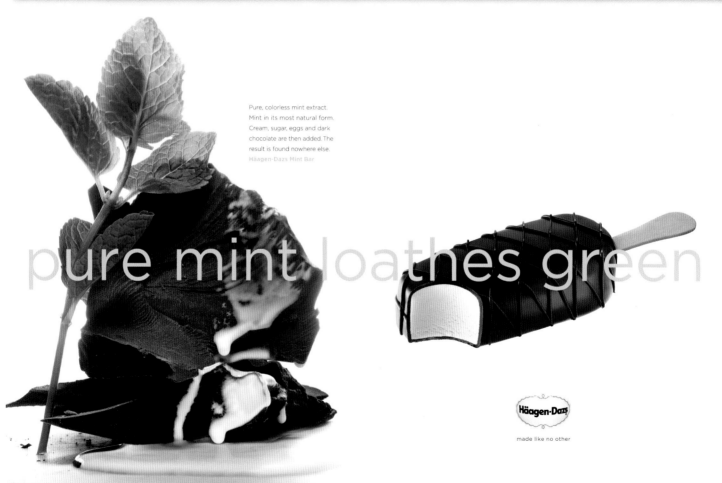

Pure, colorless mint extract.
Mint in its most natural form.
Cream, sugar, eggs and dark
chocolate are then added. The
result is found nowhere else.
Häagen-Dazs Mint Bar

pure mint loathes green

Häagen-Dazs

made like no other

In 1520, Cortez arrived in Latin America and captured the world's original recipe for chocolate: Mayan chocolate. Fortunately, you'll find it a bit easier to get your hands on this coveted chocolate and cinnamon delicacy.
Häagen-Dazs Mayan Chocolate

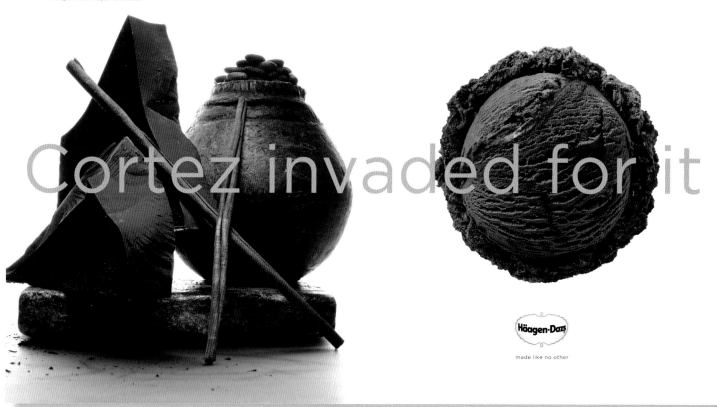

Cortez invaded for it

Häagen-Dazs

made like no other

Before we launched our Strawberry, we searched six long years to find the perfect variety of berry. And only the Pacific Northwest berry was worthy. Pure. Intense. And found nowhere else.
Häagen-Dazs Strawberry

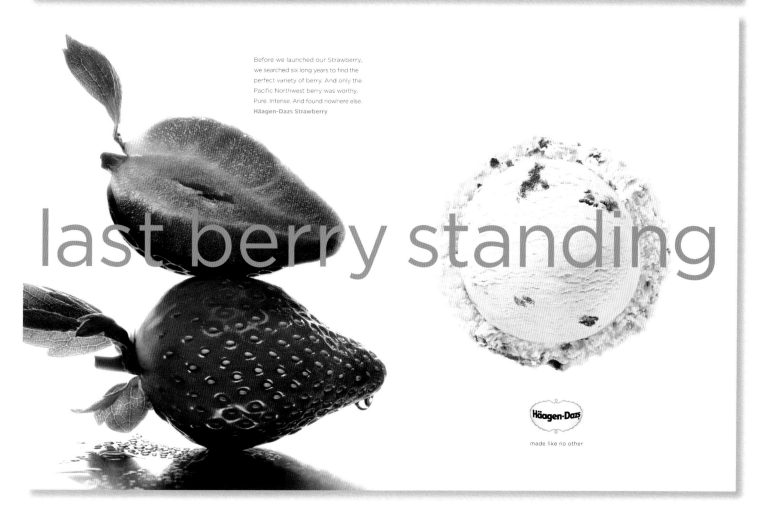

last berry standing

Häagen-Dazs

made like no other

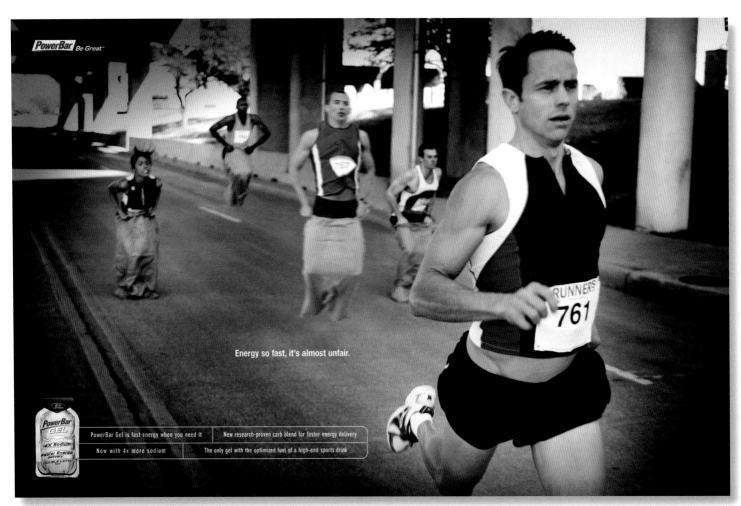

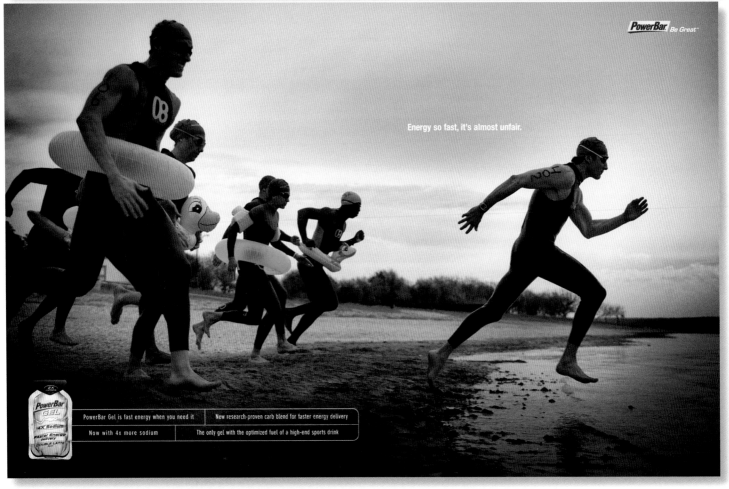

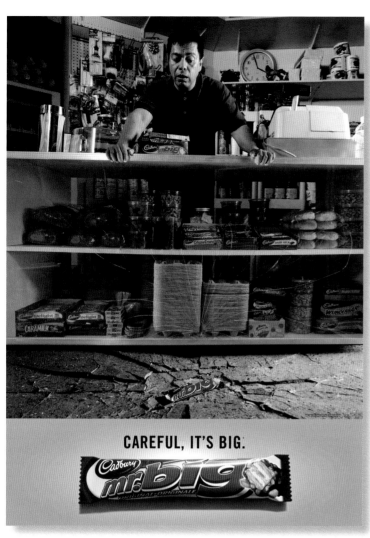

CAREFUL, IT'S BIG.

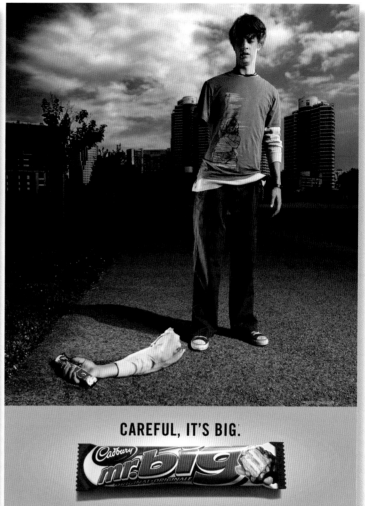

CAREFUL, IT'S BIG.

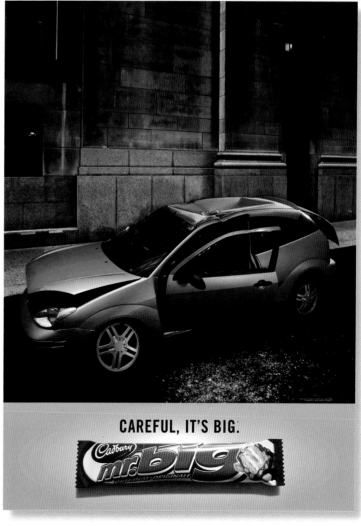

CAREFUL, IT'S BIG.

McDonald's in Birkerød re-opens in 1 week

McDonald's in Birkerød re-opens in 2 weeks

se nd
he in z

if you wanT

to sAvE

The lAmB

100% committed to ketchup

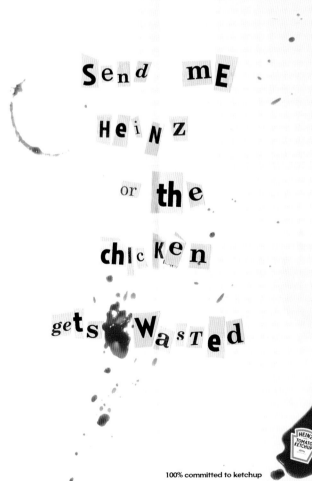

Send mE

HeiNz

or the

chicKen

getsWasTed

100% committed to ketchup

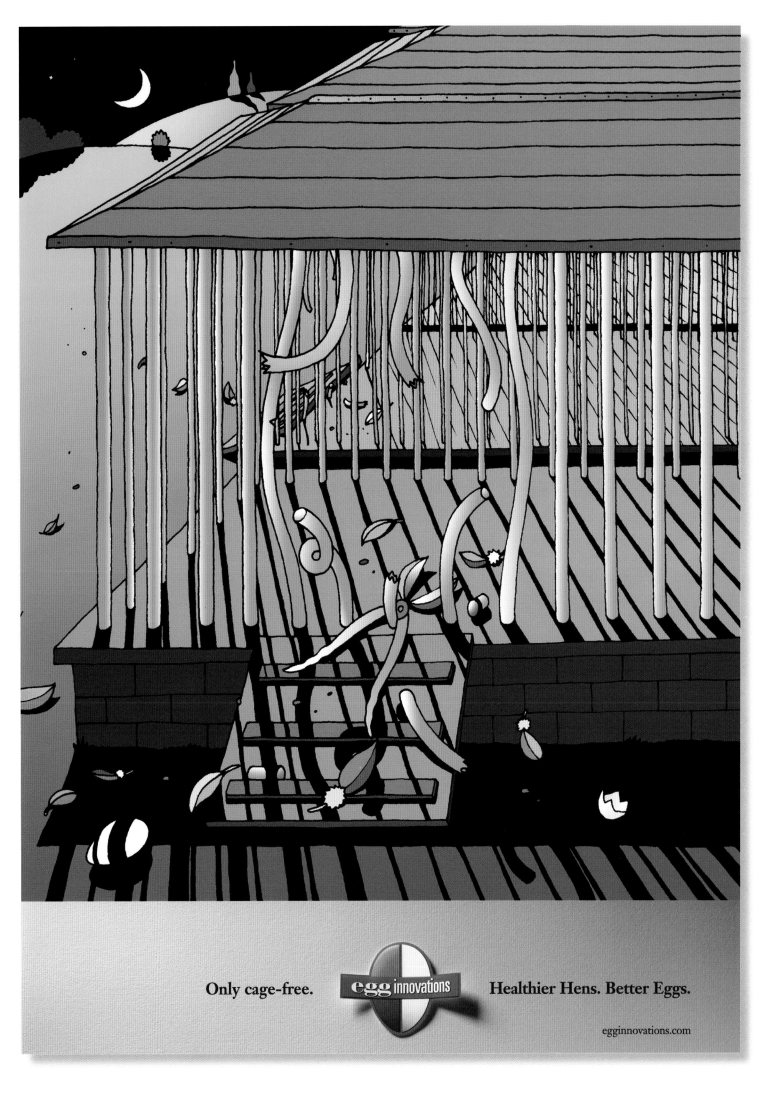

Only cage-free. **egg innovations** Healthier Hens. Better Eggs.

egginnovations.com

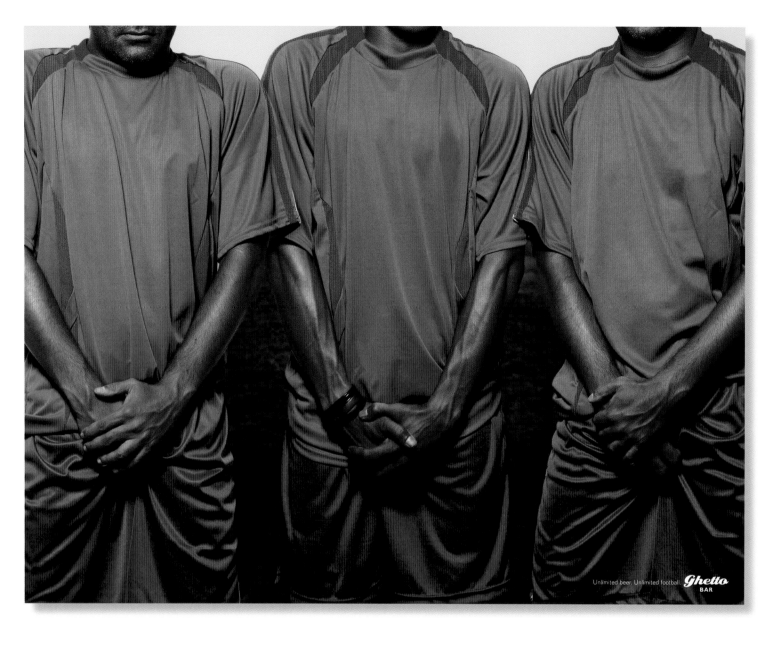

Unlimited beer. Unlimited football. *Ghetto* BAR

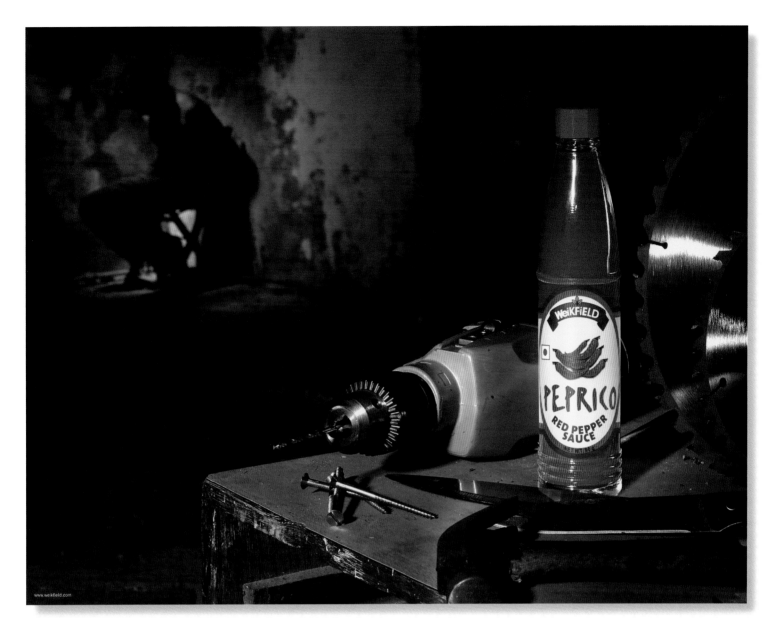

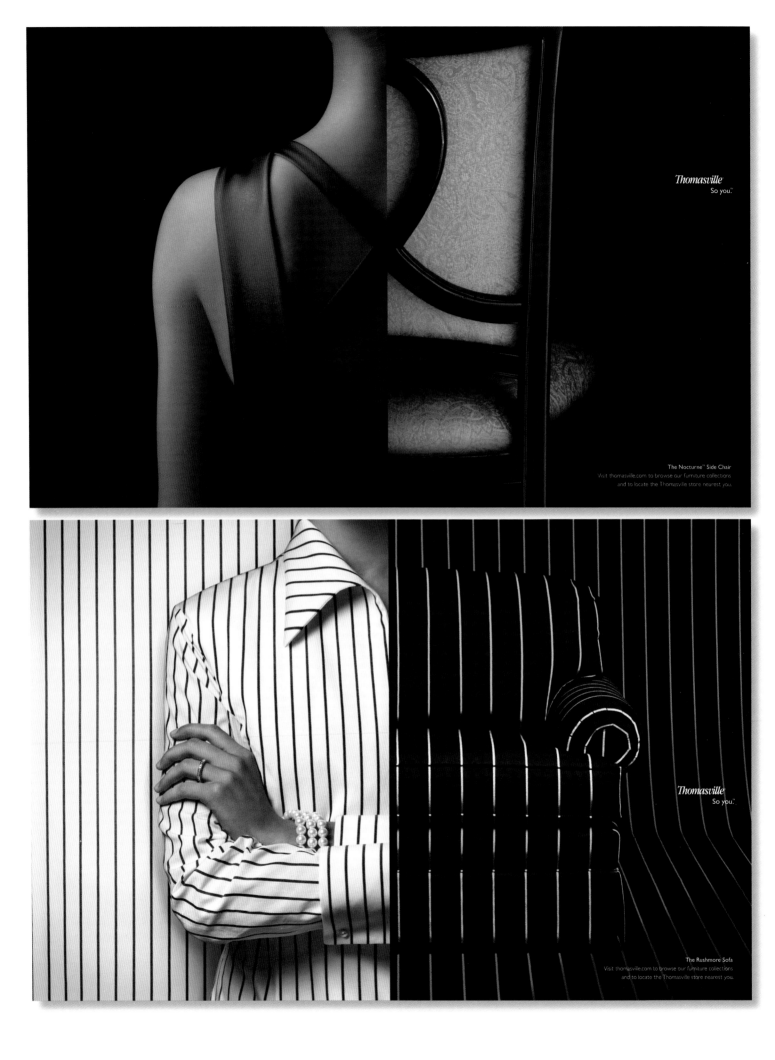

Thomasville
So you.™

The Nocturne™ Side Chair
Visit thomasville.com to browse our furniture collections
and to locate the Thomasville store nearest you.

Thomasville
So you.™

The Rushmore Sofa
Visit thomasville.com to browse our furniture collections
and to locate the Thomasville store nearest you.

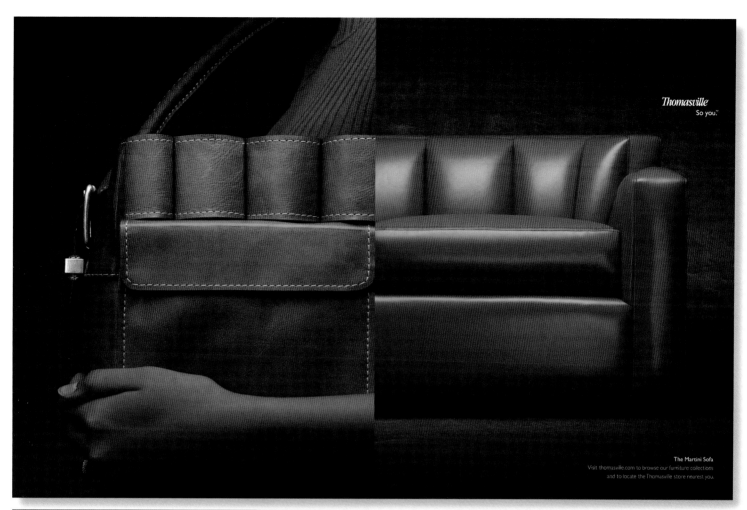

The Martini Sofa
Visit thomasville.com to browse our furniture collections
and to locate the Thomasville store nearest you.

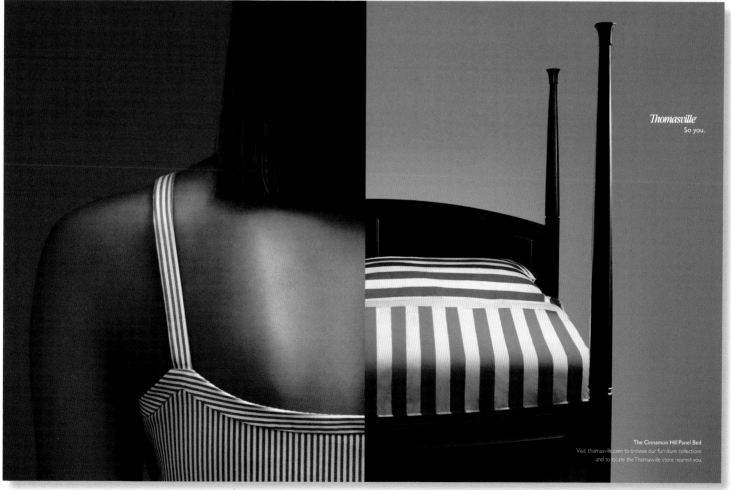

The Cinnamon Hill Panel Bed
Visit thomasville.com to browse our furniture collections
and to locate the Thomasville store nearest you.

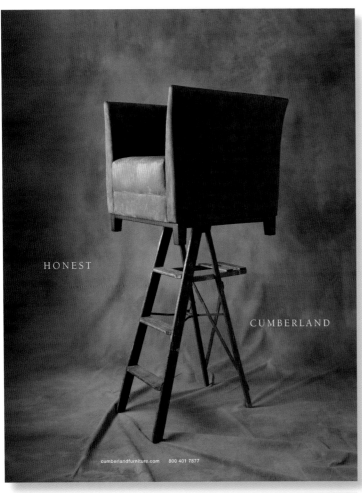

HONEST

CUMBERLAND

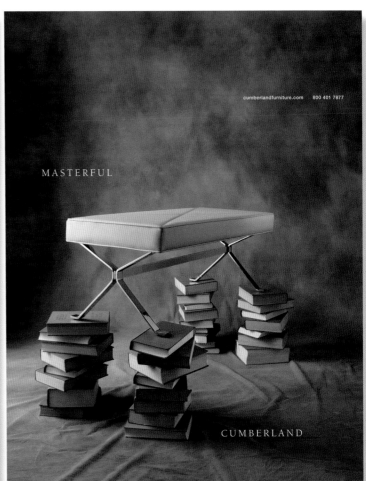

MASTERFUL

CUMBERLAND

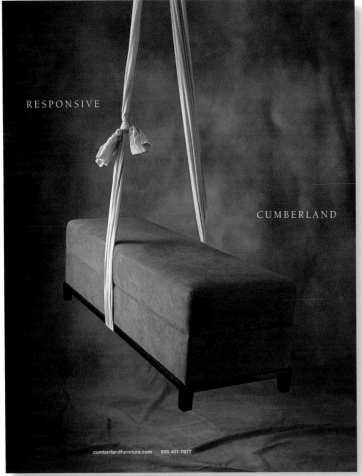

RESPONSIVE

CUMBERLAND

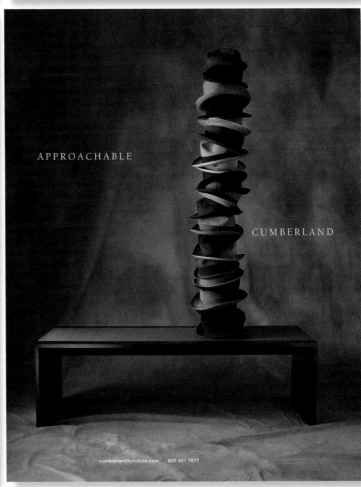

APPROACHABLE

CUMBERLAND

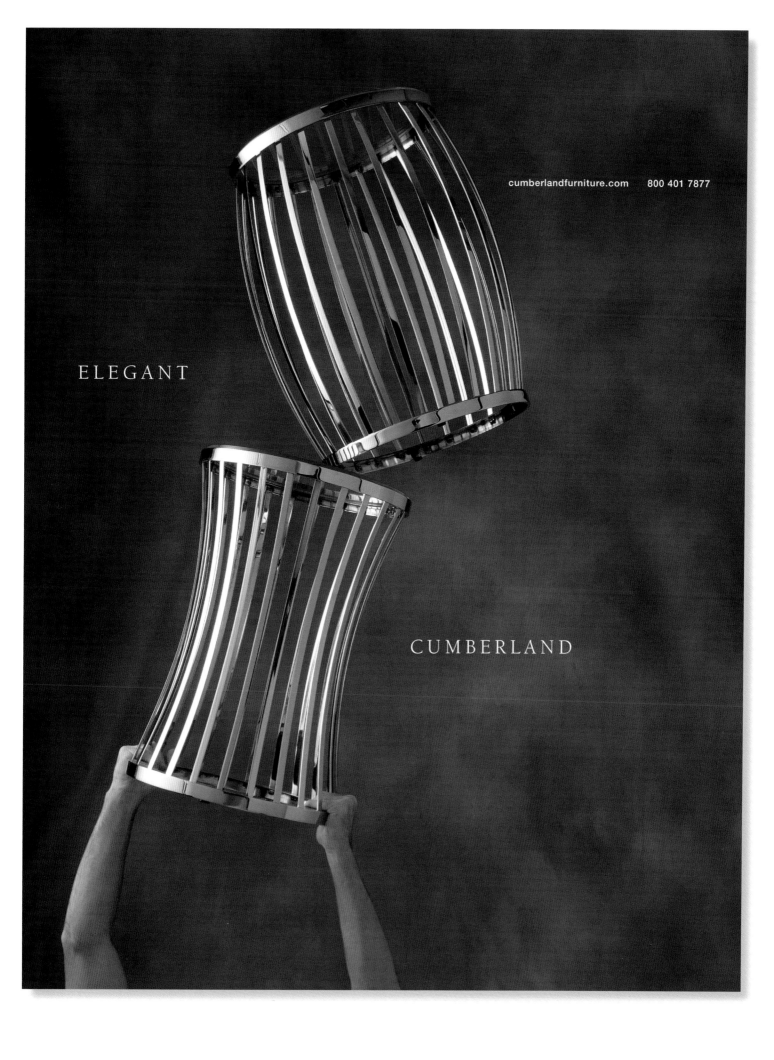

ELEGANT

CUMBERLAND

cumberlandfurniture.com 800 401 7877

Advertisement 1

REMOVING

A BRAIN TUMOR

THROUGH THE NOSE ISN'T

EXACTLY BRAIN SURGERY.

Advertisement 2

HOW

DID WE SAVE THE LIVES

OF HUNDREDS OF PATIENTS

IN ONE SURGERY?

WE SAVED THEIR DOCTOR.

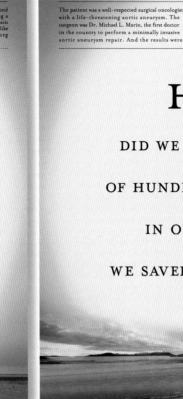
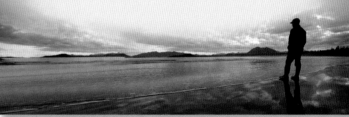

Advertisement 3

WE

TAUGHT A FIVE-YEAR-OLD BOY

A VALUABLE LESSON IN SHARING.

WE FOUND A WAY TO SAVE HIS LIFE AND

TWO OTHERS WITH ONLY ONE LIVER.

Advertisement 4

IF YOU

REALLY WANT TO SEE WHAT A REPAIRED

HEART VALVE LOOKS LIKE,

BE AT THE FINISH LINE AT THIS YEAR'S

NEW YORK CITY MARATHON.

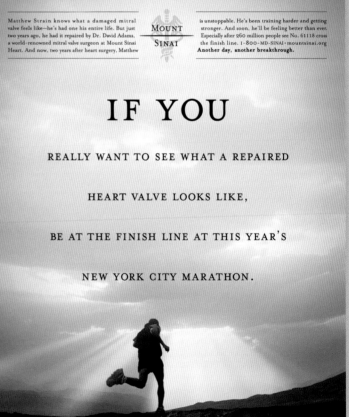

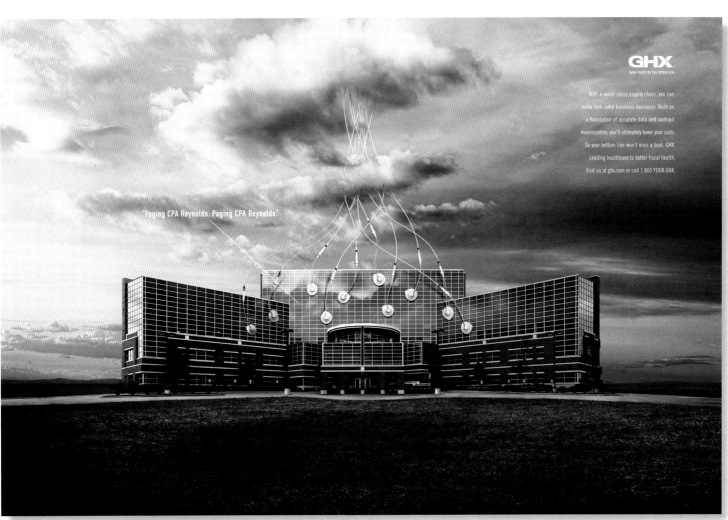

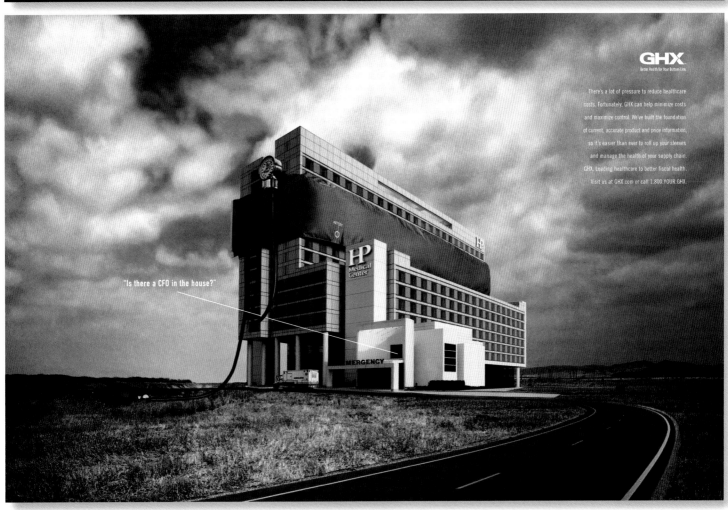

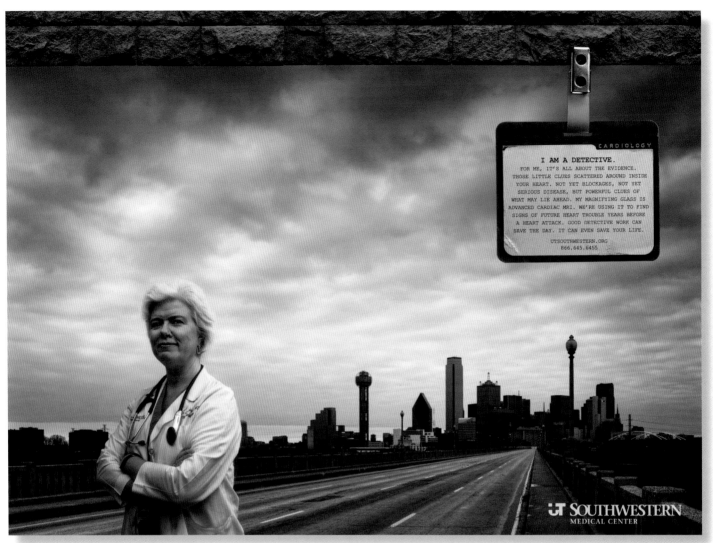

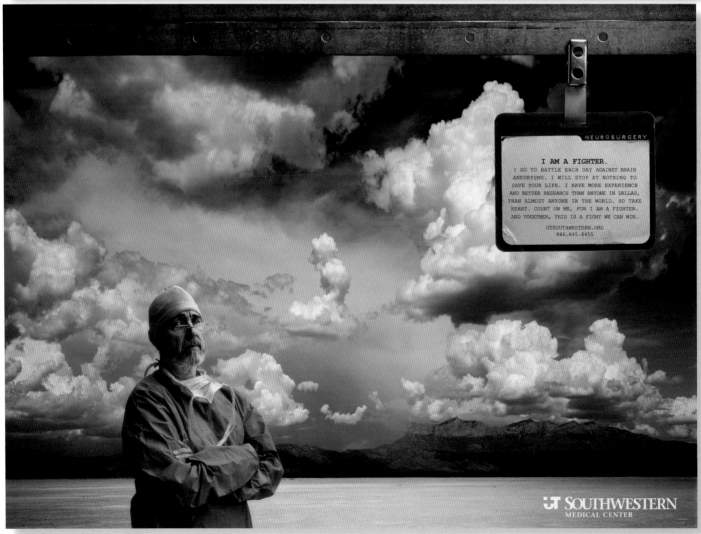

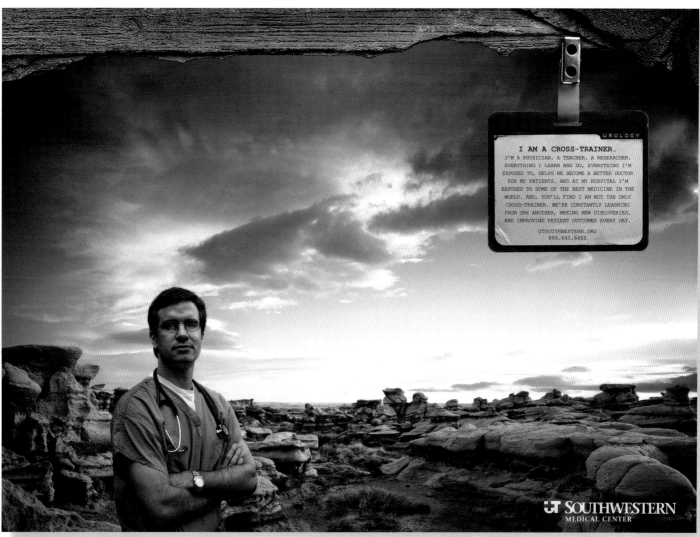

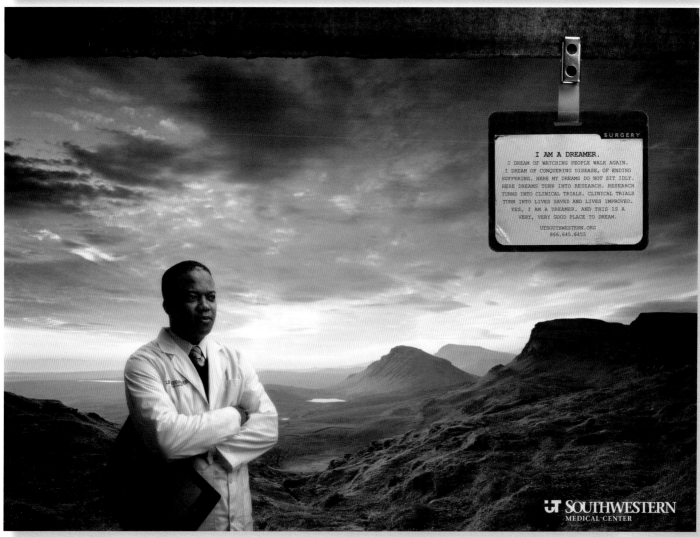

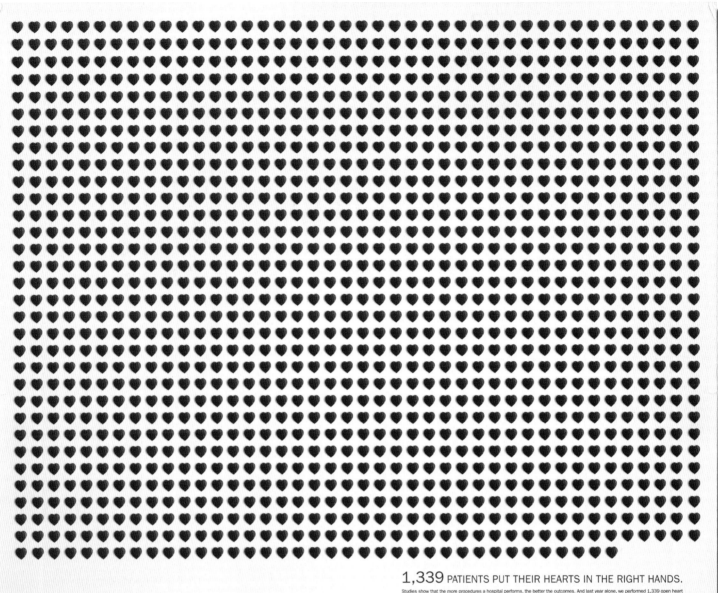

1,339 PATIENTS PUT THEIR HEARTS IN THE RIGHT HANDS.

Studies show that the more procedures a hospital performs, the better the outcomes. And last year alone, we performed 1,339 open heart surgeries. That's more than any hospital in Illinois. And that means a whole lot of happy open heart surgery patients. To learn more or find an Advocate Christ Medical Center physician, call 1-800-3-ADVOCATE (1-800-323-8622) or visit advocatehealth.com/christ.

✛ *Advocate Christ Medical Center*

4440 West 95th Street • Oak Lawn

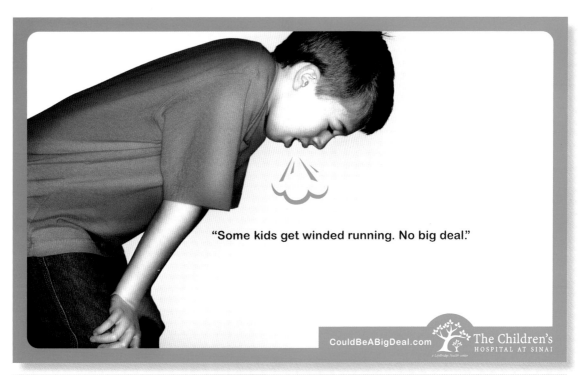

"Some kids get winded running. No big deal."

CouldBeABigDeal.com The Children's HOSPITAL AT SINAI a LifeBridge Health center

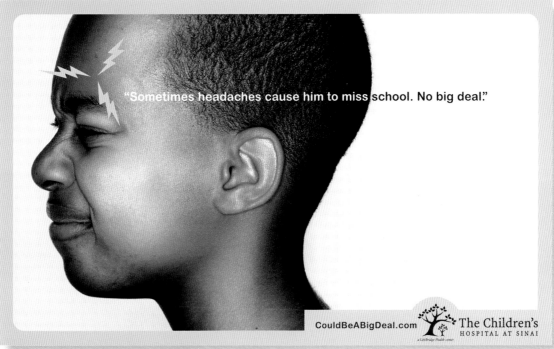

"Sometimes headaches cause him to miss school. No big deal."

CouldBeABigDeal.com The Children's HOSPITAL AT SINAI a LifeBridge Health center

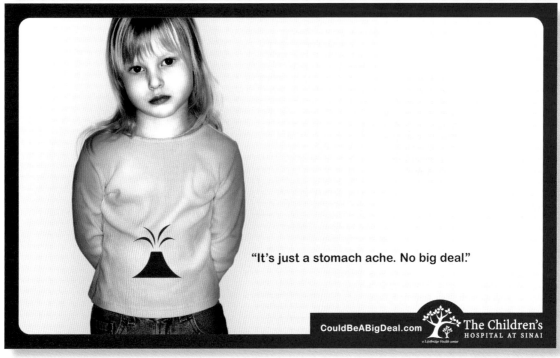

"It's just a stomach ache. No big deal."

CouldBeABigDeal.com The Children's HOSPITAL AT SINAI a LifeBridge Health center

MORE IS MORE. A luxuriant suite is just the beginning. Preferred Hotels & Resorts and Preferred Boutique have conspired to offer you one of a kind, experiential getaways that begin with a suite and continue with all sorts of bonuses from champagne and limo service to a shopping excursion extraordinaire. Visit us online and lose yourself in imaginative and exclusive *I Prefer the Suite Life* packages and reserve *more* for yourself today.

I PREFER THE SUITE LIFE To take advantage of
this package offer and for full terms and conditions, please
visit **PreferredHotels.com/SuitePHL** or call **1 877 323 7505**.

Select participating hotels: **Mexico** • Dreams Cancun Resort & Spa • Dreams Los Cabos Suites Golf Resort & Spa • Dreams Puerto Vallarta Resort & Spa • Dreams Tulum Resort & Spa • **USA** • Ambassador East Hotel, Chicago • Sanibel Harbour Resort & Spa, Ft. Myers • The Houstonian Hotel, Club & Spa • The Platinum Hotel and Spa, Las Vegas • The Sherry-Netherland, NY • Turtle Bay Resort, Oahu

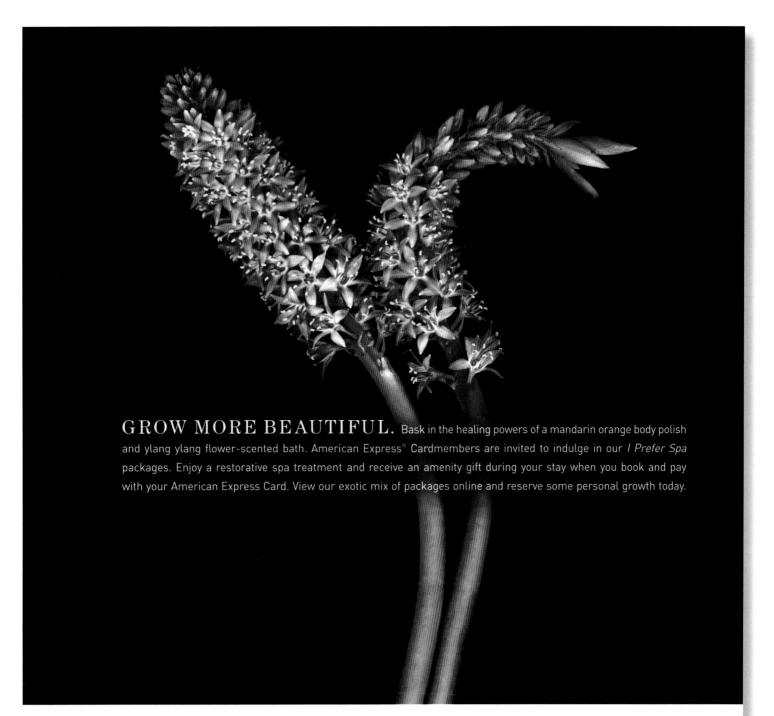

GROW MORE BEAUTIFUL. Bask in the healing powers of a mandarin orange body polish and ylang ylang flower-scented bath. American Express® Cardmembers are invited to indulge in our *I Prefer Spa* packages. Enjoy a restorative spa treatment and receive an amenity gift during your stay when you book and pay with your American Express Card. View our exotic mix of packages online and reserve some personal growth today.

I PREFER SPA PACKAGES To take advantage of this American Express Cardmember offer, please visit **PreferredSpa.com/PHL** or call **1 877 323 7505**.

Select hotels in: **USA** • Newport Beach, California • Ft. Myers and Vero Beach, Florida • Sea Island, Georgia • Oahu, Hawaii • Las Vegas, Nevada • Houston and San Antonio, Texas • Milwaukee, Wisconsin • **Mexico/Caribbean** • Cancun • Los Cabos • Puerto Morelos • Puerto Vallarta • Tortola, British Virgin Islands • **Europe** • Crete, Greece • Dublin, Ireland • Lugano, Switzerland • Prague, Czech Republic

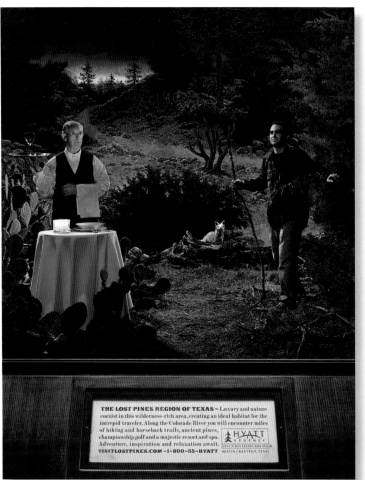

THE LOST PINES REGION OF TEXAS ~ Luxury and nature coexist in this wilderness-rich area, creating an ideal habitat for the intrepid traveler. Along the Colorado River you will encounter miles of hiking and horseback trails, ancient pines, championship golf and a majestic resort and spa. Adventure, inspiration and relaxation await. VISITLOSTPINES.COM ~ 1~800~55~HYATT

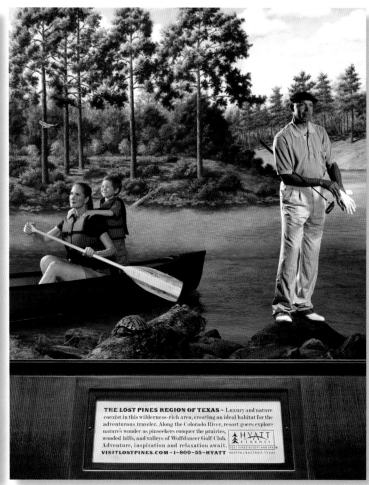

THE LOST PINES REGION OF TEXAS ~ Luxury and nature coexist in this wilderness-rich area, creating an ideal habitat for the adventurous traveler. Along the Colorado River, resort goers explore nature's wonder as pinseekers conquer the prairies, wooded hills, and valleys of Wolfdancer Golf Club. Adventure, inspiration and relaxation await. VISITLOSTPINES.COM ~ 1~800~55~HYATT

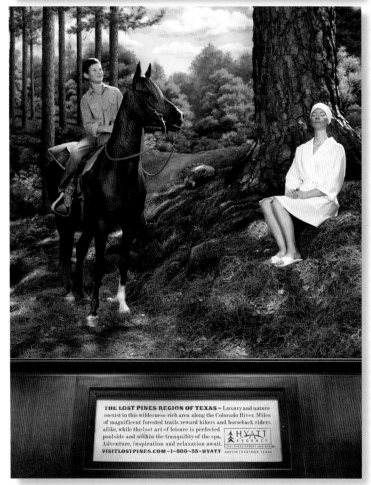

THE LOST PINES REGION OF TEXAS ~ Luxury and nature coexist in this wilderness-rich area along the Colorado River. Miles of magnificent forested trails reward bikers and horseback riders alike, while the lost art of leisure is perfected poolside and within the tranquility of the spa. Adventure, inspiration and relaxation await. VISITLOSTPINES.COM ~ 1~800~55~HYATT

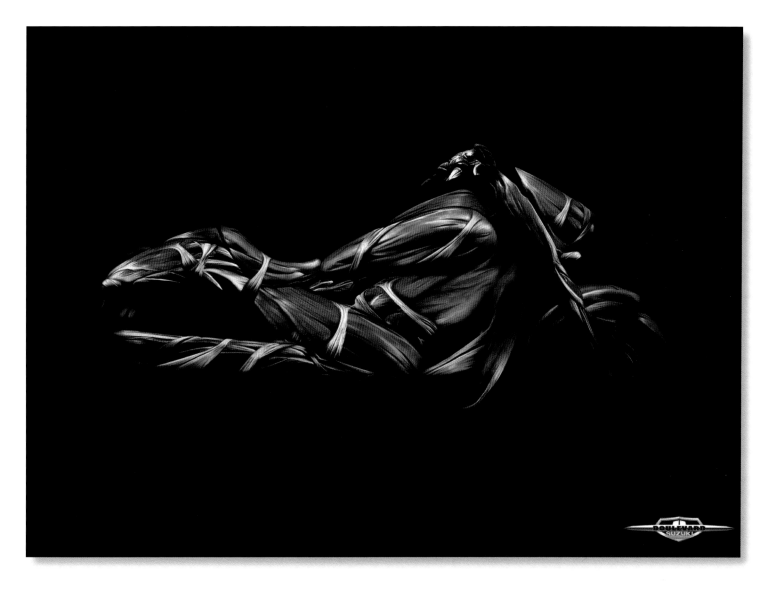

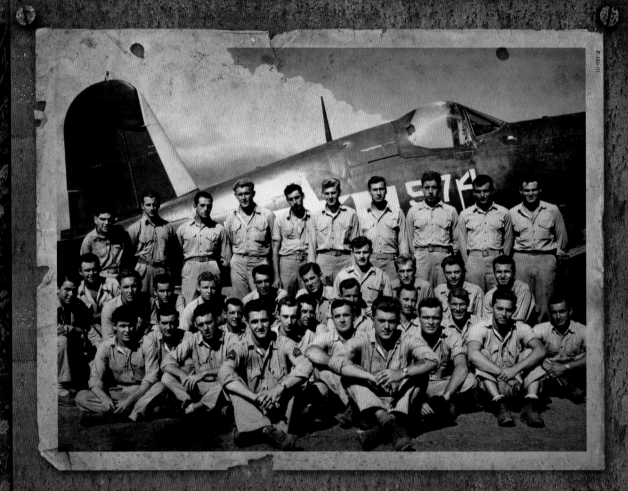

AFTER SPENDING THE WHOLE DAY SHOOTING KAMIKAZES WHAT DID THEY DO AT NIGHT? SHOOT KAMIKAZES, OF COURSE.

It's no WWII memorial, but it is a fitting tribute to countless enlisted men and officers who've ever served our country. The Subic Bay Bar and Cafe is the actual bar previously located in the Phillipines; carefully and painstakingly re-created right here in Pensacola, Florida. So next time you visit the National Museum of Naval Aviation, raise a toast to the men who saved our nation. You won't be able to match their bravery, but you can certainly knock down a kamikaze like the best of them.

THE SUBIC BAY BAR
AT THE NATIONAL MUSEUM OF NAVAL AVIATION

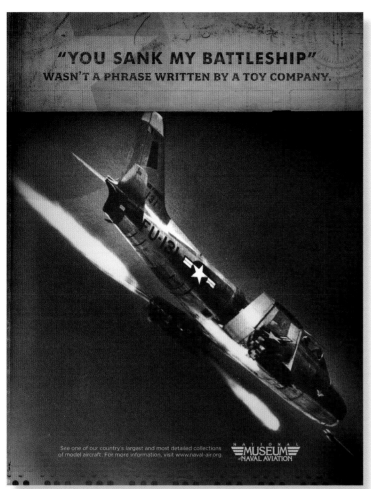

"YOU SANK MY BATTLESHIP"
WASN'T A PHRASE WRITTEN BY A TOY COMPANY.

See one of our country's largest and most detailed collections of model aircraft. For more information, visit www.naval-air.org.

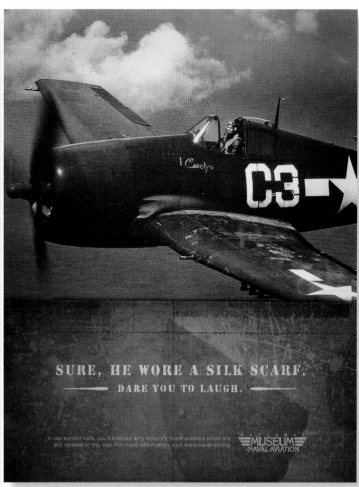

SURE, HE WORE A SILK SCARF.
—— DARE YOU TO LAUGH. ——

In our exhibit halls, you'll find out why history's finest enlisted pilots are still revered to this day. For more information, visit www.naval-air.org.

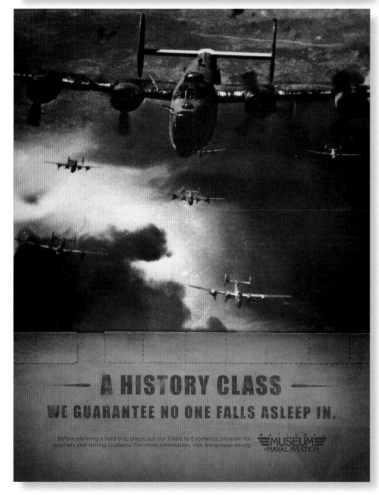

—— A HISTORY CLASS ——
WE GUARANTEE NO ONE FALLS ASLEEP IN.

Before planning a field trip, check out our Flight to Excellence program for teachers and visiting students. For more information, visit www.naval-air.org.

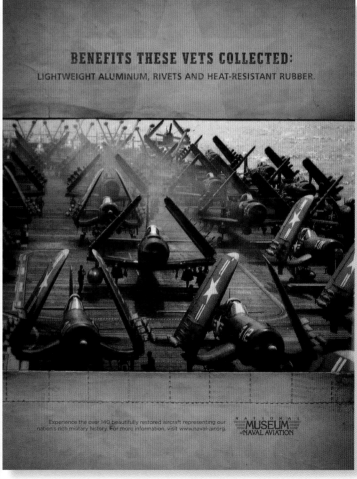

BENEFITS THESE VETS COLLECTED:
LIGHTWEIGHT ALUMINUM, RIVETS AND HEAT-RESISTANT RUBBER.

Experience the over 140 beautifully restored aircraft representing our nation's rich military history. For more information, visit www.naval-air.org.

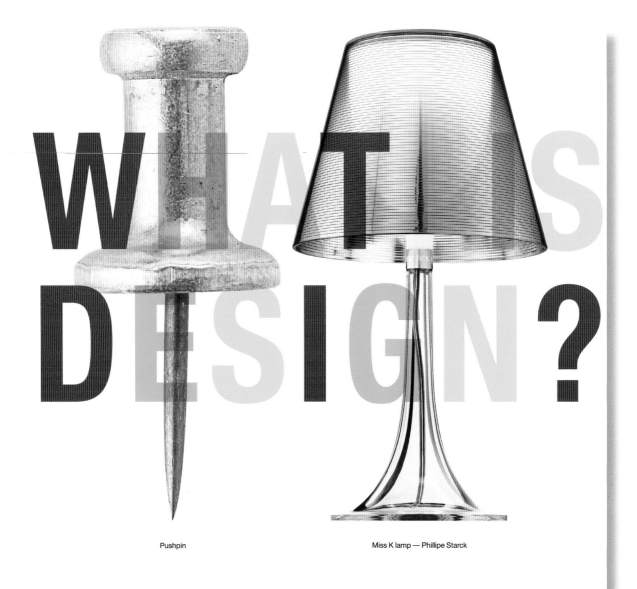

Pushpin

Miss K lamp — Phillipe Starck

YOU DECIDE.

Cooper-Hewitt announces the first-ever People's Design Award.

Vote online and share your voice at www.cooperhewitt.org by 10.16.06.

Celebrate National Design Week at Cooper-Hewitt October 15–21. You're invited to come see it for yourself, with free admission to the museum all week long courtesy of Target. This new initiative promotes better understanding of the role that design plays in all aspects of our lives. Design-focused lesson plans will be available for teachers via the Educator Resource Center at www.cooperhewitt.org.

FREE ADMISSION COURTESY OF TARGET OCT. 15–21

Cooper-Hewitt, National Design Museum is the only museum in the United States devoted solely to historic and contemporary design. With more than 250,000 objects, the Museum holds one of the largest design collections in the country. The Museum presents compelling perspectives on the impact of design on daily life through exhibitions and educational programs. **LOCATED ON MUSEUM MILE, 91st ST. & 5th AVE., NYC**

 GO ONLINE AND VOTE Make your design voice heard. Winners announced live at www.cooperhewitt.org at 10 pm EST on October 18, 2006.

DESIGN FREE FOR ALL

Free admission to Cooper-Hewitt during National Design Week October 15–21, courtesy of Target

Celebrate National Design Week at Cooper-Hewitt October 15–21. Design Week promotes better understanding of the role that design plays in all aspects of our lives. Events include a panel discussion with the National Design Award winners, the National Design Awards Gala, a high school design fair and more. Plus, you can enjoy free admission to the Museum all week. Visit **www.cooperhewitt.org** or call **212-849-8400** for hours.

Cooper-Hewitt, National Design Museum is the only museum in the United States devoted solely to historic and contemporary design. With more than 250,000 objects, the Museum holds one of the largest design collections in the country. The Museum presents compelling perspectives on the impact of design on daily life through dynamic exhibitions, educational programs and publications.

FIND DESIGN ON MUSEUM MILE at 91st Street and 5th Avenue in NYC. Take the Lexington Avenue 4, 5 or 6 subway to the 86th or 96th Street stations.

National Design Week and the National Design Awards are made possible by the generous sponsorship of **Target.** © 2006 Target Stores. Target and the Bullseye Design are registered trademarks of Target Brands, Inc. All rights reserved. 106135

 Smithsonian
Cooper-Hewitt, National Design Museum

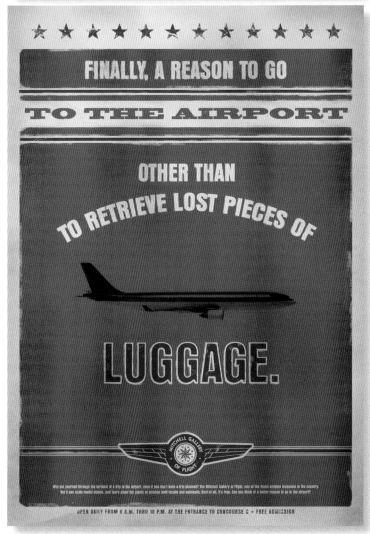

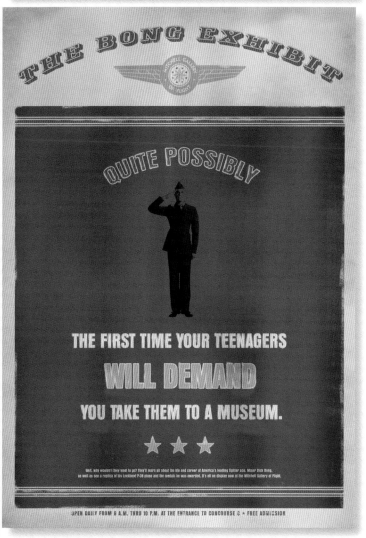

King Arthur's sword,
stir stick for witch's potion,
Tyrannosaurus Rex bone, old man's crutch,
fairy godmother wand, majorette baton,
big league baseball bat,
scepter for ruling kingdom
and oh yeah, a stick.

Use your imagination and the possibilities are endless.
Introducing Calgary's first ever interactive museum dedicated to growing
children's minds through music, theatre, drawing, and playing.
Where everything you can imagine is real.

creativekidsmuseum.com

World's biggest jaw breaker, an ogre's eyeball, flying meteor, unhatched dinosaur egg, giant gumball, the planet formerly known as Pluto and yes, a ball.

Use your imagination and the possibilities are endless.
Introducing Calgary's first ever interactive museum dedicated to growing children's minds through music, theatre, drawing, and playing.
Where everything you can imagine is real.

CREATIVE
KIDS
MUSEUM
creativekidsmuseum.com

VINTAGE VINYL RECORDS WERE CUSTOM-CUT TO CREATE THESE BUSINESS CARDS.

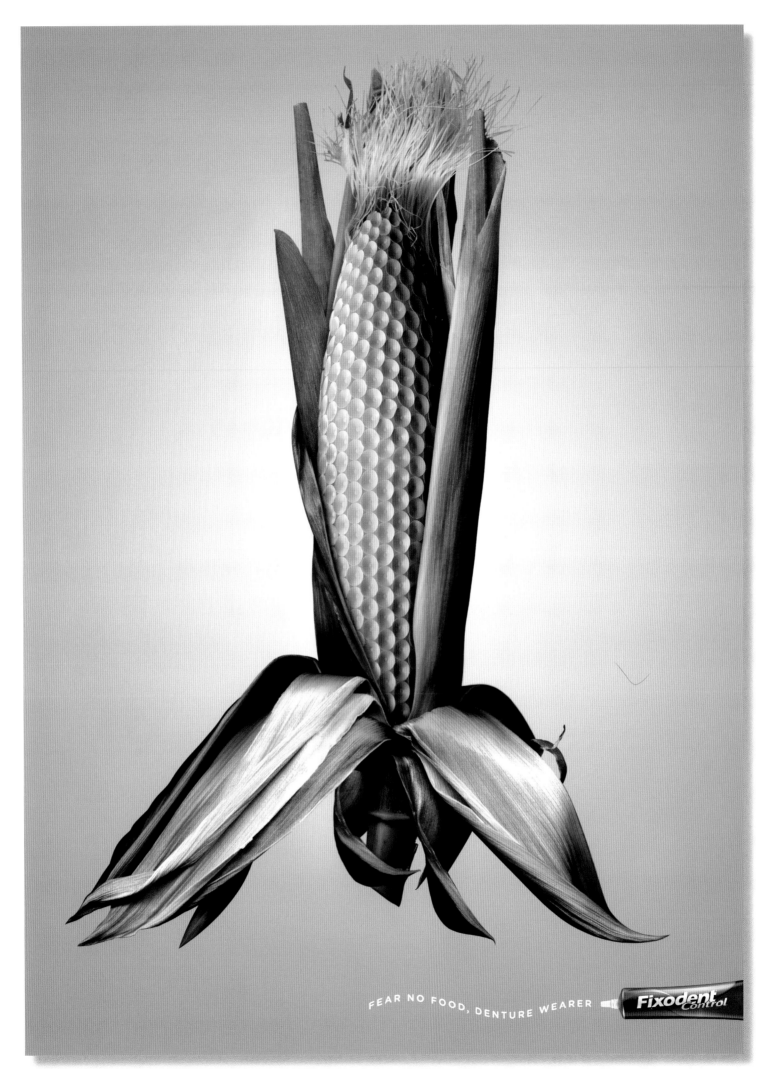

FEAR NO FOOD, DENTURE WEARER

Fixodent Control

VIAGRA®

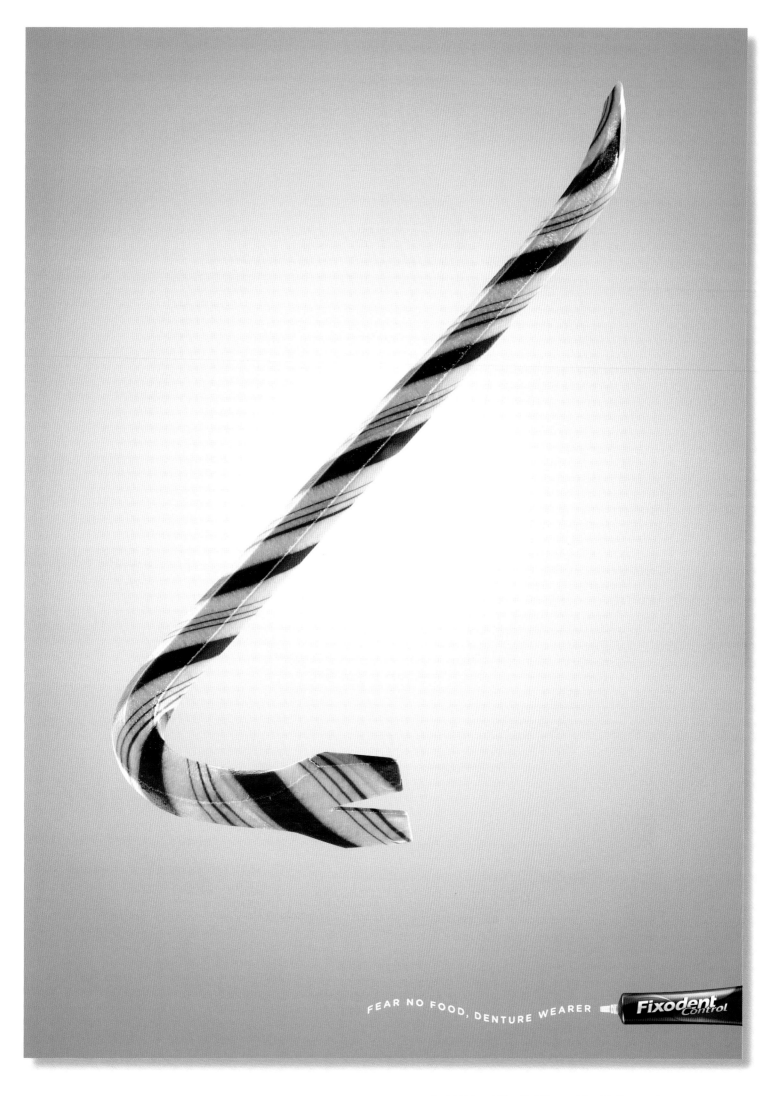

FEAR NO FOOD, DENTURE WEARER

Fixodent
Control

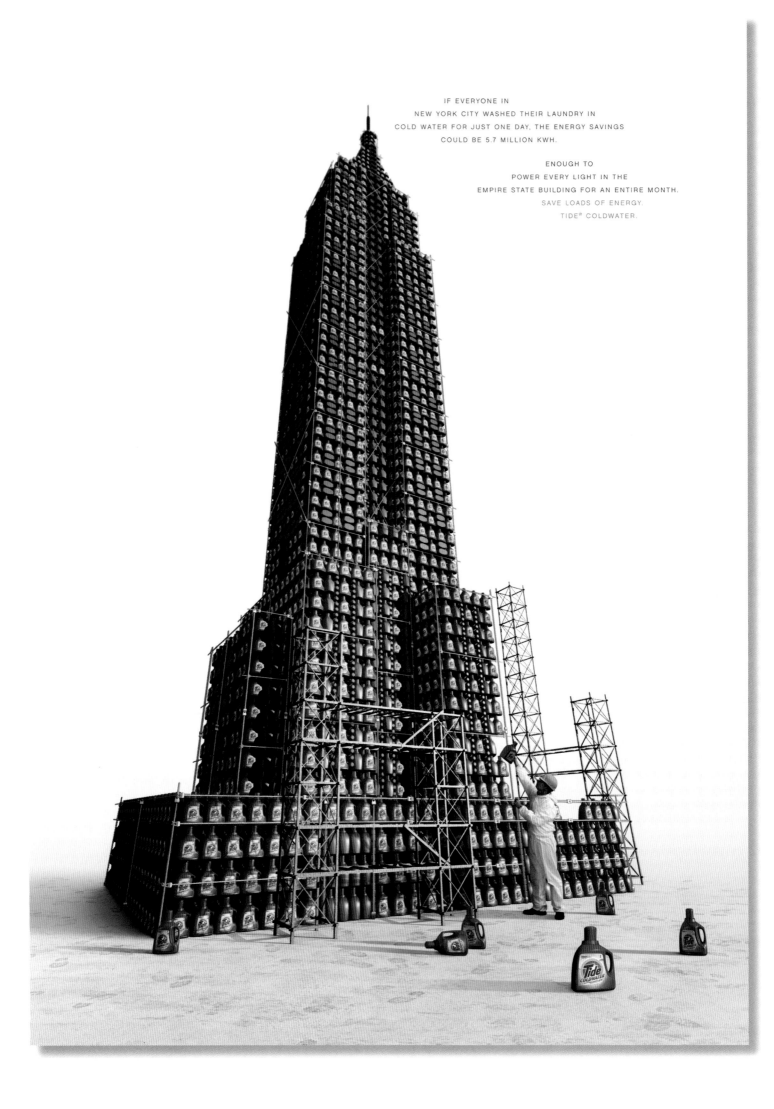

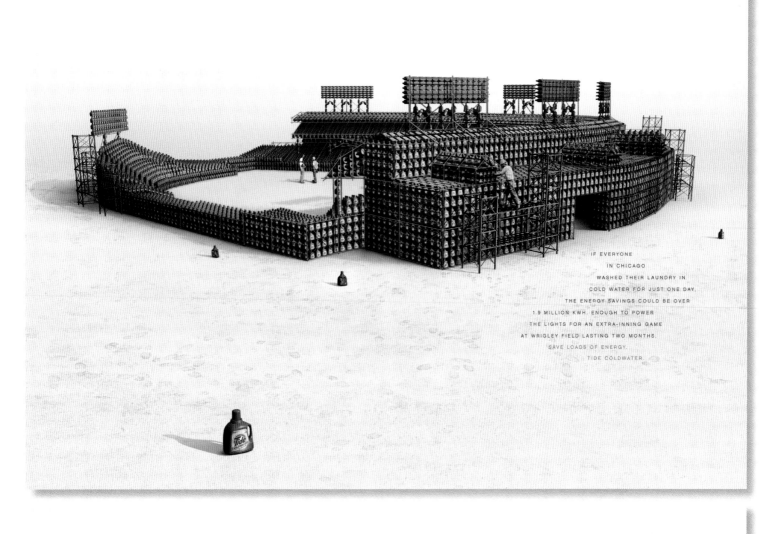

IF EVERYONE
IN CHICAGO
WASHED THEIR LAUNDRY IN
COLD WATER FOR JUST ONE DAY,
THE ENERGY SAVINGS COULD BE OVER
1.9 MILLION KWH. ENOUGH TO POWER
THE LIGHTS FOR AN EXTRA-INNING GAME
AT WRIGLEY FIELD LASTING TWO MONTHS.
SAVE LOADS OF ENERGY.
TIDE COLDWATER

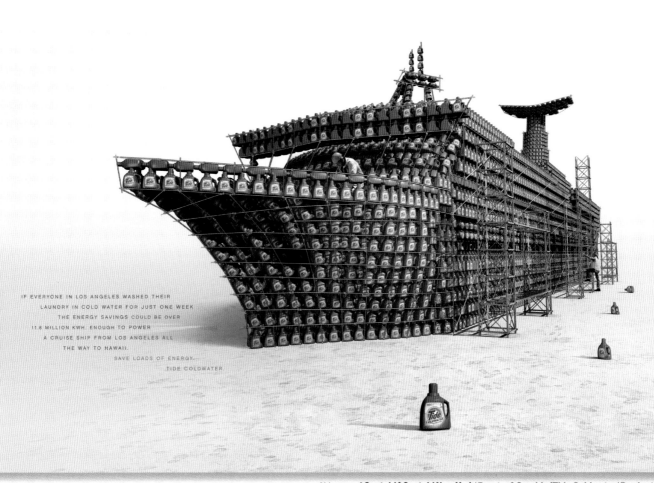

IF EVERYONE IN LOS ANGELES WASHED THEIR
LAUNDRY IN COLD WATER FOR JUST ONE WEEK
THE ENERGY SAVINGS COULD BE OVER
11.8 MILLION KWH. ENOUGH TO POWER
A CRUISE SHIP FROM LOS ANGELES ALL
THE WAY TO HAWAII.
SAVE LOADS OF ENERGY.
TIDE COLDWATER

THE BOLD LOOK
OF KOHLER.

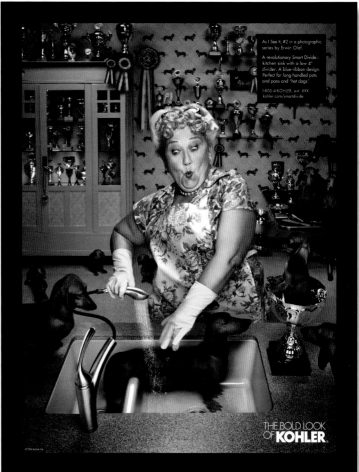

THE BOLD LOOK
OF KOHLER.

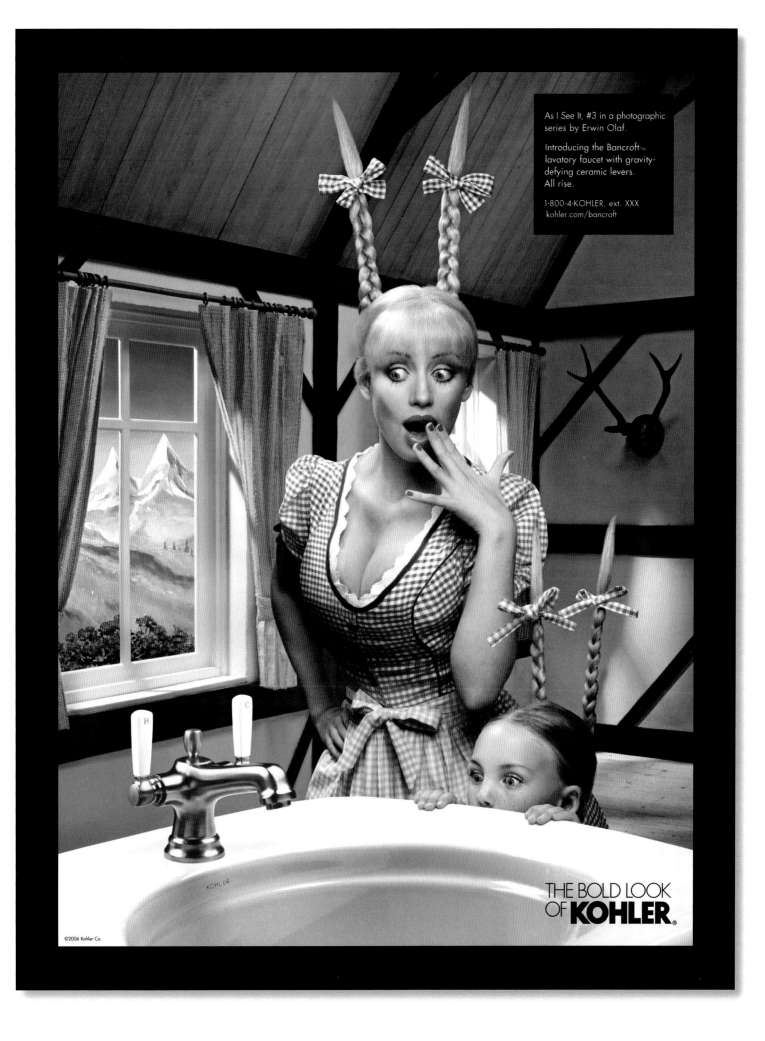

As I See It, #3 in a photographic series by Erwin Olaf.

Introducing the Bancroft™ lavatory faucet with gravity-defying ceramic levers. All rise.

1-800-4-KOHLER, ext. XXX
kohler.com/bancroft

THE BOLD LOOK
OF KOHLER®

©2006 Kohler Co.

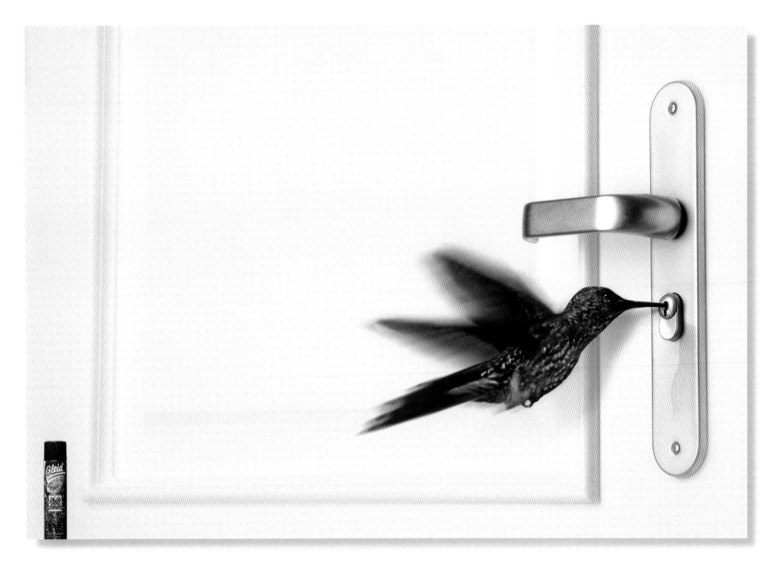

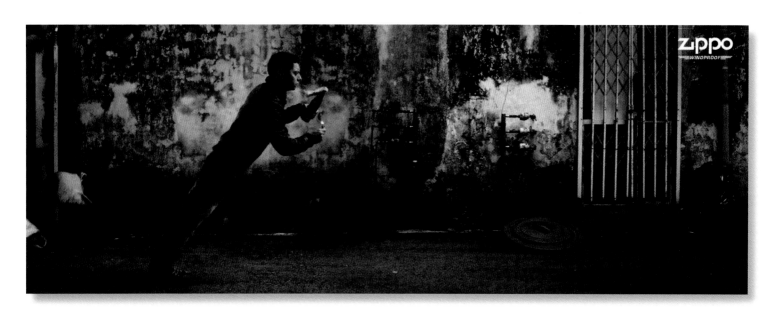

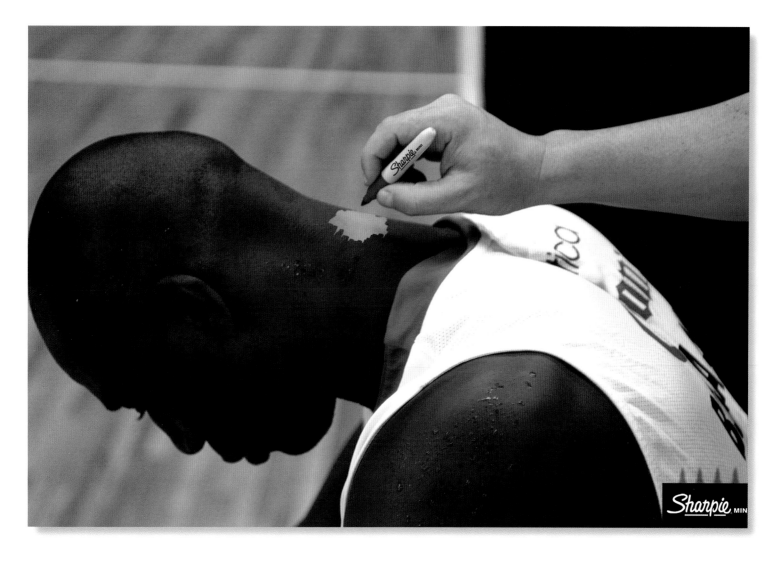

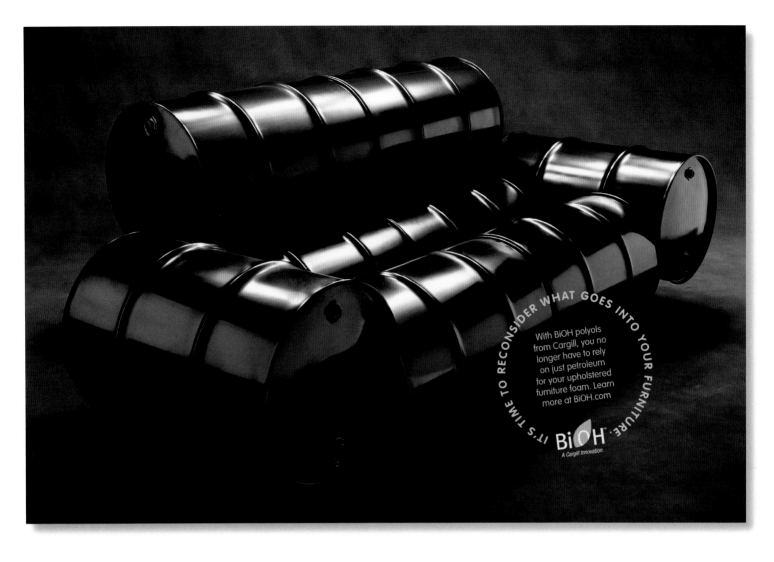

With BiOH polyols from Cargill, you no longer have to rely on just petroleum for your upholstered furniture foam. Learn more at BiOH.com

IT'S TIME TO RECONSIDER WHAT GOES INTO YOUR FURNITURE.

BiOH
A Cargill Innovation

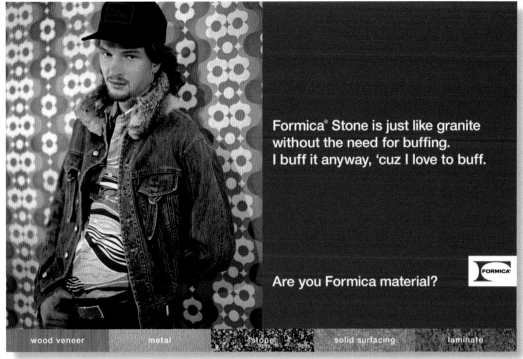

Formica® Stone is just like granite
without the need for buffing.
I buff it anyway, 'cuz I love to buff.

Are you Formica material?

FORMICA®

wood veneer metal stone solid surfacing laminate

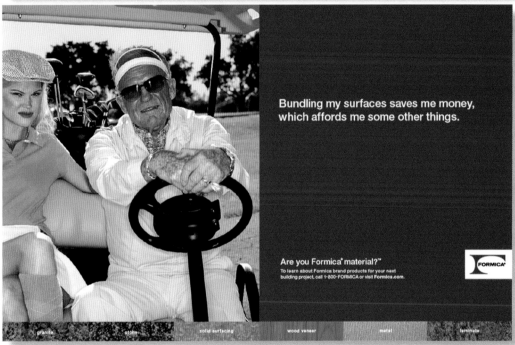

Bundling my surfaces saves me money,
which affords me some other things.

Are you Formica® material?™
To learn about Formica brand products for your next
building project, call 1-800-FORMICA or visit Formica.com.

FORMICA®

granite stone solid surfacing wood veneer metal laminate

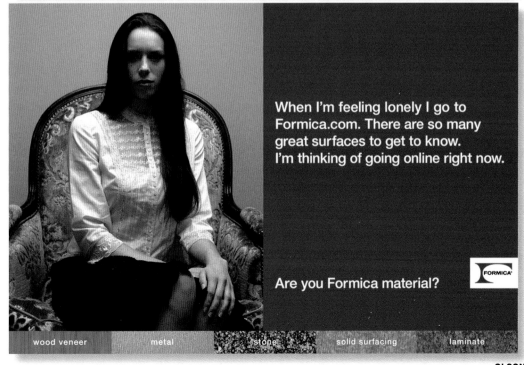

When I'm feeling lonely I go to
Formica.com. There are so many
great surfaces to get to know.
I'm thinking of going online right now.

Are you Formica material?

FORMICA®

wood veneer metal stone solid surfacing laminate

EXHAUST FANS

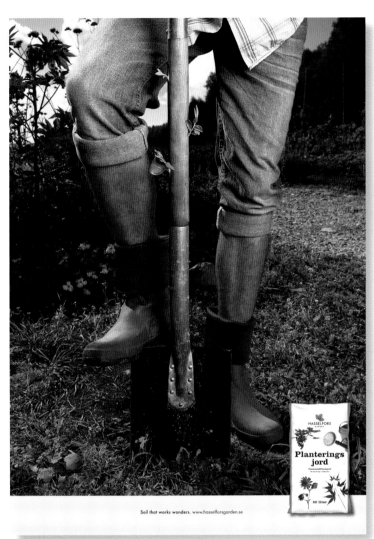

Soil that works wonders. www.hasselforsgarden.se

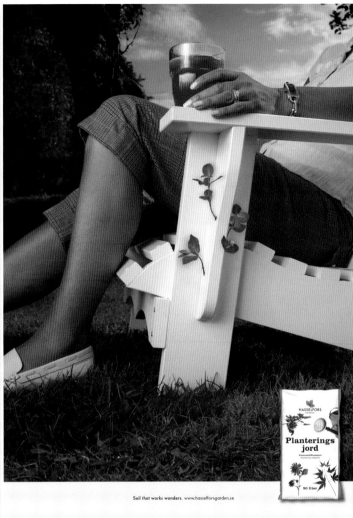

Soil that works wonders. www.hasselforsgarden.se

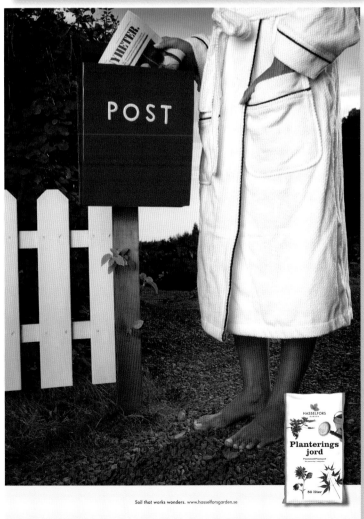

Soil that works wonders. www.hasselforsgarden.se

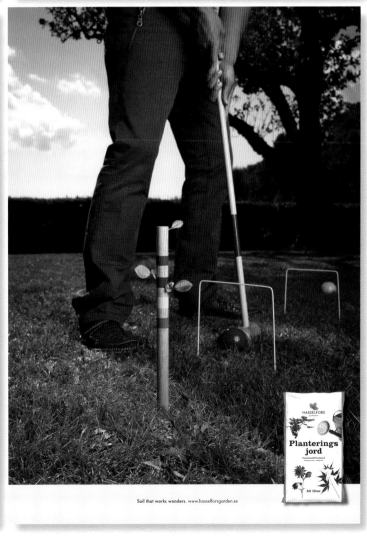

Soil that works wonders. www.hasselforsgarden.se

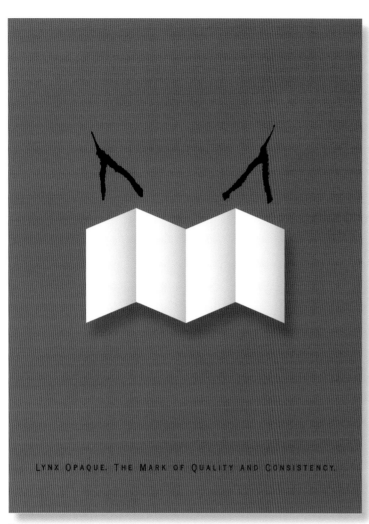

LYNX OPAQUE. THE MARK OF QUALITY AND CONSISTENCY.

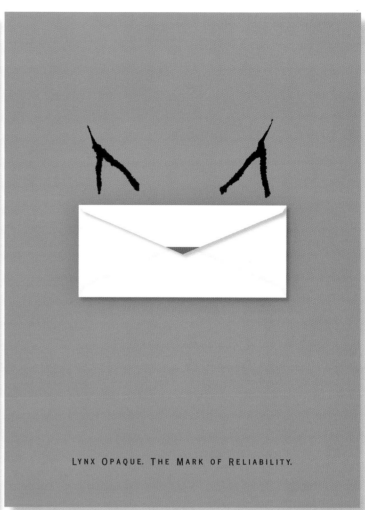

LYNX OPAQUE. THE MARK OF RELIABILITY.

LYNX OPAQUE. THE MARK OF TROUBLE-FREE PERFORMANCE.

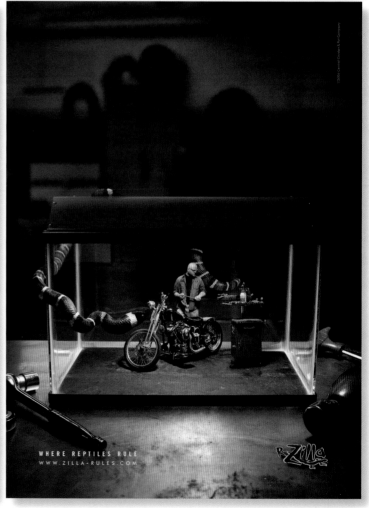

WHERE REPTILES RULE
WWW.ZILLA-RULES.COM

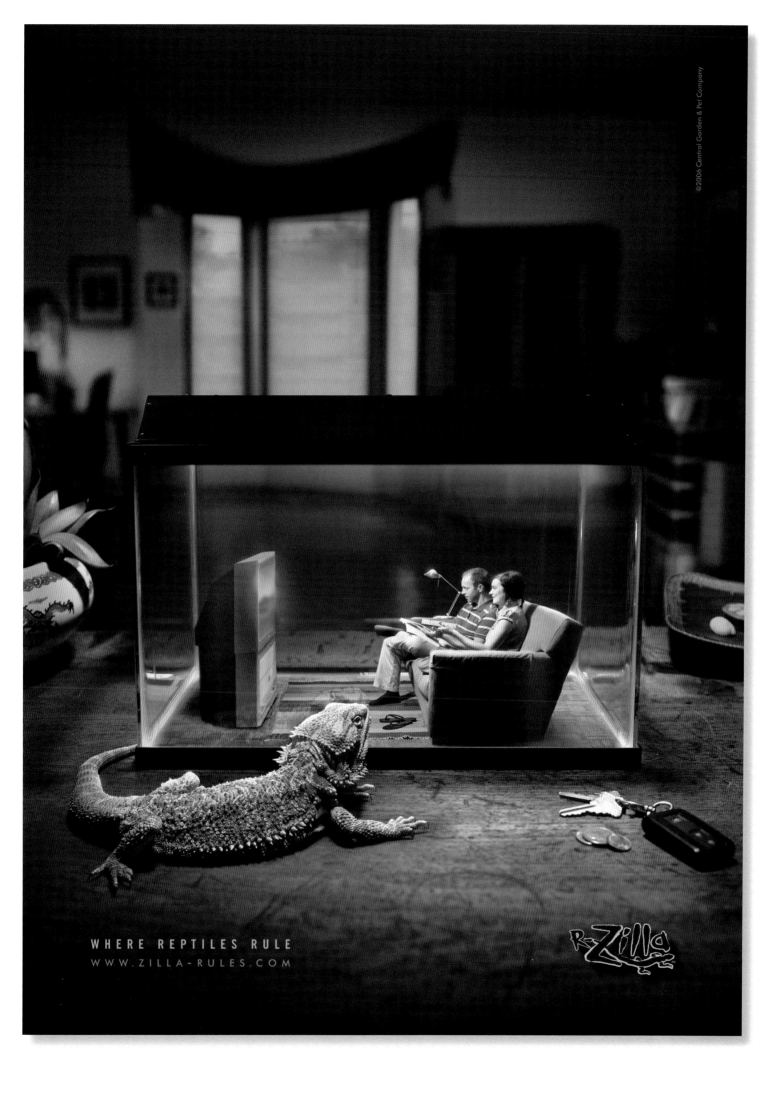

WHERE REPTILES RULE
WWW.ZILLA-RULES.COM

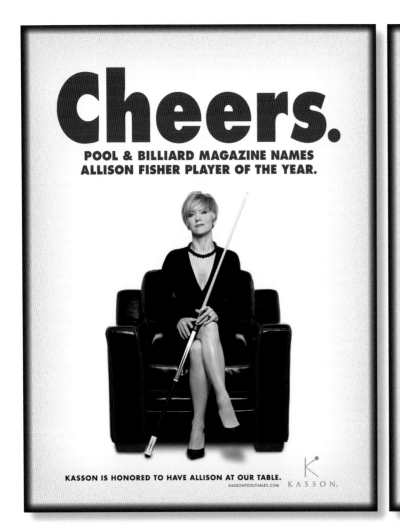

009.
LICENSE TO SINK.

KASSON PROUDLY WELCOMES ALLISON FISHER TO OUR TABLE.

KASSONPOOLTABLES.COM

KASSON.

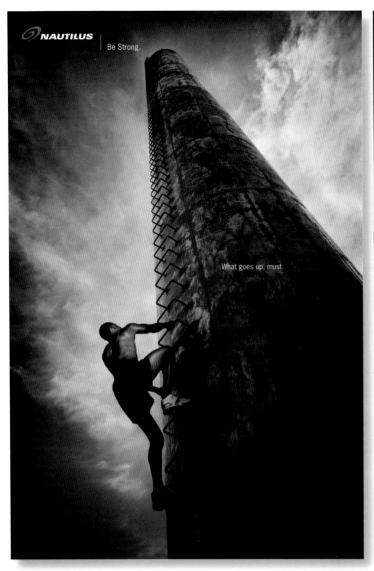
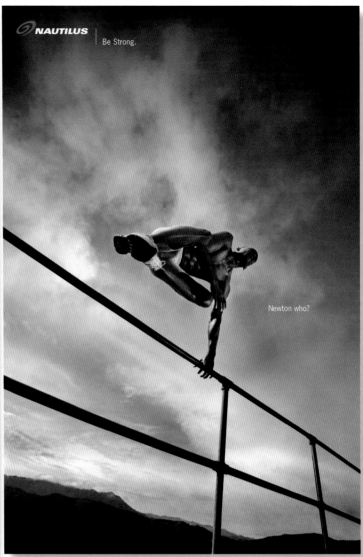

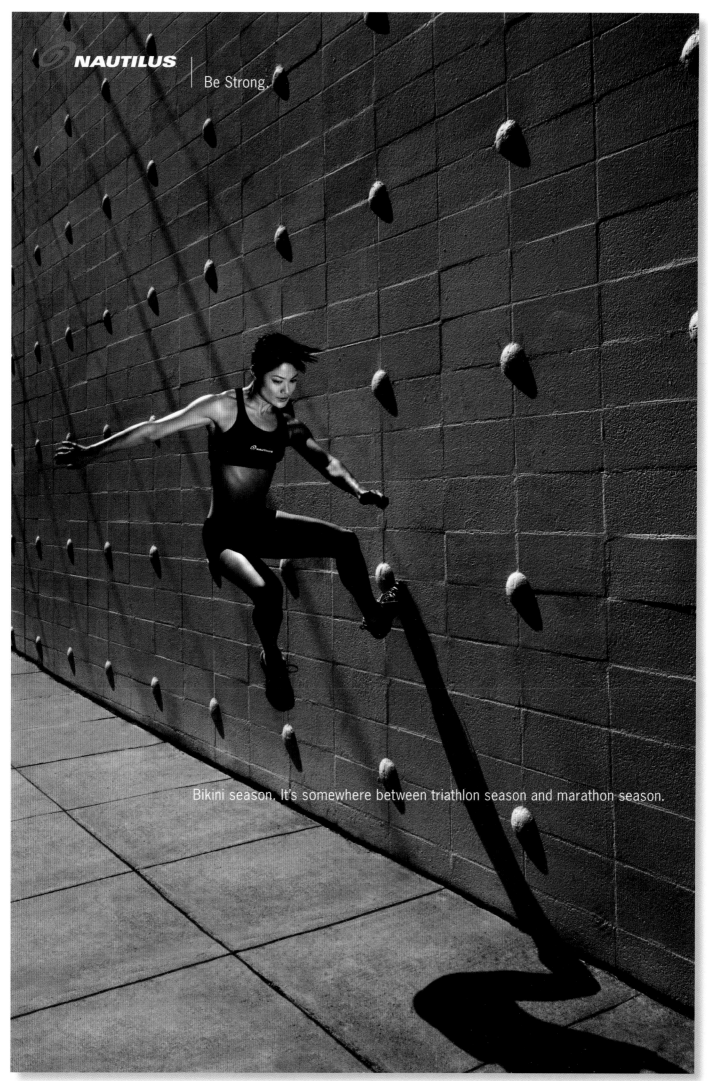

NAUTILUS

Be Strong.

Bikini season. It's somewhere between triathlon season and marathon season.

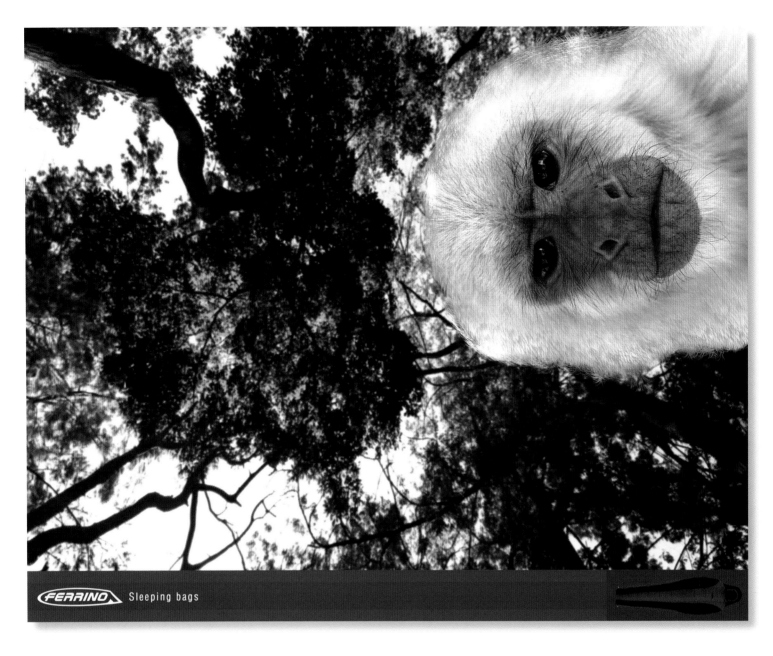

FERRINO Sleeping bags

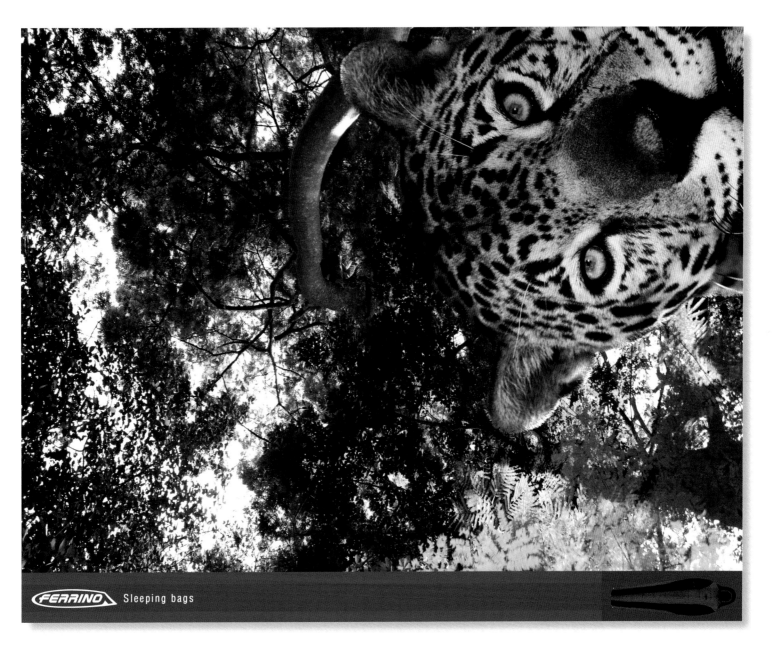

FERRINO Sleeping bags

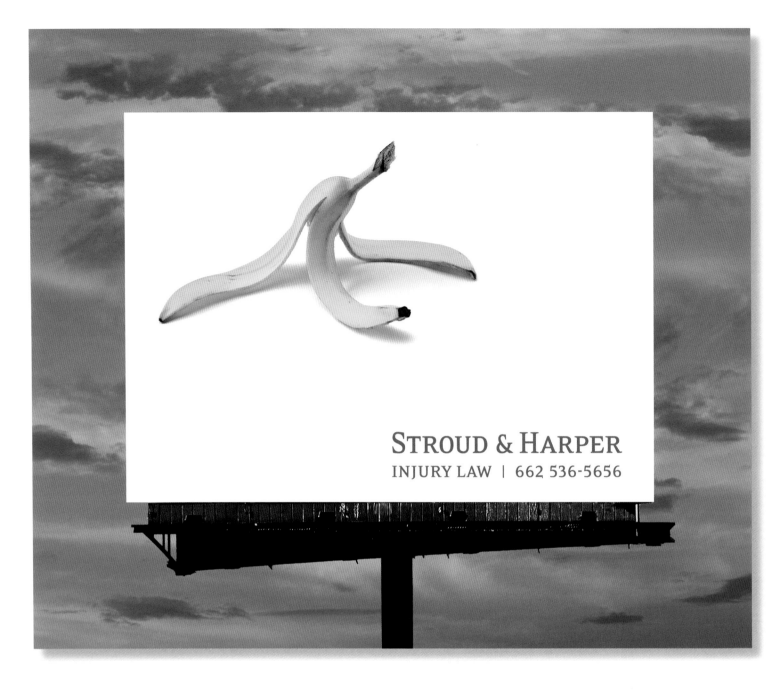

Clear a Path to Success

www.wcsr.com

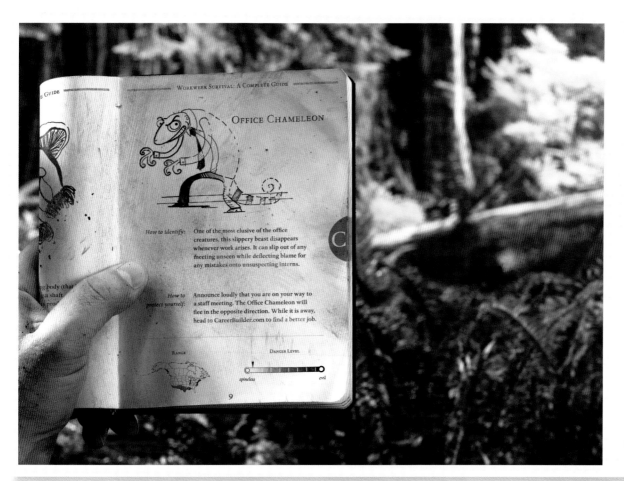

Do more than just
survive the workweek.

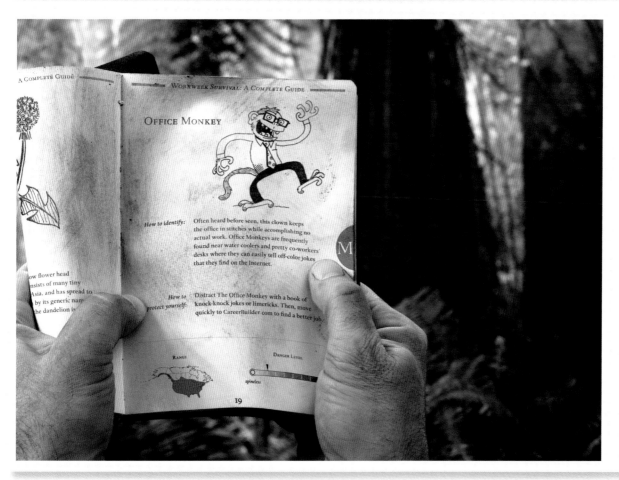

Do more than just
survive the workweek.

ADD COLOR

Catholic radio is coming.

Catholic radio is coming.

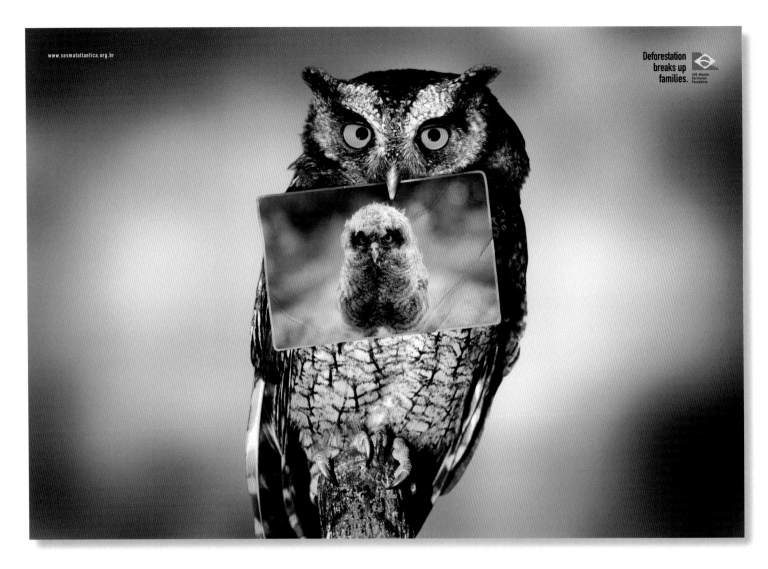

Deforestation breaks up families.

SOS Atlantic
Rainforest
Foundation

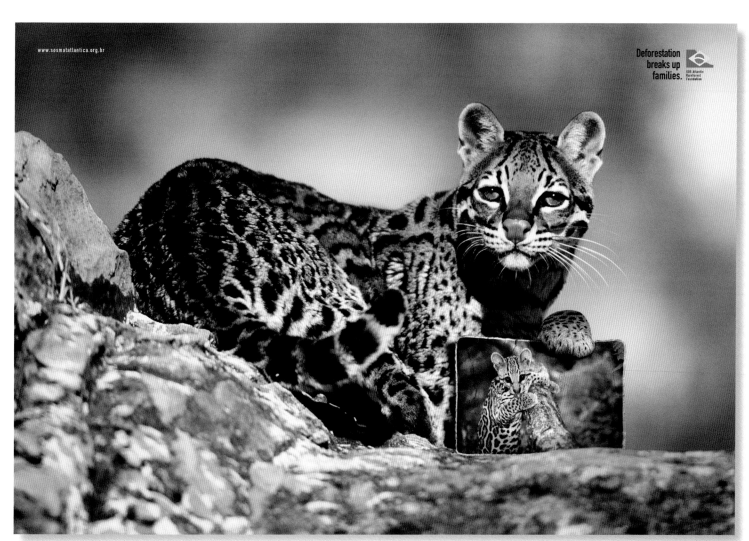

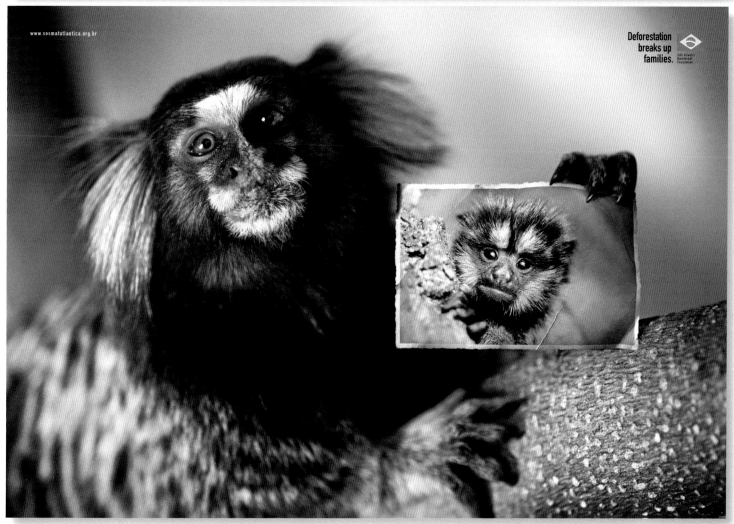

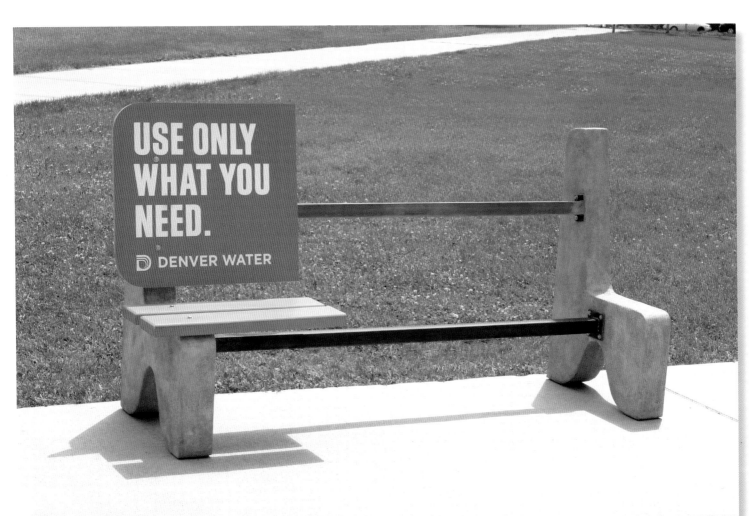

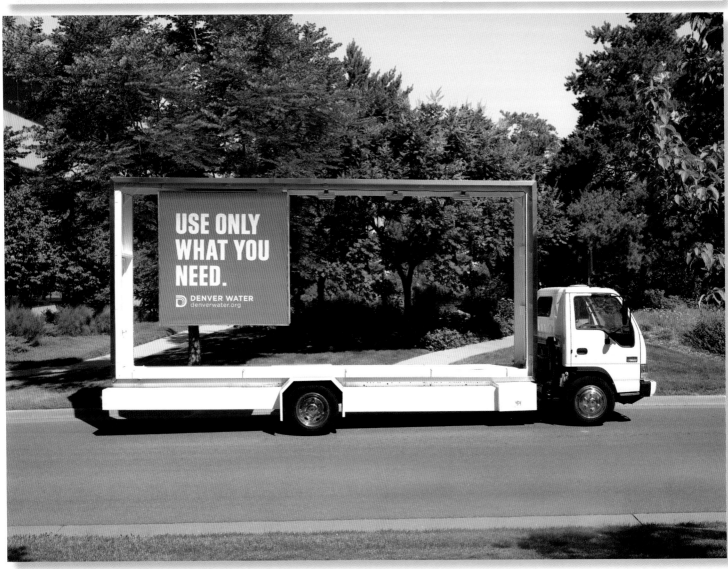

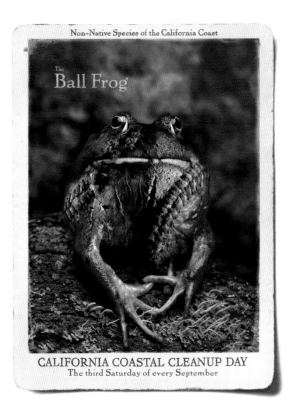

Non-Native Species of the California Coast

The
Ball Frog

CALIFORNIA COASTAL CLEANUP DAY
The third Saturday of every September

CALIFORNIA COASTAL COMMISSION
www.coast4u.org

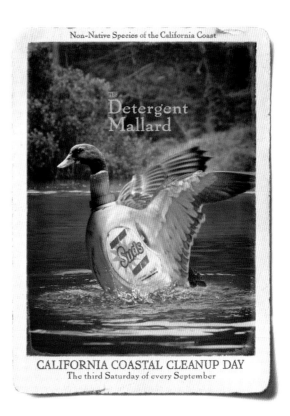

Non-Native Species of the California Coast

The
Detergent
Mallard

CALIFORNIA COASTAL CLEANUP DAY
The third Saturday of every September

CALIFORNIA COASTAL COMMISSION
www.coast4u.org

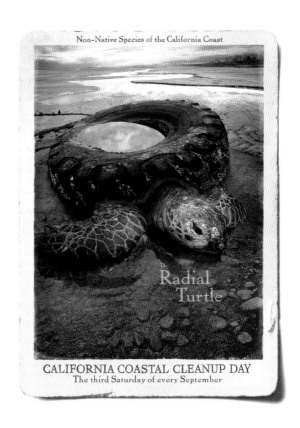

Non-Native Species of the California Coast

The
Radial
Turtle

CALIFORNIA COASTAL CLEANUP DAY
The third Saturday of every September

CALIFORNIA COASTAL COMMISSION
www.coast4u.org

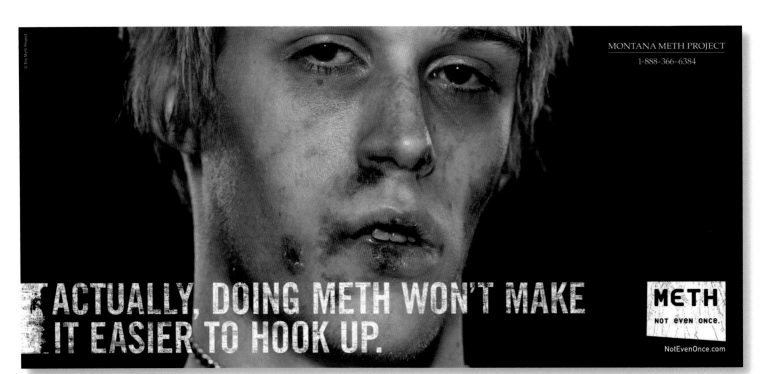

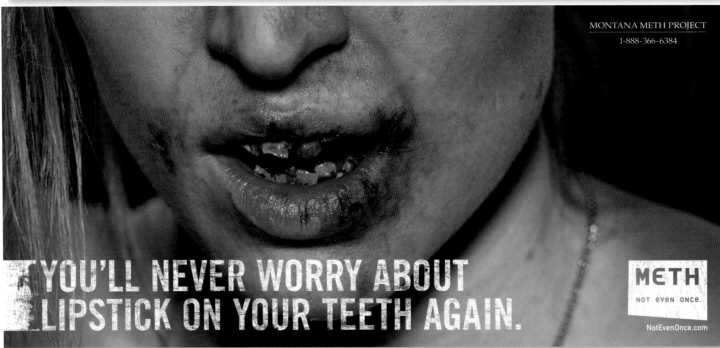

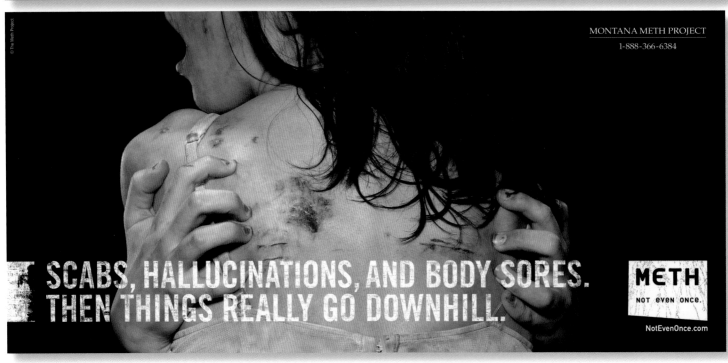

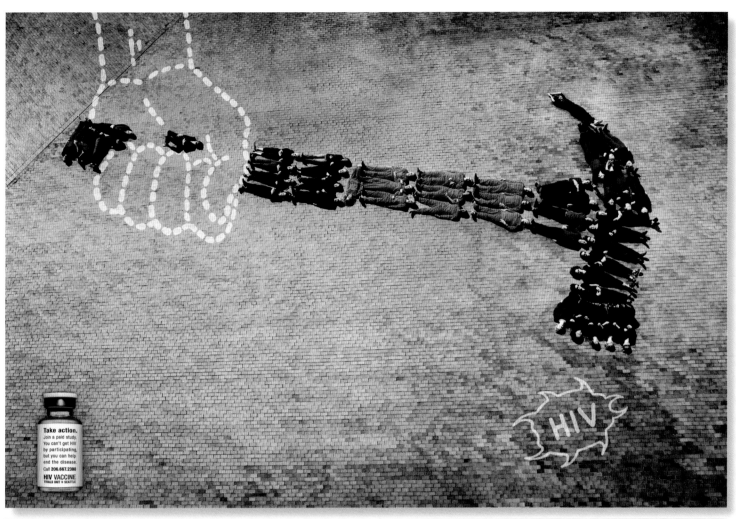

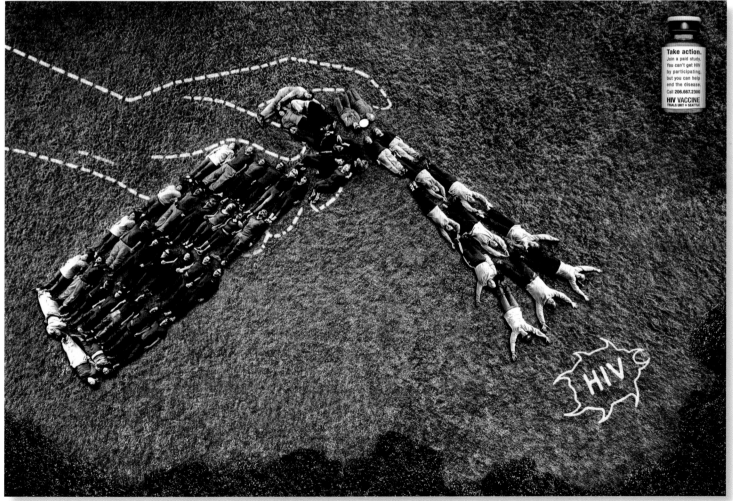

CREATIVITY
EDUCATION
CONFIDENCE
VISION

ASPIRATION
POSSIBILITIES
POTENTIAL
DREAMS

PATIENCE
SUCCESS
TALENT
HAPPINESS

Helping visually impaired children find their way in the sighted world.

Seeing isn't believing.

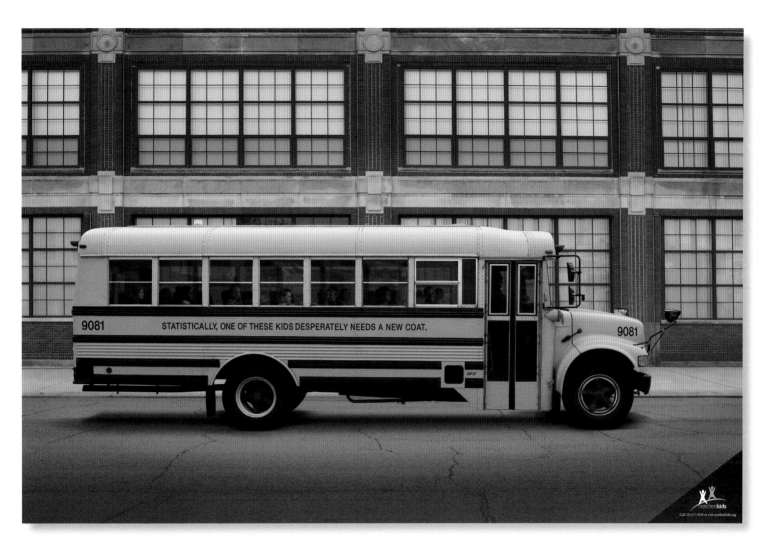

STATISTICALLY, ONE OF THESE KIDS DESPERATELY NEEDS A NEW COAT.

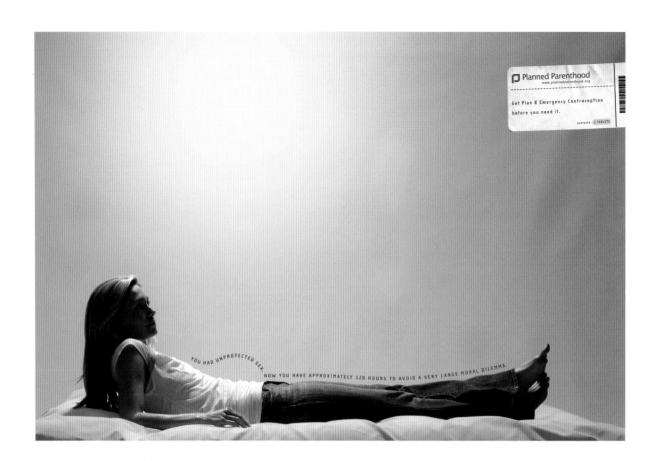

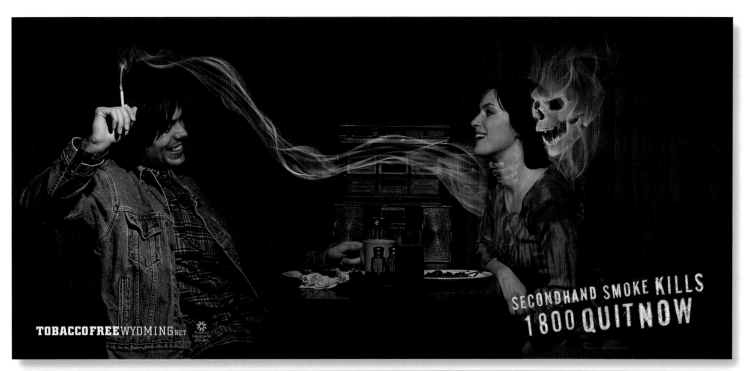

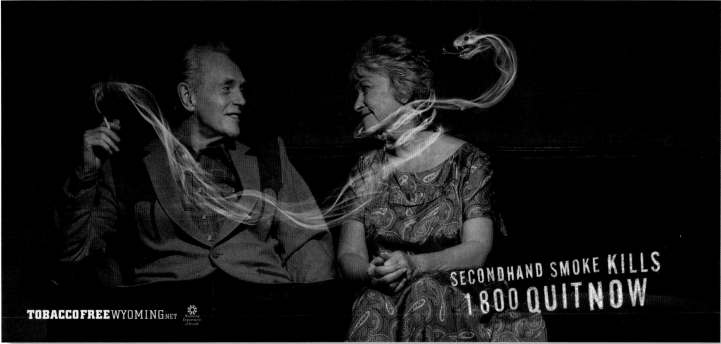

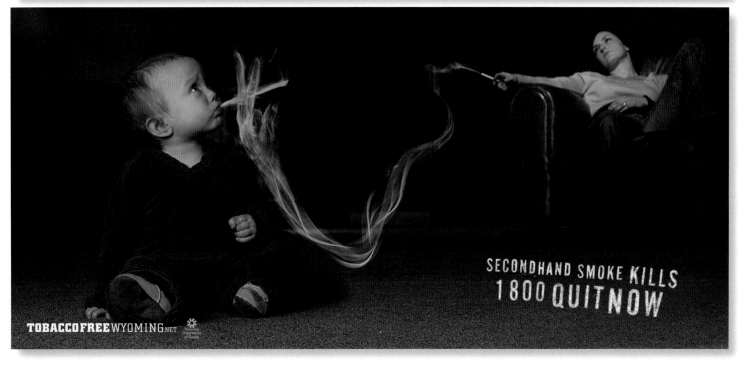

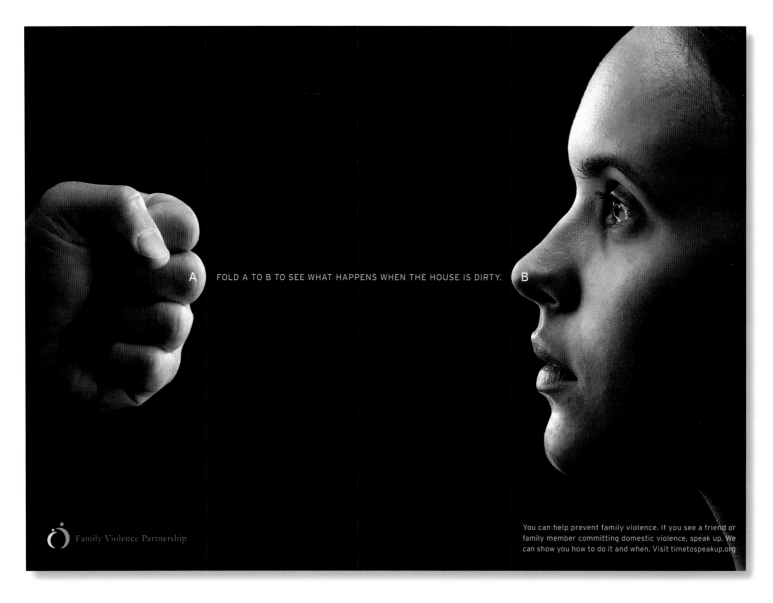

FOLD A TO B TO SEE WHAT HAPPENS WHEN THE HOUSE IS DIRTY.

Family Violence Partnership

You can help prevent family violence. If you see a friend or family member committing domestic violence, speak up. We can show you how to do it and when. Visit timetospeakup.org

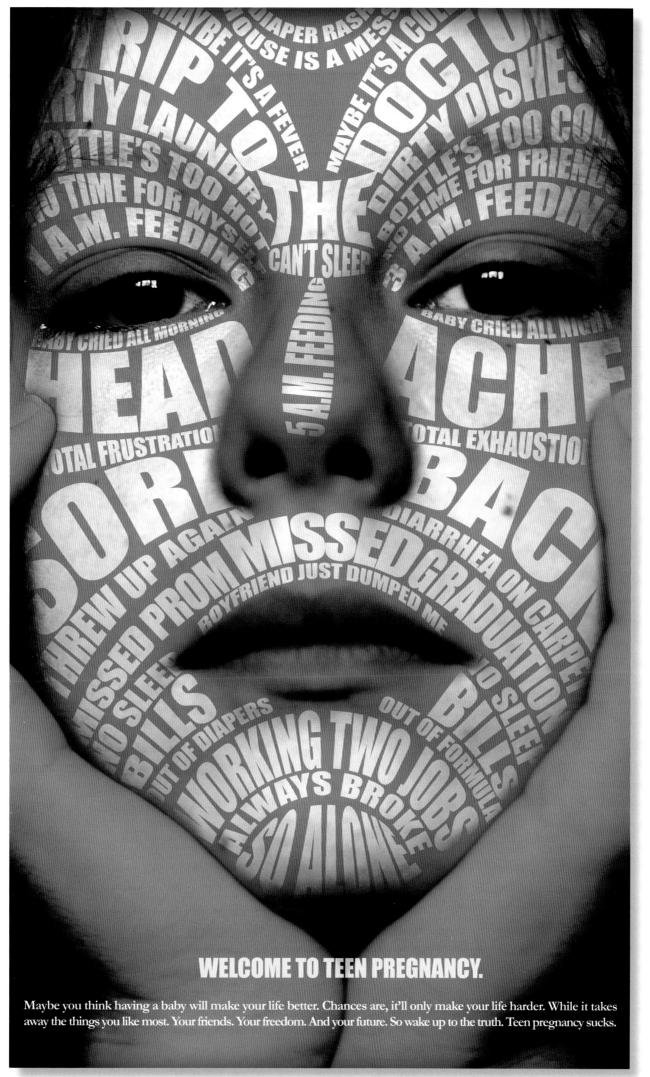

WELCOME TO TEEN PREGNANCY.

Maybe you think having a baby will make your life better. Chances are, it'll only make your life harder. While it takes away the things you like most. Your friends. Your freedom. And your future. So wake up to the truth. Teen pregnancy sucks.

Guys.

Stopping sexual harassment in the workplace means *changing* the way you think and talk about us.

NATIONAL ORGANIZATION FOR WOMEN now.org

Guys.

Stopping sexual harassment in the workplace means *changing* the way you think and talk about us.

NATIONAL ORGANIZATION FOR WOMEN now.org

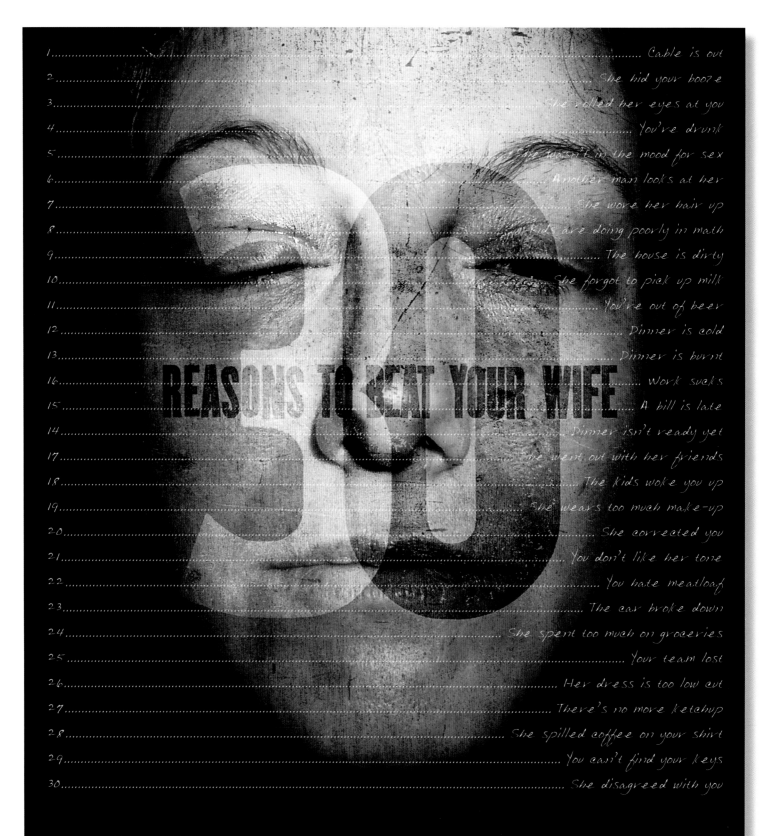

30 REASONS TO BEAT YOUR WIFE

1	Cable is out
2	She hid your booze
3	She rolled her eyes at you
4	You're drunk
5	She wasn't in the mood for sex
6	Another man looks at her
7	She wore her hair up
8	Kids are doing poorly in math
9	The house is dirty
10	She forgot to pick up milk
11	You're out of beer
12	Dinner is cold
13	Dinner is burnt
16	Work sucks
15	A bill is late
14	Dinner isn't ready yet
17	She went out with her friends
18	The kids woke you up
19	She wears too much make-up
20	She corrected you
21	You don't like her tone
22	You hate meatloaf
23	The car broke down
24	She spent too much on groceries
25	Your team lost
26	Her dress is too low cut
27	There's no more ketchup
28	She spilled coffee on your shirt
29	You can't find your keys
30	She disagreed with you

SEEM RIDICULOUS? The truth is, under no circumstances is there a reason to beat a spouse. If you know of a friend or family member being subjected to domestic violence - speak up. We can show you how to do it and when. timetospeakup.org

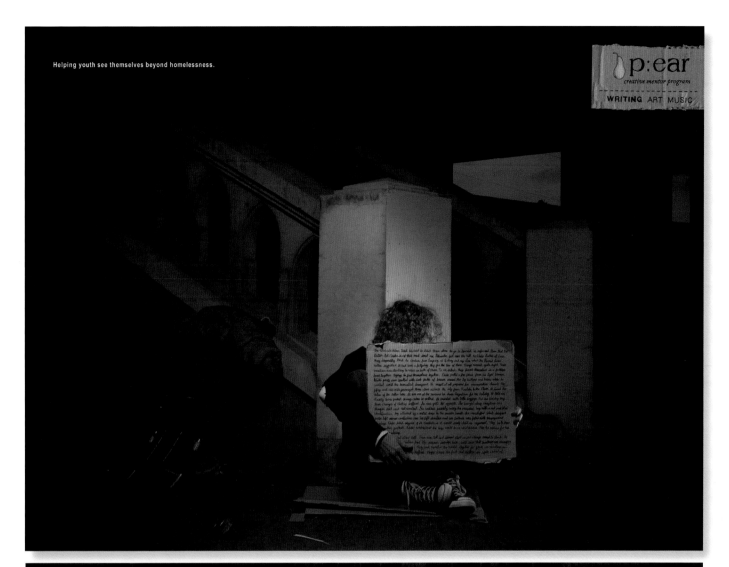

Helping youth see themselves beyond homelessness.

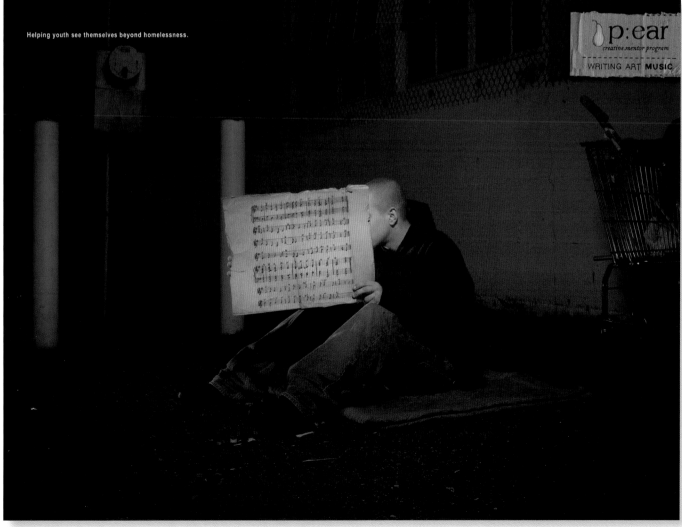

Helping youth see themselves beyond homelessness.

Why some people think *Walt Whitman* makes chocolate candy.

Whitman satisfied his sweet tooth with rich, wave-like verse. Every kid should make poetry a part of his diet.

KIDS DON'T GET ENOUGH ART THESE DAYS. So it's no wonder that some of them mistake America's most revolutionary poet for a box of chocolates.

The son of a Quaker carpenter, Walt Whitman grew up with an affinity for nature. This, along with his love for New York City, inspired him to write a truly original kind of poetry, the likes of which America had never seen. His collection of poems became known as *Leaves of Grass*. Due to its hedonistic, sensual, even narcissistic subject matter, the poems were often banned. This guy pushed the envelope all right, before most folks even knew there was an envelope to push.

Throughout his career, Whitman rewrote and reinvented *Leaves of Grass*, expanding and editing it in an effort to publish his quintessential collection. In essence, *Leaves of Grass* was Walt himself in verse form. Walt Whitman changed poetry. His life's work was ahead of its time. And though he lived long before the Summer of Love, he was the original beatnik — an inspiring example for writers like Ginsberg and Kerouac.

Too much of Whitman's art won't give you a stomachache.

Whitman can influence your child, too. That's what art does. In fact, the more art kids get, the smarter they become in subjects like math and science. So they become more well-rounded adults. For Ten Simple Ways to get more art in kids' lives, visit AmericansForTheArts.org.

Give your kids a chance to succeed. Up their daily dose of art.

ART. ASK FOR MORE.
AMERICANSFORTHEARTS.ORG

NAMM Foundation

WHY SOME PEOPLE SAY "D'OH" WHEN YOU SAY "HOMER".

Homer was a man of philosophy, not all-you-can-eat buffets.

KIDS DON'T GET ENOUGH ART THESE DAYS. Not in their schools. Not in their communities. Which is why the only Homer some kids know is the one who can't write his own last name. The original Homer created epic poetry. Homer was a storyteller. A philosopher. And he's credited with writing the most important literary texts in Greek history. Just a thought: Maybe your kid should get to know him.

Greek gods. Achilles heel. Trojan horse. All of these icons are brought to us by one very ancient dude — Homer. In *The Iliad* and in its sequel, *The Odyssey*, he presented Greek mythology in everyday language. In over 25,000 lines of lilting verse, Homer describes bravery, violence and lust in ancient Greece.

These Homeric works don't just weave a tale of Greek and Trojan warfare; they are considered by the Greeks to be the highest cultural achievements of their people — the defining moment in their society. *The Iliad* and *The Odyssey* set Greek character in stone.

If these classic texts can get passed down all the way from the eighth century B.C., then surely we can pass them down to our kids today. Make sure your kids get their daily dose of art. Take them to a museum or the opera. The experience will for sure do more than entertain them. It'll build their capacity to learn more. In fact, the more art kids get, the smarter they become in subjects like math and science. And that's enough reason to make a parent say, "D'oh!" For Ten Simple Ways to instill more art in your kids' lives, visit AmericansForTheArts.org.

Composing The Iliad didn't require an atomic reaction, but it did require art.

Give your kids a chance to succeed. Up their daily dose of art.

ART. ASK FOR MORE.
AMERICANSFORTHEARTS.ORG

NAMM Foundation

WHY SOME PEOPLE THINK VIRGINIA WOOLF IS THE STATE'S OFFICIAL ANIMAL.

One of the world's most influential writers, Virginia Woolf. Novelis writers, not Canis lupus.

KIDS DON'T GET ENOUGH ART THESE DAYS. Sort of explains why some might think Britain's most influential novelist is an East Coast predator. For the record, Virginia Woolf is not a fierce carnivorous mammal. Nor is she from Virginia.

Adeline Virginia Woolf was born in London in 1882. While her brothers attended school, she was educated at home. Only when the boys brought friends home from Cambridge University was the famed Bloomsbury Group formed with Virginia as the cornerstone. Here she escaped the conventions of society to freely explore philosophy, religion and art. With this freedom, Virginia went on to create the modern novel. During the Post-Impressionist movement, Virginia was influenced to reject linear writing. Her most well-known novel, *Mrs. Dalloway*, is a masterpiece in her "stream-of-consciousness" style. And still, more than three-quarters of a century after her death, she continues to inspire readers and writers around the world. Other than William Shakespeare, she is perhaps studied by more college students than any other author.

Art like Virginia Woolf's can transform lives. It pays off in more ways than you can imagine. In fact, the more art kids get, the more knowledgeable they become in subjects like math and science. The end result is that your well-rounded kid will become a well-rounded adult. For the Ten Simple Ways you can help instill more art in kids' lives, please visit AmericansForTheArts.org.

Virginia Woolf wrote legendary novels with opposable thumbs.

Give your kids a chance to succeed. Up their daily dose of art.

ART. ASK FOR MORE.
AMERICANSFORTHEARTS.ORG

NAMM Foundation

Why Some People Think Duke Ellington Is a Member of the Royal Family.

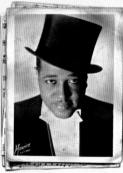

A piano player. A composer. An orchestra leader. Duke Ellington reigned over a land called Jazz.

KIDS DON'T GET ENOUGH ART THESE DAYS. So you can see why some of them might accidentally confuse a jazz legend named Duke with royalty named duke. But it's finally time to set the record straight.

Edward Kennedy "Duke" Ellington didn't rule over a small English estate. Instead he reigned supreme over jazz institutions like The Cotton Club. He riffed powerfully on the piano, but it was the full orchestra that he considered his most compelling instrument. He introduced improvisation to his compositions — a process unheard of using a 15-piece orchestra. The result was a different approach to jazz that sparked a revolution and an evolution. His music spread across the world with songs like "Sophisticated Lady," "In a Sentimental Mood," and "Take the 'A' Train." His historical concert in 1953 at the Newport Jazz Festival has entered the lexicon of legendary live performances. There is no doubt about it, Ellington's brand of jazz has contributed significantly to the American songbook and to the lives of anyone who has ever tapped their foot to a beat.

Jazz is art, you dig? Art can really transform lives. In fact, the more art kids get, the smarter they become in subjects like math and science. And the more likely they'll become well-rounded, cool members of society. For Ten Simple Ways to get more art in kids' lives, visit AmericansForTheArts.org.

Royal dukes are squaresville. They have no rhythm. And they wear crowns.

Give your kids a chance to succeed. Up their daily dose of art.

ART. Ask for More.
AMERICANSFORTHEARTS.ORG

NAMM Foundation

★ELECT★
Broken File CABINET
U.S. SENATE

PayAttention.org

ELECT
SIDE OF HASHBROWNS
for GOVERNOR

PayAttention.org

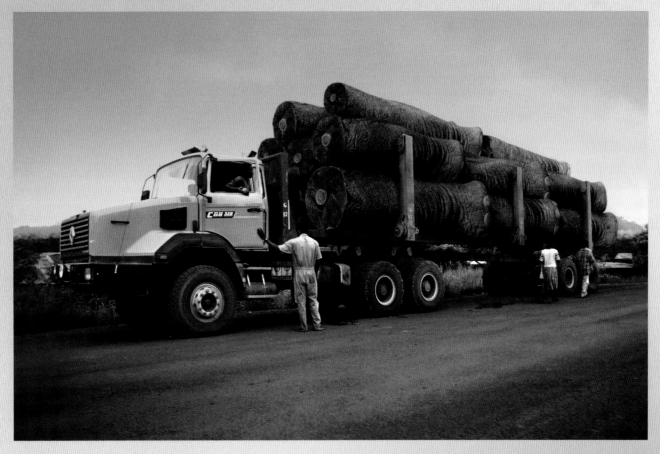

Illegal logging kills more than just trees.

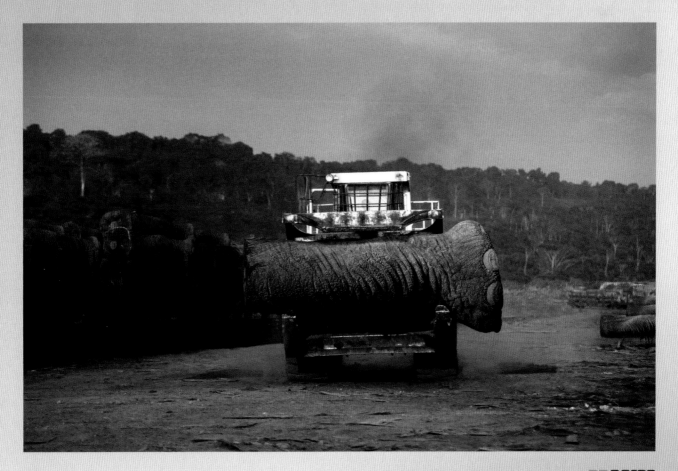

Illegal logging kills more than just trees.

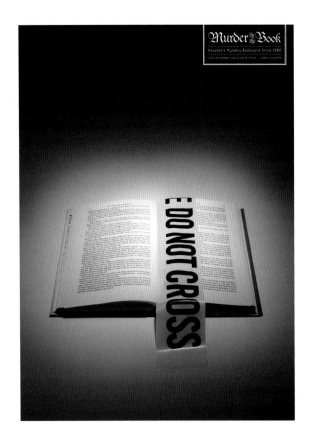

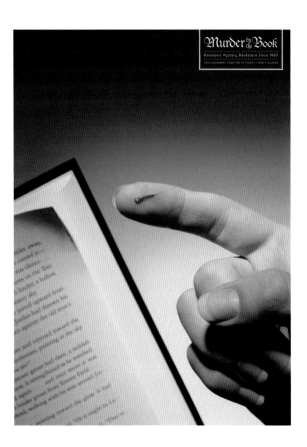

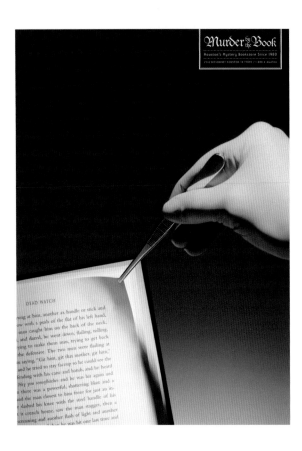

A new zinkmag.com coming soon.

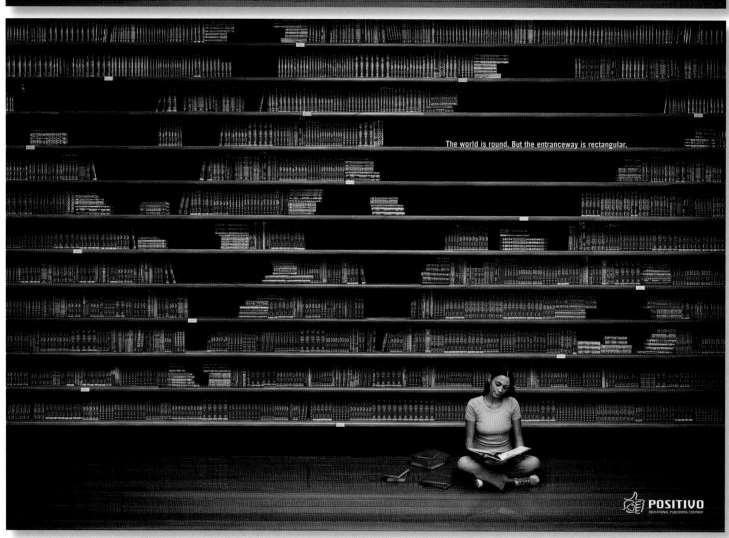

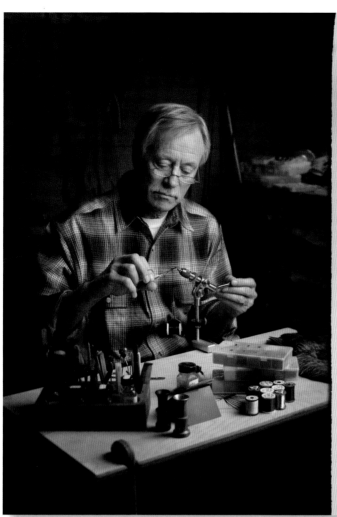

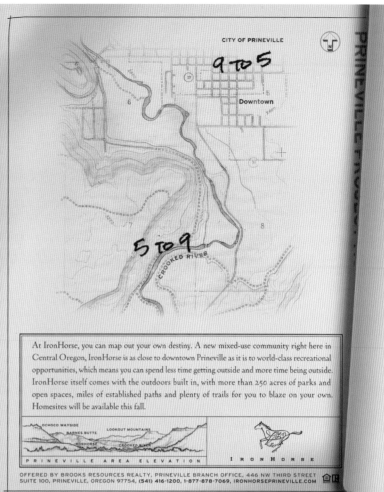

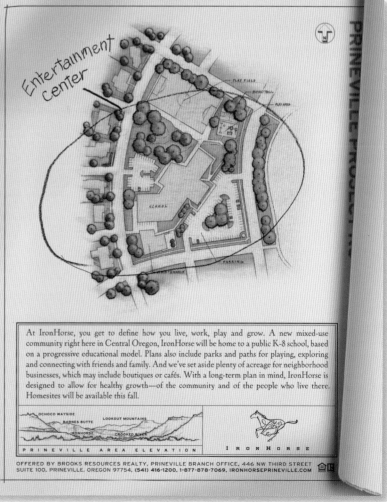

SO GOOD, EVEN
ADAM
WOULDN'T HAVE GIVEN
ONE UP

RIBS & MORE RIBS

YOU'LL NEED
3 HANDS
TO EAT THIS ONE

GOOD THING YOU GREW UP NEAR
THE NUCLEAR PLANT

THE ½ lb. BURGER

FISH IS GOOD FOR YOUR
HEALTH
BUT WE FRY IT
SO IT PRETTY MUCH EVENS ITSELF OUT

FISH AND CHIPS

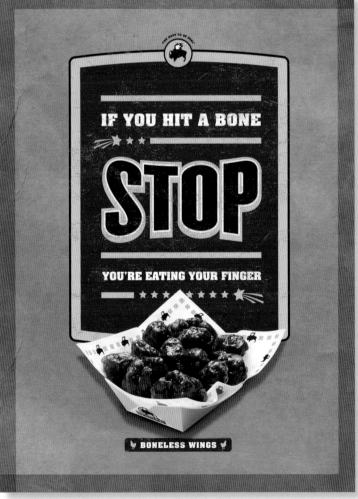

IF YOU HIT A BONE
STOP
YOU'RE EATING YOUR FINGER

BONELESS WINGS

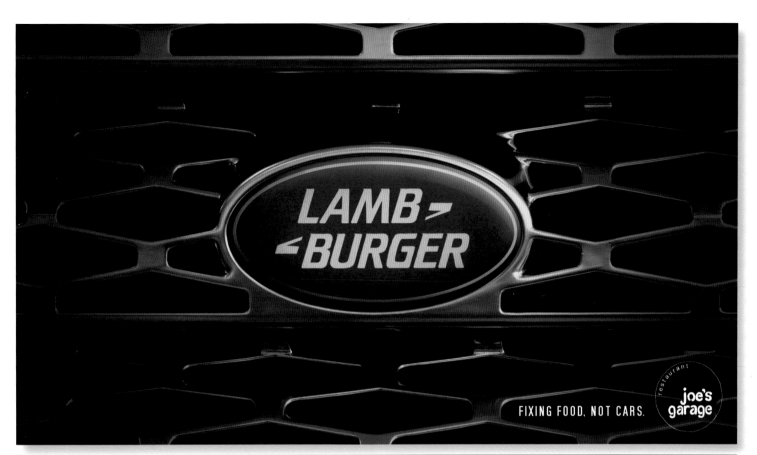

FIXING FOOD, NOT CARS.

restaurant joe's garage

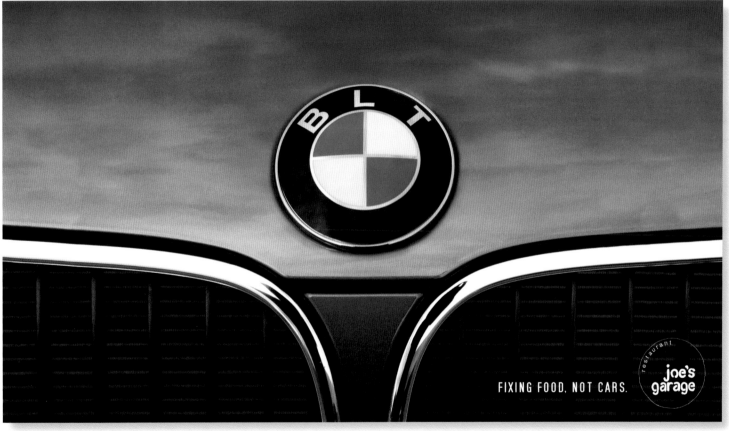

FIXING FOOD, NOT CARS.

restaurant joe's garage

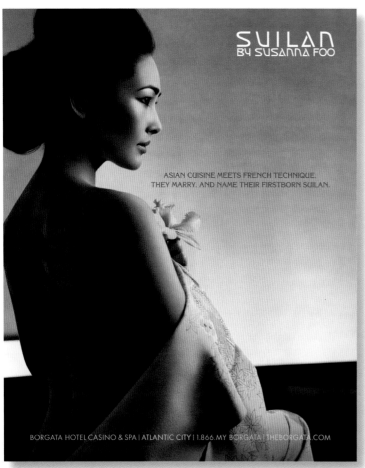

SUILAN
BY SUSANNA FOO

ASIAN CUISINE MEETS FRENCH TECHNIQUE.
THEY MARRY. AND NAME THEIR FIRSTBORN SUILAN.

BORGATA HOTEL CASINO & SPA | ATLANTIC CITY | 1.866.MY BORGATA | THEBORGATA.COM

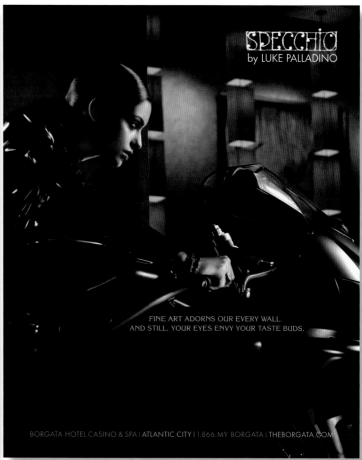

SPECCHIO
by LUKE PALLADINO

FINE ART ADORNS OUR EVERY WALL.
AND STILL, YOUR EYES ENVY YOUR TASTE BUDS.

BORGATA HOTEL CASINO & SPA | ATLANTIC CITY | 1.866.MY BORGATA | THEBORGATA.COM

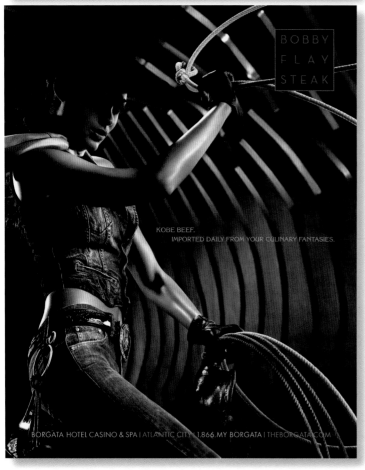

BOBBY
FLAY
STEAK

KOBE BEEF.
IMPORTED DAILY FROM YOUR CULINARY FANTASIES.

BORGATA HOTEL CASINO & SPA | ATLANTIC CITY | 1.866.MY BORGATA | THEBORGATA.COM

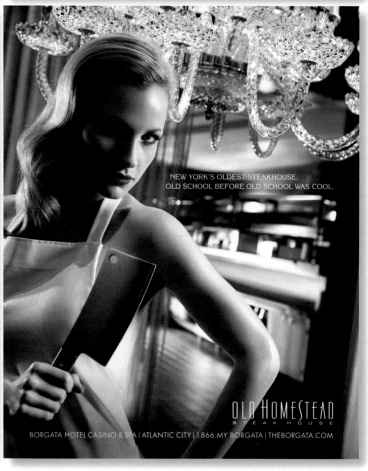

NEW YORK'S OLDEST STEAKHOUSE.
OLD SCHOOL BEFORE OLD SCHOOL WAS COOL.

OLD HOMESTEAD
STEAK HOUSE

BORGATA HOTEL CASINO & SPA | ATLANTIC CITY | 1.866.MY BORGATA | THEBORGATA.COM

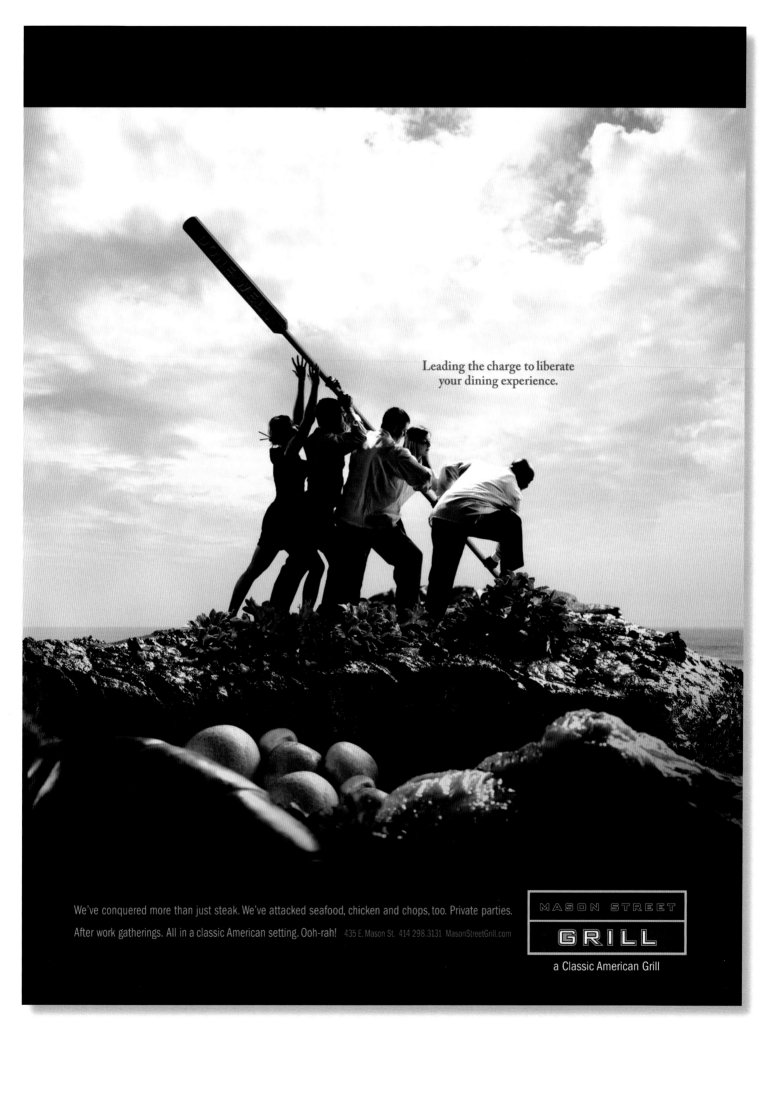

Leading the charge to liberate
your dining experience.

We've conquered more than just steak. We've attacked seafood, chicken and chops, too. Private parties.
After work gatherings. All in a classic American setting. Ooh-rah! 435 E. Mason St. 414 298.3131 MasonStreetGrill.com

MASON STREET
GRILL
a Classic American Grill

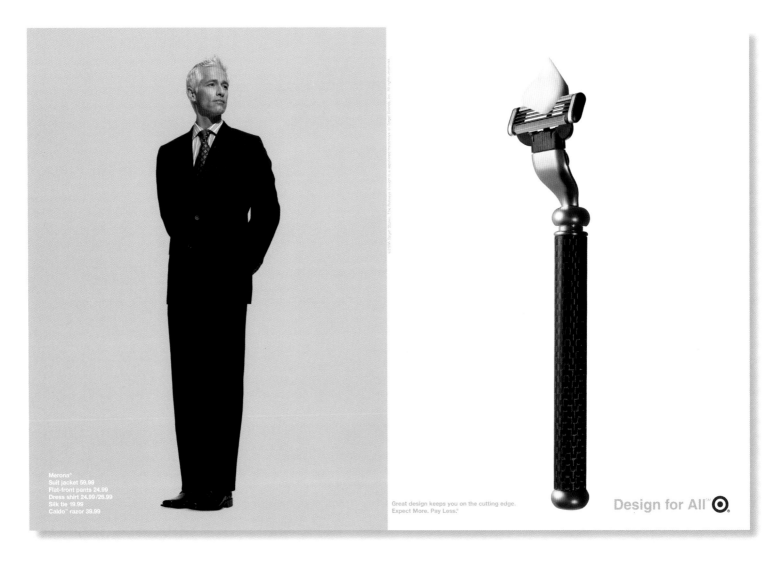

Merona®
Suit jacket 59.99
Flat-front pants 24.99
Dress shirt 24.99/26.99
Silk tie 19.99
Caldo™ razor 39.99

Great design keeps you on the cutting edge.
Expect More. Pay Less.®

Design for All™ ⊙

Mossimo®
Quilted jacket 34.99 & 39.99
Hoodie 24.99 & 26.99
Cargo pants 24.99
Utility®
Screened tee 12.99 & 14.99
Knit beanie 9.99

Samsung XM receiver & MP3 player 199.99
Kick up your style with great design.
Expect More. Pay Less.®

Design for All™ ⊙

Target.com/designforall

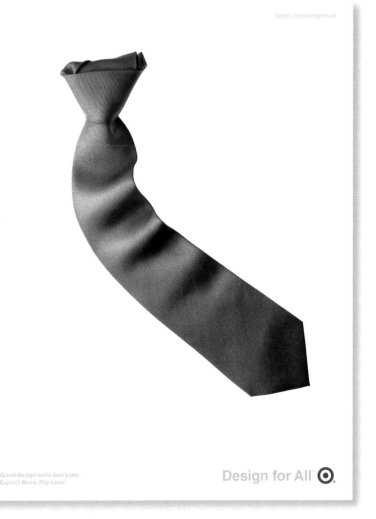

Merona®
3-button suit jacket 59.99
Flat-front suit pants 24.99
Dress shirt 19.99/21.99
Silk tie 19.99

Great design suits everyone.
Expect More. Pay Less.®

Design for All™ ⊙

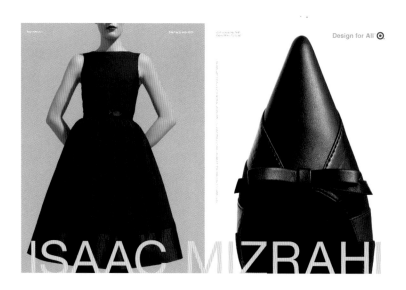

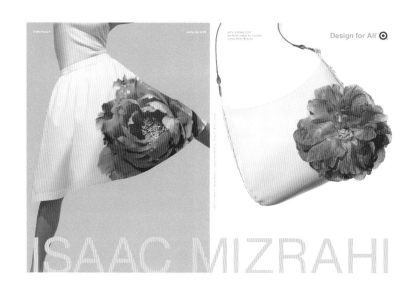

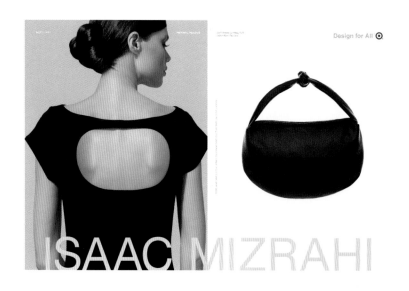

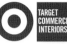

The exact place where form meets function.

Target Commercial Interiors consultants are masters at combining insight and image. We offer you smart, high-quality design solutions to meet your unique office needs. And we'll help keep your business rolling for years to come. **That's how Target does business.**

XTC CHAIRS MANUFACTURED BY SAFCO

Making waves in the traditional world of office furnishings.

Target Commercial Interiors offers your business access to state-of-the-art, high-quality design products and consultants. Whether you employ 8, 80 or 8,000, we'll make it smooth sailing. **That's how Target does business.**

RIPPLE BENCH MANUFACTURED BY BRAYTON

SALES OFFICE/SHOWROOM
1020 John Nolen Drive, Madison, WI 53713
Tel. 608.257.0521
Toll Free 800.475.1775
Fax 608.257.1859
targetcommercialinteriors.com

SALES OFFICE/SHOWROOM
1020 John Nolen Drive, Madison, WI 53713
Tel. 608.257.0521
Toll Free 800.475.1775
Fax 608.257.1859
targetcommercialinteriors.com

Where basic economics meets advanced ergonomics.

Inspired design works intellectually as well as physically. So Target Commercial Interiors offers world-renowned, well-designed office furnishings and commercial interiors, built to suit the needs of your company and your people. **That's how Target does business.**

LEAP CHAIRS MANUFACTURED BY STEELCASE

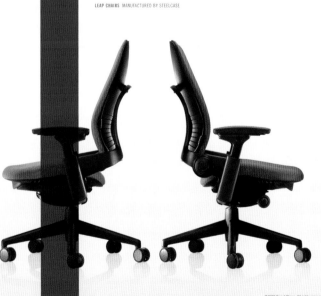

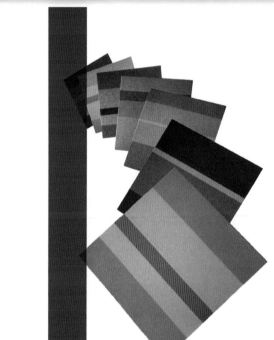

Creating a ground floor worth starting from.

For new businesses, Target Commercial Interiors provides the high-quality design ideas that will go the distance, and work space consultants who can take your vision to the next level. **That's how Target does business.**

CARPET TILES MANUFACTURED BY INTERFACE

SALES OFFICE/SHOWROOM
1305 North Road, Suite C, Green Bay, WI 54313
Tel. 920.884.0265
Toll Free 800.608.7596
Fax 920.884.0273
targetcommercialinteriors.com

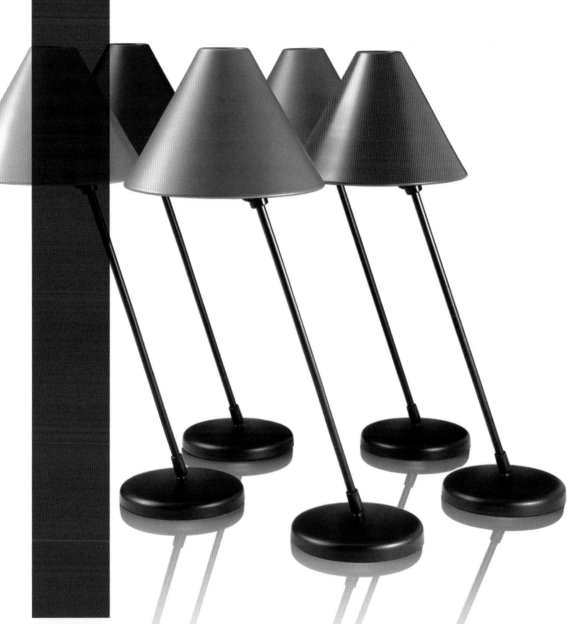

TARGET COMMERCIAL INTERIORS SM

SALES OFFICE/SHOWROOM
801 North Perryville Road, Rockford, IL 61107
Tel. 815.398.3300
Toll Free 800.688.7598
Fax 815.398.3486
targetcommercialinteriors.com

A new slant on modern office design.

When it comes to office furnishings, better designs make better options. Target Commercial Interiors gives you local access to the world's best high-design products, and our consultants provide you with every possible angle for use in your workspace. **That's how Target does business.**

PISA LIGHTS MANUFACTURED BY DETAILS

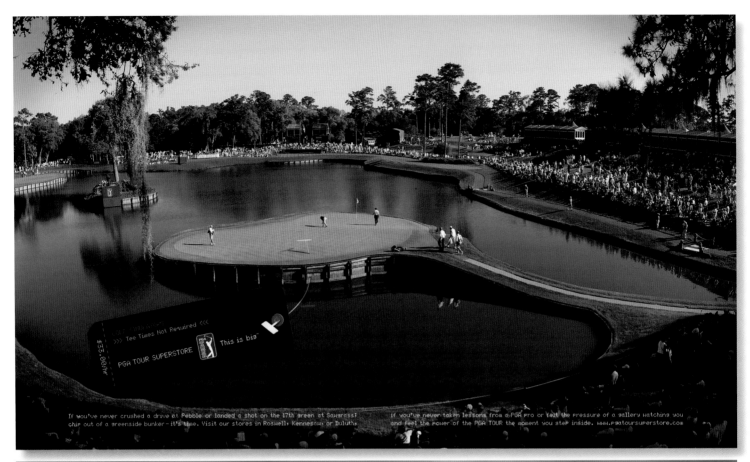

If you've never crushed a drive at Pebble or landed a shot on the 17th green at Sawgrass? chip out of a greenside bunker - it's time. Visit our stores in Roswell, Kennesaw, or Duluth. if you've never taken lessons from a PGA pro or felt the pressure of a gallery watching you and feel the power of the PGA TOUR the moment you step inside. www.pgatoursuperstore.com

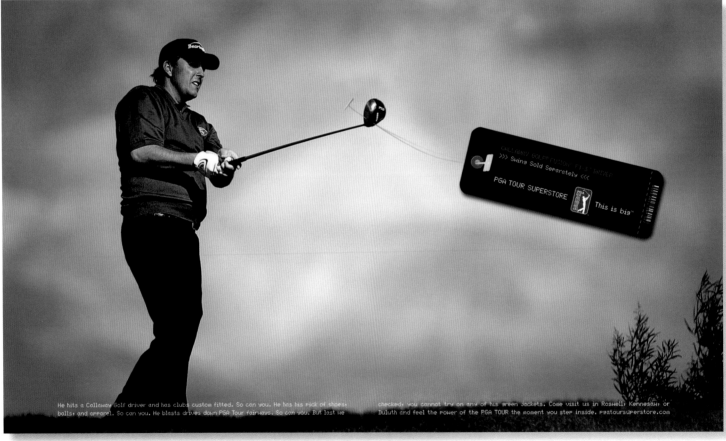

He hits a Callaway Golf driver and has clubs custom fitted. So can you. He has his pick of shoes, balls, and apparel. So can you. He blasts drives down PGA Tour fairways. So can you. But last we checked, you cannot try on any of his green jackets. Come visit us in Roswell, Kennesaw, or Duluth and feel the power of the PGA TOUR the moment you step inside. pgatoursuperstore.com

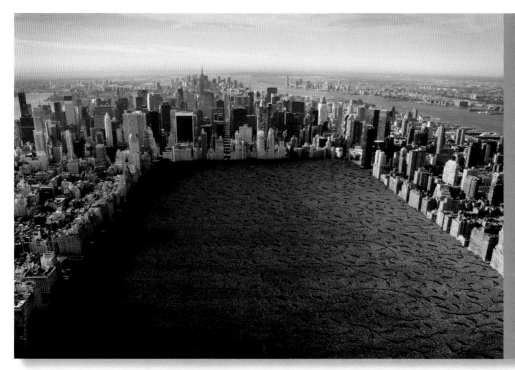

We can have it installed.

You can do it. We can help.

23rd between 5th & 6th
3rd between 58th & 59th

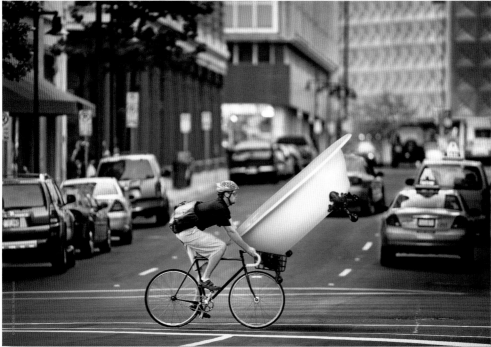

Good thing we deliver.

You can do it. We can help.

23rd between 5th & 6th
3rd between 58th & 59th

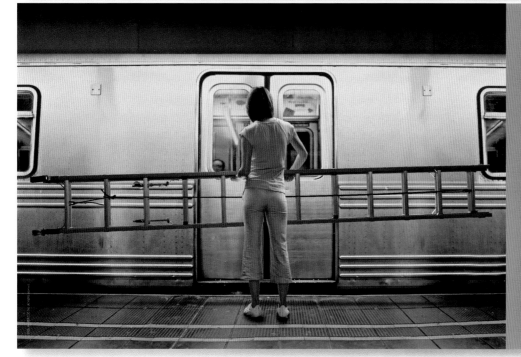

Good thing we deliver.

You can do it. We can help.

23rd between 5th & 6th
3rd between 58th & 59th

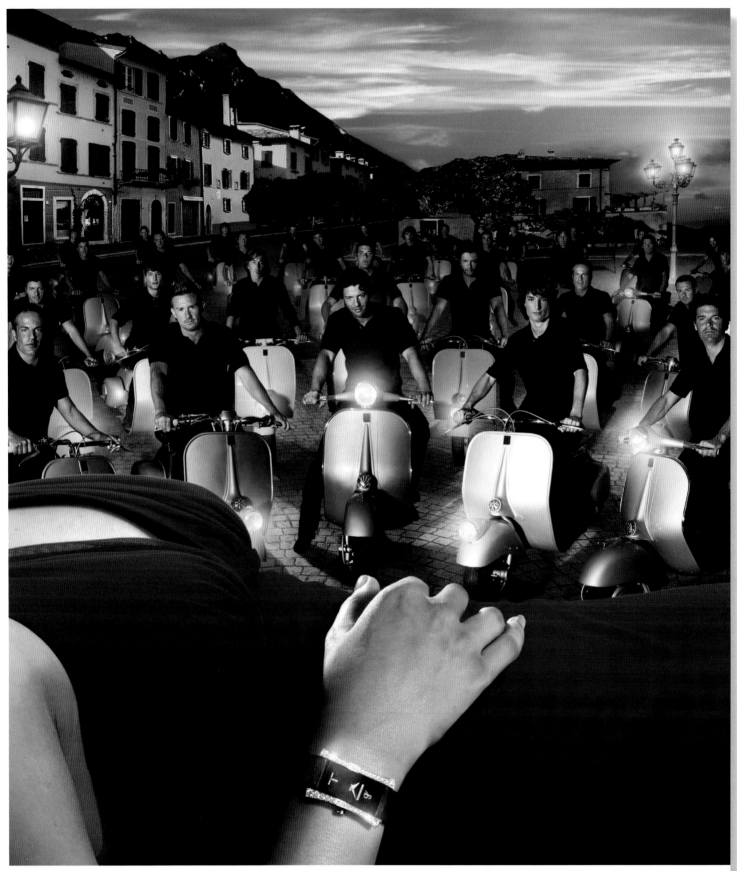

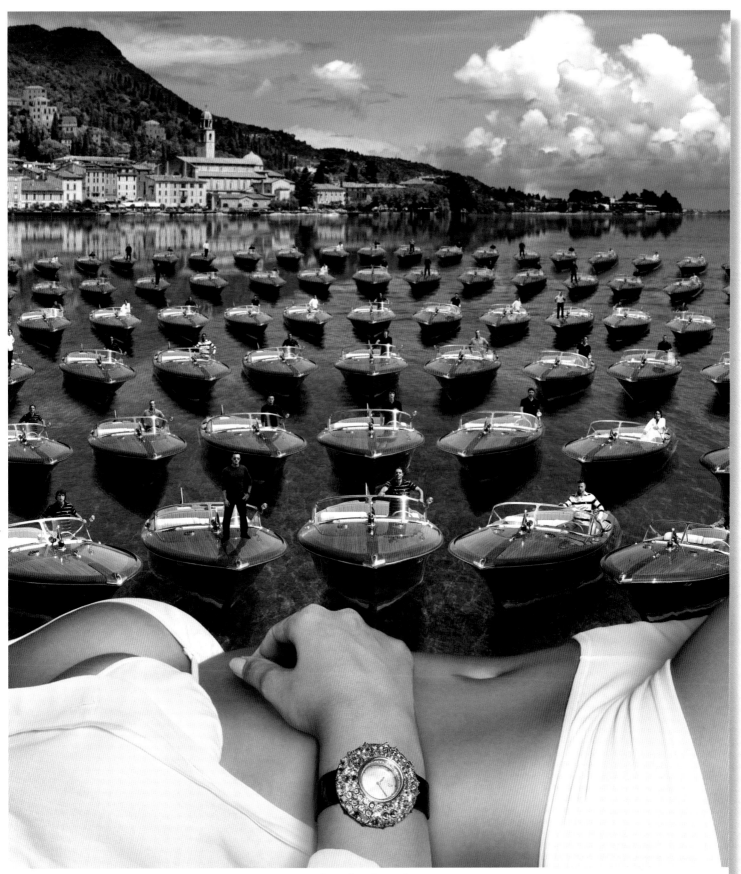

www.bertolucci-watches.com

OUNI
18 carat 3N yellow gold
full cut finest diamonds
yellow and pink sapphires, orange spessartites

B
BERTOLUCCI

THE SOURCE FOR FULLY LICENSED CLASSICS
[FROM EAMES TO STARCK]
WWW.DWR.COM | 1.800.944.2233 | DWR STUDIOS

MODERN FOR SIXTY YEARS
[1946]
THE EAMES® PLYWOOD LOUNGE CHAIR
DESIGNED BY CHARLES AND RAY EAMES

MODERN BEYOND ITS YEARS
[2002]
THE LOUIS GHOST ARMCHAIR
DESIGNED BY PHILIPPE STARCK

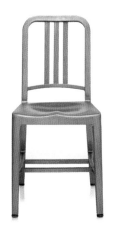

THE SOURCE FOR FULLY LICENSED CLASSICS™
[FROM PAST TO PRESENT]
WWW.DWR.COM | 1.800.944.2233 | DWR STUDIOS

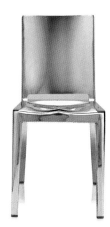

TOUGH ENOUGH TO SURVIVE A TORPEDO BLAST
[1944]
THE 1006 NAVY® SIDE CHAIR
DESIGNED FOR THE U.S. NAVY BY EMECO

TOUGH ENOUGH, BUT WHY WOULD YOU?
[1999]
THE HUDSON CHAIR
DESIGNED BY PHILIPPE STARCK FOR EMECO

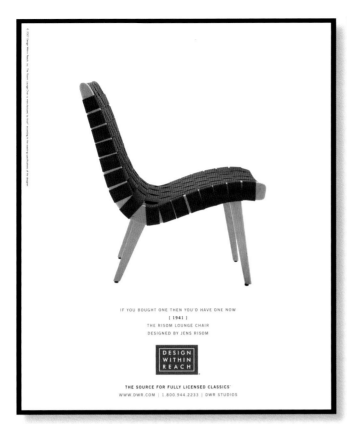

IF YOU BOUGHT ONE THEN YOU'D HAVE ONE NOW

[1941]

THE RISOM LOUNGE CHAIR

DESIGNED BY JENS RISOM

DESIGN WITHIN REACH

THE SOURCE FOR FULLY LICENSED CLASSICS

WWW.DWR.COM | 1.800.944.2233 | DWR STUDIOS

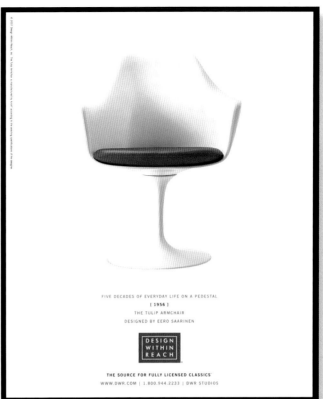

FIVE DECADES OF EVERYDAY LIFE ON A PEDESTAL

[1956]

THE TULIP ARMCHAIR

DESIGNED BY EERO SAARINEN

DESIGN WITHIN REACH

THE SOURCE FOR FULLY LICENSED CLASSICS

WWW.DWR.COM | 1.800.944.2233 | DWR STUDIOS

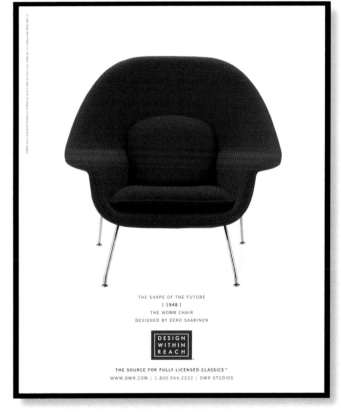

THE SHAPE OF THE FUTURE

[1948]

THE WOMB CHAIR

DESIGNED BY EERO SAARINEN

DESIGN WITHIN REACH

THE SOURCE FOR FULLY LICENSED CLASSICS™

WWW.DWR.COM | 1.800.944.2233 | DWR STUDIOS

Increase your wine I.Q.

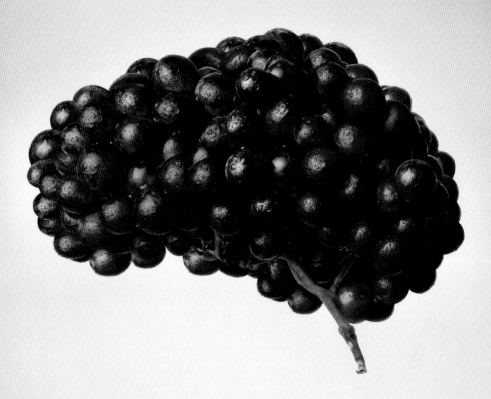

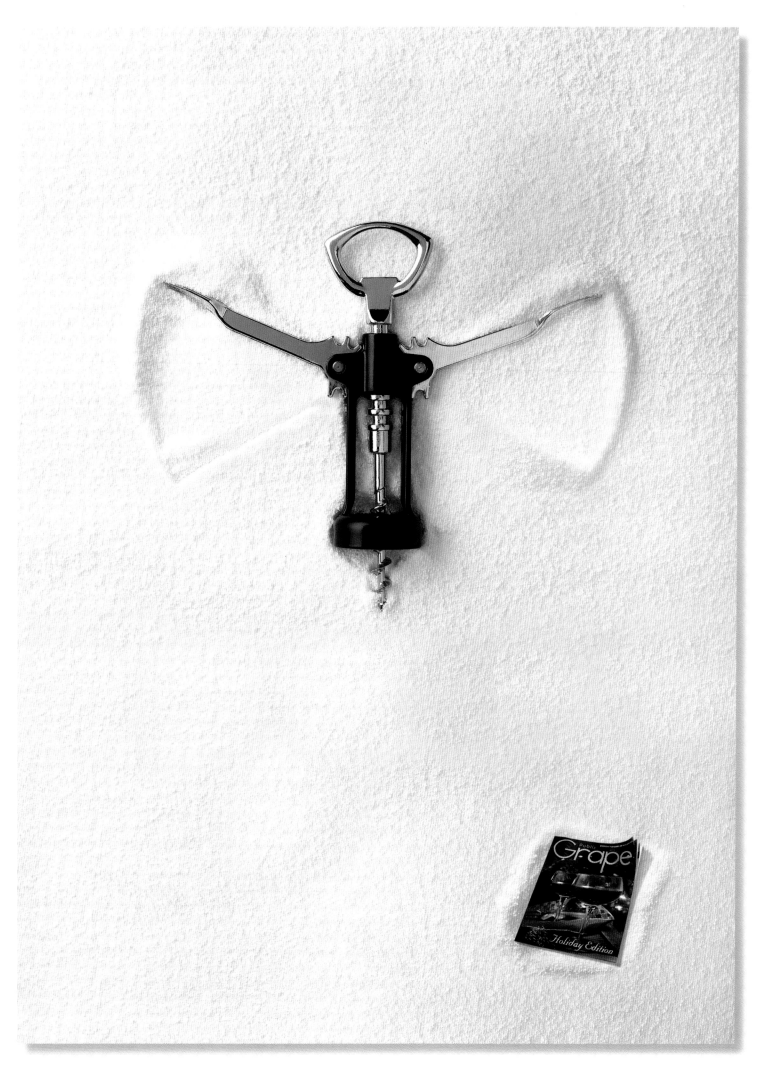

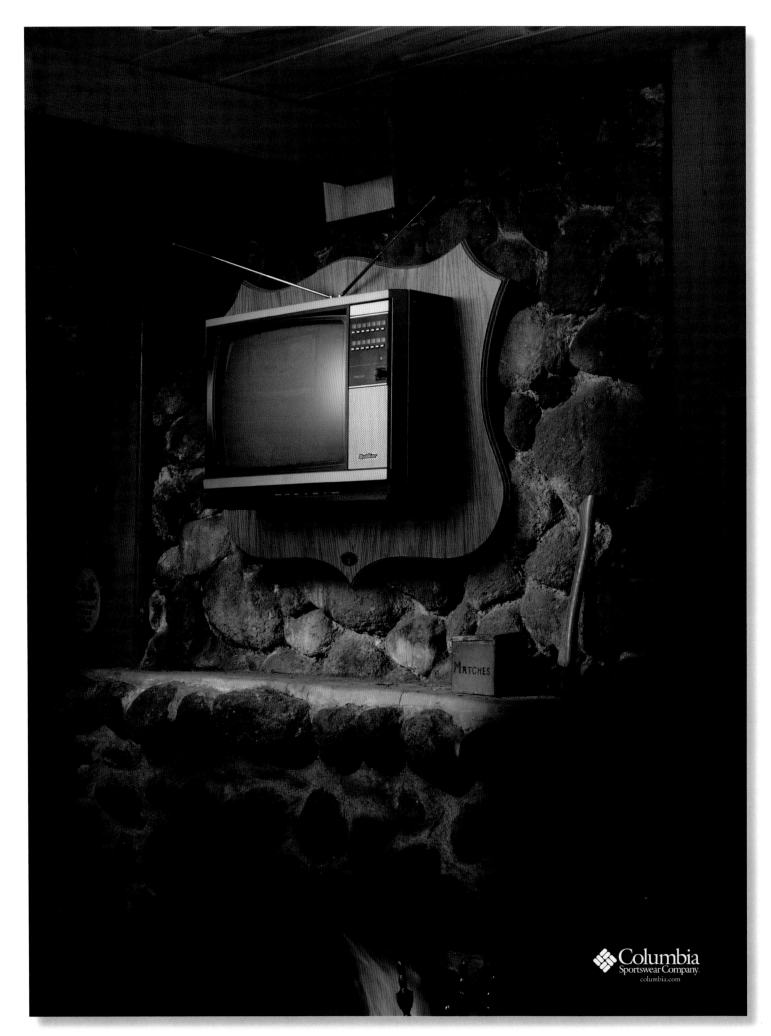

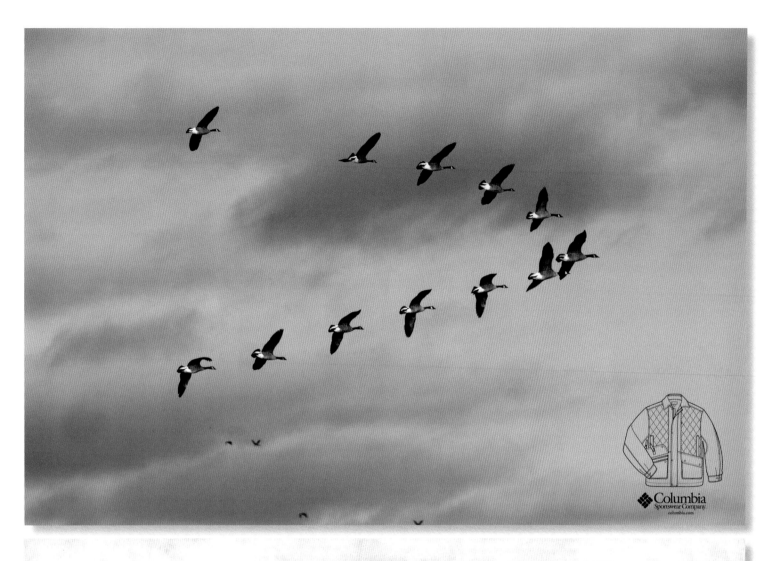

STOP

THE AREA AHEAD HAS THE WORST WEATHER IN AMERICA. MANY HAVE DIED FROM EXPOSURE. TURN BACK AT ONCE IF THE WEATHER IS BAD.*

* EXCEPT THOSE IN COLUMBIA SPORTSWEAR

WHITE MOUNTAIN NATIONAL FOREST

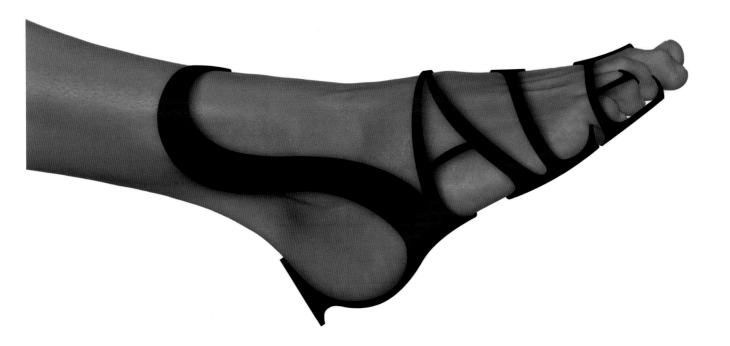

BIANCO.®
FOOTWEAR

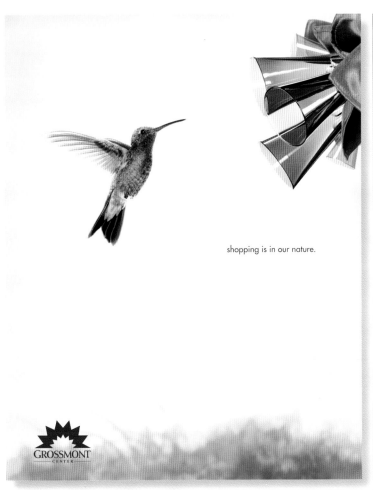

shopping is in our nature.

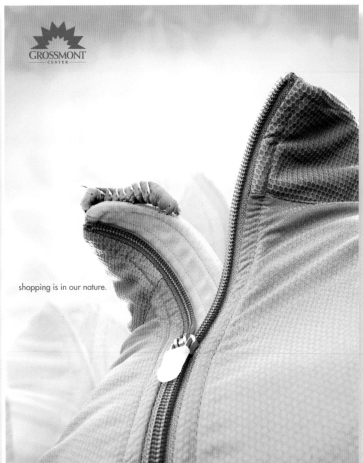

shopping is in our nature.

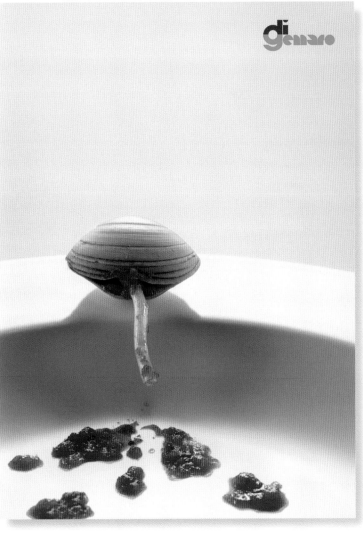

Now in Spain: erotic toys from Germany. ORION.es

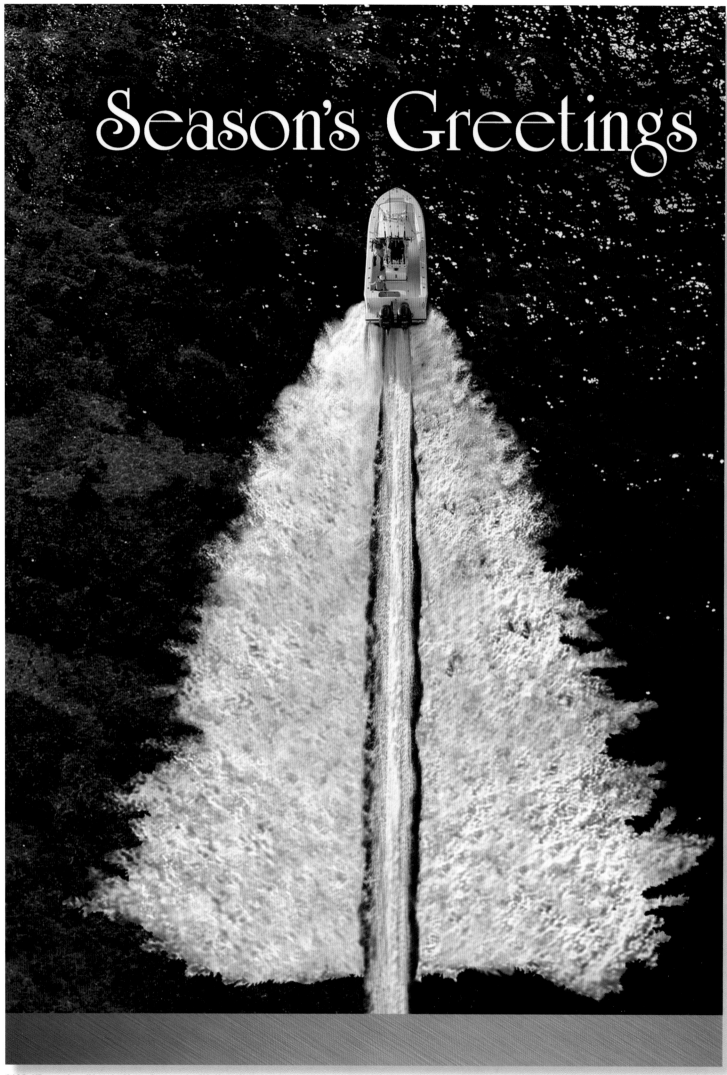

Season's Greetings

We always give you the
c0m100y66k19-carpet treatment.

capital printing co

www.capitalprintingco.com

Print quality that leaves others
c15m5y100k16 with envy.

capital printing co

| c 55 m 97 y 14 k 3 | c 13 m 5 y 72 k 0 | c 15 m 5 y 100 k 16 | c 8 m 26 y 70 k 0 | c 37 m 7 y 60 k 0 | c 57 m 28 y 1 k 0 | c 45 m 9 y 8 k 0 | c 34 m 21 y 28 k 0 | c 19 m 38 y 45 k 5 | c 3 m 13 y 15 k 0 |

ERICKSON STOCK
10,000 ORIGINAL ERICKSON, HIGH RESOLUTION IMAGES. DOWNLOAD YOUR NEXT CAMPAIGN. **ERICKSONSTOCK.COM**

DIGITAL ART BY FatCat. WWW.FATCATDIGITAL.COM

A thousand hits and counting.

02/23/07
COMPRESSED BY
STUFFIT DELUXE
SOFTWARE FOR MAC/PC

LIFE

COMPRESSED BY

STUFFIT DELUXE
SOFTWARE FOR MAC/PC

PLATINUM

THE 20th CENTURY
COMPRESSED BY

STUFFIT DELUXE
SOFTWARE FOR MAC/PC

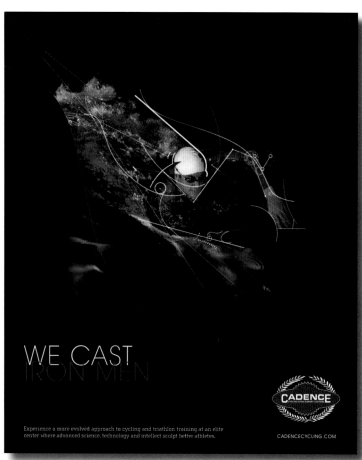

WE CAST
IRON MEN

Experience a more evolved approach to cycling and triathlon training at an elite
center where advanced science, technology and intellect sculpt better athletes.

CADENCECYCLING.COM

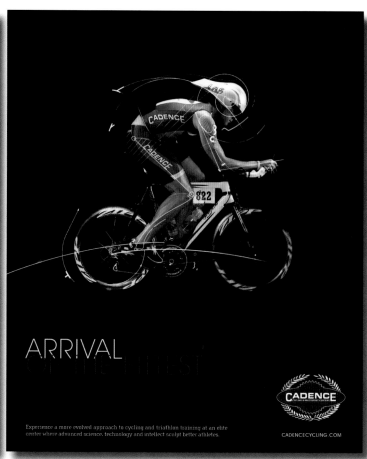

ARRIVAL
OF THE FITTEST

Experience a more evolved approach to cycling and triathlon training at an elite
center where advanced science, technology and intellect sculpt better athletes.

CADENCECYCLING.COM

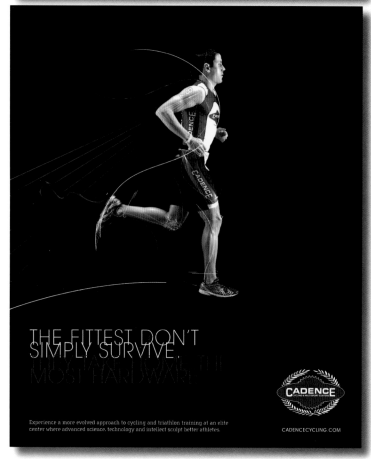

THE FITTEST DON'T
SIMPLY SURVIVE.
THEY HAVE THE
MOST HARDWARE

Experience a more evolved approach to cycling and triathlon training at an elite
center where advanced science, technology and intellect sculpt better athletes.

CADENCECYCLING.COM

PEARL IZUMI The SyncroFuel with Seamless Upper Technology. The most comfortable flying you'll ever do. www.pearlizumi.com/syncrospace

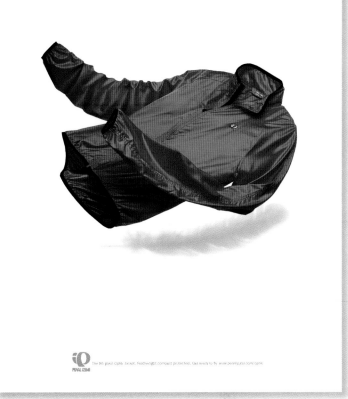

PEARL IZUMI The BG glam Optik jacket. Featherlight compact protection. Get ready to fly. www.pearlizumi.com/optik

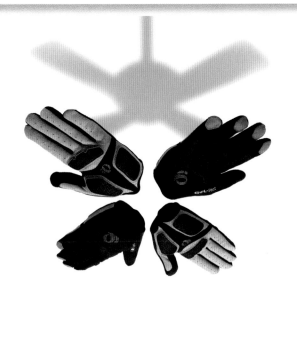

PEARL IZUMI The GelVent glove with gel cushioned ventilated palm. Get a grip and go with the flow. www.pearlizumi.com/gelvent

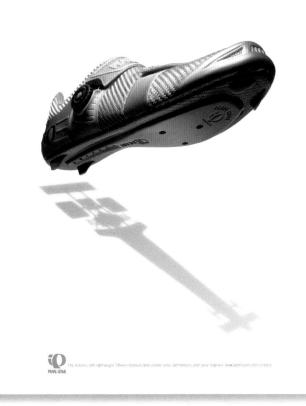

PEARL IZUMI The Octane, with lightweight Titanium titanium and carbon sole. Gentlemen, start your engines. www.pearlizumi.com/octane

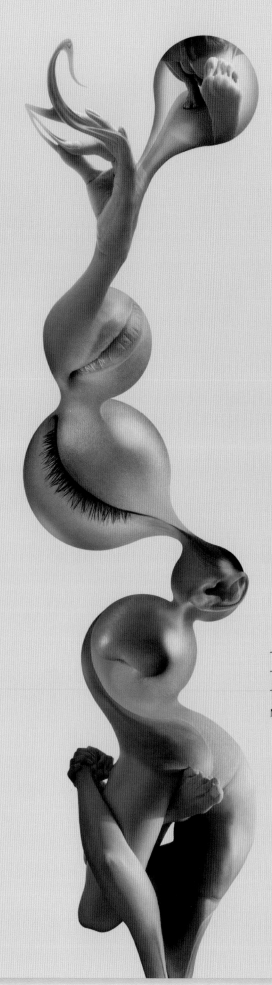

This is me.
The me that I do not know.
The me that is brand new.
Nice to meet you.

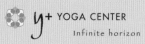 y+ YOGA CENTER
Infinite horizon

I can't.
I can't.
I already told you I can't.

Can I?

y+ YOGA CENTER
Infinite horizon

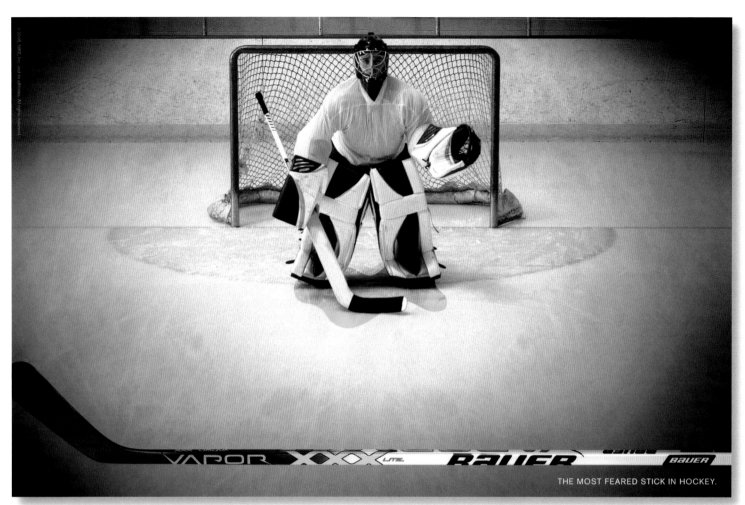

THE MOST FEARED STICK IN HOCKEY.

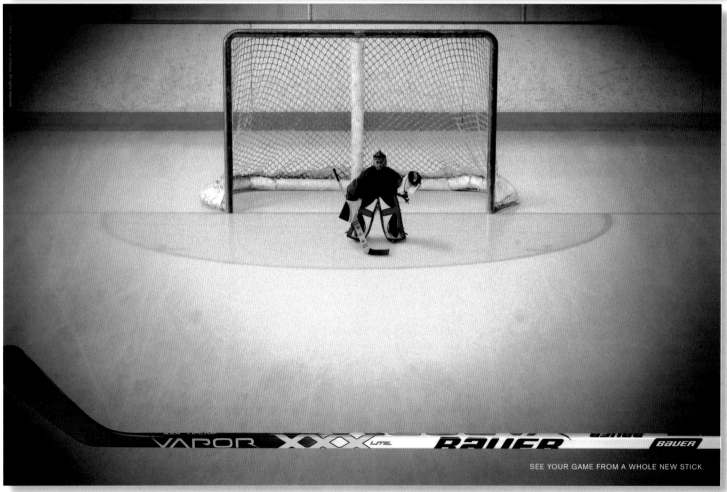

SEE YOUR GAME FROM A WHOLE NEW STICK.

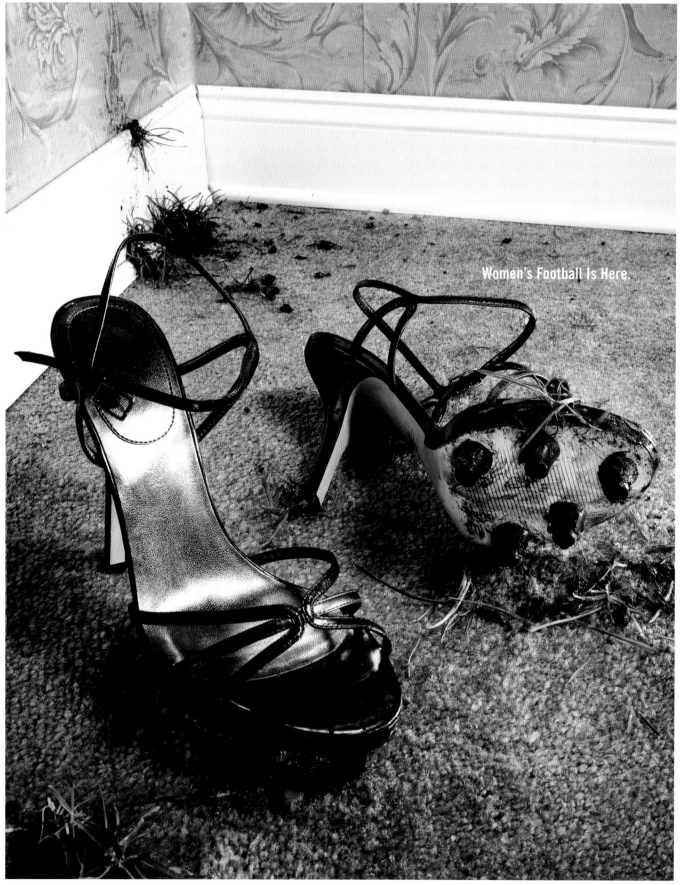

Women's Football Is Here.

Nonstop hardcore girl-on-girl action. Don't wait for the video. For ticket information visit milwaukeemomentum.com.

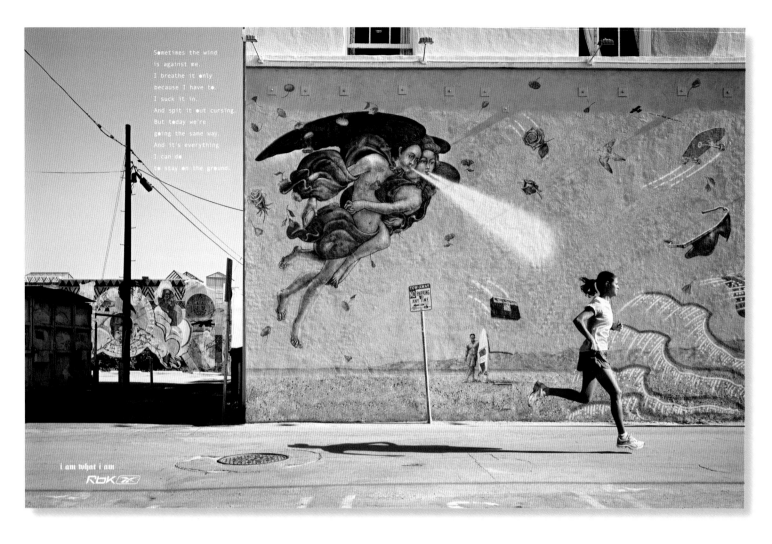

Sometimes the wind
is against me.
I breathe it only
because I have to.
I suck it in.
And spit it out cursing.
But today we're
going the same way.
And it's everything
I can do
to stay on the ground.

i am what i am
Rbk

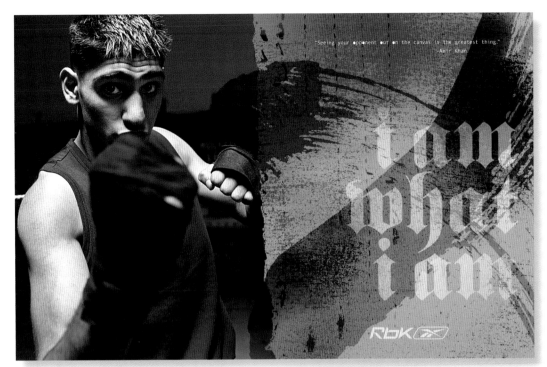

"Seeing your opponent out on the canvas is the greatest thing."
-Amir Khan

i am what i am

Rbk

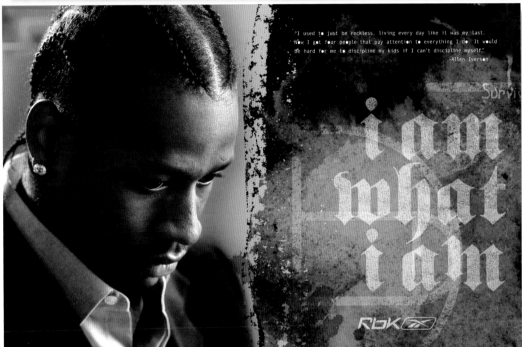

"I used to just be reckless, living every day like it was my last. Now I got four people that pay attention to everything I do. It would be hard for me to discipline my kids if I can't discipline myself."
-Allen Iverson

i am what i am

Rbk

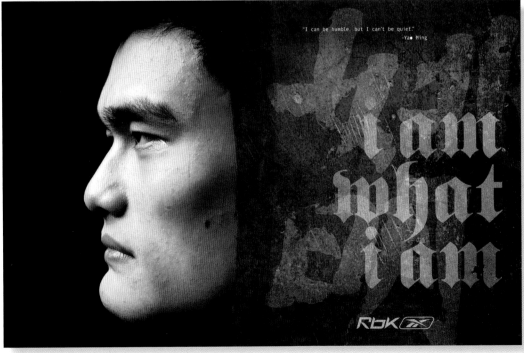

"I can be humble, but I can't be quiet."
-Yao Ming

i am what i am

Rbk

CHAPTER VII
SPRINGTIME IN THE CHISOS

"EIGHT HOURS IN A CAR? With the kids? But honey, they're going through a phase!"

Bob Hodges looked skeptical, at best. A moment before, when wife Judy announced her annual spring vacation surprise – West Texas! The Big Bend! – Bob smiled so big he nearly sprained his cheeks.

The Hodges had honeymooned at Lajitas and always dreamed of returning one day with their brood. Bob imagined riding horses and mountain bikes, teaching young Geoff how to putt and Gretchen the finer points of dinosaur tracking. He saw them rafting the river, discovering the fabled flora and fauna, *en famille*. Movie night under the stars! Chuckwagon dinners! And after the kids were tuckered out, and tucked in, he pictured himself and the missus moseying on down to the Ocotillo, enjoying succulent Chicken Mole or Buffalo Tenderloin, gently lit by candlelight and further lit by a late harvest Reisling. And after that, maybe…

"But eight hours in a car?"

"No, dear." Judy had saved the best part for last. "Two hours in a plane." *www.flylajitas.com*

CHAPTER IIX
MUSINGS OF THE FIRST GOAT

THEY SAY I SMELL. I say, is this not a goat's nature? But it stings, nonetheless, and so I drink beer. I am like my father in that regard, and his father before him. Also, I drink beer to celebrate another election-day landslide, even though it has become routine. Only a fool would run against me, would dare to try and topple the dynasty begun by my great-grandfather, the Hon. Clay Henry, Mayor of Lajitas. He was a goat to be reckoned with, and an even better mayor. Like him, I take very seriously the duties bestowed upon me by the office.

Sometimes, as the sun slips behind the Chisos Mountains and another day draws to a close, I observe the visitors who have come to my town. They are returning from the river, or the golf course, they have been luxuriating in the spa, or viewing rare birds, and they are smiling. And I imagine that in some small way I have contributed to their good feelings, and I become sentimental. And at such moments, I drink beer.

They say I am like my father in that regard, and his father before him. *www.lajitas.com*

CHAPTER IX
A SKY FULL OF VALENTINES

"LOOK! A Mexican Long-Nosed Bat!"

"Where?"

"Right there, in front of the Milky Way!"

Bob and Sandy, lost in the fantastic display of the West Texas night sky, were startled to see the nocturnal creature so far north. But then again, they'd been pretty much awestruck since they stepped off the plane.

Coming from The Windy City, the duo didn't know quite what to expect, but it certainly didn't include food fit for city slickers, mountains so big you couldn't get over them, and beds so comfy you almost couldn't get out of them. Not to mention a spectacular desert golf course (for Bob), a Rio Grande Mud Wrap (for Sandy), and a beer-drinking goat (for a mayor). Why, this trip was stocking their marriage with enough romance for four couples!

"Look!" said Bob. Another shooting star!"

"How many is that, sweetheart?"

Bob held Sandy tighter against the chill, and whispered, "Who's counting?" *www.lajitas.com*

CHAPTER XIX
A RETREAT AT TRAIL'S END

"LOCATION! LOCATION! LOCATION!" Shirley said for the umpteenth time.

She was trying to remain humble but, truly, she'd done a bang-up job. This was the best Executive Retreat ever! It was "a stroke of genius!" to have the meeting in Big Bend, and "brilliant!" to book a resort with just 92 rooms.

The team felt like "rock stars" on the chartered plane and "movie stars" as they dined on Hot and Crunchy Trout, Smoked Prime Rib and Silver Oak Cabernet.

They got plenty of work done, too. And talk about team-building! Who knew, when little Matt Murray walked into the Equestrian Center, that he was such a whiz with a pony and a bullwhip? And when Betty Jo Imamura finally hit the target during the Cowboy Action shooting, why, there wasn't a dry eye in all of West Texas.

It really wasn't until this afternoon, after golf, mountain biking and bird watching, in between the Big Bend Foot Soak and the Avocado Moisture Wrap, that Shirley let herself believe what the rest of the gang was saying.

"Damn," she said softly, "I'm good." *www.lajitas.com*

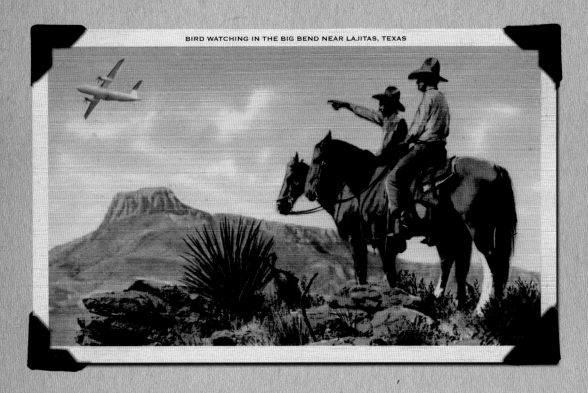

BIRD WATCHING IN THE BIG BEND NEAR LAJITAS, TEXAS

GREETINGS FROM THE BIG BEND. Right now the days are a perfect 72 degrees and the nights are cool and crisp. We've got a million ways to work up an appetite, and when that happens, plenty of ways to satisfy your cravings. In other words, The Big Bend is better than ever, and getting here has never been easier – thanks to our new charter service, you can be here in the ultimate hideout in just a couple of hours. Flights depart twice a week from Dallas or Austin and deposit you directly to Lajitas International Airport. Round trip fares start at just $399. To book your trip visit *www.flylajitas.com* or call 1-877-525-4827. LAJITAS

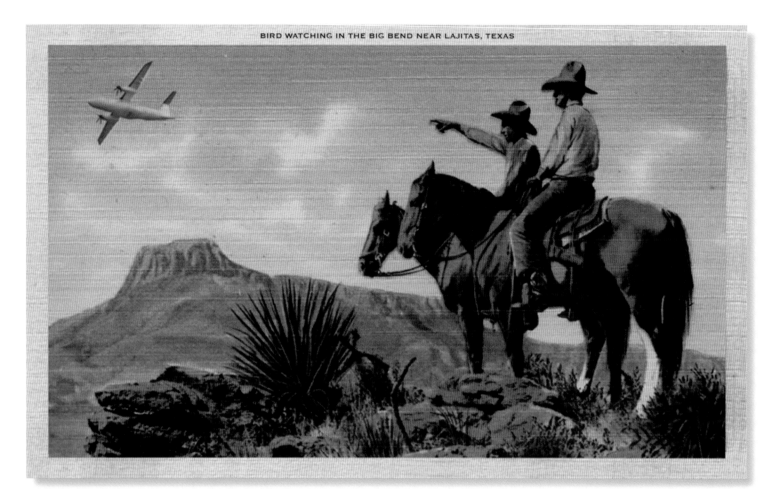

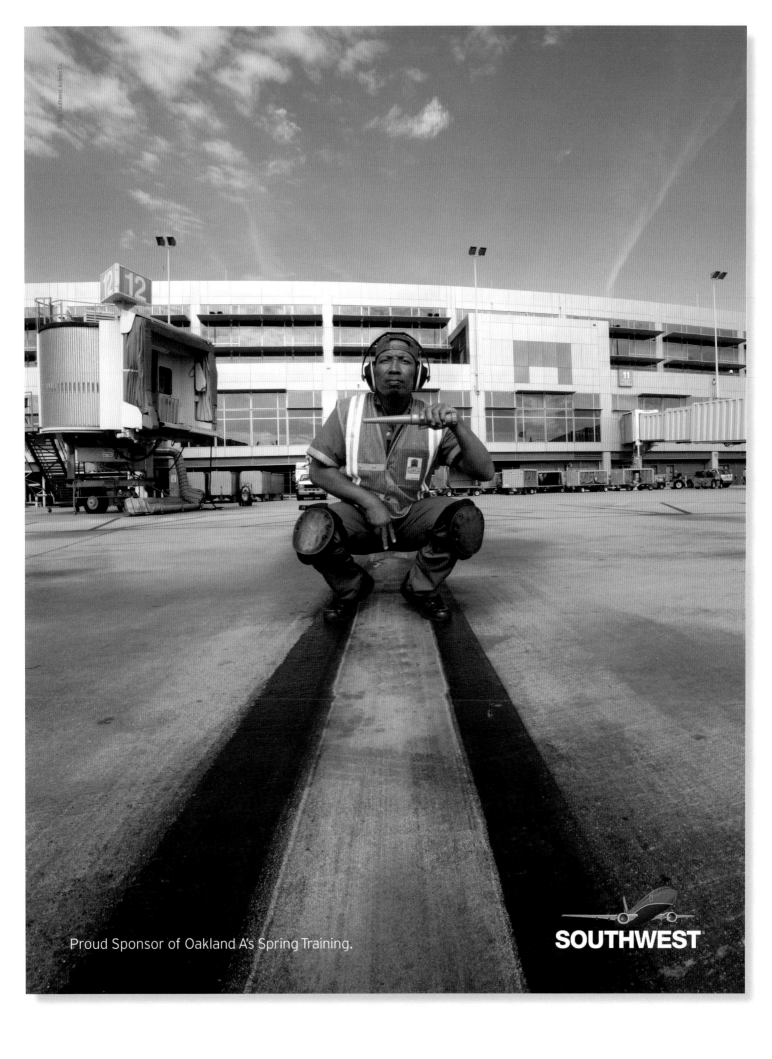

Proud Sponsor of Oakland A's Spring Training.

SOUTHWEST

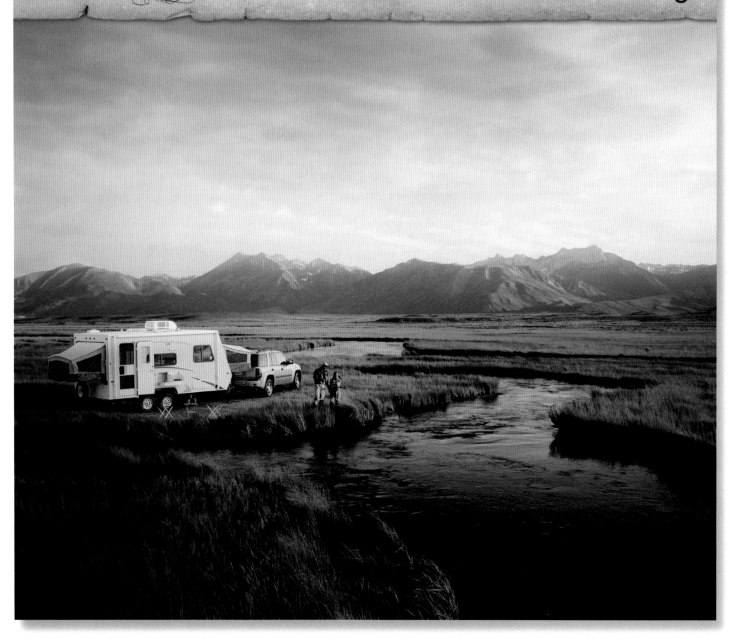

Ideal for visiting
QUIET, OUT-OF-THE-WAY PLACES
like + 89° 15'50.794"

Fig. 1 Saturn

Fig. 3 Asteroid Gaspra

Fig. 5 Mercury

Fig. 7 Jupiter

Fig. 2 Neptune

Fig. 4 Phases of the Moon

Fig. 6 Mars

Marvel over the Milky Way. Hop aboard Saturn's rings. Count your lucky stars that you can do just about anything, just about anywhere with an RV. Go to **GoRVing.com** *for a free video and visit an RV dealer.* **WHAT WILL YOU DISCOVER?**

Go RVing.

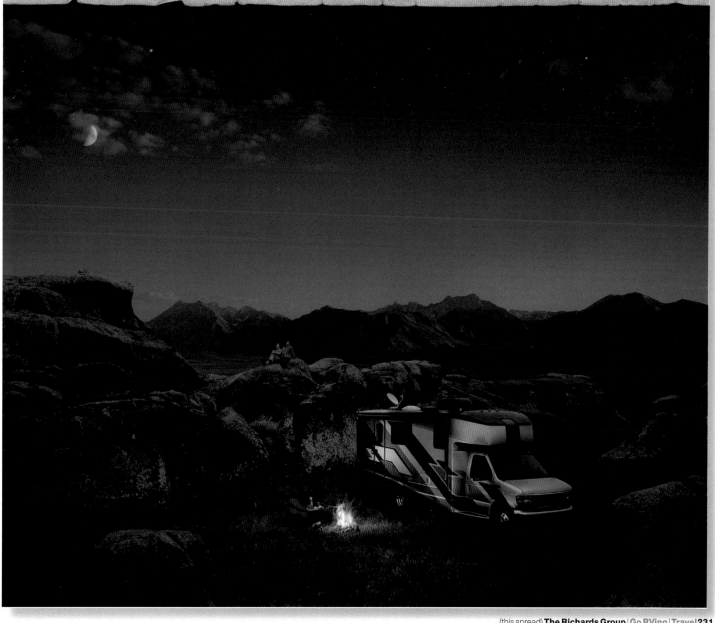

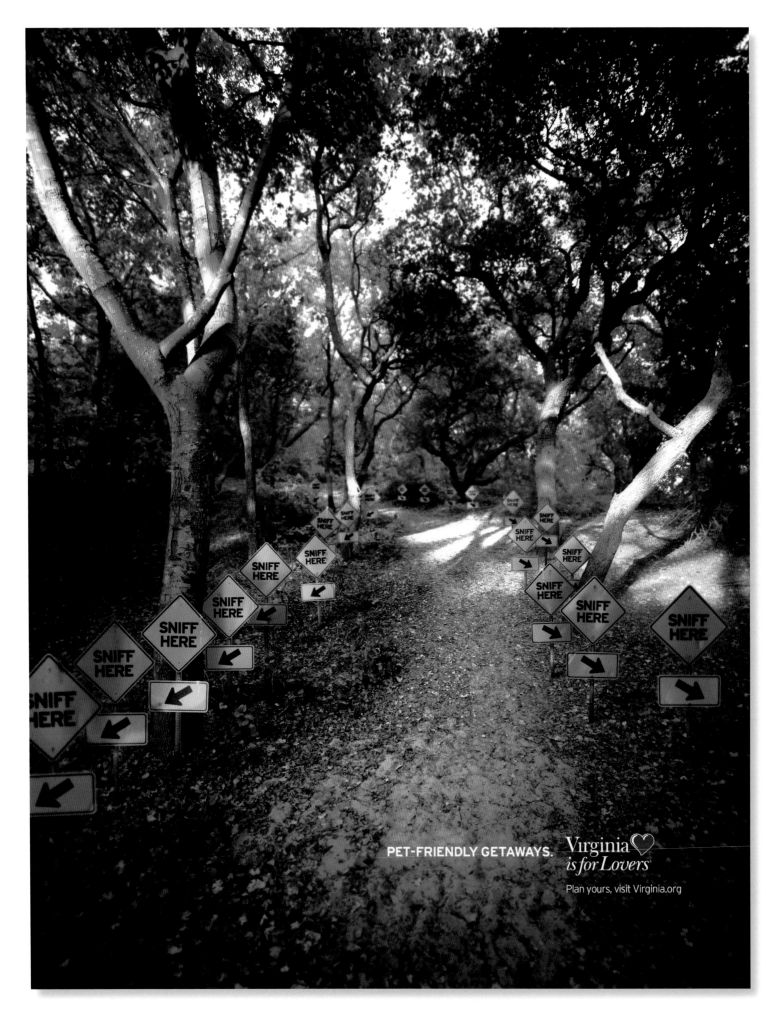

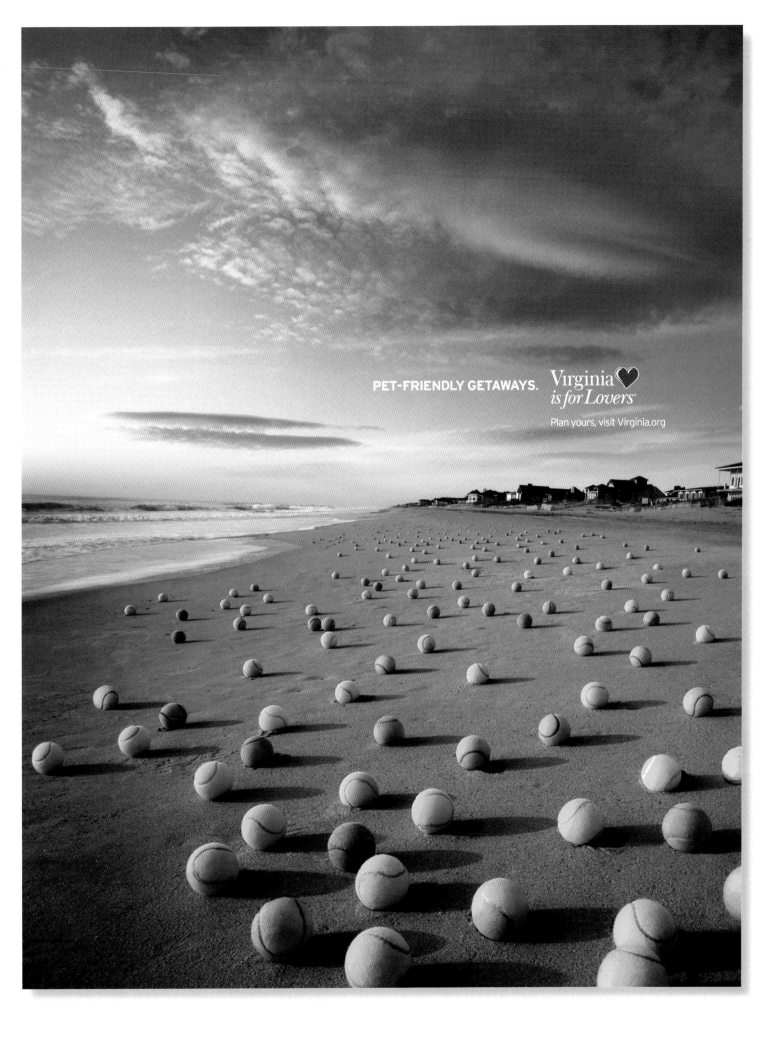

PET-FRIENDLY GETAWAYS. Virginia is for Lovers®

Plan yours, visit Virginia.org

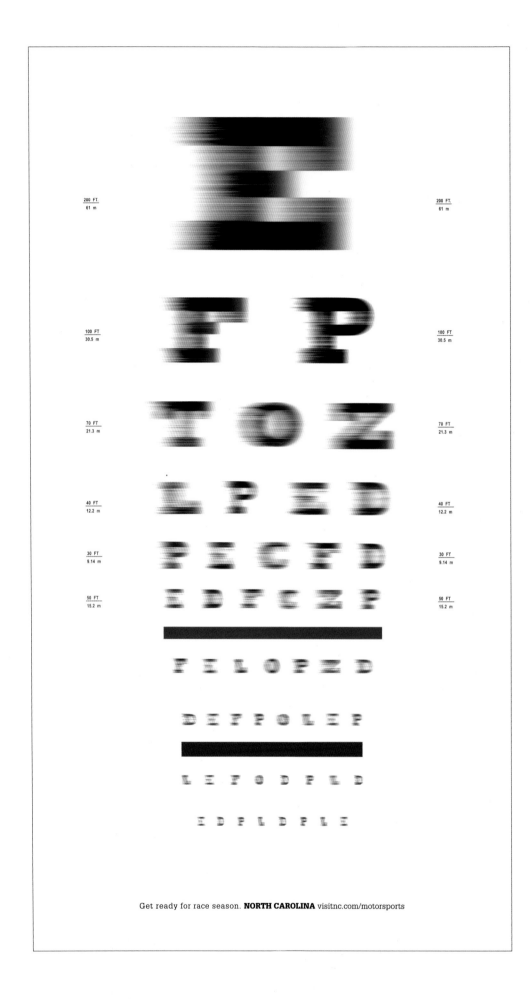

Get ready for race season. **NORTH CAROLINA** visitnc.com/motorsports

FASTER LIFTS. SHORTER LINES. MORE RUNS.

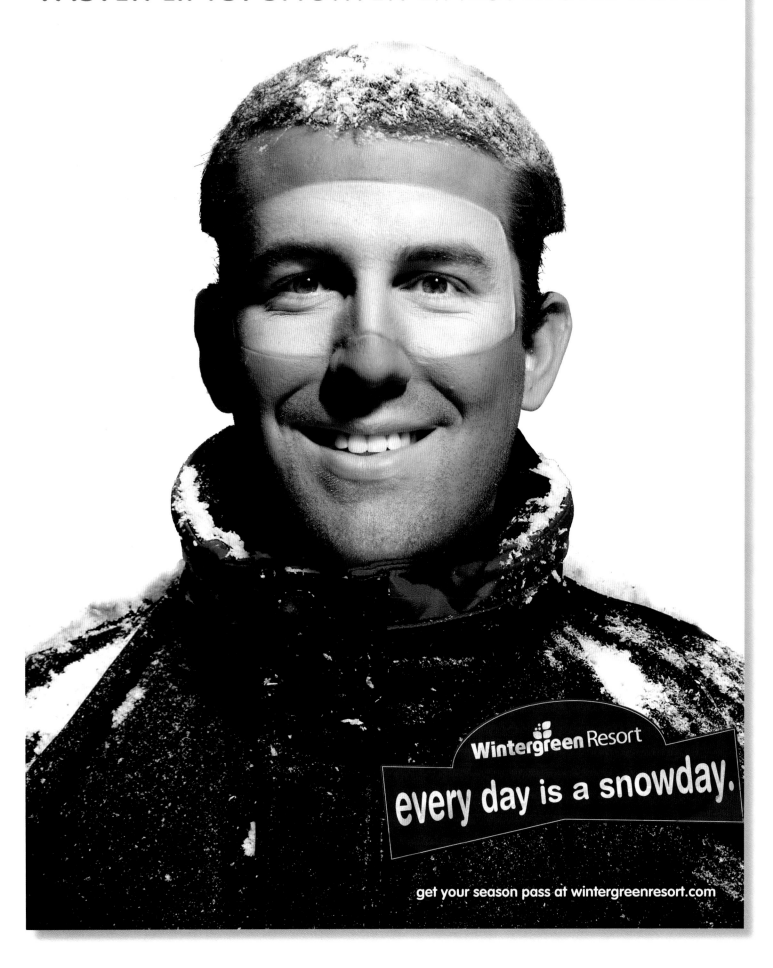

Wintergreen Resort

every day is a snowday.

get your season pass at wintergreenresort.com

JAGUAR

If you thought of a car, maybe it's time.

SAN FRANCISCO ZOO

FOX

If you thought of television, maybe it's time.

SAN FRANCISCO ZOO

PUMA

If you thought of shoes, maybe it's time.

SAN FRANCISCO ZOO

ZOOBILATION '07

SENECA PARK ZOO SOCIETY

A great cause. A wild time.

~ June 2nd, 2007 ~

ZOOBILATION '07
SENECA PARK ZOO SOCIETY
A great cause. A wild time.
~ June 2nd, 2007 ~

Credits

Automotive

20, 21 Tiffin Motorhomes Reflection Poster Campaign | Design Firm: Lewis Communications, Birmingham | Account Director: Val Holman | Art Director: Carter Lewis | Creative Directors: Paul Crawford, Stephen Curry | Photographers: Jeff Williams, Stuuert | Print Producer: Leigh Ann Motley | Chief Creative Officer: Spencer Till | Writer: Stephen Curry | Client: Tiffin Motorhomes

22, 23 Dog Skeleton | Design Firm: Colle + McVoy, Minneapolis | Art Director: Jay Miller | Creative Director: Mike Fetrow | Writer: Brian Ritchie | Client: Winnebago

24 Toy | Design Firm: WestWayne, Atlanta | Account Director: Bob Alexander | Art Director: Garen Boghosian | Chief Creative Officer: Scott Sheinberg | Creative Directors: Earl Keister, John Stapleton | Client: Southeast Toyota

25 H2 Muscles - Sand | Design Firm: Modernista!, Boston | Account Director: Mike Wilmot | Art Directors: Michael Langone, Tim Vaccarino | Chief Creative Officers: Gary Koepke, Lance Jensen | Creative Directors: Foe Fallon, Tim Vaccarino | Photographer: Tim Kent | Writers: Joe Fallon, Lance Jensen | Client: HUMMER

We stripped away the environment to highlight the athletic, muscular stance of a white H2 bursting forth from a sea of blackness, reinforcing how the truck is like nothing else.

26 Dwell Flipbook | Design Firm: Butler, Shine, Stern & Partners, Sausalito | Account Director: Neil Smith | Art Director: JP Guiseppi | Chief Creative Officers: John Butler, Mike Shine | Creative Directors: John Butler, Mike Shine | Executive Creative Directors: John Butler, Mike Shine | Writer: Charlie Gschwend | Client: MINI USA

27 R (top) | Design Firm: GSD&M, Austin | Account Director: Kelly Lee | Art Director: Lynn Sarnow Born | Creative Directors: David Crawford, Scott MacGregor, Derek Pletch, Mark Ray | Photographer: Igor Panitz | Print Producer: Leigh Ann Proctor | Project Manager: Lani DeGuire | Writer: Carole Hurst | Client: BMW

27 It's Why We Go to Work (bottom) | Design Firm: GSD&M, Austin | Account Director: Kelly Lee | Art Director: Demian Fore | Creative Directors: David Crawford, Scott MacGregor, Derek Pletch, Mark Ray | Photographer: Igor Panitz | Print Producer: Leigh Ann Proctor | Project Manager: Lani DeGuire | Writer: Ray Longoria | Client: BMW

AutoProducts

28 Maletín (top), Cartera (bottom) | Design Firm: EJE Sociedad Publicitaria, Hato Rey | Account Director: Maruchi López | Art Director: Héctor López | Creative Director: Enrique Renta | Photographer: Ernesto Robles | Writer: Jonathan Díaz | Client: Suzuki de P.R.

Launch for Suzuki Grand Vitara Special Edition, with leather seats.

29 No Fear 2 | Design Firm: Ongoing Co., Ltd., Bangkok | Account Directors: Lode Nandhivajrin, Kiatikun Siriwatchmongkonchai | Art Directors: Pijarinee Kamolyabutr, Wasin Pothikasem | Chief Creative Officer: Pijarinee Kamolyabutr | Creative Director: Theerapol Koomsorn | Photographer: Chub Nokkaew | Writers: Theerapol Koomsorn, Narongchai Prathumsuwan | Client: Thai Yarnyon Co., Ltd. (A Yontrakit Group Company)

Headline: *Please try this stunt ONLY IF you've had your VW serviced at an authorized shop - where all parts and service are warrantied for 2 years.

Aviation

30 Forward Thinking | Design Firm: HSR Business to Business, Cincinnati | Account Director: Adryanna Sutherland | Art Director: John Pattison | Chief Creative Officer: Tom Rentschler | Creative Director: John Pattison | Writer: Laura Black | Illustrator: Richard Biever | Client: HSR Business to Business

31 Organization Chart | Design Firm: HSR Business to Business, Cincinnati | Account Director: John Dobbs | Art Director: Gerry Pasqualetti | Chief Creative Officer: Tom Rentschler | Creative Director: John Pattison | Writer: Paul Singer | Client: Eclipse Aviation

Banking

32 Rock On/Fist Bump/Tie Guy/Smile Guy | Design Firm: Venables, Bell & Partners, San Francisco | Account Director: Nick Johnson | Art Director: Ellen Springer | Creative Directors: Greg Bell, Paul Venables | Creative Strategist: Liz Geddes | Photographer: Zach Scott | Print Producer: Katie Borzcik | Writer: Chip Waters | Client: Barclays Brand

33 Occupations | Design Firm: Bernstein-Rein, Kansas City | Art Director: Gene Blakeney | Chief Creative Officer: Arlo Oviatt | Creative Director: Mark Miller | Writer: Eric Knittel | Photographer: Lyndon Wade | Client: Commerce Bank

POS Posters for Commerce Bank promoting their small business account.

Beauty&Cosmetics

34 Abrigo (top), Bufanda (bottom) | Design Firm: EJE Sociedad Publicitaria, Hato Rey | Account Director: Guelmarie Sosa | Art Director: Héctor López | Creative Director: Enrique Renta | Photographer: Omar Cruz | Writer: Jonathan Díaz | Client: Johnson & Johnson

The concept makes use of scarves and coats because when the product is applied on the skin it gives a strong cooling sensation.

35 Fairies (top), Dragon (bottom) | Design Firm: Saatchi & Saatchi New York, New York | Art Director: Rebecca Peterson | Chief Creative Officer: Tony Granger | Creative Director: Sarah Barclay | Designers: Kevin Li | Digital Artist: Aaron Padin | Photographer: Zach Gold | Writer: Jason Graff | Client: Procter & Gamble/Scope mouthwash

36 For maximum hold. Super Clean Sculpting Gel. | Design Firm: Scholz & Friends, Hamburg | Art Director: Stefanie Zimmermann | Copywriter: Christian Vosshagen | Photographer: Straulino | Client: Paul Mitchell

Beverages

37 CONTAINERS-Tuba (top), GIRL IN THE RAIN (bottom) | Design Firm: mcgarrybowen, New York | Art Director: Warren Eakins | Creative Directors: Warren Eakins, Randy Van Kleeck | Photographer: Jim Fiscus | Client: Brahma

These four ads are part of a print, TV and out of home campaign. The creative idea is, "Improvise," which expresses a uniquely Brazilian attitude towards life. This campaign is called "Containers", based on observations and experiences of makeshift or improvised ways of keeping your beer cold.

38 Panda | Design Firm: Fitzgerald+CO, Atlanta | Art Director: Matt Sharpe | Chief Creative Officer: Eddie Snyder | Creative Directors: Hal Barber, Carlos Ricque | Writer: Leslie French | Client: Coca-Cola

39 Label Slide | Design Firm: The Hive Strategic Marketing Inc., Toronto | Account Director: Chris Johnston | Art Director: Jordan Heidendahl | Chief Creative Officer: Christopher Grimston | Creative Director: Phil Sylver | Illustrator: Aerographics | Photographer: Shanghoon | Print Producer: Anne Smythe | Writer: Christopher Grimston | Client: Miller Genuine Draft

This is a poster for Miller Genuine Draft that went in bars. The strategy is that Miller Genuine Draft is an incredibly smooth beer. In this execution, the beer is so smooth that the label is unable to stick to the bottle.

40 Raptor Claw | Design Firm: The Hive Strategic Marketing Inc., Toronto | Account Director: Chris Johnston | Art Director: Jordan Heidendahl | Chief Creative Officer: Christopher Grimston |

Creative Director: Phil Sylver | Illustrator: Chris Baginsky | Photographer: Shanghoon | Print Producer: Anne Smythe | Writer: Phil Sylver | Client: Miller Genuine Draft

The ad ran in a local Toronto newspaper to show Miller Genuine Draft's support for the local NBA team, the Toronto Raptors. The Raptors claw appears to have left its mark on the bottle of Miller Genuine Draft.

41 Drink Different | Design Firm: Pyper Paul + Kenney, Inc., Tampa | Art Director: Benjamin Day | Executive Creative Director: Tom Kenney | Account Director: Paul Daigle | Associate Creative Director / Writer: Michael Schilling | Client: Touch Vodka

42 Mix It, Amplify, Rock On, Mix & Mosh | Design Firm: OLSON, Minneapolis | Account Director: Laura Van Bellinger | Art Director: Kelly Gothier | Chief Creative Officer: Tom Fugleberg | Creative Director: Brian Kroening | Designers: Jeff Berg, Robb Harskamp, Milton Un | Print Producer: Irene Lockwood | Project Manager: Stephanie Madeja | Writer: Eric Luoma | Client: Phillips Distilling

43 Surprisingly strong | Design Firm: Saatchi&Saatchi, Mumbai | Copywriter: Juju Basu, Suyash Khabya | Photographer: Kishore Sali | Client: Chateau Indage

Billboards/Outdoor

44 Sub Sandwich Lightrail | Design Firm: OLSON, Minneapolis | Account Director: Mark Bubula | Art Director: Derek Till | Chief Creative Officer: Tom Fugleberg | Creative Director: Tom Fugleberg | Print Producer: Irene Lockwood | Writers: Joel Anderson, Derek Bitter, Tom Fugleberg | Project Manager: Christine Toy | Client: Cub Foods

45 POST-BOX WATERFALL | Design Firm: KNARF, New York | Art Directors: Frank Anselmo, Sue Won Chang, Jane Lee | Creative Director: Frank Anselmo | Designers: Frank Anselmo, Sue Won Chang, Jane Lee | Client: NIAGARA CHAMBER

Guerrilla/Outdoor: Busy city people don't usually think of Niagara Falls as an option for an enjoyable weekend getaway. With permission from the Post Office, post-boxes were utilized as media space for the Niagara Falls posters, therefore creating the illusion of the famous waterfall.

46 Snake Pole | Design Firm: BBDO West, San Francisco | Art Directors: Alper Kologlu, Brandon Sides | Author: Neil Levy | Creative Director: Jim Lesser | Executive Creative Director: Jim Lesser | Client: San Francisco Zoo

47 Giraffe Banner | Design Firm: BBDO West, San Francisco | Art Director: Brandon Sides | Author: Neil Levy | Creative Director: Jim Lesser | Executive Creative Director: Jim Lesser | Client: San Francisco Zoo

48 Brand Campaign | Design Firm: BBDO West, San Francisco | Art Director: Heward Jue | Author: Michael Barti | Creative Director: Jim Lesser | Executive Creative Director: Jim Lesser | Client: Air New Zealand

49 Rafting | Design Firm: BBDO West, San Francisco | Art Director: Heward Jue | Author: Michael Barti | Creative Director: Jim Lesser | Executive Creative Director: Jim Lesser | Client: Air New Zealand

50 Gate Covers | Design Firm: Saatchi & Saatchi New York, New York | Art Director: Carmine Coppola | Chief Creative Officer: Tony Granger | Creative Director: Andrew Jeske | Writer: Chuck Pagano | Client: Alcoa/Reynolds Heavy Duty Aluminum Foil

51 Art & Architecture | Design Firm: The Integer Group, Lakewood | Art Director: Scott Lary | Chief Creative Officer: Alan Koenke | Creative Director: Jane Brody | Photographer: Jeff Goldberg | Print Producer: Vicki Guntenaar | Writer: Natalie Boykin | Client: Denver Art Museum

52 Blafjoll 30 km | Design Firm: Ó!, Reykjavik | Art Director: Einar Gylfason | Creative Director: Thoromar Jonsson | Creative Strategist: Gretar Hallur Thorisson | Designer: Einar Gylfason | Client: Blafjoll Ski Resort

The outdoor Advertising was produced for the ski resort Blafjoll. The ad shows people in snowless Reykjavik that there is lots of snow only 30 km away.

53 Teeth | Design Firm: Cramer-Krasselt, Chicago | Art Director: Vince Soliven | Artists: John Carstens, Ken Erke | Writer: Andrew Gall | Client: John Mullally, DDS

This entry plays off the typical telephone pole flyers with tear off tabs by reinventing them as "teeth" that passers-by could tear off, leaving the "mouth" in dire need of dental care.

54 Ramp Board | Design Firm: TAXI, Inc. (NYC), New York | Account Director: Heather Doutt | Art Director: Scott Bassen | Chief Creative Officer: Paul Lavoie | Executive Creative Director: Wayne Best | Print Producer: Ed Burgoyne | Writer: Tom Christmann | Client: Amp'd Mobile

To seed the new tagline for Amp'd Mobile, we built a huge bike ramp complete with a life size biker. The bicycle tires were made to spin continuously, giving the illusion that the stunt-gone-wrong had just happened.

Cameras

55 The FZ series with 12-times zoom | Design Firm: Jung von Matt, Zurich | Art Director: Lukas Frei | Copywriter: Johannes Raggio | Photographers: David Kempinski, Felix Schregenberger | Client: Panasonic | Campaign for a digital camera

Communications

56 Nora(top left) | Design Firm: Rodgers Townsend, St. Louis | Account Director: Chris Hanley | Art Director: Luke Partridge | Chief Creative Officer: Tom Hudder | Creative Director: Michael McCormick | Writer: Michael McCormick | Client: AT&T

56 Mary(top right) | Design Firm: Rodgers Townsend, St. Louis | Account Director: Gary Shipper | Art Director: Luke Partridge | Chief Creative Officer: Tom Hudder | Writer: Michael McCormick | Client: AT&T

56 Miguel(bottom right) | Design Firm: Rodgers Townsend, St. Louis | Account Director: Cory Wightman | Art Director: Tim Varner | Chief Creative Officer: Tom Hudder | Writer: Kay Cochran | Client: AT&T

56 Mike (bottom left) | Design Firm: Rodgers Townsend, St. Louis | Account Director: Gary Shipper | Art Director: Luke Partridge | Chief Creative Officer: Tom Hudder | Writer: Michael McCormick | Client: AT&T

57 Doug(top), Ted (bottom) | Design Firm: Rodgers Townsend, St. Louis | Account Director: Chris Hanley | Art Director: Luke Partridge | Chief Creative Officer: Tom Hudder | Creative Director: Michael McCormick | Writer: Michael McCormick | Client: AT&T

58 Hank (top), Andy (bottom) | Design Firm: Rodgers Townsend, St. Louis | Account Director: Chris Hanley | Art Director: Luke Partridge | Chief Creative Officer: Tom Hudder | Creative Director: Michael McCormick | Writer: Michael McCormick | Client: AT&T

59 Coverage | Design Firm: Young and Rubicam, Mexico, D.F. | Art Directors: Mario Aguilar, Sofia Albanel, Edgar Rodriguez | Chief Creative Officer: Carl Jones | Creative Directors: Adrian Brizuela, Carl Jones | Photographer: Sergio Pons | Writer: Ramiro Plascencia | Client: Movistar

Computers/Electronics

60, 61 **Platinum** Elephant (left), Boat (top right), Blimp (bottom right) | Design Firm: Goodby,

Silverstein & Partners, San Francisco | Account Director: Chad Bettor | Art Director: Dave Muller | Creative Directors: Jamie Barrett, Mark Wenneker | Photographer: Tom Nagy, stock | Print Producer: Hillary DuMoulin | Writer:Rus Chao | Client: Comcast

Please see Case Studies in front for more information on this award winning ad.

62, 63 Q Campaign | Design Firm: Goodby, Silverstein & Partners, San Francisco | Account Director: Rob Smith | Art Director: Frank Aldorf | Creative Director: Guy Seese | Photographer: Robert Grischek | Print Producer: Michael Stock | Writer: Will Elliott | Client: Motorola

64 Your Art Here (top) | Design Firm: Goodby, Silverstein & Partners, San Francisco | Account Director: Nancy Reyes | Art Director: Keith Anderson | Chief Creative Officer: Rich Silverstein | Creative Directors: Keith Anderson, Stephen Goldblatt, Mike McKay, Steve Simpson | Design Director: Keith Anderson | Illustrators: Jonathan Gray, Brian Gunderson | Photographer: Claude Shade | Print Producers: Noah Dasho, Margaret Brett-Kearns | Project Manager: Lisa Borland | Typographer: Jonathan Gray | Writer: Steve Simpson | Client: Hewlett-Packard

64(bottom), 65 PSG Launch Campaign | Design Firm: Goodby, Silverstein & Partners, San Francisco | Account Director: Nancy Reyes | Art Directors: Keith Anderson, Antonio Marcato | Chief Creative Officer: Rich Silverstein | Creative Directors: Keith Anderson, Stephen Goldblatt, Mike McKay, Steve Simpson | Design Director: Keith Anderson | Illustrators: Jonathan Gray, Brian Gunderson | Photographer: Claude Shade | Print Producers: Noah Dasho, Margaret Brett-Kearns | Project Manager: Lisa Borland | Typographer: Jonathan Gray | Writers: Thomas Kemeny, Mike McKay, Nick Prout, Steve Simpson | Client: Hewlett-Packard

66 SGI Infinite Storage Ad Campaign (top) | Design Firm: Loomis Group, Boston | Account Director: Michael Weston | Art Director: George Steeley | Chief Creative Officer: George Steeley | Creative Strategist: Michael Lattig | Designers: Johnny Barlett, Paul DeGrote | Illustrators: Johnny Barlett, Paul DeGrote | Writer: Michael Lattig | Client: SGI

An ad campaign for SGI's High-Performance Storage line appearing in a monthly editorial insert of Infostor called "Storage in the Studio." In an industry that is very product- and spec-focused, these ads exemplify the benefit of SGI's storage line by casting a shadowed character behind the product.

66 Integrates (bottom left), Wired Wireless (bottom right) | Design Firm: HSR Business to Business, Cincinnati | Account Director: Cristina Sotelino | Art Director: Martin Buchanan | Chief Creative Officer: Tom Rentschler | Creative Director: Laura Black | Writer: Laura Black

67 Aviao (Airplane) | Design Firm: FabraQuinteiro | Art Director: Alexandre Manisck | Creative Directors: Paschoal Fabra Neto, Hercules Florence | Writer: Hercules Florence | Photographer: Felipe Hellmeister | Illustrator: WDS Studio | Client: Epson

68, 69 People Ready Business | Design Firm: McCann-Erickson, San Francisco | Art Directors: Steve Couture, Dan Weeks | Chief Creative Officers: Rob Bagot, John McNeil | Creative Director: Gerald Lewis | Executive Creative Directors: Rob Bagot, John McNeil | Photographer: Kristophe Morlinghaus | Writers: Kurtis Glade, Mark Krajan, Carl Loeb | Client: Microsoft

Corporate

70, 71 Thumb Print, Mountain, Table | Design Firm: OLSON, Minneapolis | Account Director: Laura Van Bellinger | Art Director: Kelly Gothier | Chief Creative Officer: Tom Fugleberg | Creative Director: Brian Kroening | Print Producer: Irene Lockwood | Project Manager: Gina Lorenz | Writer: Joel Anderson | Client: Opus

72 Untitled | Design Firm: McCann, Oslo | Art Director: Espen Lie Andersen | Copywriter: Bjornar Olsen | Client: Statoil

Top: The Norwegian oil adventure continues in Russia. Six service stations in Murmansk are currently the most visible signs of our activities in Russia, but there are more. Our work in Russia to exploit the oil and gas resources in the North is well underway…
Bottom: The Norwegian oil adventure continues in the USA. For many years, Manhattan's taxi drivers have been pumping Norwegian petrol into their yellow Dodges and Chevrolets…And shortly, tankers will be delivering liquefied natural gas from the Snohvit field to the Cove Point terminal at Washington, D.C. …

73 Izzy Does Advertising Campaign | Design Firm: BBK Studio, Grand Rapids | Creative Directors: Kevin Budelmann, Yang Kim | Designer: Michele Chartier | Writer: Kristin Tennant | Art Director: Yang Kim | Client: Izzy Design

74 Restaurant | Design Firm: HSR Business to Business, Cincinnati | Account Director: Doug Reiter | Art Directors: Gene Dow, John Pattison | Chief Creative Officer: Tom Rentschler | Creative Director: John Pattison | Photographer: Hunter Freeman | Writer: Laura Black | Client: Hobart

75 Brand Campaign | Design Firm: HSR Business to Business, Cincinnati | Account Director: Angie Fischer | Art Director: Terry Jent | Chief Creative Officer: Tom Rentschler | Creative Director: John Pattison | Writer: Bill Weinstein | Client: INTEQ

CreditCards

76 All you need | Design Firm: Grey London | Art Director: Matt Turrell | Copywriter: Alex Fraser | Photographer: Kelvin Murray | Client: Visa

Campaign for Visa, official sponsor of the Winter Olympics 2006 in Torino

77 Religion | Design Firm: Lopez Negrete Communications, Houston | Account Director: Victoria Lopez Negrete | Art Director: Guy Kirkland | Chief Creative Officer: Alex Lopez Negrete | Creative Directors:Luis Gonzales, Manuel Villegas | Print Producer: Ralph Candelario | Writer: Luis Gonzales | Client: Visa U.S.A.

Delivery

78 CCT Express Mail now with night deliveries | Design Firm: GreyHome, Lisbon | Art Director: Tico Moraes | Copywriter: Luisa Carvalho | Photographer: Getty Images | Illustrator: Tico Moraes | Client: CTT Express Mail

79 Osama Bin Laden | Design Firm: w brandconnection, Seoul | Art Directors: Jinho Choi, Taehong Min | Photographer: Base Factory Studio | Writer: Yoonjoo Hong | Creative Directors: Jinho Choi, Taehong Min | Creative Strategist: Myeongsuk Lee | Designer: Cham Wie | Client: Fedex

Education

80, 81 Redefine Smart | Design Firm: BVK, Milwaukee | Art Director: Brent Goral | Creative Director: Gary Mueller | Photographer: Brian Malloy | Writers: Jeff Ericksen, Gary Mueller | Client: Milwaukee Area Technical College

82, 83 Astronaut, Judge, Doctor | Design Firm: OLSON, Minneapolis | Account Director: Jennifer Bastian | Art Director: Andrea Carter | Chief Creative Officer: Tom Fugleberg | Creative Director: Brian Kroening | Photographer: Eric Almas | Print Producers: Joel Dodson, Irene Lockwood | Writer: Scott Dahl | Project Manager: Gina Lorenz | Client: Sallie Mae

Events

84 Country Music Marathon | Design Firm: WestWayne, Tampa | Art Director: Javier Quintana | Chief Creative Officer: Scott Sheinberg | Creative Director: Tom McMahon | Writer: Molly Molina | Client: Publix Super Markets

Publix Super Markets is a sponsor of the Nashville, TN-area Country Music marathon and half-marathon. This ad ran in the event's program as a way to publicize their support.

85 Campaign for The Gina Bachauer International Piano Competition | Design Firm: Richter7, Salt Lake City | Art Director: Ryan Anderson | Copywriter: Gary Sume | Photographer: Tyler Gourley | Client: The Gina Bachauer International Piano Competition

86, 87 Nina Advertising Campaign | Design Firm: 160over90, Philadelphia | Client: Nina Shoes

Fashion

88 Huge Capacity | Design Firm: w brandconnection, Seoul | Art Directors: Jinho Choi, Taehong Min | Creative Strategist: Myeongsuk Lee | Creative Directors: Jinho Choi, Taehong Min | Designer: Cham Wie | Writer: Hyunguem Kim | Photographer: Base Factory Studio | Client: Wonderbra

89, 90 This is the Only Copy | Design Firm: GSD&M, Austin | Account Director: Jerry Bodrie | Art Directors: Wes Whitener, Jonathan Williams | Photographer: Wes Whitener | Writer: Mitch Bennett | Client: Time After Time

91 Iggy Pop | Design Firm: YARD, New York | Art Director: Stephen Niedzwiecki | Creative Director: Stephen Niedzwiecki | Photographer: Danny Clinch | Print Producer: Jennifer Carter-Campbell | Client: John Varvatos

We wanted a campaign that was authentic, with imagery that married the worlds of music and fashion in a striking, new way—expressing this union differently than fashion brands had attempted in the past. To achieve this, we commissioned Danny Clinch—a Photographer primarily known for documenting rock & roll history—to shoot a fashion story with rock legend Iggy Pop. The resulting campaign of iconic images captures a precise moment in time in music and fashion, and continues to receive acclaim.

92 Hello Cleveland | Design Firm: Butler, Shine, Stern & Partners, Sausalito | Account Director: John Sheehan | Art Director: Peter Vattanatham | Creative Directors: John Butler, Mike Shine | Executive Creative Directors: John Butler, Mike Shine | Writer: Tom Coates, ACD | Client: Converse, Inc.

93 First School Bosh, First School Hinrich, First School Nelson, First School Sweetney | Design Firm: Butler, Shine, Stern & Partners, Sausalito | Account Director: John Sheehan | Art Director: Peter Vattanatham | Creative Directors: John Butler, Mike Shine | Executive Creative Directors: John Butler, Mike Shine | Writer: Tom Coates, ACD | Client: Converse, Inc.

Film

94, 95 Welcome to Rome | Design Firm: Venables, Bell & Partners, San Francisco | Account Director: Colleen McGee | Art Director: Erich Pfeifer | Creative Directors: Greg Bell, Paul Venables | Photographer: David Emmite | Print Producer: David Russ | Writer: Quentin Shuldiner | Client: HBO Video, Rome Season 1

96 Sideways Centerfold | Design Firm: Venables, Bell & Partners, San Francisco | Account Director: Colleen McGee | Art Director: Ben Ballyuto | Creative Directors: Greg Bell, Paul Venables | Print Producer: David Russ | Writer: Mary Hernandez | Creative Strategist: Keri O'Brien | Client: HBO Video, The Notorious Bettie Page

97 Shank | Design Firm: Venables, Bell & Partners, San Francisco | Account Director: Colleen McGee | Art Director: Ray Andrade | Creative Directors: Greg Bell, Paul Venables | Photographer: David Emmite | Print Producer: Katie Borzcik | Writer: James Robinson | Client: HBO Video, OZ Season 6

FinancialServices

98 Light bulb(top), Storybook (bottom) | Design Firm: The Halo Group, New York | Client: Guy Carpenter & Company, LLC

99 Accept No Substitute | Design Firm: Flow Creative, Chicago | Art Directors: Jeff Clift, Aaron Potter | Chief Creative Officer: Peter Zapf | Creative Directors: Jeff Clift, Peter Zapf | Creative Strategist: Peter Zapf | Design Director: Jeff Clift | Designer: Jeff Clift | Executive Creative Strategists: Leonard Rau, Peter Zapf | Makeup: Reyna Pecot / Ennis Inc | Photographer: Vincent Dixon | Photographer's Assistants: John Bennett Fitts, Joey Bernheimer, Amy Gayeski | Print Producer: David Safian / Brite Productions | Set Designer & Props: Jonny R. Long | Stylist: Christina Kretschmer / Ennis Inc. | Writers: Susan Tang, Peter Zapf | Client: Chicago Board Options Exchange | Location: Chicago, IL

2007 CBOE Branding Campaign. To raise awareness of the CBOE within the financial marketplace, while positioning specific leadership attributed.

Food

100 Mint Chocolate | Design Firm: Goodby, Silverstein & Partners, San Francisco | Account Director:Kate Jenkins | Art Director: Margaret Johnson | Creative Directors: Jeffrey Goodby, Rich Silverstein | Photographers: Raymond Meier, Peter Pioppo | Print Producer: Jenny Taich | Writer: Mike McKay | Client: Haagen Dazs

100, 101 Ingredients | Design Firm: Goodby, Silverstein & Partners, San Francisco | Account Director: Kate Jenkins | Art Director: Margaret Johnson | Creative Directors: Jeffrey Goodby, Rich Silverstein | Photographers: Raymond Meier, Peter Pioppo | Print Producer: Jenny Taich | Writer: Mike McKay | Client: Häagen-Dazs

102 Sacks (top), Inflatables (bottom) | Design Firm: Publicis Mid America, Dallas | Art Director: Pete Voehringer | Creative Director: Pete Voehringer | Photographer: Scott Harben | Print Producer: Brad Robinson | Writer: Greg Szmurlo | Client: Nestle PowerBar

103 Careful, it's big. | Design Firm: MacLaren McCann, Toronto | Account Director: Ryan Timms | Art Director: Ken Morgan | Chief Creative Officer: Ian Mirlin | Creative Directors: Andy Manson, Kerry Reynolds | Photographer: Andrej Kopac | Print Producer: Ken Kukay | Writer: Tim Thompson | Client: Cadbury Adams

For the predominantly male teen target, one of the most important attributes of a candy bar is its gut-fill factor. So, the intention of this campaign is to remind the consumer about Mr. Big's most notable attribute: its sheer size. Through the use of humor and hyperbole, we show that we have to be cautious when we take on such a big bar. This campaign ran in bus shelters.

104 Untitled (top) | Design Firm: DDB, Copenhagen | Art Directors: Tim Ustrup Madsen, Mikkel Moller | Photographer: Mikkel Moller, Tim Ustrup Madsen | Illustrator: Morten Hagstrom | Client: McDonald's

104 Ransom Note 1, Ransom Note 2 (botom) | Design Firm: Momentum Seven, Dubai | Account Director: Rahul Padukone | Art Directors: Brendan Reid, Ivona Sutila | Designer: Ivona Sutila | Photographer: Latif | Writers: Brendan Reid, Ivona Sutila | Client: Heinz Africa & Middle East

Brief: Communicate with adults who like Ketchup but feel a little childish eating it. To allay their fears, we chose more mature but extreme situations where the individual has gone to extraordinary lengths to get a bottle of Heinz Tomato Ketchup.As this target group is already familiar with the product, we didn't think it necessary to show the product with food. Instead, the focus

Credits

was on how people feel when they don't have it. With 'ransom note,' we've shown that Heinz Tomato Ketchup will go with whatever one wants to eat and demonstrated the feeling that, without it, the meal will be ruined.

105 Jail Break | Design Firm: Hoffman York, Inc., Milwaukee | Art Director: Ken Butts | Artist: Ingo Fast | Chief Creative Officer: Tom Jordan | Creative Director: Tom Jordan | Print Producer: Robin Finco | Client: Egg Innovations

106 Soccer | Design Firm: Percept H Pvt. Ltd, Mumbai | Art Director: Manish Ajgaonkar | Creative Director: Anil Kakar | Photographer: Amit Thakur | Writer: Anil Kakar | Client: Ghetto Bar n Grill

To announce the screening of football matches at the Ghetto Bar

107 Torture | Design Firm: Percept H Pvt. Ltd, Mumbai | Art Director: Manish Ajgaonkar | Creative Director: Anil Kakar | Photographer: Raj Mistry | Writer: Anil Kakar | Client: Weikfield Products Co India Pvt Ltd

To portray Peprico as the hottest available sauce

Furniture
108, 109 Platinum So You | Design Firm: The Richards Group, Dallas | Art Director: Naomi Cook | Creative Directors: Jeff Hopfer, Mike Renfro | Photographer: Stan Musilek | Print Producer: Brenda Talavera | Writer: Bennett Holloway | Client: Thomasville

Please see Case Studies at front for more information on this award winning ad.

109 Platinum The Cinnamon Hill Panel Bed | Design Firm: The Richards Group, Dallas | Art Director: Naomi Cook | Creative Directors: Jeff Hopfer, Mike Renfro | Photographer: Stan Musilek | Print Producer: Brenda Talavera | Writer: Bennett Holloway | Client: Thomasville

Please see Case Studies at front for more information on this award winning ad.

110, 111 Cumberland Brand Advertising Campaign | Design Firm: BBK Studio, Grand Rapids | Art Director: Kevin Budelmann | Designers: Tim Calkins, Brian Hauch | Photographer: Chuck Shotwell | Print Producer: Various | Client: Cumberland Furniture

Cumberland, a contract furniture manufacturer founded in the 1950s, wanted to raise awareness of their reinvented company and modern American, classics-inspired furniture. The furniture was photographed in unique environments, elevating it to the level of art that asks for interpretation. The series of 5 ads ran for 18 months in Metropolis and other contract furniture magazines. The campaign uses Cumberland's products in symbolic settings that visually interpret the company's brand attributes. The abstract, aspirational quality of the Photography invites the reader to participate in the ad. The smoky, warm feel of the Photography gives a sense of history, while the unique settings give the furniture a modern, contemporary twist. The campaign has significantly increased awareness of the brand among Designers and consumers.

Healthcare
112 Another day. Another breakthrough. | Design Firm: DeVito/Verdi, New York | Art Directors: Jamie Kleiman, Zack Menna, Manny Santos | Creative Director: Sal DeVito | Writers: John DeVito, Bonnie Pihl, Rich Singer | Client: Mount Sinai Medical Center

112 Finish Line (bottom right) | Design Firm: DeVito / Verdi, New York | Art Director: Manny Santos | Creative Director: Sal DeVito | Writer: John DeVito | Client: Mount Sinai Medical Center

This ad was placed in bus shelters along the route of the New York City Marathon route.

113 Paging CPA Reynolds (top) | Deisgn Firm: Kohnke Hanneken, Milwaukee | Account Director: Denise Kohnke | Art Directors: Dave Hanneken, Rich Kohnke | Artist: Jim McDonald | Author: Dave Hanneken | Chief Creative Officers: Dave Hanneken, Rich Kohnke | Creative Directors: Dave Hanneken, Rich Kohnke | Creative Strategist: Sue Hoeft | Executive Creative Directors: Dave Hanneken, Rich Kohnke | Photographers: Jim McDonald, Stock | Print Producer: Kevin Gardner | Writer: Dave Hanneken | Client: Global Healthcare Exchange

Because healthcare costs are rising so fast, hospitals and hospital systems are beginning to feel the pinch. It's almost as if the hospitals are getting sick. Global Healthcare Exchange is positioned as an organization that can help. As an online resource, hospitals and hospital systems can procure everything from tongue depressors to MRIs for significantly less cost.

113 Is there a CFO in the house? (bottom) | Design Firm: Kohnke Hanneken, Milwaukee | Account Director: Denise Kohnke | Art Director: Rich Kohnke | Artist: Jim McDonald | Author: Dave Hanneken | Chief Creative Officers: Dave Hanneken, Rich Kohnke | Creative Directors: Dave Hanneken, Rich Kohnke | Creative Strategist: Sue Hoeft | Illustrator: Jim McDonald | Photographers: Jim McDonald, Stock | Print Producer: Kevin Gardner | Writer: Dave Hanneken | Client: Global Healthcare Exchange

Because healthcare costs are rising so fast, hospitals and hospital systems are beginning to feel the pinch. It's almost as if the hospitals are getting sick. Global Healthcare Exchange is positioned as an organization that can help. As an online resource, hospitals and hospital systems can procure everything from tongue depressors to MRIs for significantly less cost.

114, 115 UTSW "I Am" print campaign | Design Firm: Lewis Communications, Birmingham | Account Director: Carlton Wood | Art Director: Ryan Gernenz | Creative Director: Stephen Curry | Photographer: Olaf Veltman | Print Producers: Benjamin Fine, Leigh Ann Motley | Writer: Stephen Curry | Chief Creative Officer: Spencer Till | Client: UT Southwestern Medical Center

116 Hearts | Design Firm: Hoffman York, Inc., Milwaukee | Art Director: Tony Bonilla | Writer: Eric Oken | Client: Advocate Health Care

117 Could Be A Big Deal | Design Firm: BVK, Milwaukee | Art Directors: Ben Gray, Scott Krahn | Creative Director: Gary Mueller | Writer: Gary Mueller | Photographer: Dave Gilo | Client: LifeBridge Health

Hotel
118 More Is More | Design Firm: On Target Advertising, Los Angeles | Art Director: Benjamin Nicolas | Creative Director: Pam Patterson | Client: Preferred Hotels & Resorts

Ad for Preferred's Suite Life program of bookings packages. Goal: to stand apart from high-end targets with unique visuals and black background.

119 Grow More Beautiful | Design Firm: On Target Advertising, Los Angeles | Art Director: Benjamin Nicolas | Creative Director: Pam Patterson | Client: Preferred Hotels & Resorts

An ad for Preferred's Spa program that offers an amenity gift package for bookings. Our goal is to stand apart from high-end targets with unique "spa" visuals, a thought provoking headline and black background.

120 Austin Hyatt Regency Ad Campaign | Design Firm: Redux Pictures, New York | Art Director: Rob Story | Photographer: Brent Humphreys | Client: Austin Hyatt Regency

Brent Humphreys won a 2007 Gold Addy for his Hyatt Regency, local Austin Ad campaign with Ad Agency McGarrah/Jessee Inc.

Motocycles
121 Ad for the Suzuki Boulevard M109R motorcycle | Design Firm: Leo Burnett, Melbourne | Art Director: Richard Walker | Copywriter: Andrew Woodhead | Photographer: Untold Images | Client: Suzuki

Museums
122 The Subic Bay Bar Poster | Design Firm: Lewis Communications, Birmingham | Account Director: Ellen Wingard | Art Director: Spencer Till | Creative Director: Stephen Curry | Chief Creative Officer: Spencer Till | Writer: Stephen Curry | Client: The National Museum of Naval Aviation

123 The National Museum of Naval Aviation Poster Campaign | Design Firm: Lewis Communications, Birmingham | Art Director: Carter Lewis | Creative Director: Stephen Curry | Account Director: Ellen Wingard | Chief Creative Officer: Spencer Till | Writer: Chris Miller | Client: The National Museum of Naval Aviation

124, 125 Cooper-Hewitt Promotions | Design Firm: Target, Minneapolis | Art Director: Jason Miller | Chief Creative Officer: Minda Gralnek | Creative Directors: Ron Anderson, Connie Soteropulos | Designer: Jason Miller | Print Producer: Melissa Rothman | Writer: Susan George | Client: Cooper-Hewitt

Target partnered with the Cooper-Hewitt National Design Museum to increase national awareness of the museum, its website, and National Design Week. We asked the question, "What is Design?" and invited participants to nominate their favorite designed products. What followed was a true celebration of Design, encompassing everything from Tupperware to the paper clip. As for the Cooper-Hewitt, it experienced a remarkable 240% increase in museum visits and a 34% increase in website hits.

126 Whistle (left), Memory Lane (right) | Design Firm: The Richards Group, Dallas | Art Director: Jimmy Bonner | Creative Directors: Rob Baker, Jimmy Bonner | Writer: Rob Baker | Client: Railroad Museum

127 Brand Image Campaign | Design Firm: Hoffman York, Inc., Milwaukee | Account Director: Grant Bernstein | Chief Creative Officer: Tom Jordan | Illustrator: Grant Bernstein | Writer: Eric Oken | Client: Mitchell Gallery of Flight

128, 129 Creative Kid's Museum | Design Firm: TAXI Canada Inc, Toronto | Account Director: Karen Pearce | Art Director: Troy McGuinness | Chief Creative Officer: Zak Mroueh | Illustrator: Nabil Elsaadi | Photographers: Richard Heyfron, Chal Styles | Print Producer: Bill Mascall | Writer: Jordan Doucette | Client: Creative Kid's Museum

Music
130 VINYL RECORD BUSINESS CARD | Design Firm: KNARF, New York | Art Director: Frank Anselmo | Creative Director: Frank Anselmo | Designer: Frank Anselmo | Client: DJ Luke LoCastro

Pharmaceutical
131 Corn | Design Firm: Saatchi & Saatchi New York, New York | Art Director: Michael Vaughan | Chief Creative Officer: Tony Granger | Creative Director: Alison Gragnano | Digital Artist: Aaron Padin | Photographer: Ed Rysinski | Writer: Neil Levin | Client: Procter & Gamble/Fixodent

132 Platinum VIAh~Ah~Ah~ | Design Firm: w brandconnection, Seoul | Art Directors: Jinho Choi, Taehong Min | Photographer: Base Factory Studio | Writer: Yoonjoo Hong | Creative Directors: Jinho Choi, Taehong Min | Creative Strategist: Myeongsuk Lee | Designer: Cham Wie | Client: VIAGRA

133 Candy Cane | Design Firm: Saatchi & Saatchi New York, New York | Art Director: Michael Vaughan | Chief Creative Officer: Tony Granger | Creative Director: Alison Gragnano | Digital Artist: Aaron Padin | Photographer: Ed Rysinski | Writer: Neil Levin | Client: Procter & Gamble/Fixodent

Products
134, 135 Bottles | Design Firm: Saatchi & Saatchi New York, New York | Art Director: Mark Voehringer | Chief Creative Officer: Tony Granger | Creative Directors: Jan Jacobs, Leo Premutico | Designer: Kevin Li | Digital Artists: Yan Apostolides, Aaron Padin | Writer: Jake Benjamin | Client: Procter & Gamble/Tide Coldwater

136 Candystore (left), Dachsund (right) | Design Firm: GSD&M, Austin | Account Director: Lilian Ojeda | Art Director: Lynn Sarnow Born | Creative Director: David Crawford | Photographer: Erwin Olaf | Print Producer: Kelly Grant | Project Manager: Sara Rosales | Writer: Carole Hurst | Client: Kohler

137 Pig Tails | Design Firm: GSD&M, Austin | Account Director: Lilian Ojeda | Art Director: Rob Story | Creative Director: David Crawford | Photographer: Erwin Olaf | Print Producer: Kelly Grant | Project Manager: Sara Rosales | Writer: David Parson | Client: Kohler

138 Dimmer | Design Firm: Fitzgerald+CO, Atlanta | Art Director: Brian Locascio | Chief Creative Officer: Eddie Snyder | Photographer: Greg Slater | Writer: Kevin Rhodes | Client: C-Lighting

139 Beija-flor (Humming Bird) Print Ad | Design Firm: Giovanni+Draftfcb | Art Directors: Fernando Barcellos, Sergio Lobo | Creative Directors: Cristina Amorim, Fernando Barcellos, Adilson Xavier | Writer: Aline Arantes | Photographer: Studio H | Client: S.C. Johnson

140 Zippo. Windproof. | Design Firm: McCann Erickson, Singapore | Art Director: Ivan Hady Wibowo | Copywriter: Craig Rosenthal | Photographer: Jean Leprini | Client: Zippo | Campaign for Zippo brand lighters.

141 Pelon | Design Firm: Young and Rubicam, Mexico, D.F. | Art Director: Edgar Rodriguez | Chief Creative Officer: Carl Jones | Creative Directors: Aaron Alamo, Adrian Brizuela, Carl Jones | Photographer: Gonzalo Morales | Writers: Pavel Munoz, Ramiro Plascencia | Client: Berol /Sharpie

142 Couch | Design Firm: LKM | Account Director: Cory Hughes | Art Director: Shawn Perritt | Creative Director: Jim Mountjoy | Photographer: Jim Arndt | Print Producer: Sarah Peter | Writer: Lee Remias | Client: Cargill BiOH

143 Old Man, I like to buff, Lonely woman | Design Firm: OLSON, Minneapolis | Account Director: Nicole Nye | Art Director: Gabe Gathmann | Chief Creative Officer: Tom Fugleberg | Creative Director: Chris Henderson | Print Producer: Irene Lockwood | Writer: Eric Luoma | Project Manager: Christine Toy | Client: Formica

144 Fan of Flowers | Design Firm: Bates Enterprise, New Delhi | Art Director: Prasanth G | Creative Directors: Radharani Mitra, Ravi Narain | Designer: Prasanth G | Illustrators: Prasanth G, Amit Goyal | Writer: Pradeep Daniel | Client: USHA Fans

145 Soil that works wonders | Design Firm: Clara, Karlstad | Account Director: Clara | Art Director: Clara | Creative Director: Clara | Photographer: Lipkin | Writer: Clara | Client: Hasselfors Garden | Gardening Products. Soil

146 Lynx Opaque - The Mark Ad Series | Design Firm: Sibley/Peteet Design, Dallas | Account Director: Dailey & Associates | Art Director: Don Sibley | Creative Director: Don Sibley | Designer: Brandon Kirk | Illustrator: Brandon Kirk | Print Producer: Neil Prehmus | Writer: Don Sibley | Client: Domtar

146 Garage (bottom right) | Design Firm: Howard, Merrell & Partners, Raleigh | Account Director: Lisa Powell | Art Director: Joe Ivey | Creative Director: Billy Barnes | Photographer: George Simhoni | Print Producer: Sharon Fred | Writer: Billy Barnes | Client: Central Garden & Pet/R-Zilla

R-Zilla, a maker of premium reptile products, needed a brand campaign targeted to people who own reptiles as pets. We needed to create interest and build awareness. So, playing off the idea of "where reptiles rule," we turned the pet/owner world on its head by reversing the situation and putting the reptiles in charge. Using original Photography, we created the types of scenes that our edgy audience would appreciate. Ads are running in national consumer and trade magazines in the U.S.

147 Living Room | Design Firm: Howard, Merrell & Partners, Raleigh | Account Director: Lisa Powell | Art Director: Joe Ivey | Creative Director: Billy Barnes | Photographer: George Simhoni | Print Producer: Sharon Fred | Writer: Billy Barnes | Client: Central Garden & Pet/R-Zilla

R-Zilla, a maker of premium reptile products, needed a brand campaign targeted to people who own reptiles as pets. We needed to create interest and build awareness. So, playing off the idea of "where reptiles rule," we turned the pet/owner world on its head by reversing the situation and putting the reptiles in charge. Using original Photography, we created the types of scenes that our edgy audience would appreciate. Ads ran in national consumer and trade magazines in the U.S.

148, 149 Kasson Pool Tables Print Series | Design Firm: Fairly Painless Advertising, HOLLAND | Art Director: Kate Trogan | Creative Director: Peter Bell | Photographer: Greg Vandenburg | Client: Kasson Pool Tables

150 What Goes Up (left) | Design Firm: Draftfcb Seattle, Seattle | Account Director: Rip Warendorf | Art Director: Sue Boivin | Chief Creative Officer: Mary Knight | Photographer: R.J. Muna | Print Producer: Mark Jahnke | Writer: Mary Knight | Client: Nautilus, Inc.

150 Newton (right) | Design Firm: Draftfcb Seattle, Seattle | Account Director: Rip Warendorf | Art Director: Sue Boivin | Chief Creative Officer: Mary Knight | Photographer: R.J. Muna | Print Producer: Mark Jahnke | Writer: Dustin Taylor | Client: Nautilus, Inc.

151 Bikini | Design Firm: Draftfcb Seattle, Seattle | Account Director: Rip Warendorf | Art Director: Sue Boivin | Chief Creative Officer: Mary Knight | Photographer: R.J. Muna | Print Producer: Mark Jahnke | Writer: Anne Webster | Client: Nautilus, Inc.

152, 153 Campaign for Ferrino brand sleeping bags | Design Firm: Ogilvy, Guatemala City | Art Directors: Jonathan Bell, Fernando Mira | Copywriter: Jonathan Bell | Client: Ferrino

ProfessionalServices

154 Stroud & Harper Banana Peel Injury Law | Design Firm: Tactical Magic, Memphis | Art Director: Sloan Cooper | Creative Director: Trace Hallowell | Designer: Ben Johnson | Photographer: Woody Woodliff | Client: Stroud & Harper | Billboard for Legal Services.

155, 156 Womble Ad Campaign | Design Firm: Greenfield/Belser Ltd., Washington | Account Director: Erika Ritzer | Art Director: Burkey Belser | Creative Director: Burkey Belser | Designer: Burkey Belser | Illustrators: Jaime Chirinos, Marc Dole from Hatchling | Writer: Burkey Belser | Client: Womble Carlyle

Early research showed that Womble Carlyle's name recognition among buyers of legal services was not much higher than any other North Carolina firm, even though many of its competitors were substantially smaller or younger firms. Womble Carlyle embarked on an aggressive marketing campaign to boost its visibility and become a southeast regional powerhouse.

157 Jungle, Inc. | Design Firm: Cramer-Krasselt, Chicago | Account Director: Louis Slotkin | Art Director: Matt Spett | Chief Creative Officer: Marshall Ross | Creative Director: Pat Hanna | Designer: Matt Webb | Executive Creative Director: Dean Hacohen | Illustrator: Steve Hamann | Photographer: Leonard Gertz | Print Producer: Sharon Trager | Writer: Rick Hamann | Client: Careerbuilder.com | Location: Chicago

158, 159 Add Color | Design Firm: The Richards Group, Dallas | Art Director: Kiran Koshy | Creative Director: Jim Baldwin | Writer: Kiran Koshy | Client: Kam Naidoo-Immigration Law

PublicService

160 Platinum Knees | Design Firm: LKM, Charlotte | Art Director: Jim Mountjoy | Creative Director: Jim Mountjoy | Print Producer: Sarah Peter | Writer: Ed Jones | Client: Catholic Radio

Please see Case Studies at front for more information on this award winning ad.

161 Platinum Radio Tower | Design Firm: LKM, Charlotte | Art Director: Jim Mountjoy | Creative Director: Jim Mountjoy | Print Producer: Sarah Peter | Writer: Ed Jones | Client: Catholic Radio

Please see Case Studies at front for more information on this award winning ad.

162, 163 Family | Design Firm: JWT Brazil | Art Director: Silvio Medeiros | Creative Directors: Ricardo Chester, Roberto Fernandez | Writer: Thiago Carvalho | Client: Fundação SOS Mata Atlântica

164 Use Only What You Need | Design Firm: Sukle Advertising & Design, Denver | Account Director: Molly Mueller | Art Directors: Andy Dutlinger, Jamie Panzarella | Creative Director: Mike Sukle | Print Producer: Gail Barker | Writer: Jim Glynn | Client: Denver Water

Campaign to promote water conservation

165 Ball Frog, Detergent Mallard, Radial Turtle | Design Firm: Goodby, Silverstein & Partners, San Francisco | Account Director: Rene Cournoyer | Art Director: Paul Foulkes | Chief Creative Officers: Jeffrey Goodby, Rich Silverstein | Creative Directors: Paul Foulkes, Tyler Hampton | Photographers: Claude Shade, stock | Print Producer: Michael Stock | Writer: Tyler Hampton | Client: California Coastal Commission

166 Lipstick/Hook Up/Hallucinations | Design Firm: Venables, Bell & Partners, San Francisco | Account Director: Megan Redford | Art Director: Tavia Holmes | Photographer: David Stewart | Print Producer: Alisa Latvala | Writer: Eric Liebhauser | Creative Directors: Greg Bell, Paul Venables | Creative Strategist: Liz Geddes | Client: The Montana Meth Project

167 Hammer(top), Spray Can (bottom) | Design Firm: Draftfcb Seattle, Seattle | Account Directors: Mark Hall, Jacci Johnson | Art Director: Brad Dundas | Chief Creative Officer: Mary Knight | Creative Director: Steve Rudasics | Photographer: Olugbenro Ogunsemore | Print Producer: Mark Jahnke | Writer: John Zilly | Client: Seattle HIV Vaccine Trials Unit

168 Seeing Isn't Believing | Design Firm: Bernstein-Rein, Kansas City | Art Director: David Thornhill | Chief Creative Officer: Arlo Oviatt | Creative Director: Bob Morrow | Writer: Eric Knittel | Client: Children's Center for the Visually Impaired

We wanted parents and donors to understand that CCVI helps children live a more normal life.

169 Worthy Cause | Design Firm: Bailey Lauerman, Lincoln | Account Director: Tim Geisert | Art Director: Randell Myers | Creative Director: Carter Weitz | Designer: Joe McDermott | Illustrator: Joe McDermott | Photographers: Gary Brown, Bob Ervin | Print Producer: Brian Robinson | Writer: Neveen Hegab | Client: Neediest Kids

This campaign needed to convince readers to donate money to a worthy cause. The hurdle was distinguishing this organization from all of the others that ask the same readers to do that exact thing. Under the guise of high-end fashion ads and a school bus poster, we were able to deliver our message in a thought-provoking way.

170 "Bump" Poster | Design Firm: Borders Perrin Norrander, Portland | Art Director: Jeremy Boland | Creative Director: Terry Schneider | Designer: Eric Stevens | Photographer: Michael Jones | Print Producer: Bev. Petty | Writer: Eric Terchila | Client: Planned Parenthood

171 Second Hand Smoke Kills | Design Firm: Sukle Advertising & Design, Denver | Account Director: Amy Stroh | Art Director: KC Koch | Creative Director: Mike Sukle | Illustrator: Matt Carpenter | Photographer: Gary Land | Print Producer: Gail Barker | Writer: Jim Glynn | Client: Wyoming Department of Health

172 Fist/Face | Design Firm: BVK, Milwaukee | Art Director: Brent Goral | Creative Director: Gary Mueller | Photographer: Jeff Salzer | Writer: Ross Lowinske | Client: Family Violence Partnership

173 Welcome to Teen Pregnancy | Design Firm: BVK, Milwaukee | Art Director: Giho Lee | Creative Director: Gary Mueller | Writers: Mike Holicek, Gary Mueller | Client: United Way of Greater Milwaukee

174, 175 Harassment | Design Firm | Fitzgerald+CO, Atlanta | Art Director: Phyllis Greene | Writer: Duncan Stone | Client: National Organization of Women [NOW]

176 30 Reasons | Design Firm: BVK, Milwaukee | Art Director: Brent Goral | Creative Director: Gary Mueller | Photographer: Brent Goral | Writer: Ross Lowinske | Client: Family Violence Partnership

177 Beyond Homelessness Newspaper | Design Firm: Borders Perrin Norrander, Portland | Art Directors: Jeremy Boland, Ben Carter | Creative Director: Terry Schneider | Photographer: David Emmite | Print Producer: Bev Petty | Writers: Jeremy Boland, Ben Carter | Client: p:ear

178 Walt Whitman (top left) | Design Firm: GSD&M, Austin | Account Director: Stacey Schwab | Art Director: Rob McKinnie | Creative Directors: David Crawford, David Parson | Designer: Blue Hopkins | Print Producer: Nancy Kirsch | Project Manager: DeeDee Jonas | Writer: Sarah Lassiter | Client: American For The Arts

178 Homer (top right) | Design Firm: GSD&M, Austin | Account Director: Stacey Schwab | Art Director: Rob McKinnie | Creative Directors: David Crawford, David Parson | Print Producer: Nancy Kirsch | Project Manager: DeeDee Jonas | Writer: Sarah Lassiter | Client: American For The Arts

178 Virginia Woolf (bottom left) | Design Firm: GSD&M, Austin | Account Director: Stacey Schwab | Art Director: Rob McKinnie | Creative Directors: David Crawford, David Parson | Print Producer: Nancy Kirsch | Project Manager: DeeDee Jonas | Writer: Sarah Lassiter | Client: American For The Arts

178 Duke Ellington (bottom right) | Design Firm: GSD&M, Austin | Account Director: Stacey Schwab | Art Director: Rob McKinnie | Creative Directors: David Crawford, David Parson | Designer: Tom Kirsch | Print Producer: Nancy Kirsch | Project Manager: DeeDee Jonas | Writer: David Parson | Client: American For The Arts

179 Pay Attention | Design Firm: WestWayne, Atlanta | Account Directors: Anne Muller, Will Thomason | Art Director: Matt Heck | Chief Creative Officer: Scott Sheinberg | Creative Directors: Dave Damman, Bobby Pearce | Designer: Kirstin Streiff | Photographers: Arington Hendley, Bill Lisenby | Print Producers: Jodi Godwin, Donna Smith | Writer: Jackie Lee | Client: Ad Council

180 Platter | Design Firm: Percept H Pvt. Ltd, Mumbai | Account Director: Mohit Totlani | Art Director: Anvi Parikh | Creative Director: Anil Kakar | Photographer: Shekhawat | Stylist: Rahul Tushar | Writer: Anil Kakar | Client: The Vegetarian Society

Objective: To portray The Vegetarian Society as an environmentally conscious non-profit organization.

181 Illegal logging kills more than just trees | Design Firm: Young & Rubicam, Singapore | Art Director: Eddie Wong Yew Heng | Copywriter: Nirmal Pulickal | Illustration: Evan | Photography: Sebastian Siah, Corbis | Client: Animal Concerns Research & Education Society

Campaign for the Animal Concerns Research & Education Society

Publishing

182 Murder Books: Tape, Cut and Gloves | Design Firm: The Richards Group, Dallas | Art Director: Kiran Koshy | Creative Director: Jim Baldwin | Photographer: Tom Hussey | Writer: Ed Johnson | Client: Murder By The Book

Established in 1980 by Martha Farrington, Murder By The Book is one of the nation's oldest&largest mystery specialty bookstores. Located in Houston, Texas, the store stocks over 25,000 books—new and used, hardbacks and paperbacks, first editions, collectibles, gift items, mystery magazines and more. They host dozens of the hottest mystery and crime authors for book signing events every year. Murder By the Book is the proud recipient of Mystery Writers of America's Raven Award and Houston Press's Best Bookstore 2006. *What was the problem?*

Book readership, in general, has been on the decline due to various factors, including the Internet and TV. Murder By The Book needed to build awareness and grow its customer base in Houston and surrounding areas. The mystery and crime genre has seen a surge of interest and viewership on TV, through serials such as CSI, Law & Order, Medium, and Court TV - an entire channel dedicated to crime and investigation. Murder By The Book wanted to tap into this surge of interest and attract more readers to the mystery and crime genre. So the time seemed right for a campaign that addressed this task. *What was your solution?*

We hoped to make mystery and crime books appealing by portraying them as intense experiences your imagination could delve into. We leveraged the store as the place you'd go to for such books - the ones you'd immerse yourself in, and at times lose yourself in by reliving and reacting to the pages you read. *How did this project evolve from a concept into a finished project?*

The first ad, with crime tape, was the insight into blending the two worlds (books and crime) in the reader's mind, which set the campaign tone. Our imagery stayed true to the dark and murky world that is crime and mystery. The Photographer, Tom Hussey, did a great job composing the images appropriately and creating a mood for the campaign, which stayed true to the idea.

Credits

The images required almost no retouching. Keeping the idea simple allowed the campaign to work well across mediums – as ads, in-store posters, and direct/electronic mail. *For more information, visit www.richards.com and www.murderbooks.com*

183 Zink Ad | Design Firm: PUSH, Orlando | Art Director: Mark Unger | Chief Creative Officer: Chris Robb | Creative Director: Chris Robb | Designer: Forest Young | Photographer: Mark Unger | Client: Zink Magazine

184 Design Firm: Publicis, Shanghai | Art Directors: Kens Cao, Larry Ong | Copywriter: Gladys Meng, Paul Chai | Photographer: Xin Yu | Client: World Traveller Magazine

185 Don't let it go to your head. | Design Firm: Saatchi & Saatchi New York, New York | Art Directors: Carmine Coppola, Menno Kluin | Chief Creative Officer: Tony Granger | Photographer: Kurt Stallaert | Writers: Icaro Doria, Chuck Pagano | Client: Lürzer's Archive

186 Shake / Stairs – Our books take you further / World Map – The world is round. But the entranceway is rectangular. | Design Firm: JWT Brazil | Art Directors: Rodrigo Duarte, Fábio Miraglia | Creative Directors: Mario D'Andrea, Fábio Miraglia | Photography: Platinum (estante) | Writer: Alexandre "Nego Lee" Popoviski | Client: Editora Positivo | Print ads for a publishing house

RealEstate

187 IronHorse "Architect of Your Own Life" Campaign | Design Firm: tbdadvertising, Bend | Account Director: Jenni O'Keefe | Art Director: Audelino Moreno | Chief Creative Officer: Paul Evers | Creative Director: Paul Evers | Creative Strategist: René Bristow | Designer: Audelino Moreno | Illustrator: Adam Haynes | Photographer: Pete Stonw | Writer: Angela Reid | Client: Brooks Resources

This print campaign was created to introduce a new development in the rural community of Prineville, Oregon. Because of resident's fear of growth and change, it was very important that the print ads be authentic to the community, convey a sense of small town roots and capitalize on Prineville's heritage and tradition. The ads also needed to appeal to out-of-area markets by focusing on personal potential as a way to promote a more hopeful and optimistic future. Awareness of IronHorse is high in the community and surrounding areas. The first phase of the development has already sold out.

Restaurants

188 So good even Adam (top left) | Design Firm: WestWayne, Atlanta | Account Director: Jeff Baker | Art Directors: Garen Boghosian, John Stapleton | Chief Creative Officer: Scott Sheinberg | Creative Directors: Tom McMahon, James Rosene | Writer: Ryan Stafford | Client: Buffalo Wild Wings

188 Nuclear Plant (top right) | Design Firm: WestWayne, Atlanta | Account Director: Jeff Baker | Art Directors: Garen Boghosian, John Stapleton | Chief Creative Officer: Scott Sheinberg | Creative Directors: Tom McMahon, James Rosene | Writer: James Rosene | Client: Buffalo Wild Wings

188 Fish Fried (bottom left) | Design Firm: WestWayne, Atlanta | Account Director: Jeff Baker | Art Directors: Garen Boghosian, John Stapleton | Chief Creative Officer: Scott Sheinberg | Creative Directors: Tom McMahon, James Rosene | Writer: James Rosene | Client:Buffalo Wild Wings

188 Fingers to the Bone (bottom right) | Design Firm: WestWayne, Atlanta | Account Director: Jeff Baker | Art Directors: Garen Boghosian, John Stapleton | Chief Creative Officer: Scott Sheinberg | Creative Directors: Tom McMahon, James Rosene | Writer: Ryan Stafford | Client: Buffalo Wild Wings

189 Lamb Burger (top), BLT (bottom) | Design Firm: Colle + McVoy, Minneapolis | Art Director: Mike Caguin | Chief Creative Officer: Mike Fetrow | Group Creative Director: Mike Caguin | Photographer: John Christenson | Retouching: Greg Goranson | Writer: John Neerland | Client: Joe's Garage

What was the problem?

The primary problem was a lack of awareness for Joe's in an increasingly crowded Minneapolis restaurant landscape. A secondary problem was that ever since it opened, on a weekly basis, people would call Joe's Garage to ask about getting an estimate on a brake job.

What was the client's directive?

Create Advertising that would boost awareness of his restaurant during the crucial summer dining season.

What was your solution?

Our solution was not to run away from the car connection, but to fully embrace it. Joe's menu offerings are not the most traditional fare, so we thought our concept should reflect that.

How did this project evolve from a concept into a finished project?

Let's just say, matching up menu items and car logos isn't quite as easy as it might seem. Whenever we tried to force something like Porsche/Porcini or Chevrolet/Chardonnay, we knew it was time to take a break. In the end, thanks to some amazing photography from John Christenson and some expert retouching from Greg Goranson, we were put together something everyone was happy with.

What is your definition of good Advertising?

Really good Advertising has pass around or talk value amongst peers. If you get the, "Hey did you see that..." coming out of people's mouths than you know that you've created something special.

How do you establish an agency environment that fosters creativity?

For us, having lots of open space and no personal offices is a huge benefit. Having scooters, skateboards, soccer balls, and free soda doesn't hurt either.

Who do you most admire in the Advertising profession, past or present?

The Taco Bell chihuahua. I heard that dog was making more money and staying in much nicer hotels than I ever will. Little bitch.

Name a specific ad or campaign by one of your peers that you admire.

I love, love, love Goodby Silverstein's gettheglass.com. Brilliant.

What is your creative approach and/or philosophy?

There are two kinds of Advertising: Buy One Get One Free!, and the kind that creates an immediate emotional connection and builds loyalty over time. My approach is to quickly decide what kind of Advertising the assignment calls for and, if it's the latter, go all out.

190 Restaurants | Design Firm: SK+G, Las Vegas | Account Director: Norm Craft | Art Director: Irwina Liaw | Creative Director: Clay James | Executive Creative Director: Eric Stein | Photographer: Steven Lippman | Project Manager: Tory Kooyman | Writer: Jason Rohrer | Client: Borgata Hotel Casino & Spa | Location: Borgata - on location at restaurants

After the recent expansion of the Borgata Hotel Casino & Spa, the resort led the Atlantic City market with an astounding seven gourmet restaurants developed by some of America's most highly-regarded chefs. This seven-part print campaign was designed to convey to the target that Borgata is the best choice for unique dining options in the area. In the execution, we attempted to tie the venues together with some common graphic standards while also expressing each as a completely different experience. The voice throughout is singular and confident with a sense of wit and intellect. In some cases, the seven ads ran consecutively in The New York Times Magazine and Philadelphia Style. Five of the seven ads are being submitted.

191 Iwo Jima | Design Firm: Kohnke Hanneken, Milwaukee | Account Director: Denise Kohnke | Art Director: Rich Kohnke | Artist: Jim McDonald | Author: Dave Hanneken | Creative Directors: Dave Hanneken, Rich Kohnke | Illustrator: Jim McDonald | Photographer: Glen Gyssler | Writer: Dave Hanneken | Client: Mason Street Grill

This new restaurant positioned itself as a "Classic American Grill." So we used icon imagery to position it in this way.

Retail

192, 193 Platinum DFA Men | Design Firm: Peterson Milla Hooks, Minneapolis | Art Director: Amy Demas | Chief Creative Officer: Dave Peterson | Creative Director: Dave Peterson | Photographer: Ilan Rubin | Print Producer: Ellen Frego | Writer: Jenny Shears | Client: Target

What was the problem?

How do we go from the place guys buy bargain underwear to a destination for men's fashion? Without alienating the ducktape crowd.

What was the client's directive?

Stay true to Target and the message of Design for All. We sell toilet paper and well-priced designer digs. That's the beauty of it.

What was your solution?

Celebrate it. Pair the unexpected: the stuff guys need with the stuff guys want. But do it in a Target, way: well designed, simple, optimistic and to the point. Then place spreads in trusted fashion authority publications like Esquire and GQ.

How did this project evolve from a concept into a finished project?

The tricky part was finding shapes that compliment a model's pose amongst the thousands of items Target sells, and still allow for the wardrobe to be shown in all its glory. In the end, we shot the model first, then picked the product that matched and also told a bit of an incongruous story.

194 Platinum DFA Women | Design FirmDesign Firm: Peterson Milla Hooks, Minneapolis | Art Director: Amy Demas | Chief Creative Officer: Dave Peterson | Creative Director: Dave Peterson | Print Producer: Ellen Frego | Writer: Jenny Shears | Client: Target

What was the problem?

Fashion ads have become formulaic: a model wearing a trend-right outfit. If she's sullen, she's for a high priced brand. If she's beaming ear to ear, a discount retailer. How can Target break the mold and actualize its mission of Design for All.

What was the client's directive?

Focus on Issac Mizrahi's collection and make it feel like it could only come from Target.

What was your solution?

Eye-catching visual pairings that reaffirm Target's commitment to design. We utilized shape, color and styling to create the most compelling statement.

How did this project evolve from a concept into a finished project?

The process was certainly a little tricky. We had to find items within Isacc's collection that had an interesting shape that could mirror a model's pose (and do justiceto the clothes). So we photographed the model first, made our selects, then shot the products to match.

195 Platinum DFA In-Store | Design FirmDesign Firm: Peterson Milla Hooks, Minneapolis | Art Director: Amy Demas | Chief Creative Officer: Dave Peterson | Creative Director: Dave Peterson | Print Producer: Ellen Frego | Writer: Jenny Shears | Client: Target

What was the problem?

Target needed to get credits for its diverse range of products while not losing sight of its major core equities: celebrating the Design of everyday.

What was the client's directive?

Catch the eye of the busy moms walking through the doors and remind her why she shops at Target.

What was your solution?

Dramatic lighting set against rich black and white backgrounds made the product hero. The pairings gave it a Design aesthetic you'd expect from Target.

How did this project evolve from a concept into a finished project?

Item selection became critical. What shape/color/style compliments what? Ultimately, it was a whole lot of trial and error to find the perfect fit.

What is your definition of good Advertising?

Good Advertising connects the consumer to the brand emotionally. It showcases the personality of the brand while keeping the consumer surprised and entertained. Good Advertising also works.

What is your agency's greatest professional achievement?

Our work on Target. Helping to give the bullseye 98% consumer recognizibilty.

What part of your work do you find most demanding?

Making the same things everyone else sells stay fresh.

Why should a client come to you, and what do you feel you or your agency offers?

A client comes to us when they feel like their brand has more to say.

What inspires you?

Great Design.

What is your creative approach and/or philosophy?

Our philosophy is to persuade by provoking an emotional response.

196, 197 Target Commercial Interiors | Design Firm: Design Guys, Minneapolis | Art Director: Barry Townsend | Chief Creative Officer: Steve Sikora | Creative Director: Steve Sikora | Designer: Kelly Munson | Photographer: Chris Sheehan | Writer: Karen Lokensgard | Account Director: Rachel Lucia Buckvold | Client: Target

Objective: A Target branded look and feel with a professional edge. Their core audience is large business but they want to expand to small business opportunities, too. The new look and feel is Target branded with clean sensibility, a strong Design emphasis and direct copy that is friendly to both large and small businesses. The campaign is developing a stronger presence in the marketplace and products featured in the ads are selling very well.

198 Tee (top) | Design Firm: The Richards Group, Dallas | Art Director: Jimmy Bonner | Creative Directors: Rob Baker, Jimmy Bonner | Photographer: Steve Colwill | Print Producer: Natasha Naquin | Writer: Rob Baker | Client: PGA TOUR Superstore

198 Hangtags (bottom) | Design Firm: The Richards Group, Dallas | Art Director: Jimmy Bonner | Creative Directors: Rob Baker, Jimmy Bonner | Print Producer: Natasha Naquin | Writer: Rob Baker | Client: PGA TOUR Superstore

199 Carpet(top), Manhattan Outdoor (middle, bottom) | Design Firm: The Richards Group, Dallas | Art Director: Linsey Parks | Creative Director: Gary Gibson | Photographer: Barth Tillotson | Writer: Mackenzie Squires | Client: The Home Depot

200, 201 Watches | Design Firm: Avrett Free Ginsberg, New York | Art Director: Erik Denno | Creative Director: Scott Carlson | Client: Bertolucci

202, 203 Brand Advertising | Design Firm: Design Within Reach, San Francisco | Account Director: Frank Wild | Art Director: Tina Yuan | Creative Director: Jennifer Morla | Writer: Gwendolyn Horton | Client: Design Within Reach

204 Brain | Design Firm: WestWayne, Atlanta | Account Directors: Cindy Haynes, Scott Stuart | Art Director: Tom McMahon | Chief Creative Officer: Scott Sheinberg | Creative Director: John Stapleton | Photographer: Dave Spataro | Writer: Ryan Stafford | Client: Publix Supermarkets

205 Snow Angel | Design Firm: WestWayne, Atlanta | Account Directors: Cindy Haynes, Scott Stuart | Art Director: Taylor Crawford | Chief Creative Officer: Scott Sheinberg | Creative Directors: Tom McMahon, John Stapleton | Photographer: Dave Spataro | Writer: Molly Molina | Client: Publix Supermarkets

206 Taxidermy TV POS Poster | Design Firm: Borders Perrin Norrander, Portland | Art Director: Jeremy Boland | Creative Director: Terry Schneider | Photographer: David Emmite | Print Producer: Bev. Petty | Writer: Eric Terchila | Client: Columbia Sportswear

207 Geese POS Poster (top) | Design Firm: Borders Perrin Norrander, Portland | Art Director: Jeremy Boland, Kent Suter | Creative Director: Terry Schneider | Print Producer: Bev. Petty | Writer: Eric Terchila | Client: Columbia Sportswear

207 STOP POS Poster (bottom) | Design Firm: Borders Perrin Norrander, Portland | Art Director: Kent Suter | Creative Director: Terry Schneider | Photographer: Pete Stone | Print Producer: Bev. Petty | Writer: Kent Suter | Client: Columbia Sportswear

208 Design Firm: & Co., Copenhagen | Art Director: Thomas Hoffmann | Copywriter: Thomas Hoffmann | Photographer: Morten Larsen | Client: Bianco Footwear

209 Shopping is in our nature. (top right, top left) | Design Firm: Two By Four, Chicago | Account Director: Jen Nicks | Art Directors: Andy Kohman, Dave Wilson | Chief Creative Officer: David Stevenson | Creative Director: Dan Consiglio | Photographer: Glen Gyssler | Writer: Kelly Hardwick | Project Manager: Stephanie Deutch | Client: Grossmont Center

New campaign for outdoor shopping center.

209 Spaghetti Vongole (bottom right) | Design Firm: Heye&Partner GmbH, Unterhaching | Account Directors: Caro Aigner, Bianca Moser | Art Directors: Hannes Ciatti, Oliver Diehr | Photographer: Camillo Büchelmeier | Writer: Gunnar Immisch | Client: Di Gennaro

209 Bull (bottom left) | Design Firm: Heye&Partner GmbH, Unterhaching | Art Directors: Stefan Ellenberger, Sebastian Hackelsperger | Creative Director: Norbert Herold | Photographer: Ludwig Leonhardt | Print Producer: Matthias Remmling | Writer: Jan-Florian Ege | Client: Orion

SelfPromotions

210 Season's Greetings | Design Firm: Hoffman York, Inc., Milwaukee | Account Director: Dave Woelfel | Designer: Michael Sifuentes | Photographer: Mike Fuller | Client: Yamaha Motor Corporation

211, 212 Color Print | Design Firm: The Bradford Lawton Design Group, Inc., San Antonio | Art Director: Laura Trial | Creative Director: Bradford Lawton | Writer: Laura Trial | Client: Capital Printing Co.

213 Communication Arts Ad | Design Firm: Erickson Productions, Inc. | Designer: Carolee Coker | Photographer: Jim Erickson | Client: Erickson Productions, Inc.

Advertisement for Photographer Jim Erickson appeared in Communication Arts Magazine

214 Rolling Stone Lenticular Cover | Design Firm: Target | Art Director: Peterson Milla Hooks | Chief Creative Officer: Dave Peterson, Peterson Milla Hooks | Client: Target

Target partnered with Rolling Stone magazine on a back cover ad celebrating the magazine's 1000th issue. We offered a limited time only compilation CD featuring artists who made the magazine famous. A lenticular effect brought an audience to life: concertgoers swayed and waved flickering lighters while bullseyes danced in the background. The blend of innovative design, in-store support, and an exclusive offer elevated this idea from a single ad to a buzz-garnering, integrated strategy.

Software

215, 216, 217 Platinum The Chronological Series | Design Firm: Saatchi & Saatchi New York, New York | Art Director: Menno Kluin | Chief Creative Officer: Tony Granger | Creative Directors: Jan Jacobs, Leo Premutico | Writer: Icaro Doria | Client: Allume Systems/StuffIt Deluxe

Sports

218 Advertising for New York Store | Design Firm: 160over90, Philadelphia | Client: Cadence Cycling and Multisport Centers

219 Shadow Campaign | Design Firm: Commune, Lafayette | Account Director: Cache Mundy | Art Directors: Georgianna Allen, Greg Leschisin | Creative Directors: Georgianna Allen, Greg Leschisin | Illustrator: Pete Delong | Photographer: Brian Mark | Writer: Georgianna Allen | Client: Pearlizumi

220, 221 Platinum Infinite horizon - Molecular body (left), Infinite horizon - Elastic body (right) | Design Firm: Cetric Leung Design Co, Hong Kong | Account Director: Christine Man | Art Directors: Cetric Leung, Lee Pui Ho | Artist: Lee Pui Ho | Creative Directors: Danny Chan, Cetric Leung, Eliza Yick | Design Director: Cetric Leung | Designer: Lee Pui Ho | Executive Creative Director: Cetric Leung | Illustrator: Lim Peng Yam | Photographer: Daniel Zheng | Writers: Danny Chan, Antonius Chen, Eliza Yick | Client: Y+ Yoga Center

The objective of this campaign is to reinforce the branding philosophy: Yoga is not only physical training; it's also a journey of one's mind. Please see the Case Studies at front for more information on this award winning ad.

222 Puddle (top), Shrinking Goalie (bottom) | Design Firm: OLSON, Minneapolis | Account Director: Bob Molhoek | Art Directors: Gabe Gathmann, Derek Till | Chief Creative Officer: Tom Fugleberg | Creative Director: Brian Kroening | Print Producer: Irene Lockwood | Writers: Derek Bitter, Scott Dahl | Client: Nike Bauer Hockey

223 Cleats | Design Firm: Kohnke Hanneken, Milwaukee | Art Director: Grant Simpson | Author: Mike Holicek | Creative Directors: Dave Hanneken, Rich Kohnke | Executive Creative Directors: Dave Hanneken, Rich Kohnke | Photographer: Glen Gyssler | Writer: Mike Holicek | Client: Milwaukee Momentum Women's Football

Generates awareness of Milwaukee's only women's football league.

224 ANGEL | Design Firm: mcgarrybowen, New York | Art Director: Lew Willig | Creative Directors: Mark Koelfgen, Lew Willig | Executive Creative Directors: Warren Eakins, Randy Van Kleeck | Photographer: Kai Uwe Gundlach | Client: Reebok

A global print campaign for Reebok running that expresses a common way for runners to push themselves is using their surroundings as mental fuel.

225 I AM WHAT I AM/Amir Khan (top) | Design Firm: mcgarrybowen, New York | Art Directors: Warren Eakins, Matt Even | Creative Directors: Warren Eakins, Randy Van Kleeck | Photographer: Gary Land | Client: Reebok

225 I AM WHAT I AM/Allen Iverson (middle) | Design Firm: mcgarrybowen, New York | Art Directors: Warren Eakins, Matt Even | Creative Directors: Warren Eakins, Randy Van Kleeck | Photographer: John Huet | Client: Reebok

225 I AM WHAT I AM/Yao Ming (bottom) | Design Firm: mcgarrybowen, New York | Art Directors: Warren Eakins, Matt Even | Creative Directors: Warren Eakins, Randy Van Kleeck | Photographer: Walter Iooss | Client: Reebok

Travel

226, 227, 228 Platinum The Ultimate Hideout | Design Firm: Yield, Austin | Account Director: Marti Grandinetti | Art Director: Mike Coffin | Designers: Gaby Hoey, John Tullis | Executive Creative Director: Mike Coffin | Executive Creative Strategist: Scott Murray | Illustrator: A. J. Garces | Writer: Teresa Elliot | Client: Lajitas, The Ultimate Hideout

Lajitas is a four-star resort, secluded in Texas' Big Bend. A one-time stomping ground for Pancho Villa and "Blackjack" Pershing, Lajitas now boasts an international golf course, gourmet dining, a spa and plenty of activities to keep guests engaged as they connect with The Bend. See Case Studies at front for more information on this award winning ad.

229 Sponsors of the Oakland A's | Design Firm: GSD&M, Austin | Account Director: Crystal Potts | Art Director: Jeff Spillane | Creative Directors: Brent Ladd, Steve Miller | Photographer: Ken Anderson | Print Producer: Ellen Hanrahan | Project Manager: Marlo Gil | Writer: Heather Gorman | Client: Southwest Airlines

230, 231 What Will You Discover | Design Firm: The Richards Group, Dallas | Art Director: Jimmy Bonner | Creative Director: Glenn Dady | Illustrator: Dugald Stermer | Photographer: Andy Anderson | Print Producer: Kathleen Pendergast | Writer: Rob Baker | Client: Go RVing

232, 233 Pet Friendly Poster Campaign | Design Firm: BCF, Virginia Beach | Account Director: Jacinthe Pare | Art Director: Keith Ireland | Creative Director: Keith Ireland | Digital Artist: Alice Blue | Photographer: Keith Lanpher | Print Producer: Laura Walker | Writer: Ginny Petty | Client: Virginia Tourism Corporation

Poster campaign used to promote Virginia as a pet friendly travel destination

234 Motorsports Eye Chart | Design Firm: LKM, Charlotte | Account Director: Scott Gilmore | Art Director: Shawn Perritt | Creative Director: Jim Mountjoy | Print Producer: Sarah Peter | Writer: Lee Remias | Client: North Carolina Travel & Tourism

235 Goggles | Design Firm: BCF, Virginia Beach | Account Director: Greg Ward | Art Director: Keith Ireland | Creative Director: Keith Ireland | Photographer: Keith Lanpher | Print Producer: Laura Walker | Writer: Keith Ireland | Client: Wintergreen Resort

Poster to promote Wintergreen Resort's new high speed ski lifts

Zoos

236 Words Campaign | Design Firm: BBDO West, San Francisco | Art Director: Brandon Sides | Author: Neil Levy | Creative Director: Jim Lesser | Executive Creative Director: Jim Lesser | Client: San Francisco Zoo

237 Zoobilation Poster-Ibis | Design Firm: jay advertising, Rochester | Account Directors: Courtney Smith, Greg Smith | Art Director: Tim Winter | Chief Creative Officer: Ferdinand Jay Smith III | Creative Director: Bob Nisson | Photographer: John Myers | Print Producer: Marianne Warfle | Writer: Greg Shainman | Client: Seneca Park Zoo Society

Description: 8 x 3 ft. event posters. Zoobilation is the major fundraising bash held annually at Seneca Park Zoo. Our goal—as expressed in the tagline—was to excite people about a fun charitable event. To achieve this, we put the animals in their natural habitat and juxtaposed it with festive imagery, specifically, party icons that work organically with the animal's physical makeup.

238 Zoobilation Poster-Frog | Design Firm: jay advertising, Rochester | Account Directors: Courtney Smith, Greg Smith | Art Director: Tim Winter | Chief Creative Officer: Ferdinand Jay Smith III | Creative Director: Bob Nisson | Photographer: John Myers | Print Producer: Marianne Warfle | Writer: Greg Shainman | Client: Seneca Park Zoo Society

Description: 3.5 x 5 ft. event posters. Zoobilation is the major fundraising bash held annually at Seneca Park Zoo. Our goal was to excite people about a fun charitable event. To achieve this, we put the animals in their natural habitat and juxtaposed it with festive imagery, specifically, party icons that work organically with the animal's physical makeup.

DesignersDirectory

& Co. www.andco.dk
St. Strandstræde 9, Postbox 2231, 1019 Copenhagen, Denmark
Tel +45 3346 3300 | Fax +45 3346 3301

160over90 www.160over90.com
One South Broad St. 10th Floor, Philadelphia, Pennsylvania, United States, 19107
Tel 215 732 3200 | Fax 215 732 1664

Avrett Free Ginsberg www.afg1.com
1 Dag Hammarskjold Plaza, 34th Floor, New York, NY, United States, 10017
Tel 212 862 3800 | Fax 212 486 7854

Bailey Lauerman www.baileylauerman.com
1248 O Street, Suite 900, Lincoln, NE, United States, 68508
Tel 402 475 2800 | Fax 402 475 0428

Bates Enterprise
8A Bahadurshah Zafar Marg, Milap Niketan, New Delhi, India, 110002 | Tel 011 43529000

BBDO West www.bbdo.com
555 Market Street, 17th floor, San Francisco, CA United States, 94105
Tel 415 808 6200 | Fax 415 808 6221

BBK Studio www.bbkstudio.com
648 Monroe Ave. NW Suite 212, Grand Rapids, MI, United States, 49503 | Tel 616 459 4444

BCF www.bc-f.com
240 Business Park Drive, Virginia Beach, VA, United States, 23462
Tel 757 497 4811 | Fax 757 497 3684

Bernstein-Rein www.bernstein-rein.com
4600 Madison Ave. Kansas City, MO, United States, 64112 | Tel 816 756 0640

Borders Perrin Norrander www.bpninc.com
808 SW Third, 8th Floor, Portland, OR, United States, 97204 | Tel 503 227 2506 | Fax 503 227 4827

Butler, Shine, Stern & Partners www.bssp.com
20 Liberty Ship Way, Sausalito, CA, United States, 94965 | Tel 415 331 6049 | Fax 415 331 3524

BVK www.bvk.com
250 West Coventry Court, Suite 300, Milwaukee, WI, United States, 53217 | Tel 414 228 1990

Cetric Leung Design Co www.cld.com.hk
1504 Valley Centre, 80-82 Morrison Hill Road, Hong Kong , Hong Kong,
Tel (852) 2520 0311 | Fax (852) 2572 0310

Clara www.clara.se
Box 216 Karlstad, Sweden, 65106 | Tel +4654102444 | Fax +4654102099

Colle + McVoy www.collemcvoy.com
400 First Ave N, Suite 700, Minneapolis, MN, United States, 55401 | Tel 612 305 6169

commune
108 E Cleveland Street, Lafayette, CO, United States, 80026 | Tel 303 664 9292

Cramer-Krasselt www.c-k.com
225 N. Michigan Ave. 24th Floor, Chicago, IL, United States, 60601
Tel 312 616 9600 | Fax 312 616 9600

DDB, Copenhagen www.ddbdanmark.dk
Bredgade 6, PO Box 2074, DK-1013 Copenhagen, Denmark | Tel 45 33 46 30 00 | Fax 45 33 46 30 01

Design Guys www.designguys.com
119 North 4th Street, Suite 400, Minneapolis, MN, United States, 55401 | Tel 612 338 4462

Design Within Reach www.dwr.com
225 Bush Street, 20th floor, San Francisco, CA, United States, 94104
Tel 415 676 6586 | Fax 415 676 6886

DeVito/Verdi www.devitoverdi.com
111 Fifth Avenue, 11th Floor, New York, NY, United States, 10003 | Tel 212 431 4694 | Fax 212 431 4940

Draftfcb Seattle www.draftfcb.com
605 Fifth Avenue, South Suite 900, Seattle, WA, United States, 98104
Tel 206 628 3621 | Fax 206 223 2765

EJE Sociedad Publicitaria
#122 Eleanor Roosevelt, Hato Rey, PR, United States, 00918 | Tel 787 766 7140 | Fax 787 766 7178

Erickson Productions Inc. www.jimerickson.com
2 Liberty Street, Petaluma, CA, United States, 94952 | Tel 707 789 0405 | Fax 707 789 0459

FabraQuinteiro www.fabraquinteiro.com.br
Rua Manuel Guedes, 330, Itaim Bibi, 04536-070, Sao Paolo, Brazil
Tel 55 11 3512 6000 | Fax 55 11 3078 5725

Fairly Painless Advertising www.fairlypainless.com
44 E Eighth Street, Holland, MI, United States, 49423 | Tel 616 394 5900

Fitzgerald+CO www.fitzco.com
3060 Peachtree Road, Suite 500, Atlanta, GA, United States, 30305 | Tel 404 504 6963

Flow Creative www.flowcreative.net
1644 North Honore, Suite 105, Chicago, IL, United States, 60622
Tel 773 276 4425 | Fax 773 276 4425

Giovanni+Draftfct www.giovannidraftfcb.com.br
Praia de Botafogo, 228, Centro Empresarial Botafogo, Rio de Janeiro, Brazil 22359-900
Tel + 55 (21) 3501-8500 | Fax + 55 (21) 2553-5807

Goodby, Silverstein & Partners www.gspsf.com
720 California Street, San Francisco, CA, United States, 94108 | Tel 415 392 0669 | Fax 415 955 6291

Greenfield/Belser Ltd. www.gbltd.com
1818 N Street NW, Suite 110, Washington, DC, United States, 20036
Tel 202 775 0333 | Fax 202 775 0402

Grey London www.grey.co.uk
The Johnson Building, 77 Hatton Garden, London EC1N 8JS | Tel +44 (0)20 30337 3000

GreyHome, Lisbon www.greyhome.pt
1495-014 Lisbon, Portugal | Tel 351 214 111 000 | Fax 351 214 111 038

GSD&M www.gsdm.com
828 West 6th Street, Austin, TX, United States, 78703 | Tel 512 242 4736 | Fax 512 242 8800

Heye&Partner GmbH
Ottobrunner Street 28, Unterhaching Bavaria, Germany, 82008
Tel 004989665321340 | Fax 004989665321380

Hoffman York, Inc. www.hoffmanyork.com
1000 N. Water Street, 16th Floor, Milwaukee, WI, United States, 53202
Tel 414 289 9700 | Fax 414 289 0417

Howard, Merrell & Partners www.merrellgroup.com
8521 Six Forks Road, Raleigh, NC, United States, 27615 | Tel 919 848 2400 | Fax 911 845 9845

HSR Business to Business www.hsr.com
300 E-Business Way, Suite 500, Cincinnati, OH, United States, 45241
Tel 513 671 3811 | Fax 513 671 8163

Jay Advertising www.jayadvertising.com
170 linden oaks, Rochester, NY, United States, 14625 | Tel 585 264 3644

Jung von Matt www.jmv.ch
Wolfbachstrasse 19, 8032 Zürich, Switzerland | Tel +41 44 254 66 00 | Fax +41 44 254 66 01

JWT Brazil www.jwt.com.br
R. Mária Amaral. 50 – Paraiso, CEP 04002-020 – Sao Paulo – SP
Tel 11 3888 8000 | Fax 11 3887 0173

KNARF
10 West 15th Street #204, New York, NY, United States, 10011 | Tel 516 413 3825

Kohnke Hanneken www.khmojo.com
233 North Water Street, 5th Floor, Milwaukee, WI, United States, 53202 | Tel 414 271 1314

Leo Burnett, Melbourne www.leoburnett.com
Level 4, 464 St. Kilda Road, Melbourne, Victoria 3004 | Tel 61 392511300 | Fax 61 392511350

Lewis Communications www.lewiscommunications.com
600 Corporate Parkway, Suite 200, Birmingham, AL, United States, 35242
Tel 205 980 0774 | Fax 205 437 0250

LKM www.lkmideas.com
6115 Park South Drive, Suite 350, Charlotte, NC, United States, 28210
Tel 704 364 8969 | Fax 704 364 8470

Loomis Group www.loomisgroup.com
425 Boylston St #5, Boston, MA, United States, 02116 | Tel 671 638 0022 | Fax 617 638 0033

Lopez Negrete Communications www.lopeznegrete.com
3336 Richmond Avenue, Houston, TX, United States, 77098 | Tel 713 877 8777

MacLaren McCann www.maclaren.com
10 Bay Street, Toronto, Ontario, Canada, M5J 2S3 | Tel 416 594 6000 | Fax 416 643 7027

McCann, Oslo www.mccann.no
Sandakerveien 24 C, bygning C1, Postboks 4228 Nydalen, NO-0401 OSLO
Tel +47 22 54 36 00 | Fax +47 22 54 36 03

McCann-Erickson, San Francisco www.mccann.com
600 Battery Steet, San Francisco, A, United States, 94111 | Tel 415 262 5600

McCann Erickson, Singapore www.mccann.com
40A Orchard Road, #06-00 The MacDonald House, Singapore, 238869
Tel 65 67 379 911 | Fax 65 62 359 576

mcgarrybowen www.mcgarrybowen.com
601 W. 26th Street, Suite 1150, New York, NY, United States, 10001 | Tel 212 488 4460

Modernista! www.modernista.com
109 Kingston Street, Boston, MA, United States, 02111 | Tel 617 451 1110 | Fax 617 451 8680

Momentum Seven
P.O.Box 6834, Emarat Atrium, Sheihk Zayed Rd. Dubai, United Arab Emirates
Tel 971 50 42 950 69

Ó! www.oid.is
Armuli 11, Reykjavik, Iceland, 108 | Tel +354 562 3300

Ogilvy, Guatemala City www.ogilvy.com
Ave. Reforma 6-39 Z. 10, Centro Corporativo Guayacn, Nivel 9, Guatemala City 010010, Guatemala
Tel +502 2420 8300

OLSON www.oco.com
1625 Hennepin Ave, Minneapolis, MN, United States, 55403 | Tel 612 215 7298

On Target Advertising www.ontargetad.com
1955 Mayview Drive, Los Angeles, CA, United States, 90027 | Tel 323 668 2743 | Fax 323 668 2037

Ongoing Co., Ltd. www.ongoing.co.th
4/3 Decho Road, Suriyawongse, Bangrak, Bangkok, Thailand, 10500
Tel 662 634 8700 | Fax 662 233 1401

Percept H Pvt. Ltd www.perceptindia.com
P2, Raghuvanshi Estate, S B Marg, Mumbai Maharashtra, India, 400 013
Tel 91 22 30428811 | Fax 91 22 24923337

Peterson Milla Hooks www.pmhadv.com
1315 Harmon Place, Minneapolis, MN, United States, 55403 | Tel 612 349 9116 | Fax 612 349 9141

Publicis Mid America www.publicis-usa.com
14185 N. Dallas Pkwy, Suite 400, Dallas, TX, United States, 75254
Tel 972 628 7651 | Fax 972 628 7805

Publicis, Shanghai www.publicis.com
6/F, Building A, 98 Yan Ping Rd, Shanghai 200042 | Tel +86 21 2208 3838 | Fax +86 21 2208 3990

PUSH www.pushhere.com
150 N. Orange Ave. Suite 300, Orlando, FL, United States, 32801
Tel 407 841 2299 | Fax 407 841 0999

Pyper Paul + Kenney, Inc. www.pyperpaul.com
1121 E. Twiggs Street, Level 1, Tampa, FL, United States, 33602
Tel 813 496 7000 | Fax 813 496 7002

Redux Pictures www.reduxpictures.com
116 E. 16th Street, 12th Floor, New York, NY, United States, 10003
Tel 212 253 0399 | Fax 212 253 0397

Richter7 www.richter7.com
280 South 400 West, Ste 200, Salt Lake City, Utah, United States 84101
Tel 801 521 2903 | Fax 801 359 2420

Rodgers Townsend www.rodgerstownsend.com
1310 Papin Street, St. Louis, MO, United States, 63103 | Tel 314 436 9960 | Fax 314 436 9960

Saatchi & Saatchi, Mumbai www.saatchi.com
1st Floor Sitaram Mills, N M Joshi Marg, Mumbai 400011. India
Tel +912266103017 | Fax +912223000302

Saatchi & Saatchi, New York www.saatchiny.com
375 Hudson Street, 18th floor, New York, NY, United States, 10014 | Tel 212 463 2703

Scholz & Friends www.s-f.com/hamburg
Hanseatic Trade Center, Am Sandtorkai 76, 20457 Hamburg, Germany
Tel +49(0)40-3 76 81–0 | Fax +49(0)40-3 76 81–681

Sibley/Peteet Design www.spddallas.com
3232 McKinney Avenue, Suite 1200, Dallas, TX, United States, 75204
Tel 214 969 1050 | Fax 214 969 7585

SK+G www.skgadv.com
8912 Spanish Ridge Ave. Las Vegas, NV, United States, 89148
Tel 702 478 4060 | Fax 702 478 4360

Sukle Advertising & Design www.sukle.com
2430 West 32nd Avenue, Denver, CO, United States, 80211 | Tel 303 964 9100

Tactical Magic www.tacticalmagic.com
1460 Madison Ave. Memphis, TN, United States, 38104 | Tel 901 722 3001 | Fax 901 722 2144

Target www.target.com
1000 Nicollet Mall, TPS-2777, Minneapolis, MN, United States, 55403 | Tel 612 696 4446

TAXI Canada Inc www.taxi.ca
495 Wellington Street, West, Suite 102, Toronto, Ontario, Canada, M5V 1E9
Tel 416 979 7001 ext 321 | Fax 416 979 7626

TAXI, Inc. (NYC) www.taxi-nyc.com
11 Beach Street, 10th Floor, New York, NY, United States, 10013 | Tel 212 414 8294

tbdadvertising www.tbdadvertising.com
856 NW Bond Street #2, Bend, OR, United States, 97701 | Tel 541 388 7558 | Fax 541 388 7532

The Bradford Lawton Design Group, Inc. www.bradfordlawton.com
1020 Townsend, San Antonio, TX, United States, 78209 | Tel 210 832 0555 | Fax 210 832 0007

The Halo Group www.thehalogroup.net
350 Seventh Avenue, 21st Floor, New York, NY, United States, 10001
Tel 212 643 9700 | Fax 212 871 0150

The Hive Strategic Marketing Inc. www.thehiveinc.com
431 King Street West, Third Floor, Toronto, Ontario, Canada, M5V 1K4
Tel 416 923 3800 | Fax 416 923 4123

The Integer Group www.integer.com
7245 West Alaska Drive, Lakewood, CO, United States, 80226 | Tel 303 393 3000

The Richards Group www.richards.com
8750 N. Central Expressway, Suite 1200, Dallas, TX, United States, 75231
Tel 214 891 5700 | Fax 214 891 5700

Two By Four www.twoxfour.com
208 South Jefferson, 410, Chicago, IL, United States, 60661
Tel 312 382 0100 | Fax 312 382 8003

Venables, Bell & Partners www.venablesbell.com
201 Post Street, Suite 200, San Francisco, CA, United States, 94108
Tel 415 288 3300 | Fax 415 421 3683

w brandconnection
4F. GIIR Partners Bldg., 269-13 Nonhyun-dong, Gangnam-gu, Seoul, 135-010, Republic of Korea
Tel 82 2 2056 3690 | Fax 82 2 2135 9980

WestWayne, Atlanta www.westwayne.com
1170 Peachtree Street, Suite 1500, Atlanta, GA, United States, 30309
Tel 404 347 8726 | Fax 404 347 8907

WestWayne, Tampa www.westwayne.com
401 E. Jackson St. Suite 3600, Tampa, FL, United States, 33602 | Tel 813 202 1200

YARD www.yardnyc.com
5 West 19th Street, 6th Floor, New York, NY, United States, 10011 | Tel 212 625 8372

Yield www.yieldinc.com
823 Congress Ave. Suite 525, Austin, TX, United States, 78701 | Tel 512 450 5050

Young & Rubicam, Mexico www.yr.com
Bosques de Duraznos No. 61-5, Col. Bosques de las Lomas, Mexico, D.F. D.F., Mexico, 11700
Tel 1500 0000 | Fax 1500 0129

Young & Rubicam, Singapore www.yr.com
300 Beach Road, #30-00 The Concourse, Singapore | Tel (65) 62950025 | Fax (65) 62949790

Writers

Clients

Graphis Standing Orders (50% off):

Get 50% off the list price on new Graphis books when you sign up for a Standing Order on any of our periodical books (annuals or bi-annuals).

A Standing Order is a subscription to Graphis books with a 2 year commitment. Secure your copy of the latest Graphis titles, with our best deal, today online at *www.graphis.com*.

Click on Annuals, and add your selections to your Standing Order list, and save 50%.

Graphis Titles

DesignAnnual2008

Spring 2007　　　　　*Trim: 8.5 x 11.75"*
Hardcover: 256 pages　　*ISBN: 1-932026-43-6*
300 plus color illustrations　　*US $70*

GraphisDesignAnnual2008 is the definitive Design exhibition, featuring the year's most outstanding work in a variety of disciplines. Featured categories include Books, Brochures, Corporate Identity, Interactive, Letterhead, Signage, Stamps, Typography and more! All winners have earned the new Graphis Gold and/or Platinum Awards for excellence. Case studies of Platinum winning artists and their work complete the book.

Brochures6

Fall 2007　　　　　*Trim: 8.5 x 11.75"*
Hardcover: 256 pages　　*ISBN: 1-932026-48-7*
300 plus color illustrations　　*US $70*

GraphisBrochures6 demonstrates the potency of the brochure medium with close ups, reproductions of covers and inside spreads from the award winners. Each of these outstanding brochures has earned a Graphis Gold and/or Platinum Award for excellence. Case studies of a few, carefully selected Platinum winning artists and their work complete the book. The sixth volume of this popular series also features an index of firms, creative contributors and clients.

AdvertisingAnnual2008

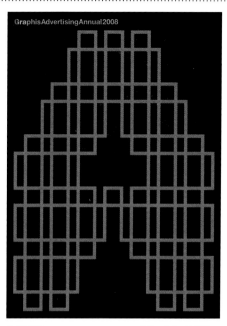

Fall 2007　　　　　*Trim: 8.5 x 11.75"*
Hardcover: 256 pages　　*ISBN:1-932026-44-4*
300 plus color illustrations　　*US $70*

GraphisAdvertisingAnnual2008 showcases over 300 single ads and campaigns, from trade categories as varied as Automotive, Film, Financial Services, Music, Software and Travel. All have earned the new Graphis Gold Award for excellence, and some outstanding entries have earned the Graphis Platinum Award. This year's edition also includes case studies of a few Platinum-winning Advertisements. This is a must-have for anyone in the industry.

PosterAnnual2007

Summer 2007　　　　*Trim: 8.5 x 11.75"*
Hardcover: 256 pages　　*ISBN: 1-932026-40-1*
200 plus color illustrations　　*US $70*

GraphisPosterAnnual2007 features the finest Poster designs of the last year, selected from thousands of international entries. These award winning Posters, produced for a variety of corporate and social causes, illustrate the power and potential of this forceful visual medium. This year's edition includes interviews with famed Japanese Designer **Shin Matsunaga, Marksteen Adamson** of Britain's ASHA and Swiss Poster Curator **Felix Studinka**.

PhotographyAnnual2007

Winter 2006　　　　*Trim: 8.5 x 11.75"*
Hardcover: 240 pages　　*ISBN: 1-932026-39-8*
200 plus color illustrations　　*US $70*

GraphisPhotographyAnnual2007 is a moving collection of the year's best photographs. Shot by some of the world's most respected artists, these beautiful images are organized by category for easy referencing. This book includes interviews with **Albert Watson** on his latest work, "Shot in Vegas," **Joel Meyerowitz** on the dramatic September 11th recovery series, *Aftermath*, and **Paolo Ventura** on his recently released and haunting *War Souvenir* series.

AnnualReports2007

Fall 2007　　　　　*Trim: 8.5 x 11.75"*
Hardcover: 224 pages　　*ISBN: 1-932026-41-X*
200 plus color illustrations　　*US $70*

GraphisAnnualReports2007 features the year's best Annual Reports in a variety of industries. Designed by **Kuhlmann-Leavitt, Inc.** and selected by an elite panel of judges, each piece has earned a new Graphis Gold and/or Platinum award. Includes covers and spreads, Q&As with each award winner, a judges' roundtable discussion, as well as standout Annual Reports from the judges' own careers. Detailed credits and index complete the book.

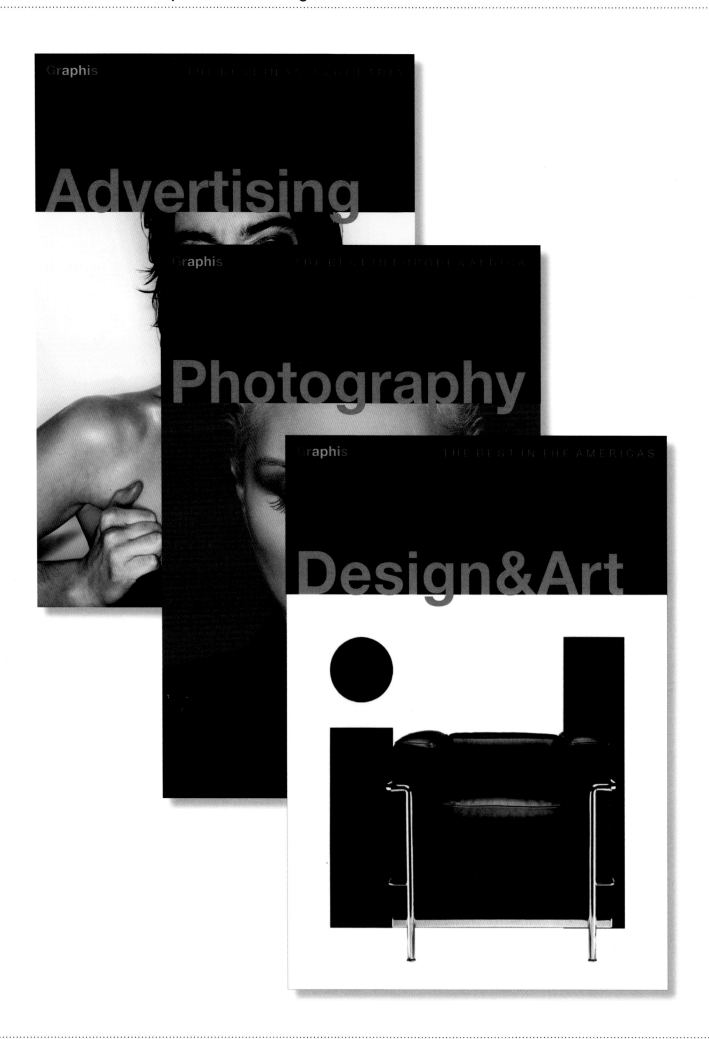